MONET'S GIVERNY

An Impressionist Colony

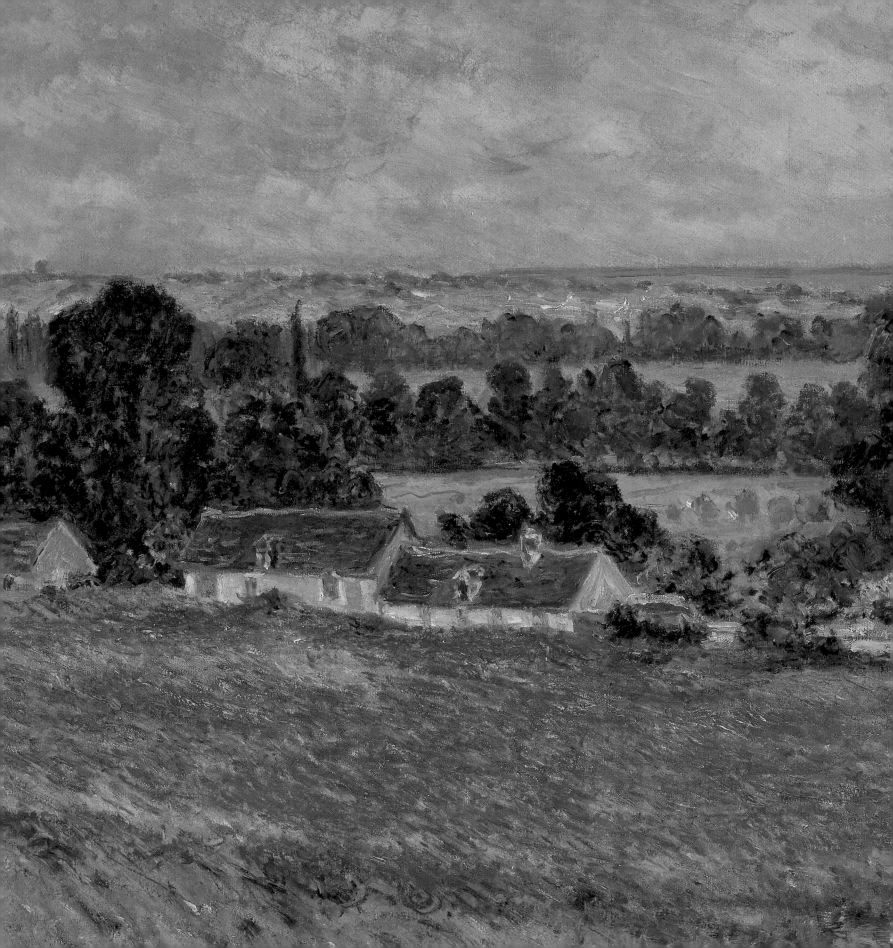

MONET'S GIVERNY

An Impressionist Colony

WILLIAM H. GERDTS

ABBEVILLE PRESS PUBLISHERS

New York London Paris

For Florence and Ralph Spencer

Front cover: Detail of Frederick Frieseke, *The Garden Parasol,* c. 1909. See plate 142.
Back cover: Mary Hubbard Foote, *View Through the Studio Window,*
Giverny, c. 1899–1901. See plate 122.
Endpapers: Arthur B. Frost, *Giverny,* 1908–10. Pencil on paper,
8½ x 11¼ in. (21.6 x 28.6 cm). Private collection.
Frontispiece: Detail of Claude Monet, *Field of Poppies, Giverny,* 1885. See plate 58.
Title page: Detail of John Singer Sargent, *Claude Monet Painting at the Edge*
of a Wood, 1885. See plate 20.

EDITOR: NANCY GRUBB
DESIGNER: JOEL AVIROM
PRODUCTION EDITORS: SARAH KEY AND PAUL MACIROWSKI
PICTURE EDITORS: LAURA STRAUS, FERRIS COOK, AND CHRISTA KELLY
PRODUCTION SUPERVISOR: MATTHEW PIMM
SIDEBARS COMPILED BY CAROL LOWREY

First edition

Library of Congress Cataloging-in-Publication Data

Gerdts, William H.
 Monet's Giverny : an impressionist colony / William H. Gerdts.
 p. cm.
 Includes bibliographical references and index.
 ISBN 1-55859-386-1
 1. Impressionism (Art)—France—Giverny. 2. Artist colonies—France—Giverny.
3. Impressionist artists—France—Giverny. 4. Giverny (France)—Social life and customs—
19th century.
I. Monet, Claude, 1840–1926. II. Title.
ND551.G5G47 1993
709'.44'24—dc20 93-7379

CONTENTS

Claude Monet in Giverny

In late April 1883 the forty-three-year-old French Impressionist Claude Monet moved from Poissy to the small peasant community of Giverny, forty miles northwest of Paris. There he would remain for the rest of his career, and there he would paint many of his most famous canvases. He had produced very few pictures in Poissy, and he had not stayed there long before seeking a more suitable environment for his common-law wife, Alice Hoschedé, and for his two sons and the six Hoschedé children. Monet had traveled by train down to the Epte Valley and explored along the Seine until he came upon the little village of Giverny.

The town basically consisted of two streets lined with low stone houses covered with faded pink or green stucco and with slate or thatched roofs. These streets were, and are still, bisected by a few narrow lanes just wide enough for two farm wagons to pass. Bordering the roadways were walls enclosing barnyards and poultry sheds, over which were visible the tops of fruit trees.

The village was situated on the Epte, a poplar- and willow-lined branch of the Seine, which served as a subject for Monet and for countless other painters. Monet was also to utilize the Ru, a lesser branch of the Epte that also issued into the Seine, diverting a small part of it so that he could have flowing, not stagnant water to nurture his great lily-pond garden. The Ru was bordered by pollarded willows, which

1. Detail of Claude Monet, *The Artist's Garden at Giverny,* 1895. See plate 9.

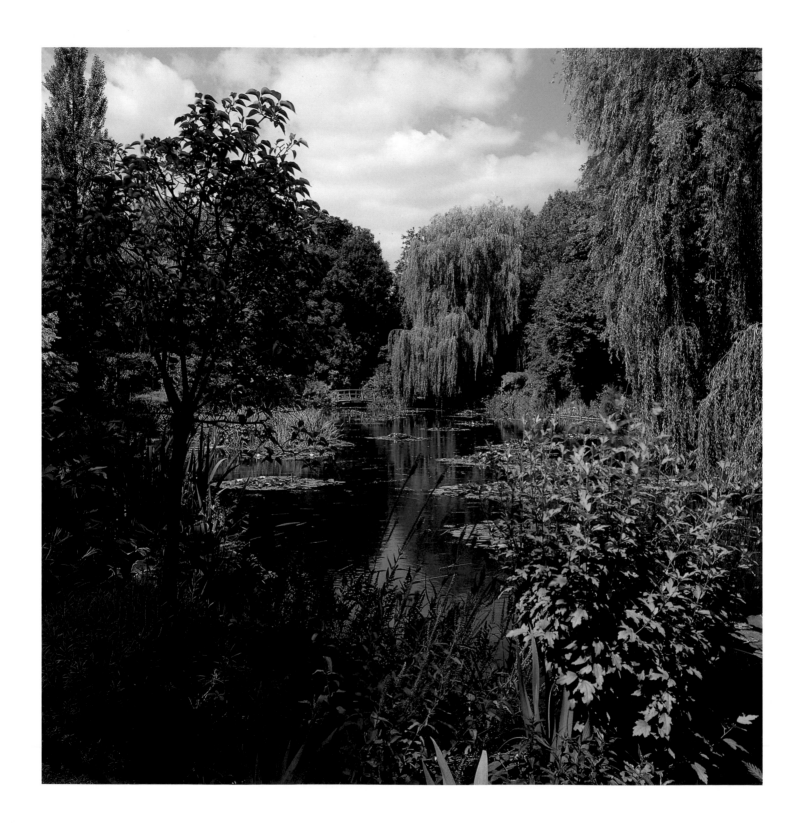

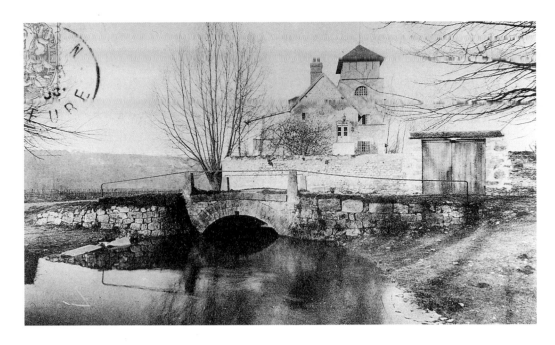

OPPOSITE

2. *Lily Pond, Giverny.* Photograph by Allen Rokach.

LEFT

3. *Bridge on the Epte and the Old Mill,* c. 1900. Vintage postcard.

BELOW

4. *The River Epte near the Giverny Railroad Station.* Vintage postcard.

assumed distinctive shapes as their lower branches were removed for firewood, and they, too, became favorite motifs for both Monet and the visiting foreign artists.

Just a few miles from Giverny was the commercial town of Vernon, with its monumental church that would become a subject for Monet. Vernon was a railroad hub on the Paris-Rouen line; a branch line from Vernon to Gisors passed through Giverny, but most travelers preferred to reach the latter by coach, bicycle, or foot. The road out of Vernon passes over a bridge traversing the Seine and then turns upstream along the north bank of the river, passing the hamlet of Vernonnet and reaching the mouth of the Epte. The hills above Giverny, rugged at their summit, slope gently down toward the plains called the Ajoux and the Essarts, which the Seine often flooded in winter. On the south bank of the Seine, opposite Giverny, wooded hills rose more abruptly, ranging from Bonnières in the east to Vernon.

Giverny was not a particularly picturesque village, consisting for the most part of farmers' houses, four cafés, a blacksmith's shop, three mills, a school, the early Norman church of Sainte Radégonde (parts of which date back to the eleventh century), the *mairie* (town hall), and a train station. The local inhabitants rose

The village [Giverny] is on the road from Paris to Rouen, in the lovely Seine valley. . . . A long winding road is bordered with plastered houses, whose lichen-covered, red-tiled roofs gleam opalescent red and green in sunlight, or look like faded mauve velvet in the shadow. High walls surround picturesque gardens; and long hillsides, checkered with patches of different vegetable growths, slope down to low flat meadows through which runs the river Epte, bordered with stunted willows . . . poppies and violets are everywhere. Peasants . . . call a greeting as they sit or lie on the grass beside their grazing cattle, or drive their great Norman horses, made picturesque by high blue fur-trimmed collars.

Guy Rose, "At Giverny,"
Pratt Institute Monthly 6
(December 1897): 81.

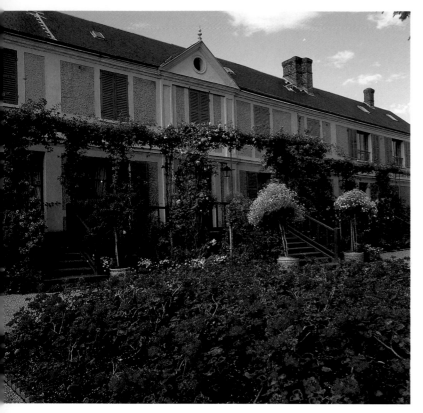

early and worked long, growing grain and vegetables, cultivating their orchards, attending their grazing cattle and sheep, and making cider.

Monet's house, in fact, was called the Maison du Pressoir (Cider-Press House). At first he rented it from a major landowner, Louis-Joseph Singeot, who had retired to Vernon; not until November 1890 was Monet able to purchase the property. A farmhouse with a kitchen garden and orchard, it was situated on two acres located between the rue de l'Amsicourt—the "high" or village road (now rue Claude Monet)—and the chemin du Roy, which connected Vernon and Gasny. The house was large enough to contrast with those of his poor neighbors, who regarded the artist with suspicion. They considered him proud and disinclined to join in local gossip; he, in turn, tended to ignore them. The town was quite insular, and some of the local inhabitants had not visited Paris since childhood, with nearby Vernon usually their farthest destination.[1] The villagers took advantage of Monet and his family, requiring them to pay a toll to walk to the Seine along the path between the Ajoux and the Essarts fields. They would also set his boats adrift from their moorings among the willow trees where the Epte meets the Seine. This forced Monet to purchase a parcel of land where he built a shed for his four boats (see plate 7), which also served as shelter for his easels and canvases.

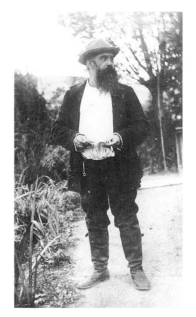

Monet, unlike the foreign artists who later arrived in Giverny, never painted the local inhabitants. His disinclination to incorporate his neighbors into his paintings was no doubt intensified by their opposition to the development of his property. Eventually, though, as time went on and as Monet's increasing wealth allowed him to make ever more elaborate adjustments to his property, local workers of all kinds—masons, gardeners, the blacksmith, and the farmers too—profited from his presence. And so admiration grew for the man, if not especially for his art.

Monet's social life in the village revolved around his extended family, the local priest, and visits by artists, patrons, and friends from Paris and elsewhere. Monet developed a special fondness for the automobile he acquired in 1901. Although he never learned to drive, the family used it for excursions in and around Giverny and beyond, and the car was also called into service to bring visitors to the house from the train station in Vernon.

Once Monet had purchased his Maison du Pressoir, much of his attention and income was devoted to improving the house. The shutters and trim of the dull pink

7. John Leslie Breck (1860–1899). *The River Epte with Monet's Atelier-Boat*, c. 1887–90. Oil on canvas, 13 x 16 in. (33 x 40.6 cm). Adelson Galleries, Inc., New York.

plaster house were painted a bright green. Later, as the village prospered, that color became known as "Monet green," and the inhabitants used it to paint their doors and garden furniture.[2] Soon after Monet moved to Giverny he incorporated an adjacent barn into the main house to serve as a studio; he enlarged it in the mid-1880s and further altered it in 1891. This became the family sitting room, hung with his earlier paintings, after he built a second studio in 1897; a third was built in 1914, in which he worked on his Water Lily paintings. By late 1893 Monet had established the basic decoration of the house itself, centered on the dining room, which was painted in shades of yellow, with the backs of the doors in violet. A small salon was also painted violet or blue. Monet's collection of Japanese prints hung in the dining room, while his collection of works by his Impressionist friends, especially Auguste Renoir and Paul Cézanne, hung upstairs.

Even before he purchased the property, Monet replaced the vegetable garden in front of the house with a flower garden, so that he would have flowers to paint on inclement

An hour's ride by train . . . we get to Vernon. At the station exit . . . a sort of delivery van . . . waits to take me to Giverny. . . . The road is delightful with meadows on either side, livestock grazing in lush grassland . . . and here and there you catch a glimpse of the brook, ringing with the merry noise of washing women, and . . . on the hillside, the open wounds of sandstone quarries, which tumble down in grey and whitish streams. . . . Under the sun, the ribbon-like road stretches for four kilometers. We pass by a countrywoman leading her cow. . . . This is the real country. Paris is forgotten—indistinct in our memory.

Maurice Guillemot,
"Claude Monet," *La Revue
illustrée* 13 (March 15, 1898).

days; a new kitchen garden was installed at the Maison Bleue (Blue House), which Monet also acquired, at the other end of town, on the rue du Chêne. In the flower garden behind the main house, he designed paths bordered by planters full of flowers and trellises for climbing roses, and he created greenhouses to ensure a proliferation of blooms through all the seasons of the year. The garden was divided into squares, each crowded but not overgrown with explosive arrangements of colors. Surrounded by only a low wall, it was visible to all who passed along the road bordering the property. Monet did his own gardening at first, then began to hire gardeners in 1892.

The following year, with the conscious plan of creating an appealing motif for his brush, he bought the meadow and pond beyond the railroad. After much deliberation and controversy, in July 1893 the town council permitted Monet to redirect the Ru, which flowed through the meadow, in order to enlarge and reshape his garden. Work began immediately and was completed that autumn, resulting in the water garden made famous in his paintings—filled with lilies, bordered by flowers and willows, and crossed by a green Japanese bridge. During the first quarter of the twentieth century Monet enlarged the water garden several times, and he devoted almost all of his pictorial energy to rendering the two adjacent gardens. Their increasingly spectacular beauty and the growing numbers of paintings he derived from them served as inspiration for the foreign artists who began to settle in Giverny during the 1890s.

The nature of Monet's garden—a purely decorative floral fantasy created to delight the eye as well as to furnish motifs for paintings—distanced him even further from his agrarian neighbors, whose gardens and orchards were pragmatically devoted to vegetables and fruits. Flower gardens were the province of an artist, not a peasant, and Monet was the first to develop one in Giverny, followed by a number of the American colonists. Only later, in the early years of the twentieth century, would the natives' houses be covered with trellised roses and surrounded by box-bordered flower gardens.[3] Monet shared his floral interests with Abbé Anatole Toussaint, the Giverny priest, who became renowned for his study of the local flora and who assisted the botanical researches of two of the youths in the Monet-Hoschedé ménage—Monet's son Michel and Alice's youngest child, Jean-Pierre; the latter published a book with Toussaint on the subject in 1898.[4]

BELOW

11. *Bridge in Monet's Garden.*
Vintage photograph. Lilla Cabot
Perry Papers, Archives of American Art, Smithsonian Institution,
Washington, D.C.

RIGHT

12. *Lily Pond, Giverny.*
Photograph by Allen Rokach.

OPPOSITE

13. *Lily Pond, Giverny.*
Photograph by Allen Rokach.

Until Monet began to limit himself to painting his own extensive gardens, some of his principal Giverny themes were the rivers, fields, and trees of his adopted village. Except for one rendering of peasant houses painted in 1884, the village itself began to figure in his work only in 1885. That year he painted a number of winter scenes in and near town, especially eastward along the chemin du Roy, on the way to the village of Gasny. Monet was drawn to winter weather generally, painting winter scenes again in 1886 at Giverny and the nearby villages of Limetz and Falaise, and he was to become fascinated by the appearance of glistening snow and frost in his later Grain Stack series (plate 17).

In the spring of 1885 Monet created two paintings of the fields of Le Prairie, just south of his home, as well as two views of Giverny itself—one in the morning and

the other an afternoon scene, anticipating the serial imagery that would start to occupy him a few years later. That same year Monet also began painting many other of the Giverny themes that would eventually be investigated by foreign artists in the village. The artists were almost surely inspired both by the local landscape and by Monet's own pictorial achievements, which some of them might have seen in Giverny and, equally likely, in Paris and New York. In 1885 Monet painted four pictures of willows along the Ru, with poplars in the background, and he continued to investigate that motif the following year, with *Willows in Haze, Giverny* (plate 14). Poplars also appear in his three Grain Stack paintings of 1885 (plate 59), two of which include figures.

Fields of poppies, another floral subject favored by Monet in Giverny, had first appeared in his oeuvre in 1873, painted at Argenteuil. In 1885 he created a number of views of poppy fields in and around Giverny. Two of these (see plate 58) were among

14. Claude Monet (1840–1926). *Willows in Haze, Giverny,* c. 1886. Oil on canvas, 29 x 36½ in. (73.5 x 93 cm). Göteborgs Konstmuseum, Göteborg, Sweden.

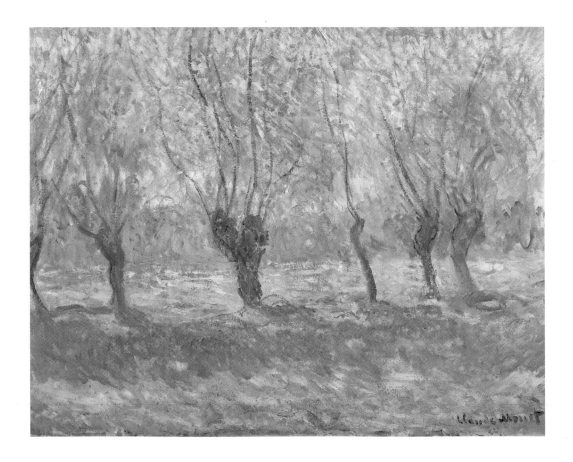

the most celebrated of the forty-two paintings by Monet featured in the great exhibition of almost three hundred Impressionist paintings sent from Paris by Monet's dealer, Paul Durand-Ruel, and shown in New York at the American Art Association in April 1886. The exhibition was so popular that it was transferred the following month to the National Academy of Design. Also in the New York exhibition was Monet's *Meadow with Haystacks near Giverny* (plate 59). For many American art lovers and artists, these works helped define Impressionism and establish Monet's contribution to the movement, just before the beginning of the art colony in Giverny the following year. Many of the young Americans who were to make up the art colony in Giverny surely saw the exhibition; ten years later the American expatriate painter Theodore Butler, then living in Giverny, reminded his friend and colleague Philip Leslie Hale of their having seen Gustave Caillebotte's painting of floor scrapers in that exhibition.[5]

In 1890, just before beginning his Grain Stack series, Monet painted four different renderings of fields of poppies bordered by poplars in the Essarts field below his property, and another four of oat fields. Created just a few years after the discovery of Giverny by American and European artists and art students, these works offered immediate inspiration, both in style and subject, for many of the artists newly arrived in Giverny.

At the Monet-Rodin show held in Paris at the Galerie Georges Petit in 1889, Monet exhibited *Mill on the Epte* (location unknown) and *Limetz Mill* (private collection, U.S.A.), both painted in 1888. The latter mill, located across a branch of the Epte known as the Bras de Limetz, would subsequently be painted by many of the young foreign artists. There were three mills in Giverny itself—the Moulin de Chennevières on the Ru, the Moulin de Cossy, and the Old Mill, east of Monet's house—the last two on the Epte. In addition, there was the mill at Limetz and the Moulin de Gommecourt at Sainte-Geneviève-les-Gasny, both east of Giverny.

The works in Monet's Haystack series (now identified more accurately as Grain Stacks) are his most significant and most extensive depictions of the local environment. Among Monet's first pictures painted within the boundaries of Giverny itself were three renderings of rounded haystacks painted in 1884; his three excursions into that subject the following year have already been mentioned. He returned to the theme after the harvest of 1888 with five more, painted during the winter of 1888–89 in the *clos* Morin, a field adjoining the property Monet was renting. All five show a row of poplars behind the stacks and, in the distance, the hills rising above the south bank of the Seine. In three of these paintings, including *Haystacks, Frost Effect* (plate

Giverny, May 19 . . . The country is very beautiful now; I never saw such luxuriance of way-side growth. Every day there are new varieties of flowers. When we first came the fields were brilliantly yellow with tall mustard; now they are white with daisies, like ours. One day there was a big, red poppy, the next morning there were fifty, now the fields are blood-red and the wheat is sprinkled thickly with them and with the blue corn-flower.

Charlotte Warton, "A Girl-Student's Year in Paris," *Jenness Miller Magazine* 5 (May 1891): 535.

17), two of the circular stacks of grain are depicted; the other two paintings depict a single stack (Tel Aviv Museum; private collection).

The majority of the Grain Stacks—the truly serial images—were created in the autumn and winter of 1890–91, and fifteen were exhibited with enormous success at Durand-Ruel's Paris gallery in May 1891. These pictures, begun in the fields just beyond Monet's house but almost certainly completed in the studio, define not only the artist's aesthetic concerns—the documentation of light and atmosphere as they changed with the times of day and varying weather conditions—but also purely formal experimentation with color and composition. They also designate the basic components of Giverny and its economy: the rich agricultural produce and the relationship of that produce to the houses, farm buildings, and local topography, seen in the distance of many of the paintings in the series.

Shortly after Monet settled in Giverny with the members of his extended family, they began to serve as models for his last sustained foray into figure painting, during the late 1880s—affirmation of his strengthened bond with the Hoschedé clan. Monet even spoke of abandoning landscape work, but Alice's disapproval of his using a hired model seems to have negated that decision. Two of the Hoschedé daughters, Suzanne and Blanche, were his favorite models during this period, and both appear in many paintings of the late 1880s, standing in the meadows and on the hillsides or boating and fishing in the Epte. They both appear also in *In the Woods at Giverny* (plate 19), which depicts a scene in the Marais, southeast of Monet's house, with Blanche working at her easel while Suzanne sits on the ground, reading.

Blanche, who married Monet's son Jean in 1897, was devoted to Monet and took care of him after the death of her mother in 1911. Blanche remained a part of the Monet-Hoschedé household even after her marriage; she and Jean lived in Rouen but returned to Giverny at the end of each week. She was also a painter and a faithful follower of Monet's, adopting his Impressionist strategies as she developed her own art in her

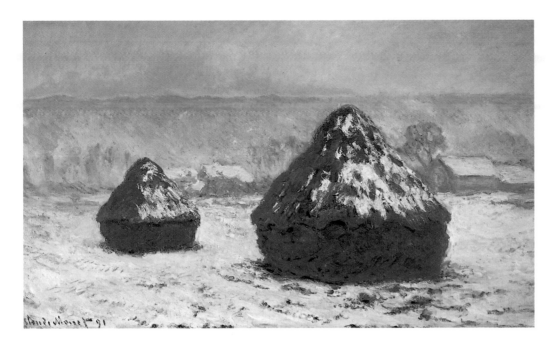

early twenties. Blanche's *Grain Stack (Snow Effect)* (plate 16) is particularly similar to Monet's *Grain Stack (Snow Effect; Overcast Day)* (Art Institute of Chicago); both were probably painted relatively late on a winter day in the *clos* Morin. Many of Blanche's other Giverny pictures—lush garden paintings, rows of poplar trees, fields of poppies, winter scenes in the village, and views along the road to Falaise—are extremely similar in style and subject to those by her stepfather. She did not start to exhibit her work until 1905, at the Salon des Indépendants in Paris; two years later she began to submit her pictures to the newly founded Salon de la Société des Artistes Rouennais in her adopted city of Rouen. She seems not to have become involved to any great extent with the artists' colony that developed in Giverny, with the exception of her brother-in-law, Theodore Butler, and those foreigners who were his closest associates.

Though Giverny became the painting ground of hundreds of artists, it was so intimately associated with Monet that merely mentioning the name of the village conjures up the great French master. His good friend the poet Stéphane Mallarmé wrote:

> *Monsieur Monet, whose vision*
> *Neither winter nor summer can blur*
> *Lives and paints in Giverny*
> *Near Vernon, in the Eure.*[6]

17. Claude Monet (1840–1926). *Grainstacks, Frost Effect,* 1889. Oil on canvas, 25½ x 36 in. (64.8 x 91.4 cm). Hill-Stead Museum, Farmington, Connecticut.

19

The First Generation

It is unclear when the first American artists visited Giverny, and uncertain, too, what motivated that initial visit. We do know that long before the railroad was built, neighboring Vernon was a coach station on the way to Paris. As early as August 1774 the Boston painter John Singleton Copley dined in Vernon en route to Paris from England, after having passed through Dieppe and Rouen.[1] Many other American artists undoubtedly traveled through the region along a similar route, but it was not until over a hundred years later that American artists first came to visit and to stay in Giverny.

The first American artist to paint in Giverny in connection with Monet's presence there seems to have been John Singer Sargent. He may have met Monet as early as April 1876, at the second Impressionist exhibition,[2] but not until the later 1880s did their relationship develop into a close friendship. It was at this time that Sargent began to work out of doors, adopting many of the strategies of Impressionism. Between 1887 and 1891 he also acquired four of Monet's canvases. The most important pictorial document of their relationship is Sargent's *Claude Monet Painting at the Edge of a Wood* (plate 20), in which Sargent depicted Monet furiously at work in a grove of trees on the edge of Giverny, with Alice Hoschedé seated on the ground at the right. The picture is a testimonial to the friendship

18. Detail of Philip Leslie Hale, *French Farmhouse*, 1890–94. See plate 36.

between the two artists, but it is more than that: Sargent, in creating this work, emulated Monet's own methodology of outdoor painting—recording the appearance of nature at a particular moment—rather than formulating a composition in the studio.

Yet compared to Monet's work, Sargent's Impressionism is tempered. Even though Sargent's bravura brushwork gives a sense of immediacy, the picture is still a Tonalist work, painted with strong contrasts of light and dark rather than the sparkling colorism of Monet's Giverny canvases of the period. Indeed, it is likely that this picture commemorates the occasion later described by Monet to the Parisian art dealer René Gimpel. According to Monet's account, he and Sargent went to paint together outdoors. Monet had to lend Sargent a canvas, an easel, and paints, and at one moment Sargent requested some black paint. Monet replied, "'But I haven't any.' 'Then I can't paint,' he cried, and added, 'How do you do it?'"[3]

There has always been some uncertainty concerning the date of *Claude Monet Painting at the Edge of a Wood;* the dates 1887, 1888, and 1889 have been variously assigned to the picture. Sargent is known to have visited Giverny early in June 1887; he is also believed to have been there in 1888 and again in 1889.[4] The year 1887 seems to be a particularly persuasive date because Sargent would have had the opportunity at that point of viewing several of Monet's recent figural canvases, which could have provided inspiration for his own Impressionist excursions. *Claude Monet Painting at the Edge of a Wood* seems extraordinarily similar to Monet's *In the Woods at Giverny* (plate 19), not only in its methodology but even in its juxtaposition of a painter actively at work with a seated figure reading in a landscape.

However appealing the 1887 date may be for Sargent's *Claude Monet Painting at the Edge of a Wood,* it seems, nonetheless, to be incorrect. The picture on which Monet is working so furiously has been convincingly identified as *Meadow with Haystacks near Giverny* of 1885 (plate 59); the forms in Monet's canvas are not totally clear, but no other known picture by him seems to conform as accurately.[5] Presuming that Sargent has correctly transcribed the appearance of Monet's work, both pictures would therefore have to date from 1885, thus identifying Sargent as a visitor to Giverny that year. Sargent did spend that spring in Paris; he and Monet exhibited together that May, at the fourth *Exposition internationale de peinture* at the Galerie Georges Petit, and Sargent may have visited Giverny at that time. Given this dating, it is possible that Sargent's picture may even precede Monet's *In the Woods at Giverny.* Also, *Claude Monet Painting at the Edge of a Wood* may be the earliest of a long series of paintings

by Sargent depicting other artists painting out of doors. Documenting his many professional friendships, these are among the most fascinating autobiographical pictures of his career.

Sargent continued to visit Monet in Giverny at least through 1891, and the dates of his visits there bracket his period of greatest involvement with the Impressionist aesthetic. His last recorded visit occurred in late May or early June 1891, when he spent a few days with Monet in Giverny after wintering in Greece, Egypt, and Turkey. During this Giverny stay Sargent also visited Theodore Robinson, who had recently returned to Giverny after spending the winter of 1890–91 in Italy.[6] Sargent's presence lingered in Giverny, for Monet hung several of his paintings with the other pictures by his artist friends that he kept in his bedroom; few of the Giverny art colonists, however, are likely to have seen these.[7] In any case, all of Sargent's visits appear to have been quite brief, and he seems not to have involved himself with the developing art colony.

The painters who did establish the colony in Giverny may or may not have been attracted there by the presence of Monet. Almost certainly, they had no initial ambition to originate an ongoing community of artists like those in Pont-Aven and Concarneau in Brittany or in villages adjacent to the Forest of Fontainebleau, such as Barbizon, Grèz-sur-Loing, Montigny, and Moret, where some of the earliest Givernyites had previously visited and painted. These colonies, Giverny included, included painters from many nations—primarily students at the art schools and academies in Paris or recent graduates from those institutions, who spent their summers exploring the French countryside. They were attracted by the picturesqueness of the setting and of its local inhabitants, by the availability of cheap accommodations, and perhaps most significantly, by each other—that is, by a community of artists that offered social intercourse as well as professional inspiration, encouragement, and even innovative example. Only rarely in such informal colonies was there an established master in residence, even for a limited duration. Monet's permanent presence in Giverny thus distinguishes that colony from almost all the others.

There exists some less than compelling documentation that two other American artists besides Sargent had separately visited Giverny as early as 1885, the same year that Renoir is also reported to have visited Monet there. One of these was Willard Metcalf, whose posited 1885 visit is documented only by an annotated bird's egg![8] That same year Theodore Robinson—an older painter who had studied and painted

PAGE 24

19. Claude Monet (1840–1926). *In the Woods at Giverny: Blanche Hoschedé-Monet at Her Easel with Suzanne Hoschedé Reading,* 1887. Oil on canvas, 36 x 38.5 in. (91.4 x 97.8 cm). Los Angeles County Museum of Art; Mr. and Mrs. George Gard De Sylva Collection.

PAGE 25

20. John Singer Sargent (1856–1925). *Claude Monet Painting at the Edge of a Wood,* 1885. Oil on canvas, 21¼ x 25½ in. (54 x 64.8 cm). The Tate Gallery, London.

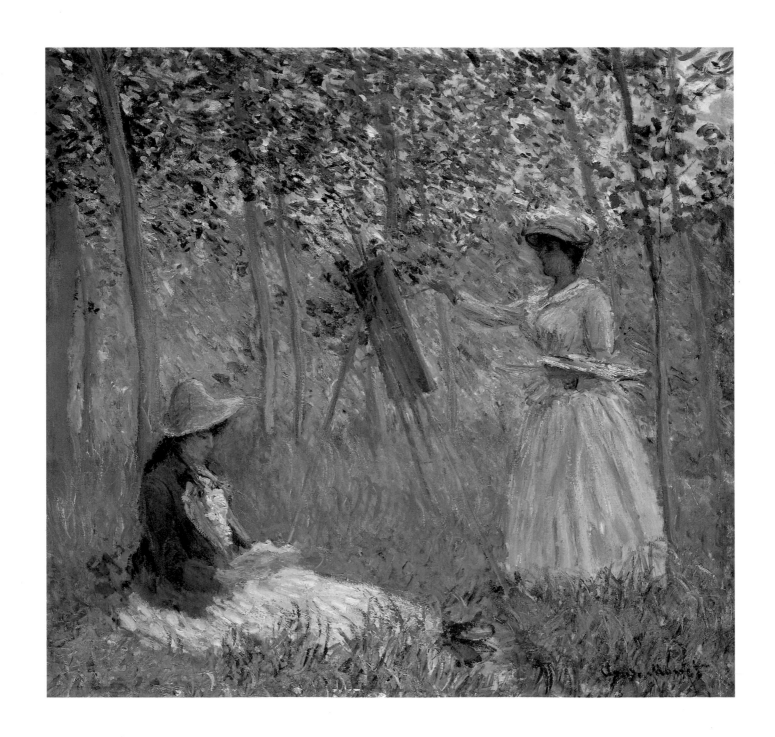

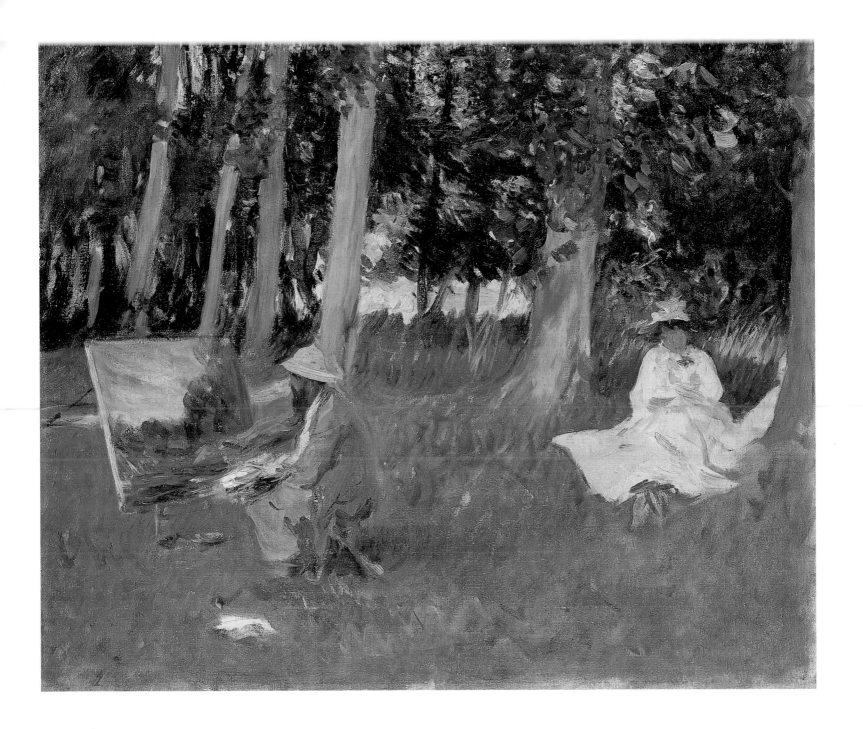

in Paris and Grèz during the 1870s and had returned to France from the United States in 1884—was taken to visit Monet by their mutual friend, the landscape painter Ferdinand Deconchy.[9]

Metcalf is reported to have returned to Giverny in 1886 on a walking tour. Angélina Baudy—proprietess of the local bar and grocery store, who had had no previous experience with foreigners, much less with bearded foreign art students—eventually helped him find lodging in the village at the Ferme de la Côte, owned by Mme Baudy's family, the Ledoyens.[10] It was on this 1886 visit that Metcalf is said to have lunched with Monet and to have spent that afternoon painting in his garden with Blanche Hoschedé.[11] With Metcalf in Giverny were a couple of unnamed companions, who may have been Robinson and Theodore Wendel (a Munich-trained artist from Cincinnati studying at the Académie Julian in Paris).

No Giverny works are known by Robinson from 1885–86, but several by Wendel are dated 1886 and annotated "Giverny." Metcalf's *Sunny Morning in September* (Mrs. Norman B. Woolworth Collection), depicting a young woman tending cows, is dated 1886 and seems to establish the month when the artists were in Giverny that year.[12] This work, together with Wendel's *Farm Scene, Giverny* (plate 21), initiated one of the major themes favored by the artists in the colony's first generation: the agrarian nature of the village economy and the activities of the local peasantry.

The presence of Sargent, Metcalf, and others in Giverny in 1885–86 preceded the true founding of the art colony in 1887, which is recorded in several memoirs. One of the most reliable of these seems to be that by the musician Edward Breck, who came to Giverny, probably in June, accompanied by his mother, his brother the painter John Leslie Breck, and various companions. Writing on March 8, 1895, Edward Breck recalled himself as the

> only layman of the little band of artists who first went thither in 1887. In the early summer of that year Louis Ritter, of gentle memory, and his friend Willard Metcalf, visited their fellow-painter [Paul] Coquand at the château of Fourge in Eure, the proprietor of which a lucky marriage had enabled him to become. Leaving Fourge, Ritter and Metcalf strolled along through the valley that grew more and more beautiful as it neared the Seine. At the little village of Giverny on the Epte, within an hour's walk from Vernon and the Seine, the transcendent loveliness of the country cast a spell over them, and they wrote to their friends in Paris that Paradise was found and only waiting to be enjoyed.

The invitation was answered by Theodore Robinson, Theodore Wendell [sic], Blair Bruce and John Leslie Breck, who, with the present writer and his mother, formed the American colony that year, and are the "simon pure" original "Givernyites." Hardly had the little company begun eagerly to transfer the lovely motifs of the neighborhood to their canvases when they discovered that they were not the only painters in Giverny, that none other than Moret [sic] himself had already been living there for several years past. During that season, however, none of the Americans made the master's acquaintance.[13]

Breck's description suggests the primacy of Metcalf and Ritter in the "discovery" of Giverny, though Wendel and Robinson would have known the village in any case. He also suggests that Monet's residence there was irrelevant, though Metcalf and

21. Theodore Wendel (1859–1932). *Farm Scene, Giverny,* 1886. Oil on canvas, 13 x 22 in. (33 x 55.9 cm). Private collection.

22. John Leslie Breck
(1860–1899). *The River Epte,
Giverny,* c. 1887. Oil on canvas,
23⅞ x 44 in. (60.8 x 111.8 cm).
Terra Foundation for the Arts;
Daniel J. Terra Collection.

23. Louis Ritter (1854–1892).
*Valley of the Seine from Giverny
Heights,* 1887. St. Botolph Club,
Boston.

Robinson, and possibly Wendel, had apparently met Monet in the village in previous years.

Another report, based on John Leslie Breck's own account of the founding of the colony, was recorded by the English painter Dawson Dawson-Watson (who later lived in Giverny).[14] Dawson-Watson also suggested that Monet's presence in Giverny was unknown to the artists and played no part in the establishment of the colony. According to the Breck/Dawson-Watson account, Breck, Metcalf, Robinson, William Blair Bruce, Wendel, and "a chap called Taylor whose Christian name I can not recall" (Henry Fitch Taylor) were discussing in the spring of 1887 where they might spend the summer. After they discarded such popular artists' colonies as Pont-Aven in Brittany and Etretat on the Norman coast, Breck suggested going to the Gare Saint-Lazare to look over possible destinations. They latched on to Pont-de-l'Arche, whose name appealed to them, and they traveled there a few days later.

Just before changing trains in Vernon, Metcalf pointed out the beauty of "a little village of white houses and a Norman church at the foot of a fairly high plateau, seen through the poplars bordering the Seine and across perfectly flat fields." They learned the name of the town a few minutes later when they arrived in Vernon, and Metcalf suggested that they return there if Pont-de-l'Arche did not appeal. The train to which they transferred took them back up the Seine, right through Giverny, and after staying the night at Pont-de-l'Arche, they unanimously agreed to return to Giverny the next morning. They found the Café Baudy, where Lucien Baudy arranged accommodations for them all. Breck eventually induced him to build six rooms in the courtyard behind the café, and it was Breck also, over Robinson's objections, who conceived the idea of establishing an art colony, to the benefit of the local inhabitants as well as the artists.

Further confirmation of who constituted the original group is found in letters written in 1887 by William Blair Bruce, the Canadian member of this artistic fraternity. Bruce wrote especially about Robinson (already a close friend from their time together at Barbizon) and about Metcalf, Wendel, Ritter, Taylor, and the Breck family, though the last are not referred to by name.[15]

Five of the colonists were also noted in the American press that October, when "Greta," the pseudonymous Boston correspondent for *Art Amateur,* commented: "Quite an American colony has gathered, I am told, at Giverny, seventy miles from Paris on the Seine, the home of Claude Monet, including our Louis Ritter, W. L. Metcalf, Theodore Wendel, John Breck and Theodore Robinson of New York. A few pic-

I have unconsciously let the time slip by without giving you a word of the new settlement which we have formed here in this most beautiful part of France, the river Seine running by almost at our door. The village is far far ahead of Barbizon in every respect. We have rented a large and well furnished house for a year, and find it much more comfortable than any hotel could be, there are six of us in the arrangement so it comes not too expensively upon us individually.

William Blair Bruce to Janet Bruce, Hamilton, Canada, June 24, 1887, Archives, Art Gallery of Hamilton.

tures just received from these men show that they have got the blue-green color of Monet's impressionism and 'got it bad.'"[16] Actually, there is no evidence that any of the American artists had yet adopted the coloristic innovations of Monet and his French Impressionist colleagues—only a few of Bruce's 1887 pictures suggest his adoption of such novel strategies. It would be intriguing to learn who sent such paintings back from Giverny and where in Boston they might have been seen.

Given that Greta could so readily identify Monet with Giverny, it is extremely unlikely that a group of young American artists settling in a town of no more than three hundred people would have been ignorant of his presence there. It may well be true, however, as Edward Breck wrote and as other reports later confirmed, that Monet did not initially commune with any of the foreign visitors. During that summer as well as during the years ahead, the artists depended on each other for both friendship and inspiration.

The establishment in 1887 of the Hôtel Baudy as both hostel and meeting place was crucial to the development of the art colony, though the initial group of artists did not immediately take up residency there. In fact, the first artist listed in the Hôtel Baudy register (see pages 222–27) was a painter from Barcelona, Jaime Vilallonga, who had studied in Paris at the Académie Colarossi and with Raphael Collin. He registered at the Baudy on July 6, 1887.[17]

Probably some time that June the Americans had rented a large, well-furnished house for a year. According to Bruce, they divided the shares six ways, but he identified only five occupants: himself, Robinson, Taylor, Wendel, and Metcalf. The Brecks—John Leslie, Edward, and their twice-widowed mother, Ellen Frances Newell Breck Rice—took another house, and Ritter lived with them. All of these first colonists took their meals at the Baudy, where the food was excellent.[18] Though Bruce indicated that their rental was for a full year, the painters dispersed at the end of summer: some of them returned to their studios in Paris; Robinson moved into the Hôtel Baudy, where he registered on September 18. Bruce also remained in Giverny, into the spring of 1888. He interrupted his stay with a visit to Sweden in November 1887 to meet his future in-laws, and late the following year he married the Swedish sculptor Caroline Benedicks; he is not known to have returned to Giverny after that. Some of the others returned in the spring of 1888. Breck registered at the Baudy on April 4 and remained for over a year; Wendel registered on May 20. Ritter appears to have been in Giverny only the one summer of 1887, and Metcalf's name never

Y ou are right that we have a fine lot of fellows in our house and the house in a fine country. The natives are already beginning to build studios and we presume that the colony will soon be quite the thing to talk about just at present however we are very exclusive and daily letters arrive from fellows asking leave to visit us which we are obliged to refuse—on account of the lack of accommodation for them.

William Blair Bruce to Janet Bruce, Hamilton, Canada, October 3, 1887, Archives, Art Gallery of Hamilton.

24. Louis Ritter (1854–1892). *Willows and Stream, Giverny,* 1887. Oil on canvas, 25⅞ x 21⅜ in. (65.7 x 54.3 cm). Terra Foundation for the Arts; Daniel J. Terra Collection.

appears in the Baudy register, though Lucien Baudy built a studio specifically for Metcalf. The precise movements of Taylor, the least studied among the first colonists, are unknown.

Shortly after Breck returned to Giverny in 1888, a new influx of artists took rooms at the Baudy. Most of the visitors continued to be American, but the colony included painters from all over the world. Eduardo Schiaffino, from Buenos Aires, arrived at the Baudy on June 12; he was destined to become one of the leading Argentine painters of his generation and a major historian of Argentine art. The first English artist to arrive—and, for the colony, the most important—was Dawson Dawson-Watson, who settled at the Baudy on May 12, 1888. While a student in Paris, Dawson-Watson had met Breck at a café on the boulevard Montparnasse. In April 1888 Breck, either just before he returned to Giverny or on a day trip back in Paris, called on Dawson-Watson in his studio and suggested that he consider spending the summer in Giverny. Dawson-Watson decided to try Giverny for two weeks; he ended up staying five years, except for a period of about six months spent painting back in England and Wales. He was especially close to Breck and his family, and painted a portrait of Mrs. Edward Breck (Breck family collection) in the garden of the house that the Brecks had taken in Giverny.[19] In Dawson-Watson's opinion John Leslie Breck was "the biggest of the bunch, . . . the first man to exhibit impressionist pictures in this country."[20]

Eight days after Dawson-Watson settled into the Hôtel Baudy, Theodore Butler arrived, possibly traveling from Paris with Theodore Wendel, since both registered the same day; both were Ohio-born painters studying at the Académie Julian. Philip Leslie Hale from Boston, a close friend of Butler's and a far more talented artist, arrived on the first of June. Hale spent the summer in Giverny in 1888 and 1889, then returned for the season in 1891, 1892, and 1893; at some point in those visits he rented a house from Louis-Joseph Singeot, from whom Monet had earlier purchased the Maison du Pressoir.[21] Hale was registered at the Baudy only in 1888 and 1892; in 1893 he slept in a farmhouse and took his meals at William Howard Hart's house.[22]

Hale and Butler had previously been fellow students at the Art Students League in New York, along with Hart and Henry Prellwitz. These last two young artists arrived together at the Baudy on September 21, 1889. Prellwitz had also come earlier that year, first for a few days beginning May 7 and again for a two-month stay beginning June 20. Although he made sketches during his visits, he painted very little in Giverny, and none of his work done there has come to light.[23]

As Giverny's reputation as an art colony spread, the migration of artists quickened. One of the best known of the English painters to visit was William Rothenstein, who arrived in December 1889 with Prellwitz, who registered with him at the Baudy. Rothenstein loved the winter weather in Giverny and returned in late January, bringing with him the German painter Ludwig von Hofmann. And Rothenstein was back again the following winter, this time bringing the English painter John Longstaff and his wife. He wrote to Charles Conder at the Académie Julian, noting that Monet was working hard and commenting about his own outdoor work in pastel; in a few years Conder himself would spend a considerable amount of time in this region. In his autobiography Rothenstein noted that he painted his first landscapes in Giverny, but none of these has yet come to light.[24]

The artists' colony in Giverny was not confined to painters. Edmond Austin Stewardson, a pupil of Thomas Eakins at the Pennsylvania Academy of the Fine Arts, was the first American sculptor there, staying at the Baudy in the autumn of 1889 and becoming very much a part of the art colony; he died young in 1892, two years after returning to Philadelphia.[25] The Bostonian Stephen Codman, who was at the Baudy in July 1889, may have been the first American architect to stay in Giverny. And the clientele at the Hôtel Baudy was not limited to visual artists. One of the founders of the colony was the musician Edward Breck; and G. W. Chadwick, another musician from Boston, was there with his wife in the summer of 1888.

It is difficult to document the first arrival of women artists in Giverny. According to Dawson-Watson's autobiographical account, his future wife, Mary Hoyt Sellars of Aurora, Illinois (who had been raised in Scotland), arrived in Giverny at about the same time he did, traveling with the American painter Emma Richardson Cherry, but there is no record of their registration at the Hôtel Baudy. Cherry had settled in Denver by late 1889, so her visit to Giverny had to have occurred earlier that year or in 1888. She may well have been the first woman artist in the colony, and she very likely painted her *Harvesters* (plate 25) there, in 1889.[26] Cherry's stay in Giverny must have been brief; a far longer resident of the colony and far more significant a painter was Lilla Cabot Perry, who with her family first took rooms at the Hôtel Baudy on June 20, 1889. They remained there until July 18, when they leased a house, though they continued to take their meals at the Baudy. Referred to as "The Crooked House," it was recalled by Margaret, one of the Perry daughters, as "next to the blacksmith's" and with "*no* conveniences."[27] This first visit was a long one; Perry did not return to the United States until the end of November. Perry; her husband, Thomas Sergeant

During my first winter in Paris I was taken by an American friend to Giverny. . . . I had never before been in the country during the winter; nor indeed among villagers. A new aspect of life was opened to me. There was a pleasant inn at Giverny, kept by Monsieur and Madame Baudy. The little cafe was fitted with panels, half of which were already filled by painters who had frequented the inn; and there was a billiard room whose white plastered walls had also tempted them. . . . It was at Giverny that I painted my first landscapes.

William Rothenstein, *Men and Memories: Recollections of William Rothenstein, 1872–1900* (London: Faber and Faber, 1931), p. 49.

Perry; and their daughters, Margaret, Edith, and Alice, returned to Giverny for eight more seasons over the next twenty years. They were back in Giverny on June 13, 1891, staying at the Baudy for a little over a month.[28] Lilla Cabot Perry is said to have first learned about the charms of Giverny during the autumn of 1888, when she studied for two months with Fritz von Uhde in Munich, but it is extremely unlikely that she would not already have heard about the art colony while studying in Paris.[29]

The artists mentioned above, along with a host of others whose names appear in the Hôtel Baudy register in 1887–89, constitute the first of what I consider to be three generations of artists in Giverny. Obviously there was extensive overlapping among the hundreds of artists who appeared in the village during the approximately three decades of its heyday. And of course there were others, such as Philip Hale and Guy Rose, who reappeared after long absences to find that the colony and its artistic character had

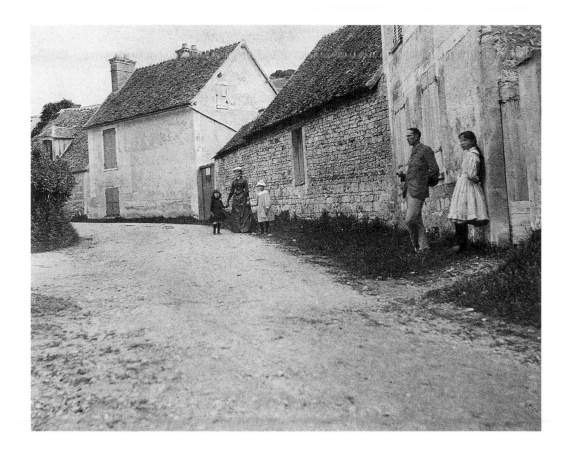

substantially changed. Yet I believe that Giverny can be best understood by analyzing its changing nature over these three generations.

Despite reports to the contrary, the presence of Monet must have been a major drawing card for the artists who came to Giverny, whether for a single day's visit or for lengthy or repeated stays. But how many of the artists came to know him at all? Monet made no effort to communicate with the young painters who had first arrived in the summer of 1887, and before too many years their presence had become oppressive enough that he was considering moving away.

Only four or five of the foreign painters appear to have formed a strong link with Monet, and all of these were among the early settlers: John Leslie Breck, Theodore Butler, Lilla Cabot Perry, Theodore Robinson, and possibly Henry Fitch Taylor. Some of the others may have visited the Monet household once or occasionally, while others

When I first came to Giverny I was quite alone, the little village was unspoiled. Now, so many artists, students, flock here, I have often thought of moving away.

Claude Monet, in Anna Seton-Schmidt, "An Afternoon with Claude Monet," *Modern Art* 5 (January 1, 1897): 33.

It was my good fortune to spend some time, the other day, at the house of Claude Monet. . . . The house outside, from the road, has much the look of the ordinary, comfortable French farm-house; but once inside the gate, all is very different. The garden is always one blaze of colour from the various flowers always in bloom. The great painter is *passioné* about flowers, and a softness of heart, which I rather admired, will never allow him to have them cut.

Philip Hale, "Our Paris Letter," *Arcadia* 1 (September 1, 1892): 179.

27. Theodore Robinson (1852–1896). *The Home of Monet at Giverny.* Drawing, in *Century*, September 1892.

had, at best, a passing acquaintance with the master, garnering an abrupt greeting along the village roads. Philip Hale appeared to consider as a very special event his opportunity to spend time at Monet's house one day during the summer of 1892, describing his visit at some length in his September 1 column in the Montreal-based periodical *Arcadia*. Dawson-Watson, in his unpublished autobiography, noted that he had only a "nodding acquaintance with Monet," but stated that Breck, Taylor, and Bruce were on good terms with the Hoschedé daughters. This is confirmed in part by Monet-Hoschedé family photographs in which those artists appear. Taylor's early experiences—indeed, both his professional career and his artistic production prior to his involvement with the Madison Gallery in New York in 1909 and with the Armory Show in 1913—are so little documented that there is no way to calculate his personal involvement with Monet.

Robinson was the one to establish the closest friendship with Monet, visiting and dining with him frequently, and Robinson's diaries and letters record the impact of

Monet and his paintings on his art.[30] Yet it is not known how their relationship was first established. It may be that Robinson, ten years older than most of his fellow colonists, seemed more mature than his mates and thus more congenial to Monet. Of all the original colonists, Robinson was the only one to make Giverny his primary residence for many years (1888–92). When he arrived back in France from an 1892 visit to the United States, he took the train directly from Le Havre to Rouen and on to Vernon, then walked to Giverny,[31] visiting Monet the following day; it was almost a month before he went into Paris. Robinson was present at Monet's wedding to Alice Hoschedé later that year, along with members of the family and Monet's colleagues Gustave Caillebotte and Paul Helleu, and he was invited to join the wedding party at dinner.[32]

First Breck and then Butler were romantically involved with Alice's daughters. Breck's pursuit of Blanche Hoschedé, which may have begun in 1888 or 1889, was effectively discouraged by Monet in 1891, after the American had returned from a

28. Theodore Robinson (1852–1896). *Claude Monet.* Drawing, in *Century,* September 1892.

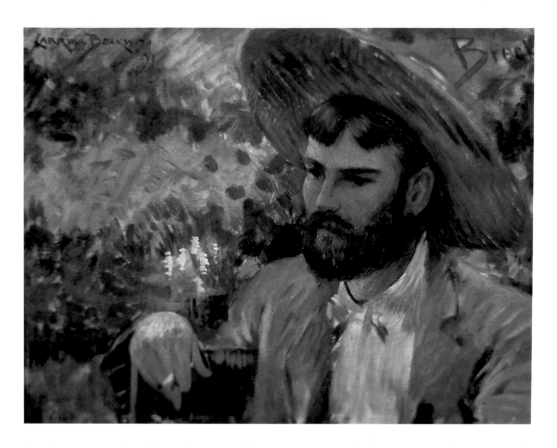

29. J. Carroll Beckwith
(1852–1917). *John Leslie Breck,*
1891. Oil on canvas, 13¾ x 17¼
in. (34.9 x 43.8 cm). Private
collection.

lengthy stay in the United States. There is reason to believe that before the break, Breck had established a closer relationship with Monet and his family than any of his colleagues. Breck made a sketchily rendered portrait of Suzanne Hoschedé (private collection) as early as February 1888, and he is known to have painted in Monet's garden, a privilege that may not have been extended to any other colonist and one that presupposes a warm invitation.

Contemporary reviews of work by many of the American Impressionists refer to them—incorrectly—as "pupils" of Monet, but such references to Breck appear with more persuasive consistency. The Boston collector Benjamin Kimball wrote: "Monet's well-known view, that a man must be a student of nature and not of another man, is so strong that he gives no one the right to call himself his pupil. Nevertheless he distinguished Breck by appreciation and encouragement and afforded him unusual opportunities to paint with him in the fields."[33] Quoted in Breck's obituary in the *Boston Sunday Globe* was Monet's invitation to him: "Come down with me to Givetny [*sic*]

and spend a few months. I won't give you lessons, but we'll wander about the fields and woods and paint together."[34]

It is possible that Breck felt free to pursue his romantic attraction to Blanche because of his friendship with Monet, and that Monet, in turn, believed that Breck had taken advantage of their relationship. At first Monet was equally opposed to Butler's pursuit of Suzanne Hoschedé, but he eventually acquiesced, though reluctantly; perhaps he was worn out from his earlier conflict with Breck or perhaps he simply bowed to the inevitable. Monet may also have been more concerned about keeping Blanche, a neophyte painter, single and nearby. It has been suggested that Monet was less opposed to Butler than to Breck because he learned that Butler's family in Columbus, Ohio, was fairly well off, but Breck's family was also. Another factor was Monet's own longstanding but unblessed union with Alice Hoschedé, which he felt

If you only knew how your letter upset me! . . . What surprises me more is that after their past frustrations and disappointments the girls could respond to advances from Americans passing through Giverny. . . . It is impossible for me to remain any longer at Giverny. I want to sell the house right away. You know what I did about Breck and the other one. . . . I don't want to start all over again.

Claude Monet to Alice Hoschedé, March 10, 1892; in Daniel Wildenstein, *Claude Monet: Biographie et catalogue raisonné,* 4 vols. (Lausanne, Switzerland: Bibliothèque des Arts, 1974–85), 3: 264.

30. *Monet's Studio Seen from across the Garden.* Photograph, in Lilla Cabot Perry, "Reminiscences of Claude Monet from 1889 to 1909," *American Magazine of Art,* March 1927.

necessary to sanctify with a church wedding in Giverny on July 10, ten days before he gave Suzanne in marriage to Butler; the Abbé Toussaint officiated.

The friendship that developed between Lilla Cabot Perry and Monet is the most clearly documented. Both Perry and her husband had admired Monet's work at the Monet-Rodin exhibition held in the spring of 1889, and Thomas Sergeant Perry subsequently attempted, unsuccessfully, to get an article on Monet published either by *Scribner's* or in the *Boston Herald*.[35] In Paris the Perrys had met a young American sculptor (almost surely Edmond Austin Stewardson) who had a letter of introduction to Monet and who begged the Perrys to go with him to meet the French artist.[36]

Subsequently, Lilla offered a number of friends the opportunity to purchase a work by Monet for five hundred dollars, but only Thomas's brother-in-law, Dr. William Pepper, responded; the Perrys returned to Boston in the autumn of 1889 with Monet's *Etretat*. The visit that led to Pepper's acquisition of this painting was recorded by Thomas Perry: "We stayed some time talking and looking and he urged us to come again, wh. we shall surely do."[37] This transaction laid the groundwork for their long-lasting relationship. Once installed in a house and garden next door to Monet's, Lilla noted that he would "sometimes stroll in and smoke his after-luncheon cigarette in our garden before beginning on his afternoon work."[38]

Whether or not the colonists enjoyed any friendship with Monet, their work appears to have changed perceptibly as they painted in Giverny. The strategies associated with Impressionism—a high-keyed color range, the elimination of neutral tones, sensitivity to light and atmosphere, a painterly surface, and broken facture—were adopted to some degree by almost all the painters discussed so far.[39] The conclusion that such change should be attributed to their Giverny experience is basically unassailable, for in all cases these were painters who had traveled to France not to associate themselves with avant-garde aesthetics but to learn academic procedures. Thus, to one degree or another, all of them were forfeiting or reacting against skills that had demanded many months or even years to acquire.

Yet the question remains, how did Giverny catalyze this transition from academic naturalism to modernist techniques? Only a few of the colonists would have had the opportunity to see Monet's paintings, along with those by his Impressionist colleagues, while visiting his Maison du Pressoir. Fewer still would have had the chance to watch him actually painting. But it is likely that American and other foreign visitors to Giverny, once engrossed with Monet's Impressionist methodology—which some of them would have first encountered at shows in Boston and New York in the early and

31. Henry Fitch Taylor (1853–1925). *Souvenir of Normandy,* 1888. Oil on canvas, 20 x 24 in. (50.8 x 61 cm). Private collection.

mid-1880s—would have sought his pictures in exhibitions at commercial galleries in Paris. For those who returned to their academic classes in the French capital, such opportunities were fairly abundant; for those, like Dawson-Watson, who remained in Giverny much of the year, this would have occurred on day trips to Paris. The most persuasive influence toward more avant-garde practices may have stemmed from mutual reinforcement. It is likely that some of the painters responded more enthusiastically than others to Impressionism—perhaps in part because they had greater access to Monet himself—and that their excitement and achievements may have spurred their more reluctant colleagues.

This does not mean that when the colonists finally departed Giverny, they did so as full-fledged Impressionists, though surely they must have realized that their art had substantially changed. And even if they had not been aware of the change, the critics back home would have convinced them that they had become part of the American avant-garde. For example, we are not yet able to identify any of Henry Fitch Taylor's Impressionist paintings done in France—his earliest located work to date, *Souvenir of*

Normandy (1888; plate 31), possibly created in or around Giverny, is a landscape painted in the Barbizon mode. But there is no doubt that he had subscribed to Impressionism by the end of that year, for the critics of his entries in the 1889 annual of the Society of American Artists in New York noted that "Henry Fitch Taylor, in his 'Bridge at Simetz [*sic*—read "Limetz"], Normandy,' and 'Sunlight and Shadow,' gives us Claude Monet and Pissarro without the shadow of an apology."[40]

The impact of the Giverny experience on the stylistic development of some of the other painters who went to Giverny in 1887–89 is difficult to gauge because in many cases their paintings created in Giverny were their first mature works. Butler, excep-

32. Philip Leslie Hale (1865–1931). *River Bank, Giverny,* 1888. Oil on canvas-board, 11¼ x 16¼ in. (28.6 x 41.3 cm). Spanierman Gallery, New York.

tionally, had won an honorable mention at the 1888 Salon with his now-unlocated *The Widow.* His earliest known Giverny picture was not painted until after he had returned from attending his father's last illness and death in Columbus, Ohio, and had settled back in at the Hôtel Baudy on October 7, 1891. His *Church at Giverny* (private collection, Bethesda, Maryland) of that year—a view of the town over a field with a haystack—demonstrates his full adoption of an Impressionist style.

Dawson-Watson quickly adopted the preferred colors of Impressionism, particularly blue and violet tones, while maintaining sharp linear delineation, as in *Gathering Firewood* (plate 64). Hale appears to have been initially the most resistant to Impressionism, judging by his *River Bank, Giverny* (plate 32), a work painted soon after he arrived in the village in 1888 and still dominated to some degree by Barbizon conventions. His *Ornithologist* (plate 33), another Giverny picture of the same year, is a strongly modeled figure informed by Hale's academic schooling, but there is a suggestion of his future interests in the brilliant sunlight and the rich colorism confined to the upper-right corner.

Artists often compromised the avant-garde procedures they were investigating when painting pictures intended for the Salon, where Impressionism had received scant

33. Philip Leslie Hale (1865–1931). *Ornithologist,* 1888. Oil on canvas, 38¼ x 48½ in. (97.2 x 123.2 cm). Rhode Island School of Design, Providence; Gift of Alfred T. Morris Collection.

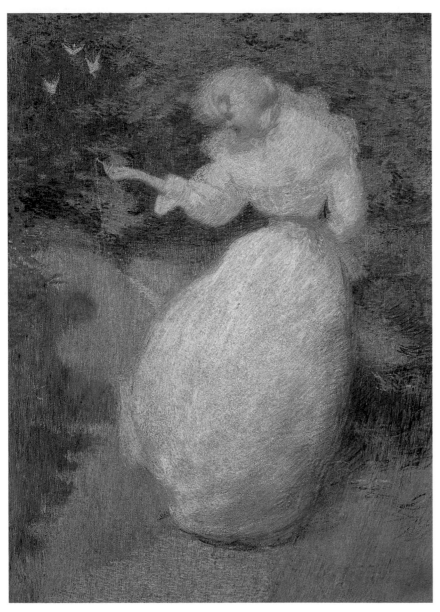

welcome in the 1870s and 1880s. Hale's *Ornithologist* did indeed appear in the 1889 Salon—the Salon of the Société Nationale des Artistes Français (the old Salon). (In 1890 a "new Salon" was founded—the relatively more liberal and more foreign-oriented Société Nationale des Beaux-Arts.) Hale chose to show with the new Salon some years after he had perfected his almost Pointillist mode of long, thin brushstrokes, total abandonment of line, and very limited tonal range, dominated by chrome yellow—seen in such summery works as *Girl with Birds* (plate 34).[41] Hale's version of Impressionism is unique among American artists; it draws on the painting and theories of the Neo-Impressionists Georges Seurat and Paul Signac and is allied with work by artists such as Henri Martin and Giovanni Segantini.[42]

Much of Hale's career is fairly well detailed in his voluminous correspondence, gathered together for an unrealized biography by Arthur J. Kennedy, but his stylistic development is tantalizingly obscure.[43] In addition to his exposure to Impressionism in work by Monet and by his colleagues in Giverny during the summers of 1888–89 and 1891–93, as well as in Paris and back in Boston, Hale was tremendously impressed by the painting of Diego Velázquez, encountered on a trip to Spain taken late in 1889 with Hart and Prellwitz.

34. Philip Leslie Hale (1865–1931). *Girl with Birds,* 1894. Oil on canvas, 38½ x 28 in. (97.8 x 71.1 cm). Peter and Mary Lou Vogt.

The dreamy, somewhat stupefied appearance of the figures in some of Hale's paintings of the 1890s, such as *Girl with Birds,* relates to contemporary European Symbolism; Hale's awareness of this movement is confirmed in his art reviews.

Hale wrote from America to Giverny on July 29, 1895, that he had gone *"très impressioniste"* and was trying to pitch his paintings a "little lower than my Giverny

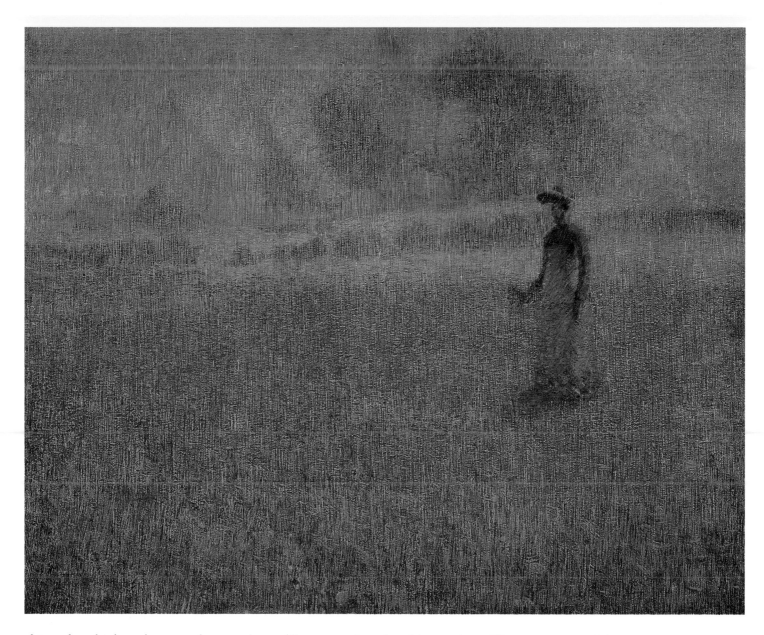

things but higher than my last year's work"—suggesting that his previous Giverny paintings, such as *Girl with Birds,* were exceptionally avant-garde. In the same letter he asked Hart: "Are you *très Impressioniste?* I am—I think." A painting such as Hale's undated and geographically unspecific *Poppies* (plate 35) may have been painted in either the United States or France. Though the motif is one associated with Monet

35. Philip Leslie Hale (1865–1931). *Poppies,* c. 1890s. Oil on board, 21¼ x 25⅝ in. (54 x 65.1 cm). Colby College Museum of Art, Waterville, Maine; Gift of Mr. and Mrs. Ellerton M. Jetté.

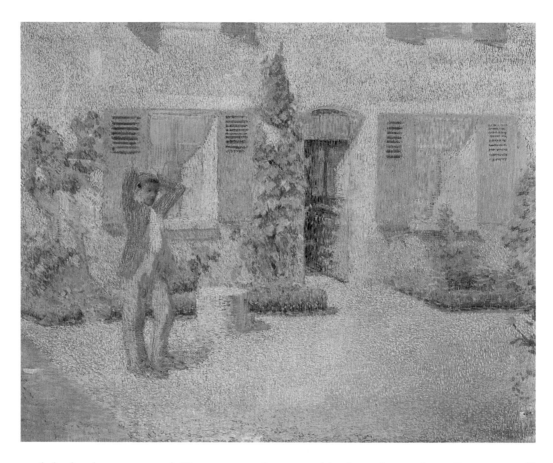

and the landscape around Giverny, poppies were ubiquitous in northern France as well as elsewhere in Europe and in the United States. Hale's *French Farmhouse* (plate 36) and *Giverny Garden* (plate 37), both undated, constitute the most complete expression of his unique application of Pointillist methodology to a Giverny subject.

Willard Metcalf's Giverny pictures of 1887 and 1888 demonstrate more generalized forms, looser brushwork, and greater concern for bright sunlight than his earlier work painted in Grèz. The interest in sunlight more likely resulted from his trip to North Africa in the winter of 1886–87, just prior to his participation in founding the art colony in Giverny. The results of Metcalf's sojourn in Giverny were first seen publicly in a show of forty-four of his works on view at the St. Botolph Club in Boston in March 1889, three months after he returned to the United States. The Tunisian scenes attracted the greatest critical attention, but his Giverny pictures such as *Sunlight and Shadow* (plate 38) and *Summer Morning, Giverny* (plate 39) were also admired.

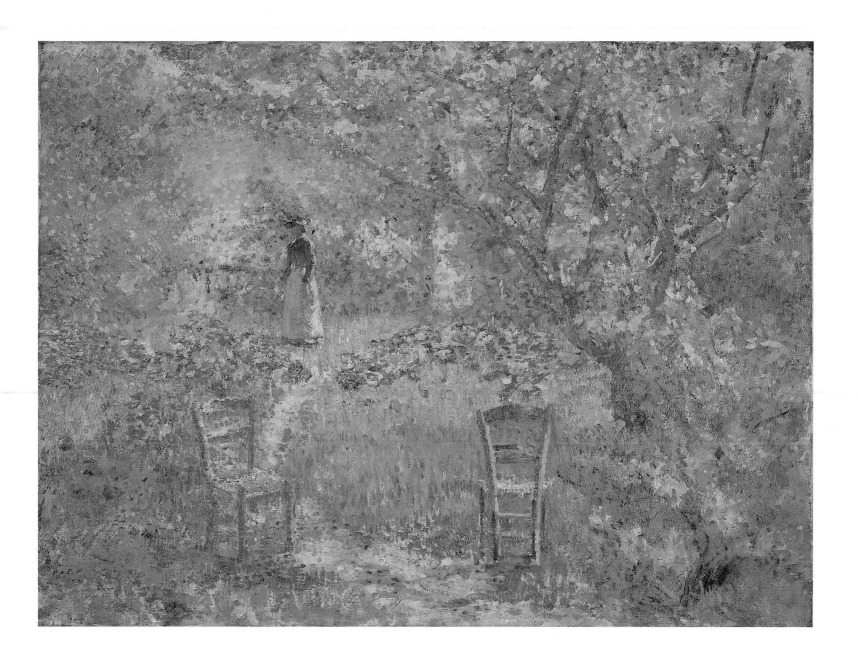

38. Willard Metcalf
(1858–1925). *Sunlight and
Shadow,* 1888. Oil on wood
panel, 12¾ x 16⅛ in. (32.4 x 41
cm). The Museum of Fine Arts,
Houston.

39. Willard Metcalf
(1858–1925). *Summer Morning,
Giverny,* c. 1888. Oil on canvas,
13 x 16 in. (33 x 40.6 cm). Mr.
and Mrs. Walter Shorenstein, San
Francisco.

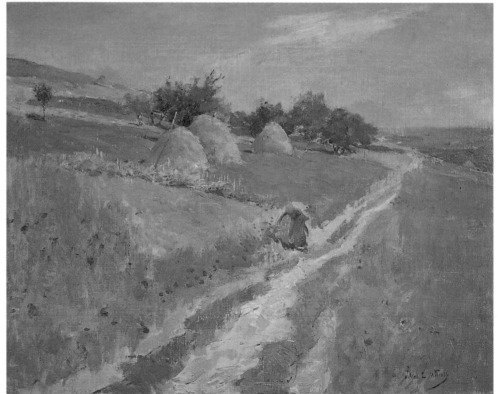

Writers found him at his "best when the sun shines" and admired "the thin, colorless veil of air, which softens all outlines and subdues . . . every tint."[44] One reviewer allied him with the "Impressionistic," "open-air" school, emphasizing Metcalf's capture of "sunshine and the intangible air."[45]

For the most part, Metcalf explored the bright blue skies and rich greens of spring and summer foliage—one writer objected to his fondness for a peculiarly bluish green, which he identified as a French mannerism. But Metcalf's distinctive concern for seasonal change, which was to characterize his later New England landscapes, was already evident in such Giverny paintings as *Summer Morning, Giverny* and *The First Snow* (plate 181).

Theodore Wendel—who may have returned to Boston at the same time as Metcalf or possibly a bit later—had a more informal show of his Giverny work (concurrently with Metcalf's) in the studio he had taken in Boston.[46] It was noted that "Mr. Wendel accompanied W. L. Metcalf on some of his sketching tours in the vicinity of the Seine during the past season and his charming studies along the quiet, green banks of some of the tributaries of that river remind one of the many paintings of the same thing done by Mr. Metcalf."[47] Nevertheless, it was Wendel rather than Metcalf whom the critics identified as having entered the Impressionist camp, adopting the colors and the dry, pastellike surface qualities associated with the "Monet-Sisley school."[48]

Wendel's most admired works were two large canvases of willows along the banks of a meandering stream—undoubtedly the Epte. *The Brook, Giverny* (plate 53) may be one of these. His works were described as painted in a "broad and summary manner" and in "violet and bluish tones," though he was still seen as stylistically situated between the "pleinairistes" (the followers of Jules Bastien-Lepage) and the true Impressionists.[49] This middle position between plein-air Naturalism and Impressionism characterizes Wendel's *Flowering Fields, Giverny* (plate 57), which has the freedom but not the chromatic brilliance of Monet's pictures of similar subjects.[50]

Among the original Giverny colonists of 1887, Louis Ritter may have been the one least attracted to Impressionist strategies. Though his artistic development is imperfectly known—Ritter is an understudied and underappreciated painter—he had certainly cast off the dark, dramatic Munich manner that informed his work of the early 1880s by the time he arrived in Giverny or during his relatively short stay there. Ritter's brilliant *Flowers: Peonies and Snowballs* (plate 40) was painted in Giverny in 1887, a rare example of a conventional indoor floral piece among artists dedicated to out-of-doors painting. Ritter here displays the hand of a master, and his colors are vivid, but

40. Louis Ritter (1854–1892). *Flowers: Peonies and Snowballs,* 1887. Oil on canvas, 39¾ x 32⁵⁄₁₆ in. (101 x 82.1 cm). Terra Foundation for the Arts; Daniel J. Terra Collection.

41. Lilla Cabot Perry (1848–1933). *Child Sewing at a Window,* n.d. Oil on canvas mounted on Masonite, 21¾ x 18¼ in. (55.2 x 46.4 cm). Private collection.

42. Lilla Cabot Perry (1848–1933). *Angela,* 1891. Oil on canvas, 36¼ x 27 in. (92.1 x 68.6 cm). Private collection.

the forms are still pretty carefully rendered rather than dissolved in light and atmosphere. Even in most of his outdoor work in Giverny, such as *Barley Field at Giverny* (plate 69), Ritter's color is intense but not especially variegated, and he handled form, space, and perspective in a traditional manner.

The great majority of images painted in Giverny during its early years as an art colony were landscapes, which quite often included figures. Lilla Cabot Perry, however, divided her attention about equally between figural and landscape images, and her work reveals the same dichotomy that developed in other artists' work, in Giverny and elsewhere, when they investigated the still-radical aesthetic of Impressionism. In her figural images she maintained firm structure through sure drawing, tonal modeling, and strong contrasts of light and shade. She concentrated on children both from her own family and from the village, such as *Child Sewing at a Window* (plate 41) and *Angela* (plate 42), arguably her finest Giverny figural piece.[51] In *Angela* the figure is almost replicated in the shadow cast behind the young woman, and the structural framework is enhanced through the sharply defined geometry of the window. Yet Perry's attraction to Impressionist color is nowhere more evident than in the violet shadows cast on Angela's dress, and the appeal of light is evident in both these pictures, which open up to sunlight and air through the windows, as do most of the indoor pictures that Perry painted in Giverny. It seems that she could not resist the lure of nature even when dealing more academically with the figure.

In her pure landscapes, such as *A Stream Beneath Poplars* (plate 112), Perry adopted the broken brushwork and variegated, high-keyed colorism of Impressionism more faithfully, perhaps, than any of her Giverny colleagues. She was obviously drawn to these strategies through her close relationship with Monet, but her Impressionist manner is much closer to Monet's of the late 1870s and early 1880s than to the more encrusted layers of his Grain Stack and Rouen Cathedral series—that is, the work he was painting when Perry actually got to know him. Perry was following Monet's own advice to her: "When you go out to paint, try to forget what object you have before you, a tree, a house, a field or whatever. Merely think, here a little square of blue, here an oblong of pink, here a streak of yellow, and paint it just as it looks to you, the exact color and shape, until

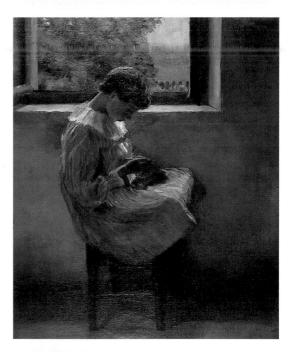

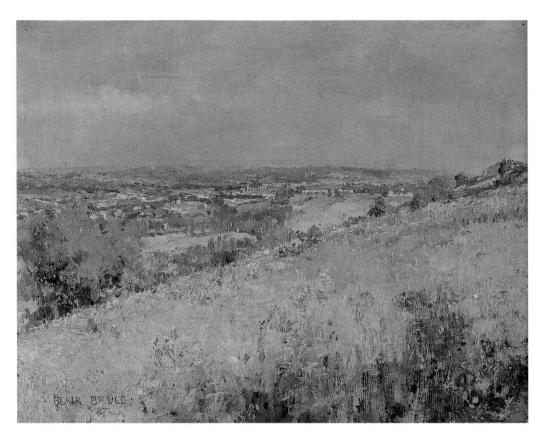

43. William Blair Bruce
(1859–1906). *Giverny, France,*
1887. Oil on canvas, 10½ x 13½
in. (26.5 x 34.6 cm). Art Gallery
of Hamilton, Hamilton, Canada;
Bruce Memorial.

it gives your own naive impression of the scene before you."[52] Like most of her Giverny colleagues, Perry worked primarily in oils, but she was also adept in the then-popular medium of pastel. She made numerous pastels in Giverny, most notably *Bridge Willows—Early Spring* (plate 132), which she replicated many times. These, however, date from one of her later sojourns in the village.

Joan Murray, William Blair Bruce's excellent biographer, suggests that the Canadian artist was influenced by his good friend Theodore Robinson, but it seems more likely that any impact occurred the other way around. Certainly the two painters shared motifs and utilized almost identical compositions, as can be seen in Bruce's *Giverny, France* (plate 43) and Robinson's *Val d'Aconville* (plate 99). Murray's suggestion that "perhaps they literally painted side by side" seems on target.[53]

Bruce was in Giverny only during the summer and early autumn of 1887 and then again in the early months of 1888. Many of his Giverny pictures are dated 1887 and several of the undated ones appear to depict warm-weather scenes, sug-

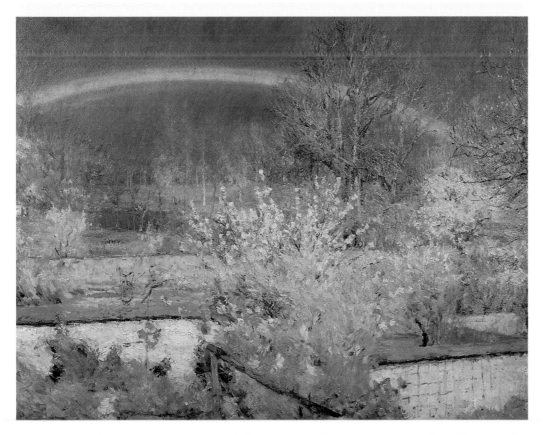

44. William Blair Bruce
(1859–1906). *The Rainbow*,
1888. Oil on canvas, 28⅜ x 36¾
in. (71.8 x 93.2 cm). The Robert
McLaughlin Gallery, Oshawa,
Canada.

gesting that they, too, were painted during Bruce's first season in the village. With their flecked brushstrokes, sparkling light, and vivid hues, they constitute perhaps the earliest truly Impressionist paintings done in Giverny by any of the colonists. Bruce's *Rainbow* (plate 44), painted in the spring of 1888, uses the prismatic subject to display the brilliant colorism of his newly adopted aesthetic. His Giverny paintings are almost entirely landscapes; the primary exception is *Pleasant Moments* (originally, *Mother and Child [Giverny, France]*) (Art Gallery of Hamilton, Hamilton, Canada), in which the features of the woman are those of his wife-to-be, Caroline Benedicks.[54]

Very few of Robinson's 1887 Giverny pictures have come to light, and with the exception of his fascinating *By the River* (private collection), none of them is major. Many of those painted in 1888 are still muted in tonality, though Robinson did develop during these two years his favorite color scheme of pale pinks and lavenders contrasting with a range of greens—yellow to blue-green. Yet even though he did

pretty much eliminate neutral tones from his palette, his spectrum remained relatively timid. It was only in his later Giverny paintings of about 1891–92—such as *Gathering Plums* (plate 73) and *Père Trognon and His Daughter at the Bridge* (plate 78)—that his colorism began to approach the brilliancy of Bruce's pictures of 1887.

Like John Leslie Breck and other of his colleagues, Robinson varied his strategies to suit the mood he was attempting to convey. Thus, such a celebratory conception as *The Wedding March* (plate 110), painted in the summer of 1892 to commemorate the marriage of Theodore Butler and Suzanne Hoschedé, is an appropriately exuberant rendition of blazing sunlight. *November* (plate 45), on the other hand—also an 1892 painting and supposedly his final picture painted in Giverny before departing for America—is a somber woodland scene. Its relative darkness and greater dramatic impact seem to suggest not only autumn but also the melancholy of imminent departure.[55]

In addition to Robinson's developing friendship with Monet in Giverny and his gradual adoption of Impressionist devices, photography helped shape Robinson's art; in the early 1880s he began to supplement the practice of painting out of doors with photographic recording. Some of the photographs, which he took himself, were stored at the Hôtel Baudy and others descended in the Robinson family. *In the Sun* (plate 76), *The Layette* (plate 47), and *Gathering Plums* are all based on known photographs. In the last named even the blurring in the photograph caused by a movement of the model's hands was transferred to the painted image. Robinson used photographs primarily to establish a composition; they did not substitute for the use of the model, nor did he abandon outdoor work for the studio. Robinson invariably softened the tight, sharp images of his photographs, and he seems not to have relied on photographs at all for his pure landscapes. At times he decried his own dependency on photographs.[56] Whether his Giverny colleagues relied on photography to any extent has not yet been determined.

Although John Leslie Breck was almost totally forgotten after his death in 1899, he appears to have been one of the first American painters, if not *the* first, to adopt the strategies of Impressionism. Indeed, his fellow Impressionist John Twachtman noted that Breck had "started the new

45. Theodore Robinson (1852–1896). *November,* 1892. Oil on canvas, 19⅞ x 25 in. (50.3 x 63.5 cm). Mr. and Mrs. Donald J. Douglass.

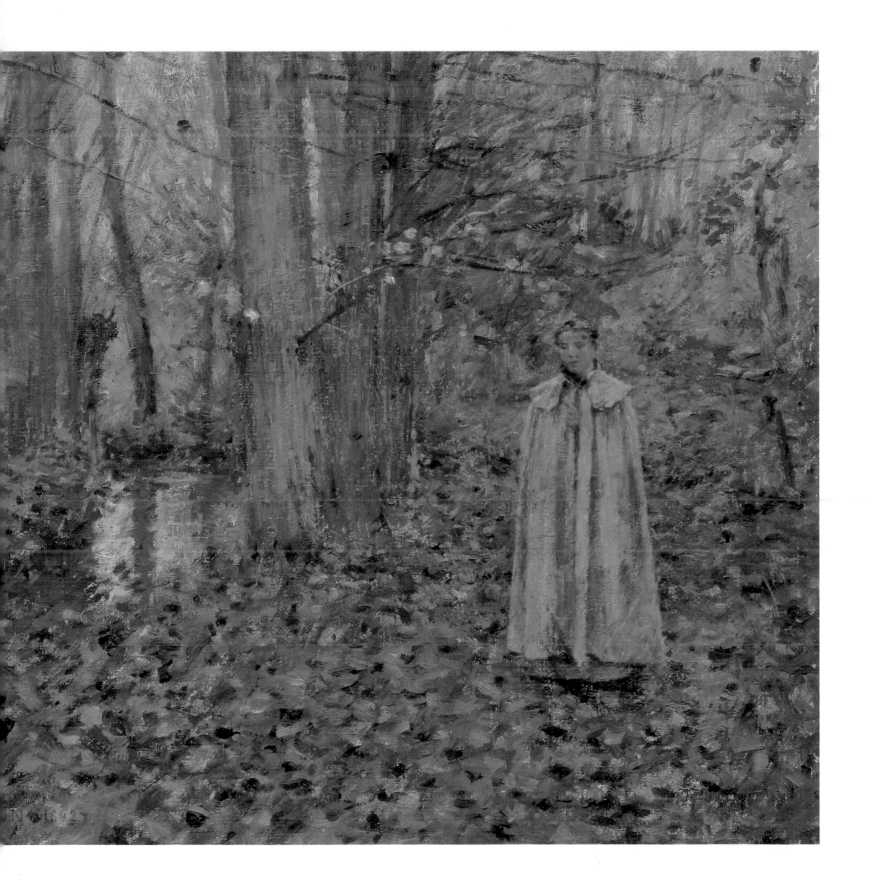

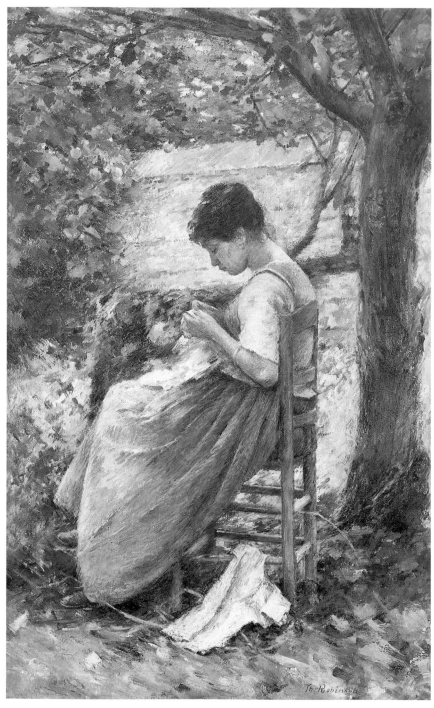

46. Theodore Robinson
(1852–1896). *The Layette,* n.d.
Cyanotype, 9½ x 6¾ in. (24.1 x
17.1 cm). Terra Museum of
American Art, Chicago; Gift of
Mr. Ira Spanierman, Washington,
Connecticut.

47. Theodore Robinson
(1852–1896). *The Layette,* 1892.
Oil on canvas, 58⅛ x 36¼ in.
(147.6 x 92 cm). Corcoran
Gallery of Art, Washington,
D.C.; Museum Purchase.

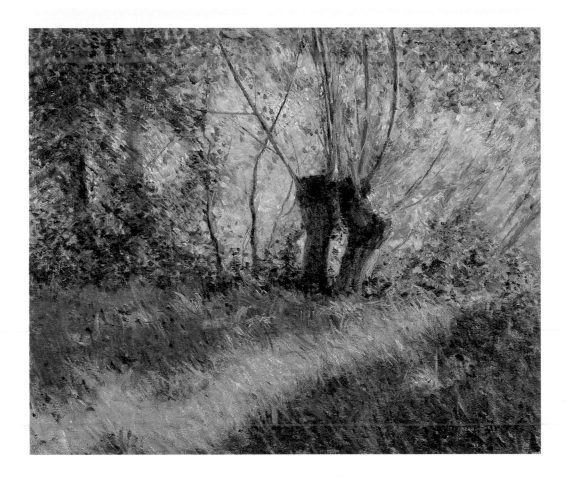

school of painting in America."[57] Certainly by 1888, when he painted *Willows* (plate 48), Breck had adopted the rich colorism and broken facture of the style, with his forms somewhat dissolving under the play of sunlight. But Breck's Impressionism was selective. His ambitious, panoramic *In the Seine Valley (Giverny Landscape)* (plate 92) displays a fully Impressionistic chromatic range and great freedom in its variations of texture, though typically maintaining firm compositional structure. But in *Autumn, Giverny (The New Moon)* (plate 49), the artist opted for a low-key Tonalist approach for a Nocturne that suggests an alliance more with Jean-François Millet and James McNeill Whistler than with Monet. This more traditional and therefore more acceptable mode was probably chosen to elicit critical approval when the picture was exhibited at the Exposition Universelle in Paris in 1889, where it won an honorable mention.[58]

48. John Leslie Breck (1860–1899). *Willows,* 1888. Oil on canvas, 18 x 22 in. (45.7 x 55.9 cm). Pfeil Collection.

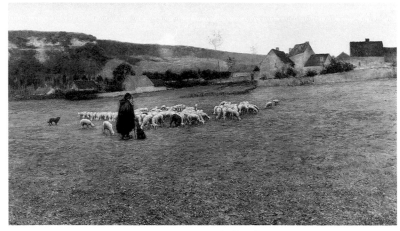

Breck, of all the early colonists, was also the one to adopt most completely Monet's serialization of imagery. Breck painted a sequence of fifteen grainstack representations in 1891, alternatively titled *Studies of an Autumn Day* and *Continual Studies of the Same Day* (plates 50, 51)—obviously inspired by Monet's tremendously successful Grain Stacks of 1890–91. Twelve of Breck's pictures have been located (all, Terra Foundation for the Arts).[59] They differ from Monet's series not only in their much smaller scale, but also in their singular devotion to one image, as seen from morning haze through rich noontime sunlight to moonlight. Unlike Monet's Grain Stack pictures, which range from late autumn of 1890 through the winter of 1891, Breck's paintings suggest their creation on a single day, though they were evidently made over a period of three days. Such compression, of course, necessitated rapid operation and accounts for the diminutive size of the paintings. Breck's inspiration was immediately recognized when the series was exhibited early in 1893 at Chase's Gallery in Boston; Louisa Trumbull Cogswell noted: "This is a favorite device of M. Monet, and indeed one does not need to read the name Giverny appended to some of the titles to guess the source of Mr. Breck's inspiration. At his best . . . his work might almost be mistaken for his master's."[60]

Robinson, too, adopted Monet's serial conception during his last stay in Giverny in 1892, inspired by Monet's earliest views of Rouen Cathedral, painted in February and March of that year. Robinson and Monet discussed these pictures at some length on May 23, 1892, the day after Robinson arrived back in Giverny. That summer Robinson created his own series of panoramic views, called Valley of the Seine (Addison Gallery of American Art, Phillips Academy, Andover, Massachusetts; Maier Museum of Art, Randolph-Macon College, Lynchburg, Virginia; Corcoran Gallery of Art, Washington, D.C.). Robinson's series was confined to just three finished pictures painted over a number of weeks and recording the changing cloud and weather conditions at what seems roughly the same time of day.[61] Still, these pictures conform to Monet's conception in that they depict the same landscape in the same medium—oil paint—on canvases of identical size.

That the Giverny artists were consciously moving toward the adoption of Impressionism is certain, but what they thought about Impressionism is sometimes difficult to fathom. We do have some guides. Lilla Cabot Perry presented an informal talk to

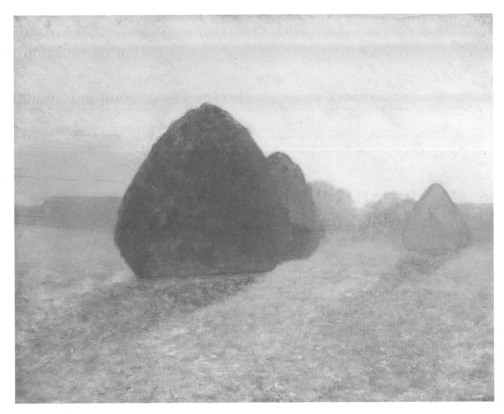

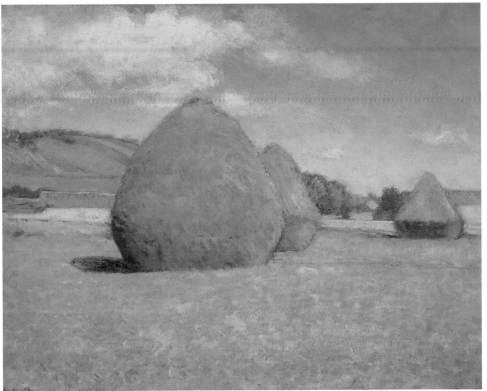

the Boston Art Students' Association of the Museum School in January 1894, communicating to them what she had learned from Monet. She spoke primarily about the atmosphere that intervenes between the viewer-painter and the object observed, and about the colors of light and of shadows as they mix with the colors of objects. Perry also spoke about Monet's insistence on painting in pure colors—colors that are not mixed on the palette but are superimposed on one another on the canvas—and on capturing the particular brightness of specific times and weather conditions. She noted that Monet considered himself an "Impressionist" in that he aimed at reproducing the impression of a scene as it was received on his retina, attempting to rid himself as much as possible of preconceptions about his subject.[62]

Robinson's diaries present a striking picture of an academically trained artist trying to adjust to Impressionism (even though the located volumes begin only with 1892, his last year in Giverny). Still in New York on May 7, 1892, he acknowledged that he needed to develop his feeling for planar construction and that he needed a greater sense of largeness and completeness, while still indulging in brilliant color and inducing a sense of vibration. Once back in Giverny, on May 30 he looked over a group of older canvases and again bemoaned his lack of completeness. A week later he repeated the advice Monet had given to Perry, noting that he should not work beyond the hour chosen for a specific effect of light and weather.

Removed from Giverny during the last years of his life, Robinson increasingly questioned his allegiance to the tenets of Impressionism. On April 14, 1894, he noted that his painting stopped too soon and that he was too satisfied with surface appearance. He needed, he said, to give special attention to line, refined color, and modeling, and to discriminate between important and unimportant details. After having admired a painting by Millet at the Metropolitan Museum of Art that November, he noted:

> I am impressed with the necessity of synthesis, an ignoring of petty details, and seeing things du grand coté. And this is not incompatible with modernité and the true plein-air feeling. . . . Altogether the possibilities are very great for the moderns, but they must draw without ceasing or they will "get left," and with the brilliancy and light of real out-doors, combine the austerity, the sobriety, that has always characterized good painting.[63]

Perhaps the best exposition of what Impressionism meant to the early colonists is a presumably unpublished manuscript written by Dawson Dawson-Watson in preparation for a lecture at the Art School of the Art Society of Hartford, Connecticut, in

1894.[64] Though written after Dawson-Watson had emigrated to America the previous year to take up his teaching position there, the treatise reflects his understanding of the Impressionist aesthetic and, by extension, the ideas of many of his colleagues in Giverny.

Dawson-Watson's thesis is, not surprisingly, colored by his English origins; he names Joseph Mallord William Turner as the "real originator of Impressionism" and commends John Constable for having advanced the concept when his works were shown in Paris in 1824. In dealing with contemporary Impressionism, Dawson-Watson's dicta reinforce the traditional understanding of that aesthetic against more recent interpretations. It may be that Monet and his colleagues did consciously rearrange elements within their chosen subject matter, and it is obvious that many works begun out-of-doors by these artists were completed in the studio. After all, the huge studios that Monet built in Giverny were intended not solely for storage and showmanship but for painting. Yet for the Impressionist artists the *ideal,* at least, was to paint what was right there before them: "Painters who change what they see in front of them are telling a falsehood on canvas & are maltreating nature."

As for indoor versus outdoor painting:

It is of course necessary to look at your work indoors to see how it is going along, & if anything is wrong, instead of working on it in the studio, do it in the open air. . . . I think it is taking a great liberty with nature to touch her indoors when she was commenced out. It is very difficult to make people understand the difference between the handling of color indoors & out. Out of doors the light comes from every quarter & brings with it all sorts of reflected color. . . . Whereas in the studio you work with the light from one quarter only. Painting from notes as some do I think absurd, when you have nature to work from.

Dawson-Watson noted that "the impressionist has abolished all useless color"— meaning such tones as lamp black and burnt umber. "It does not require brown to paint brown, or black black. . . . Nature is full of scintillating color & you want to feel that each object is surrounded by atmosphere." And he reaffirmed the concern for the momentary: "One of the very important & much neglected things & to which the impressionist pays the most minute attention is effect. An effect rarely if ever lasts more than an hour. I have had as many as three canvases going within the hour & had to be on the continual jump from one to the other all the time, so very palpable was the difference."

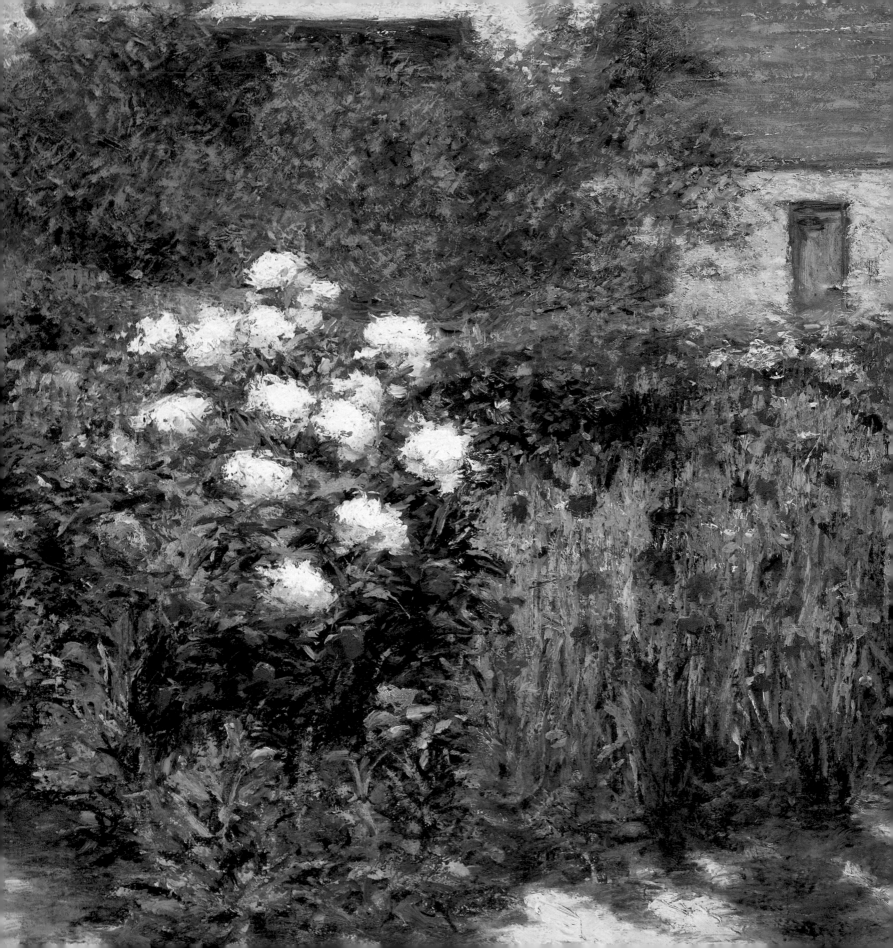

Painting the Town

The two subjects favored by the early Giverny colonists were the landscape and the figure. Portraits were fairly rare, although some examples are known. One of the most Impressionist is *John Leslie Breck* (plate 29), painted in 1891 by the visiting J. Carroll Beckwith. It was probably Breck who had urged him to visit Giverny, for Beckwith's detailed diaries document that Breck met the Beckwiths at the railroad station in Vernon on August 8 and drove them to the Hôtel Baudy; two days later the Beckwiths had moved to a rented house. Undoubtedly inspired both by the local landscape and by his colleagues, Beckwith—who had established himself as a major figure painter in New York as well as a teacher of drawing at the Art Students League—attempted pure outdoor landscape work but found it too difficult.[1] He did, however, produce a number of figural works out of doors—not only the Breck portrait, which he began on September 2, but at least one painting (location unknown) of Theodore Robinson's favorite local model, Josephine Trognon, in a garden setting.

During his month in Giverny—Beckwith left on September 7, 1891—he spent much time not only with Breck and his family but also with the Perrys and especially with Robinson, who took the Beckwiths to meet Monet on September 4. Monet and Alice Hoschedé appear to have been particularly taken with Beckwith and his wife, and they were invited to dine two days later with the Monet-

This Normandy sky with its clouds and rain every half hour is hard on a painter. . . . I am trying to get hold of handling foliage out of doors but the values trouble me. They have a way here of using blues and lilacs which is very effective.

> J. Carroll Beckwith, diaries, August 21, 1891, Archives of the National Academy of Design, New York.

52. Detail of John Leslie Breck, *Garden at Giverny,* c. 1890. See plate 75.

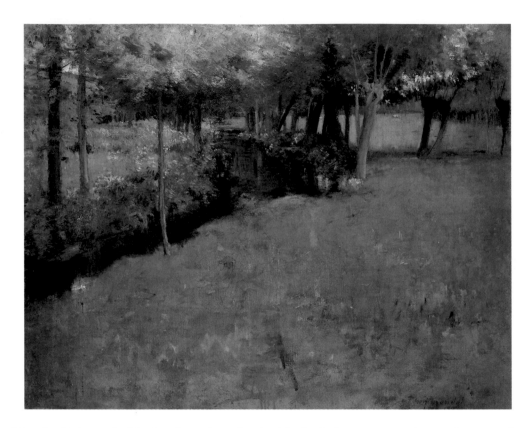

Hoschedé household. At that time Beckwith had the opportunity to inspect the paintings by Monet's colleagues that hung in his bedroom. This was the pinnacle of Beckwith's sojourn in Giverny, and it led him to true admiration for the Impressionist movement.

Some of the colonists seem to have concentrated almost totally on views of the region. Not surprisingly, their subjects often mirrored those painted by Monet, especially the poplars and pollarded willows along the Epte. Yet it may be simplistic to suggest that the Americans were directly inspired by Monet. These subjects, after all, were prominent in the landscape itself, and it is likely that the colonists either undertook them in concert with one another or selected them on the basis of recent achievements by their colleagues. Certainly they were already manifest in works by Louis Ritter (plate 24) and Theodore Wendel (plate 53), both painted in the first season of the colony in 1887, as well as in one by William Blair Bruce probably painted at the same time (plate 54). They can also be seen in works painted the next year by Willard Metcalf (plate 38), Breck (plate 48), and Philip Leslie Hale (plate 32), as well as in Robinson's *Along the Stream* (about 1889; formerly, Jeffrey Brown Fine Arts, Lincoln, Massachusetts), and Lilla Cabot Perry's *Stream Beneath Poplars* (plate 112; undated,

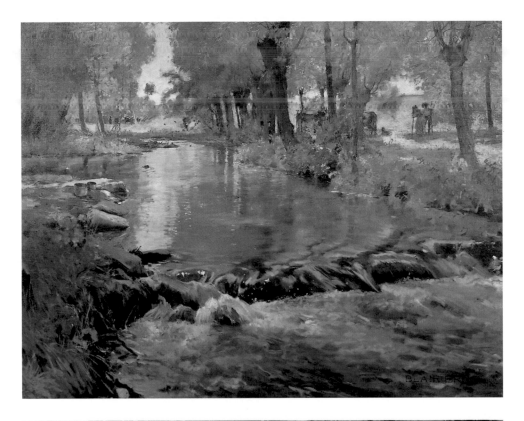

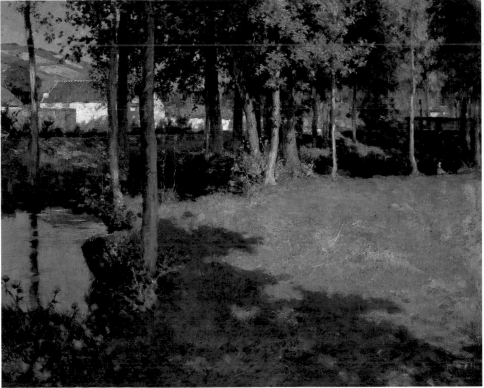

53. Theodore Wendel (1859–1932). *The Brook, Giverny,* 1887. Oil on canvas, 28½ x 35⅝ in. (72.4 x 90.5 cm). Terra Foundation for the Arts; Daniel J. Terra Collection.

54. William Blair Bruce (1859–1906). *The Stream, Giverny,* c. 1887. Oil on canvas, 28¾ x 36⅜ in. (73.2 x 92.3 cm). The Robert McLaughlin Gallery, Oshawa, Canada.

55. Willard Metcalf (1858–1925). *Giverny,* 1887. Oil on canvas, 26 x 32 in. (66 x 81.3 cm). University of Kentucky Art Museum, Lexington; Gift of the estate of Addison M. Metcalf.

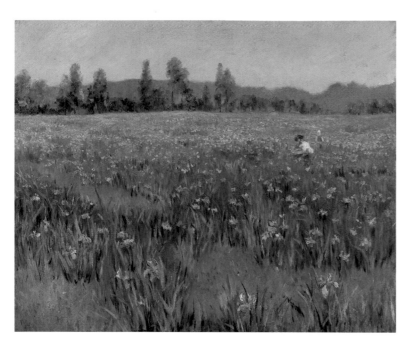

56. John Leslie Breck
(1860–1899). *Giverny Landscape,*
1888. Oil on canvas, 18½ x 22 in.
(47 x 55.9 cm). Private collection.

but probably from the mid-1890s). Some of these works are symmetrical, with the stream flowing between two rows of trees; others concentrate the land on one side of the picture and the river on the other. There may have been something of a rivalry among the painters to best express the same subject through individual strategies of color, paint application, and structure.

The theme was also undertaken by the California painter Guy Rose in his *Willows, Giverny* (plate 139). Probably encouraged to visit by Robinson, Rose made his first trip to Giverny in 1890, though he did not become a mainstay resident of the colony until the early twentieth century. In 1897, while teaching at Pratt Institute in Brooklyn, Rose wrote an essay about Giverny in which he mentioned specifically the "low flat meadows through which runs the river Epte, bordered with stunted willows."[2]

There are a number of other subjects depicted by the colonists that immediately call to mind those favored by Monet. One, certainly, is a field of wildflowers backed by rows of poplars, which appears in Breck's *Giverny Landscape* (plate 56) and Wendel's *Flowering Fields, Giverny* (plate 57) of 1889. These recall Monet's series of poppy-field pictures, in which a flat field, dotted with flowers, recedes to a curtain of trees in the middle ground (ranged parallel to the picture plane), behind which rise distant hills. The Monet series, however, was not painted until the summer of 1890, *later* than the works by Breck and Wendel.

This is not to negate Monet's inspiration, however, for of all the examples of his work shown in New York in the Impressionist exhibition of 1886, none received as much critical attention as his two Giverny pictures of poppies painted the previous year—*Poppy Field near Giverny* (Museum of Fine Arts, Boston) and *Field of Poppies, Giverny* (plate 58).[3] On the other hand neither Breck nor Wendel used the same flowers or color scheme as Monet—choosing, respectively, yellow and pink flowers. It is likely that even when the colonists did take their cues from Monet—and from each other—they also wanted to exert independence and originality by deviating from their models. Not surprisingly, both Breck and Wendel painted more literally than did Monet, who absorbed the individual blooms into a blazing tapestry of color.

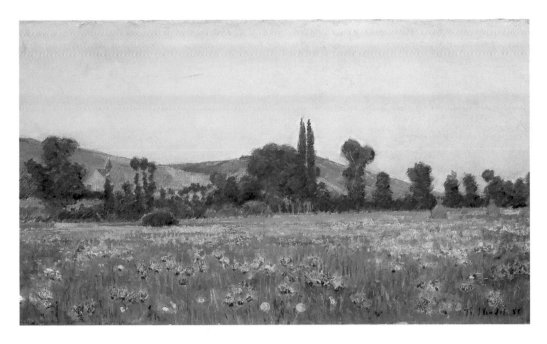

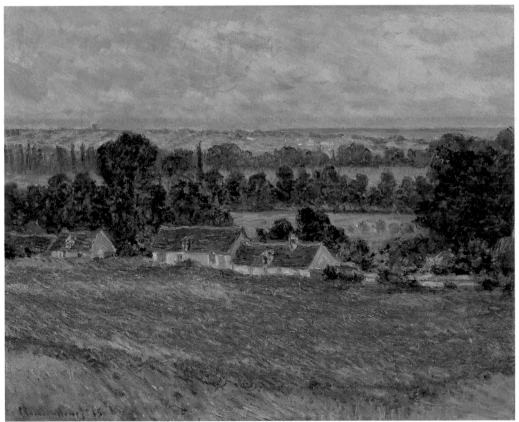

57. Theodore Wendel
(1859–1932). *Flowering Fields,
Giverny,* 1889. Oil on canvas,
12½ x 21⅝ in. (31.7 x 54.9 cm).
Terra Foundation for the Arts;
Daniel J. Terra Collection.

58. Claude Monet (1840–1926).
Field of Poppies, Giverny, 1885.
Oil on canvas, 25⅝ x 28¾ in.
(65.1 x 73 cm). Virginia Museum
of Fine Arts, Richmond; Collec-
tion of Mr. and Mrs. Paul Mellon.

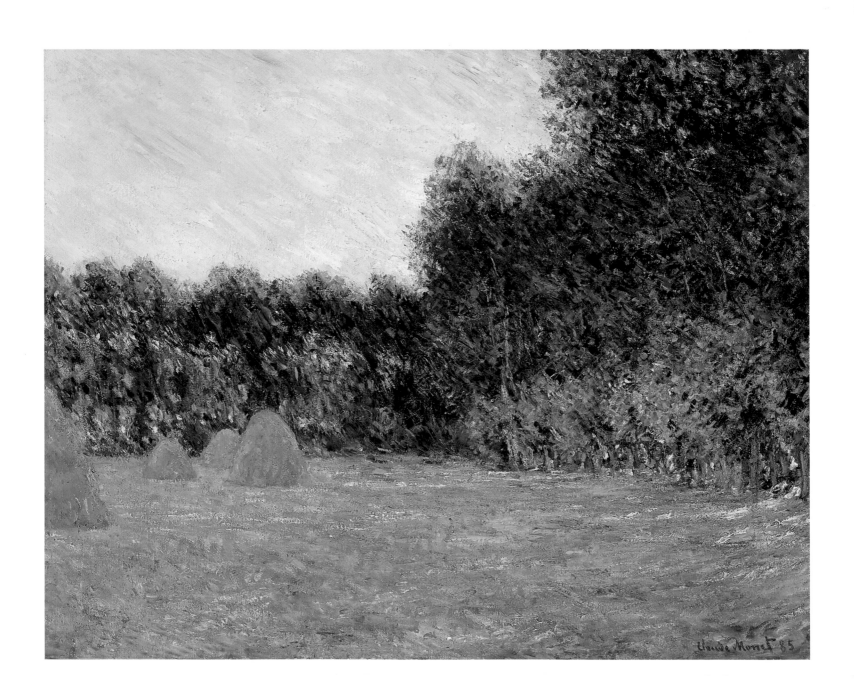

The subject undertaken by Monet that most attracted the Giverny colonists was, not surprisingly, the grain stack. Not only did Monet develop his interest in the motif during the founding years of the colony, but his greatest triumph to date came in May 1891, when fifteen of the series were exhibited in Paris. This undoubtedly sparked even greater interest among the colonists, but they were surely already familiar with the pictorial possibilities of the subject through Monet's initial renderings of it as early as 1884. One example was on view in New York in the 1886 Impressionist exhibition and another in Paris that same year, when so many of the future Givernyites were studying there.

In some cases Monet's inspiration comes through undiluted, as in the direct homage paid by Breck in his fifteen *Studies of an Autumn Day* (plates 50, 51), painted only a few months after Monet's Paris exhibition. Other works, too, such as Perry's later *Haystacks, Giverny* (plate 60), constitute a virtual pictorial tribute to the French master.[4] Like Monet and Breck, Perry concentrated on the mass of the central stack, offering only pale glimpses of the farm buildings beyond them. This is true also of Theodore Butler's *Grainstacks, Giverny* (plate 61), although he created an idiosyncratic design, zooming in on one large stack placed at the far left of the canvas and cut off by the frame. Again, however, the farm buildings are vaguely suggested, and even the road and fence in the right foreground are indicated only faintly.

OPPOSITE

59. Claude Monet (1840–1926). *Meadow with Haystacks near Giverny,* 1885. Oil on canvas, 29⅛ x 36¾ in. (74 x 93.3 cm). Museum of Fine Arts, Boston; Bequest of Arthur Tracy Cabot.

BELOW, LEFT

60. Lilla Cabot Perry (1848–1933). *Haystacks, Giverny,* 1896. Oil on canvas, 25¾ x 32 in. (65.4 x 81.3 cm). Pfeil Collection.

BELOW, RIGHT

61. Theodore Butler (1861–1936). *Grainstacks, Giverny,* c. 1897. Oil on canvas, 21¼ x 28¾ in. (54 x 60.3 cm). The Dixon Gallery and Gardens, Memphis; Purchased by the Dixon Life Members Society.

62. Theodore Robinson
(1852–1896). *A Farm House in
Giverny,* c. 1890. Oil on canvas,
23 x 40¼ in. (58.4 x 102.2 cm).
Courtesy of Spanierman Gallery,
New York.

This effacing of the surrounding elements, however, is not true of many of the grain-stack pictures painted by other colonists. In Willard Metcalf's *Summer Morning, Giverny* (plate 39) space is carefully demarcated by the long, unbroken diagonal of the earthen road, on which an elderly peasant slowly makes her way, picking poppies from the side of the road. The stacks figure as bright tan elements against the green grass, their humped forms repeating the bent shape of the old woman and reinforcing the sense of unchanging peasant life from birth through old age.

Robinson, too, incorporated the grain stack into Giverny's agrarian structure in his monumental *Farm House in Giverny* (plate 62), probably painted in 1890. Activity around the stack is suggested by the tall ladder leaning against it and the farm wagons at its base. The setting is very likely the *clos* Morin—the same field in which Monet painted his Grain Stack series but viewed to the northeast; Monet's series showed the opposite view of the same field, with the hills beyond the Seine in the distance.[5] The

extensive complex of buildings in Robinson's picture is clearly depicted immediately behind the stack, and the agriculture of the village is represented by the geometry of the tilled fields in the background, in contrasting green and golden tones. This careful concern for the economic reality of Giverny life is strikingly absent from Robinson's *Afternoon Shadows* (plate 63) of the following year, with its single small grain stack tucked in a distant corner of a field. The stack becomes no more than a decorative element in a composition otherwise given over to the exploration of light-and-shadow patterns.

Recent Monet scholarship has attempted to identify Monet's work as a conscious record of rural French economic life, but the pictures cited to exemplify this seem instead to belie it. Farm buildings do appear in the backgrounds of all his Grain Stack paintings, but they are usually fairly obscure and occasionally almost indecipherable. And there are no figures of the local farmers building the stacks or of peasants tilling

63. Theodore Robinson (1852–1896). *Afternoon Shadows,* 1891. Oil on canvas, 18¼ x 21⅞ in. (46.4 x 55.6 cm). Museum of Art, Rhode Island School of Design, Providence; Gift of Gustav Radeke.

the soil and reaping the grain. It seems a mistake to relate Monet's images to the pictorial tradition that sprang from Jean-François Millet and Barbizon imagery.[6] It was in the late 1880s—just when the foreign colonists first appeared in Giverny—that Monet began his final figure paintings, but he completely ignored the villagers and concentrated on members of his extended family. In contrast, the foreign colonists perpetuated a reverence for the Barbizon tradition that had made strong inroads in the United States. But such imagery had pretty much run its course by the 1890s, and Impressionism offered young artists—perhaps more so American and other foreign painters than French ones—a way to infuse new life into an increasingly clichéd theme.[7]

64. Dawson Dawson-Watson (1864–1939). *Gathering Firewood*, 1890. Oil on canvas, 67 x 52 in. (170.2 x 132.1 cm). Private collection.

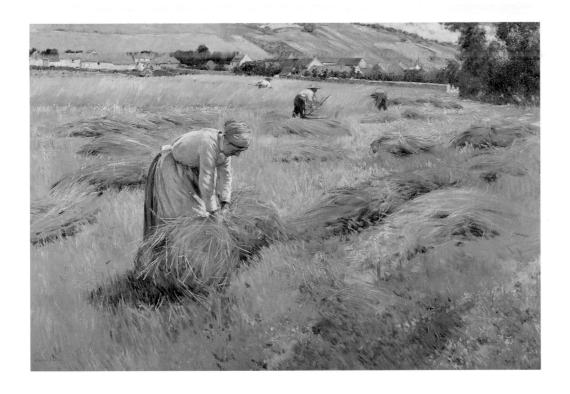

65. Dawson Dawson-Watson
(1864–1939). *Harvest Time,*
c. 1891. Oil on canvas, 34 x 50¼
in. (86.4 x 127.7 cm). Pfeil
Collection.

That the spirit of Barbizon and the tradition of academic peasant painting hovered over the Giverny colonists is nowhere better seen than in pictures by Dawson Dawson-Watson. His monumental *Gathering Firewood* (plate 64) depicts two peasant figures in the snow against a background of pollarded willows. The elderly woman carries a stack of kindling on her shoulder—taken, surely, from the pollarding of these willows. This subject is in the long tradition of depictions of faggot gatherers, the wintry equivalent of the gleaners who followed the summer harvest. The figures are carefully drawn and solidly modeled; what makes them unusual is the color range, which consists only of blues and purples offset by the white of the snow—the colors critics had come to identify with Impressionism.

A summer equivalent to this image is Dawson-Watson's *Harvest Time* (plate 65). Undated, it was probably painted in 1891, given the greater fluidity of its paint application than in *Gathering Firewood.* The most prominent figure, a woman, recalls Millet's *Gleaners* (1857; Musée du Louvre, Paris), although her blue-purple costume, contrasting with the golden harvest, again places the work in the circle of Impressionism. And even though the little world of Giverny seems to weigh down these stooped fig-

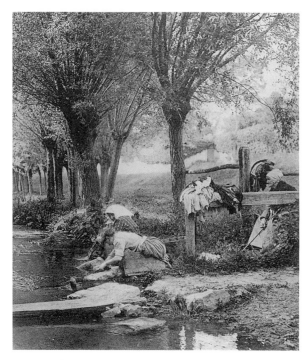

66. *Washerwomen on the Epte,* c. 1900. Vintage postcard.

67. Ernest Clifford Peixotto (1868–1940). *Woman Washing,* 1894. Oil on canvas, dimensions unknown. Destroyed; formerly collection of Walter Nelson-Rees and James Coram.

ures—sunk below the plunging hillside, the row of houses, and the separating wall—the bright light and vivid colors mitigate the oppressiveness of their toil. (*Harvest Time* may be the picture noted by J. Carroll Beckwith in his diary on August 29, 1891: "Watson who is here showed me a wheat field he is painting which is stunning."[8])

Traditionally, peasant women were represented in nineteenth-century painting more often than their male counterparts, and the Giverny colonists conformed to this preference (based in part on the association of the fertile earth with female nurturing). But it must be recognized, too, that these artists chose their subjects on the basis not only of tradition but also experience. Dawson-Watson undoubtedly witnessed farm women at work, and artists often encountered peasant women washing clothes in the Epte. In 1891 Robinson painted several of these women in *The Gossips* (plate 68), and Ernest Clifford Peixotto painted *Woman Washing* (plate 67) three years later.

Like Guy Rose, with whom he associated in Paris, Peixotto was a California artist, who trained first in San Francisco and then at the Académie Julian. A close friend of Robinson's, Peixotto was a frequent visitor to Giverny, arriving at the Hôtel Baudy first on September 10, 1889; from then on, through the next five years, he was regularly at the hotel. It is probable that he painted *Woman Washing* in Giverny (the Netherlands is another possibility), since he was at the Baudy from early March until the middle of June 1894, again from late June to early July, and from the end of September until the end of October; he was back the next spring, after which he returned to San Francisco. Although Peixotto believed that he was strongly influenced by Impressionism—his friends at the time called him "Pinkey Green"—relatively little of that aesthetic can be seen in *Woman Washing,* except perhaps in the attention paid to the effects of light. Early on, a critic noted, "From

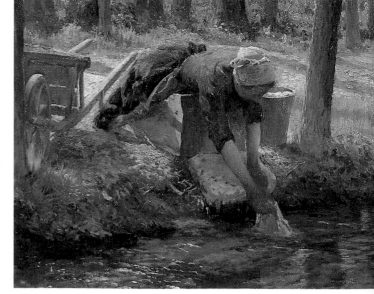

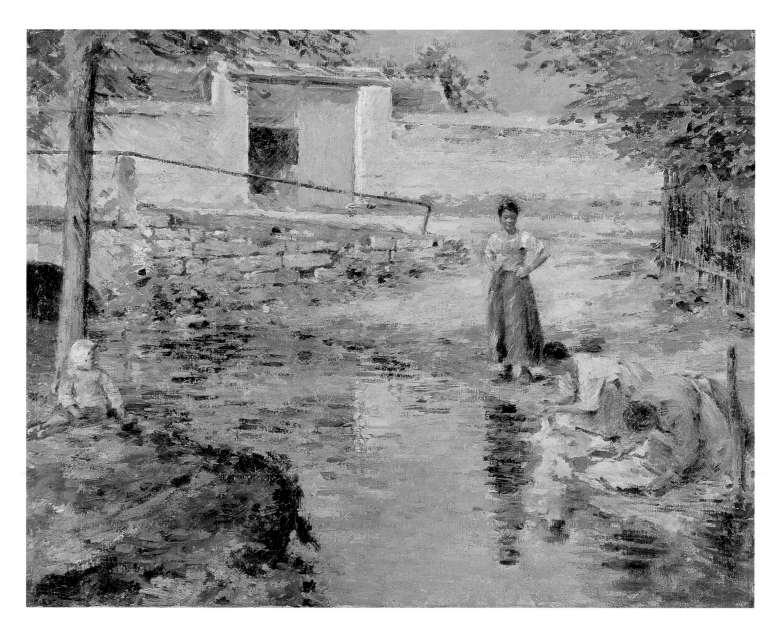

the charming rural scenery and the simple human life of the little village of Giverny he imbibed the summer beauty, the summer sunshine, the summer moonlight, and the sympathy and quiet of ingenuous human nature."[9]

One of the most beautiful pictures of Giverny farm life is Ritter's *Barley Field at Giverny* (1887; plate 69), painted during his single season in the village, in which the sense of the soil's fecundity is clearly emphasized. Ritter's brilliance as a colorist is evident, but his careful delineation of the plants precludes the work's identification as

68. Theodore Robinson (1852–1896). *The Gossips: Three Women Washing Clothes, Giverny,* 1891. Oil on canvas, 18 x 23 in. (45.7 x 58.4 cm). McKean Brothers.

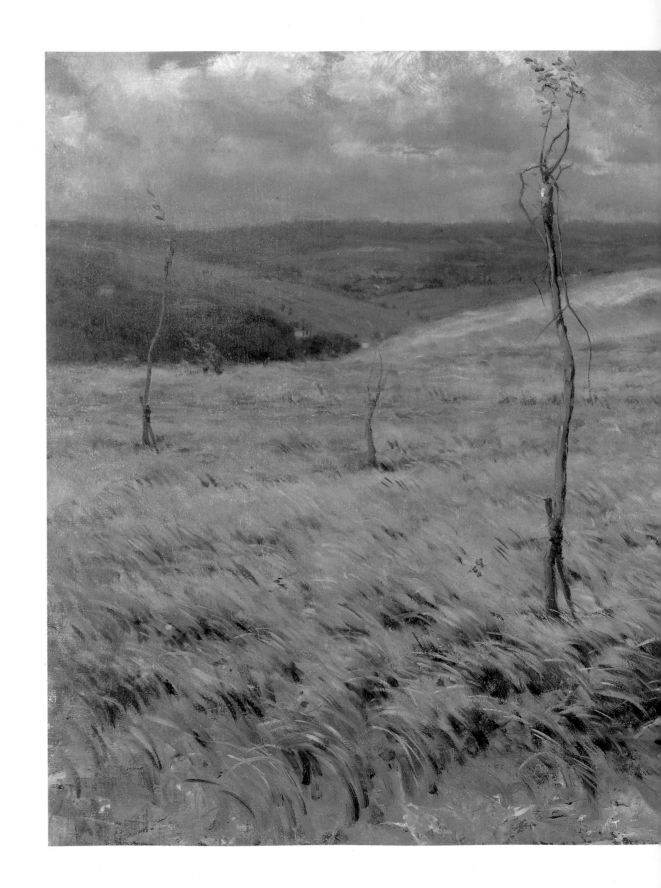

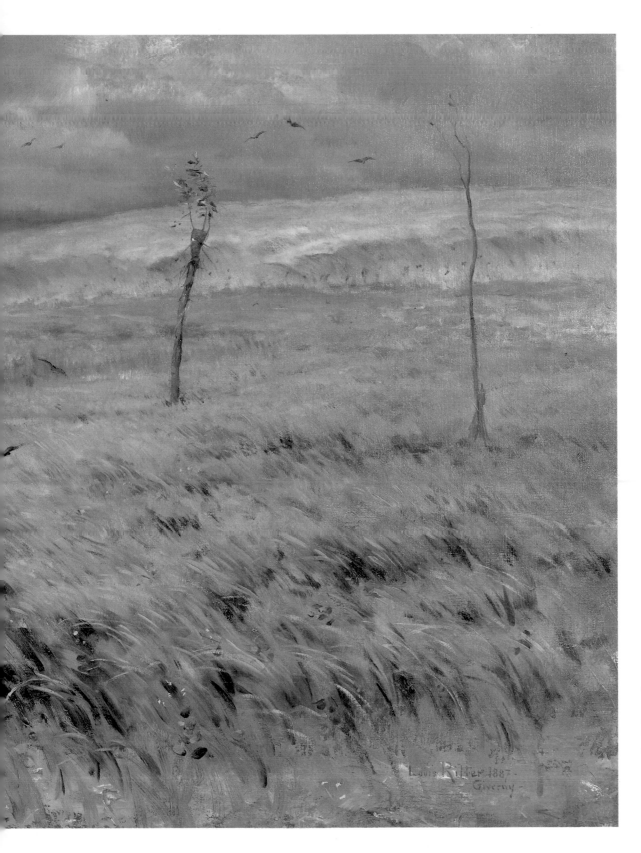

69. Louis Ritter (1854–1892). *Barley Field at Giverny,* 1887. Oil on canvas, 24 x 29¾ in. (61 x 75.6 cm). Private collection; Courtesy of Jordan-Volpe Gallery, New York.

RIGHT

70. Willard Metcalf (1858–1925). *"Auberge" on the Road to Gasny,* 1887. Oil on canvas, 13 x 16 in. (33 x 40.6 cm). Charles and Emma Frye Art Museum, Seattle.

BELOW

71. Theodore Wendel (1859–1932). *Turkeys on a Wall, Giverny,* c. 1886. Oil on canvas, 11⅞ x 21¾ in. (30.2 x 55.2 cm). Private collection.

Impressionist. The colonists were often quite precise in their portrayals of the local agriculture. Ritter's picture is specifically a barley field, and Theodore Wendel's *Farm Scene, Giverny* (plate 21) is equally concerned with agricultural details. Somewhat similar in precisely defining the relationship of the rural buildings to the land is Metcalf's *"Auberge" on the Road to Gasny* (plate 70).[10] Wendel's *Turkeys on a Wall, Giverny* (plate 71) has a full repertory of agrarian motifs—in addition to the birds, he included a group of three peasant women constituting multiple generations, a walled field with a grain stack, and distant farm buildings.

A farm is the subject of *Winter in Normandy* (1893; plate 97), the only Giverny picture by J. Stirling Dyce that has so far appeared. Dyce was a Scottish painter from Aberdeen who first arrived at the Hôtel Baudy in December 1891 and became a mainstay of the colony for the next five or more years.[11] He may have registered at the Baudy more often than any other guest, with the exception of Peixotto. Dyce was recalled as a flamboyant fellow, who wore kilts and played the trumpet.

The colonists who were not just summer visitors were obviously attracted to the picturesque characteristics of winter in the village. This is seen in Metcalf's *First Snow* (1888; plate 181), with its diagonal line of fence posts leading back to the farm buildings; and in Breck's more panoramic (and more purple) *Giverny Winter* (private collection), painted in February of the same year, with the field and village enveloped by snow. Dawson-Watson delineated the winter activities of the local peasants in several monumental canvases, including *Gathering Firewood* (plate 64).

An archetypal Giverny peasant image, *Peasant Woman and Haystacks, Giverny* (plate 72), was created by the American Louis Paul Dessar during his eight-month stay in Giverny in 1891–92. The standing figure, seen from the rear, faces a seemingly endless field, in which a long line of diminishing stacks rises to an almost disappearing horizon, below which the figure is submerged. Dessar's only Giverny work yet located, this painting seems to repeat the traditional form of peasant imagery established by Millet and other French painters. Robinson noted in his diary on October 12, 1892, that he had dined with the Dessars:

> They are excellent, friendly people and I have been wrong in seeing them so seldom. His art is not very personal, but some qualities of tone and color. He is successful, sells anything at once. He has no fear of the *banal,* of doing the already done, which is perhaps one secret of his prosperity. He has begun on the plain a square composition, setting sun, sheaves of grain . . . , two girls in foreground desperately "familiar" as motif but not without charm and color and effect.

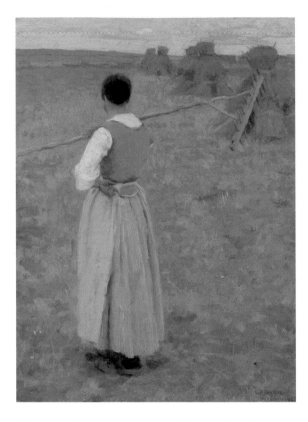

Peasant Woman and Haystacks, Giverny, one of the earliest known paintings by Dessar, may have been a study for this lost or perhaps uncompleted composition.

The Dessars had rented a house in Giverny, but after unpleasant experiences with a difficult landlord, who sold the panels that Dessar had painted on a door of the house, they were eager to leave. Robinson noted that Dessar and his wife departed Giverny on October 25, and they built a house near Etaples, an art colony on the northeastern coast favored by American painters.[12]

Images of the local peasant population are especially prevalent in Robinson's paintings. This is true, in part, because he spent more time in Giverny and may have painted more steadily there than most of his colleagues. Not all of his figurative works made there deal with the essentials of rural life, and even those that do often have a decorative aspect avoided by, say, Dawson-Watson. *Gathering Plums* (plate 73) is a "work" image, but in it Robinson was concerned as much or more with pattern, light, and color than with projecting a sense of toil.

The picture suggests comparison with several apple-picking scenes painted by Camille Pissarro in the years immediately preceding Robinson's work. It is closest to Pissarro's *Apple Picking* (1886; Ohara Museum of Art, Kurashiki, Japan), which

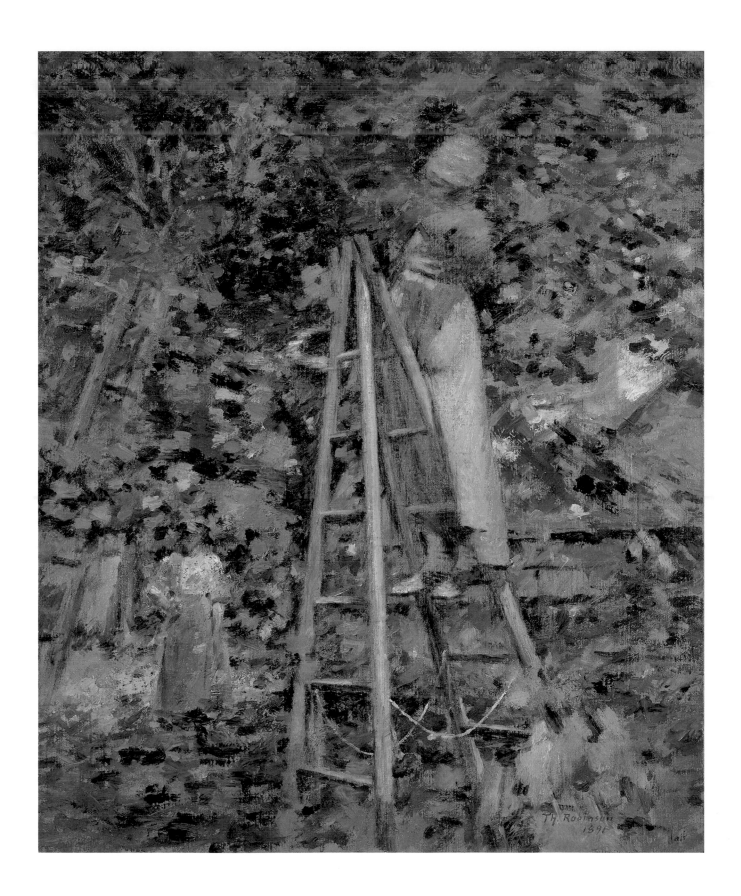

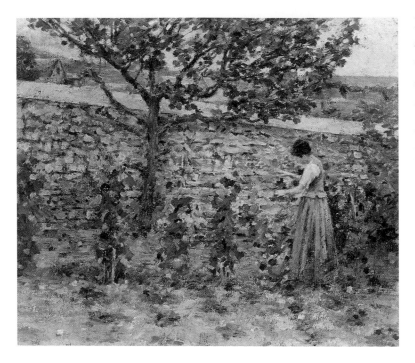

Robinson could have seen in 1886 at the last Impressionist exhibition in Paris, or the following year at the Galerie Georges Petit. An admirer of Pissarro and his art, Robinson noted the Frenchman's visit to Giverny on September 5, 1892, and praised his "happy temperament."[13] Pissarro lived not far from Giverny in Eragny (in a house that Monet had helped him buy), but even though he visited Monet occasionally, Pissarro appears never to have painted in Giverny.[14]

Gathering Plums documents a fact of agricultural life in the village—the cultivation of orchards and the gathering of fruit. But most of the rural women in Robinson's paintings are not actually engaged in strenuous exertion, though their settings suggest labor. His *In the Garden* (plate 74) shows a peasant tending to plants, but she is also a decorative foil, juxtaposed with the large tree at left. For the most part the gardens that appear in the work of the first group of Giverny colonists tend to be vegetable fields and orchards—created for sustenance, not decoration. Sometimes the artists themselves were involved in vegetable gardening; William Howard Hart wrote to Philip Hale from Giverny in February 1894, "I still take the same disgusting interest in gardening and have just come in from planting 200 ognons."[15]

Within this early group of colonists, only Breck emulated Monet in painting flower gardens, as in *Garden at Giverny* (plate 75)—just as Monet seems to have had the only extensive flower garden in the village at the time. This is one of a number of garden pictures by Breck that may have been painted in Monet's own garden—evidence of the initial closeness between the two artists. Breck is known to have painted in Monet's garden prior to his return to Boston in the summer of 1890. Breck's first one-man show, held at the St. Botolph Club in November 1890, included six garden scenes. Not all of these were necessarily painted in Giverny, but one (unlocated) was titled *M. Monet's Garden* and another was *Chez M. Monet*—perhaps also a garden picture.

Twelve of the paintings in the show, including *M. Monet's Garden,* were already owned by local collectors, who may have acquired them from Lilla Cabot Perry. She had returned to Boston in the autumn of 1889 with a group of Breck's pictures, which

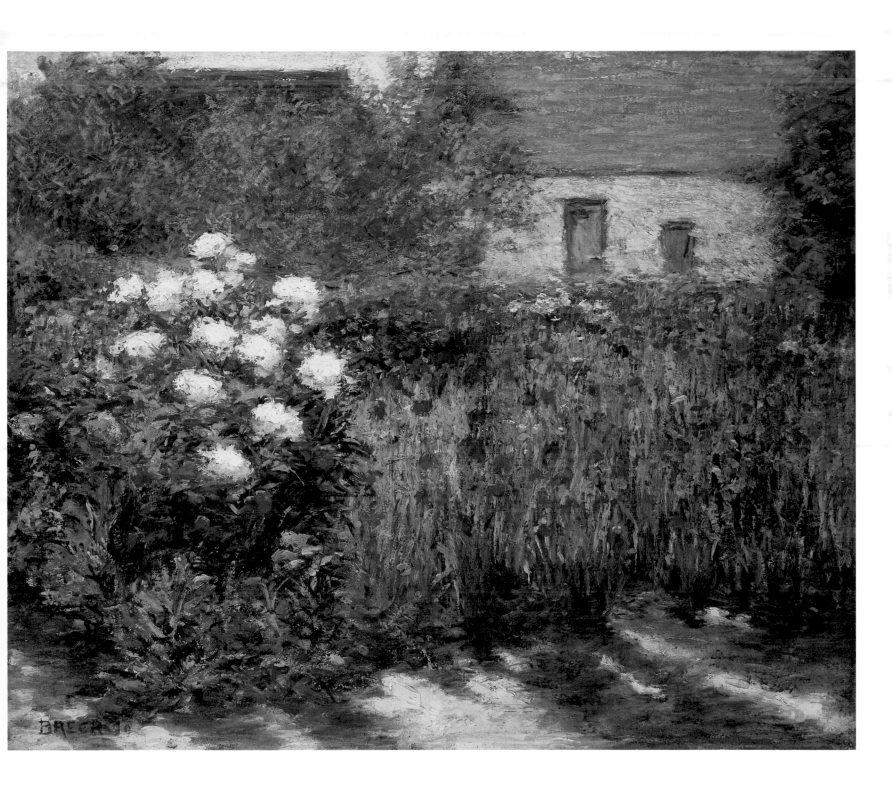

she displayed in her own studio. The critic Hamlin Garland recalled having seen there "a group of vivid canvases by a man named Breck, [which] so widened the influence of the new school. . . . I recall seeing the paintings set on the floor and propped against the wall, each with its flare of primitive colors—reds, blues, and yellows, presenting 'Impressionism,' the latest word from Paris."[16] *Garden at Giverny* may well have been one of these pictures, and Breck's *Willows* (plate 48) was almost surely another, since it was owned at one time by Thomas Sergeant Perry. Unlike Breck, Robinson devoted a great deal of his energy in Giverny to figurative works; the most critically successful was *In the Sun* (plate 76), which won the first Shaw Fund Purchase Prize, of fifteen hundred dollars, for a figure composition in oil at the 1892 exhibition of the Society of American Artists in New York. Though the painting is broadly handled, and the field in which the young woman lies is rendered in broken brushstrokes, the work comes the closest of Robinson's pictures to typical renderings of young peasant women by more traditional French painters and by American expatriates such as Daniel Ridgway Knight. The model is sensuously rendered, with full hips and swelling bosom, and her arms are extended invitingly—all a far cry from images of toiling field workers. This is an example of Robinson's having consciously and successfully directed his painting toward the art market.

A favorite image of Robinson's was a peasant woman by a cistern, which he painted a number of times, including *The Watering Pots* (plate 77). His series of these images are not replicas but variations, since each composition is different and the pictures vary even in shape. In this series the subject, typically, is presented more as a

posed model than as an active worker. Identified as "Josephine" in the title of another version, she is Josephine Trognon, who appears again in Robinson's complex composition *Père Trognon and His Daughter at the Bridge* (plate 78).

Robinson did replicate a number of his Giverny figure paintings, such as *The Layette*. Plate 47, one of two small versions of the composition, is a contemplative,

even introspective peasant image. All three versions were based on photographs (see plate 46) but also on a model, whom Robinson identified in his diary as "Yvonne"; her appearance and dress suggest that she may be the same model who appears in *In the Garden* (plate 74) and *In the Sun*.[17] The setting, too, may be the same as *In the Garden;* although the wall behind Yvonne in all the versions of *The Layette* seems to be composed of rectangular blocks, the photographs that Robinson used suggest rough, rounded stones, similar to those that make up the wall in *In the Garden*. And in that case, the setting for all these pictures can be identified, for his diary entry for October 30, 1892, notes, "Worked a. m. in Gill's Garden with Yvonne on large Layette."[18] This seems, then, to be the garden in which many of Robinson's later Giverny pictures were painted, and it is very likely that the adjoining house was Robinson's residence in 1892. He was registered at the Baudy in 1889–91, but in 1892 took a room elsewhere in the village. Since the trees and the wall of this garden appear in so many of his paintings, it may well be that he lived nearby.

"Gill's Garden" surely refers to the residence of Mariquita Gill and her mother, who first appeared at the Hôtel Baudy in October 1889. At that point their group consisted of Dr. George Gill, from Saint Louis, and Mary Gill, both age forty-five; Mariquita, twenty-four; and a second "Madame Gill," thirty-five; all three women were from Boston. Since Mariquita, the only one of the group to list herself as an artist, is known to have been traveling in Europe with her mother—presumably Mary Gill—the other two were apparently relatives. Mariquita and her mother were back at the Baudy in August 1891 (accompanied by a second, otherwise unidentified "Mlle. Gill") and again from June 11 to August 29, 1892—this time with "Mme. Gill."[19] Following that final stay at the Baudy, Mariquita and her mother took a three-year lease on a house in Giverny, which they subsequently extended through 1897. That may well have been the house and garden where Robinson painted so many of his pictures; it is possible, too, that he had already been renting a room there following his return to Giverny the previous spring.

Gill had been attracted to the Impressionist approach after seeing a show of Monet's work in Paris, most likely the Monet-Rodin show of 1889; even more influential was a display of paintings by Camille Pissarro—very possibly the exhibition at Boussod et Valadon in February 1890. Gill later met Pissarro in Paris and had several critiques from him of her work. His art was a "revelation" to her—the word she used—and having discovered it, she abandoned formal instruction. When she was first in Giverny, Gill used the same motifs for which Monet was renowned: grain stacks,

78. Theodore Robinson (1852–1896). *Père Trognon and His Daughter at the Bridge,* 1891. Oil on canvas, 18¼ x 22⅛ in. (46.4 x 56.1 cm). Terra Foundation for the Arts; Daniel J. Terra Collection.

Hardly an afternoon passed without a half dozen congenial spirits assembling in Mrs. Gill's garden for afternoon tea and jam. Both the summers . . . were hot and dry and the glow of the afternoon light in the hill-bordered valleys of the Epte and the Seine, and the intense blue and violet of the shadows, made color effects such as I have never seen elsewhere. It seemed truly a land where it was "always afternoon," for the amber glow was prolonged, especially in the early summer days, so that painting was usually done after the tea hour in that light which comes at the lingering end of a summer day.

J.I.H.D. [John Ireland Howe Downes], *Mariquita Gill* ([New Haven, Conn.?]: Tuttle, Morehouse and Taylor, [1915?]), p. 19.

RIGHT

79. Mariquita Gill (1865–1915). *Lilies,* c. 1890s. Oil on canvas, 32 x 25½ in. (81.3 x 64.8 cm). Private collection.

OPPOSITE, TOP

80. Dawson Dawson-Watson (1864–1939). *Giverny: Road Looking West toward Church,* c. 1890. Oil on canvas, 17⅜ x 32½ in. (44.2 x 82.6 cm). Daniel J. Terra Collection.

OPPOSITE, BOTTOM

81. Willard Metcalf (1858–1925). *Road to the Village, Normandy,* 1888. Oil on canvas, 13 x 16 in. (33 x 40.6 cm). Private collection.

poplar trees, the distant view of Vernon. But she may have been one of the first American artists there to cultivate her own flower garden, and it provided the motifs upon which she eventually concentrated: a series of floral landscapes—not formal still lifes, but flowers growing outdoors. Among the flowers that Gill favored were roses, hollyhocks, poppies, and "white lilies, marching along the pathway border,"[20] as in *Lilies* (plate 79), shown against the gray wall of her garden.

Gill and her mother remained in the house they had leased until they returned to America in the autumn of 1897. After Gill's death in 1915, her mother asked John Ireland Howe Downes, a close friend and fellow Giverny colonist who had stayed at the Baudy in 1895–96, to write a memorial monograph.[21]

The first Giverny colonists bestowed pictorial attention not only on the farms and the agricultural pursuits of the local populace but also on the town itself. Only occasionally would Monet render an isolated building in and around Giverny or depict a range of structures in the distance behind his monumental grain stacks, but the streets and buildings of the village itself attracted a number of the colonists. As early as 1888, the year he arrived in the village, Dawson-Watson painted a quiet, winding, narrow Giverny street (*Giverny;* Daniel J. Terra Collection); probably somewhat later, he produced a larger and broader view, *Giverny: Road Looking West toward Church* (plate 80).

The latter is an exemplary "road" picture—a compositional formula that was developed by the Italian painter Giuseppe de Nittis in the 1870s and that received its

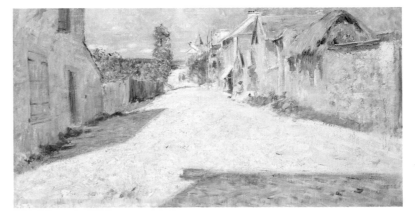

classic representation in William Lamb Picknell's *Road to Concarneau* (1880; Corcoran Gallery of Art, Washington, D.C.). In the foreground of Dawson-Watson's painting the street cuts a wide-angled swath across the entire breadth of the canvas and plunges into the distance, suggesting greater depth than actually existed in the little village. All this is rendered in the bright sunlight and colored shadows of Impressionism, but the strong geometry of the buildings and their reflections adds both interest and structure to the composition. Similar in design but both more sharply rendered and more Tonalist, rather than Impressionist, is Metcalf's *Road to the Village, Normandy* (plate 81), in which buildings and walls on the left form a strong vertical barrier, perpendicular to the flat roadway traversed by a peasant family. This is a view along what is now rue Claude Monet (on the way to the Maison du Pressoir); at the left is the Rendezvous des Artistes, a *café-tabac* that is now the restaurant La Givernoise.[22]

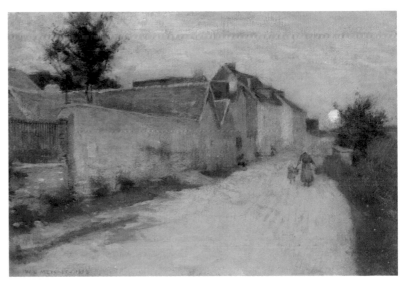

A number of night views of the town mix the Giverny experience with the influence of Whistler's Nocturnes, and perhaps these works also share the spirit of fin-de-siècle Symbolism. Breck painted a large moonlit view of the town (1891; private collec-

tion, Napa, California), in which the buildings cast dark shadows into the greenish glow of the roadways. Perhaps the best known of these moonlight village scenes is the small *Giverny, Moonlight* (plate 82), by the American Thomas Buford Meteyard. After attending Harvard University, Meteyard had plunged into the milieu of the Aesthetic movement in England in 1888, then moved to Paris at the end of the year to study with Léon Bonnat. Meteyard was already an admirer of Breck's Impressionist work by the spring of 1890, recommending it to his friend the poet Richard Hovey back in America: "If you should hear of an exhibition of pictures by a man named Breck this summer in N.Y. or Boston, be sure to see them. . . . He is an impressionist, rather of the Monet school, and a friend of Monet's. I admire his work immensely."[23] That November, Breck included a number of moonlit Giverny scenes in his first one-man show at the St. Botolph Club in Boston, and that work may have inspired Meteyard to undertake the nocturnal theme.

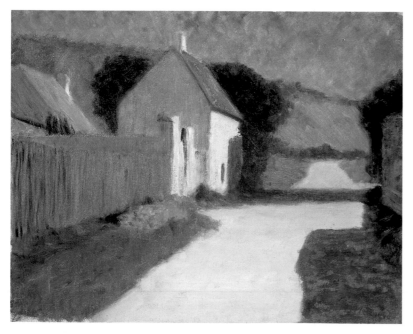

82. Thomas Buford Meteyard (1865–1928). *Giverny, Moonlight,* 1890. Oil on canvas, 12¾ x 16⅛ in. (32.4 x 41 cm). Terra Foundation for the Arts; Daniel J. Terra Collection.

Meteyard is recorded at the Baudy in July 1891, and he returned in spring and summer during the next several years, becoming integral to the art colony. Given his experiences in England and his association in Paris with the Norwegian painter Edvard Munch and the poet Stéphane Mallarmé, as well as his admiration for Pierre Puvis de Chavannes, it may have been Meteyard who encouraged his colleagues to paint moody, nocturnal views of the village. He also painted somewhat mysterious night scenes of Paris and Washington, D.C.[24] Robinson painted *Harvest Moon, Giverny* in 1889 (location unknown), a work similar to the village night scenes by Meteyard and Breck, and in 1892 he introduced several moonlit views in his series of images of the old mill. According to his diary for October 4, he discussed night and moonlit scenes that year with Philip Hale.

Curiously, except for Butler, who portrayed the church, inside and out, a number of times and painted a series of at least five sunset views of it as late as 1910, the colonists paid relatively little attention to what may be the most conspicuous architectural feature of the village, the eleventh-century church of Sainte Radégonde. The building can be made out in the distance in a number of Giverny

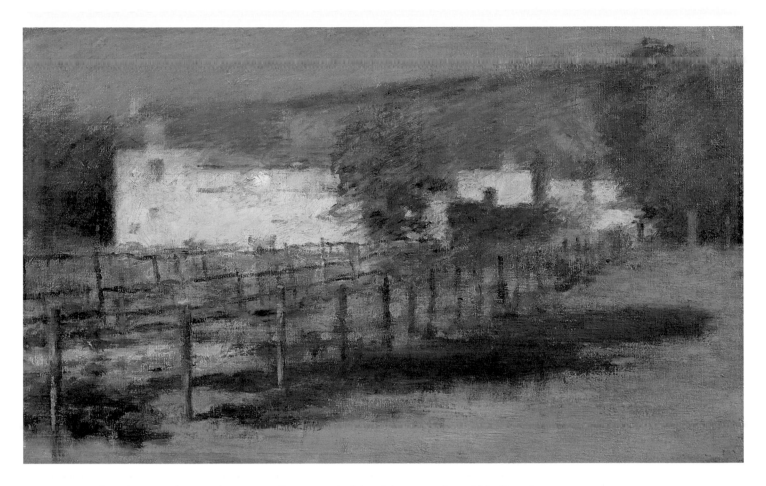

canvases, and Robinson depicted it, partially concealed by foliage, in his *Old Church in Giverny* (National Museum of American Art, Smithsonian Institution, Washington, D.C.). The structure also appears in Metcalf's small *Souvenir du Village* (location unknown).

On a visit to Giverny in 1893 the painter and art writer Polly King was fascinated by seeing "on a warm morning, the Sunday for first communion in the little parish church, the people passing by to service—old peasant women with bent backs, hobbling along in ill-fitting shoes—women in light dresses with gay parasols—the artistic community in spotless linen suits and the little communicants wrapped in white tuile [*sic*]." King compared the spectacle to scenes painted by Renoir and Albert Besnard, but none of the colonists appear to have immortalized such an occasion, as painters frequently did in other French art colonies.[25]

83. Theodore Robinson (1852–1896). *Moonlight, Giverny,* 1892. Oil on canvas, 15⅝ x 25¾ in. (39.7 x 65.4 cm). The Parrish Art Museum, Southampton, New York; Littlejohn Collection.

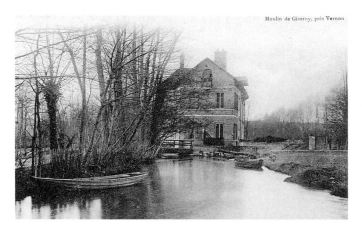

Moulin de Giverny, près Vernon

The structures that the colonists depicted most prominently were the mills in and around Giverny. They are especially featured in Robinson's paintings of 1891 and 1892—above all, in his 1892 mill series, begun by early August and continued through November. The works in this series include *The Old Mill* (plate 85), *Road by the Mill* (plate 86), and *Moonlight, Giverny* (plate 83), as well as a study for the latter (Graham Williford Collection) and *A Normandy Mill,* a watercolor of the scene under moonlight (Mr. and Mrs. Raymond J. Horowitz).[26] The five versions of this composition are depicted under different light conditions, at different times of day and night, and in different media. They can be viewed, in a sense, as the artist's response to Monet's recently begun series portraying Rouen Cathedral,

which the two painters had discussed. But Robinson pointedly chose a secular structure that was significant to the economy of the village, rather than a structure with spiritual resonance. This may have been a deliberate avoidance on Robinson's part, perhaps in order to avoid charges of imitating Monet. And it may again indicate the artist's interest in agrarian themes.

The largest and most ambitious of his series of mill scenes, the colorful, sun-filled *Road by the Mill* (plate 86), is undoubtedly the version that was commended by his and Monet's friend Ferdinand Deconchy on September 5, 1892: "Deconchy liked the greens in my 'Mill' which he thinks often I modify too much." Monet, however, offered a somewhat different opinion ten days later, noting "some undecided tones in the 'moulin' around the figure and values rather equal." Robinson continued to work on "the mill in sunlight" on November 14 and probably again on November 17, when he "worked on the little mill." On November 29, the day he left Giverny, he "took

86. Theodore Robinson (1852–1896). *Road by the Mill,* 1892. Oil on canvas, 20 x 25 in. (50.8 x 63.5 cm). Cincinnati Art Museum; Gift of Alfred T. and Eugenia I. Goshorn.

ABOVE

87. Theodore Wendel
(1859–1932). *The Bridge,
Giverny,* c. 1888. Oil on canvas,
12¾ x 22 in. (32.4 x 55.9 cm).
Private collection.

OPPOSITE

88. William Blair Bruce
(1859–1906). *The Bridge at
Limetz,* c. 1887. Oil on canvas,
29 x 36½ in. (73.7 x 92.7 cm).
Private collection.

two photos of the little mill," so that he could continue to work on one or more of the canvases in the series back in New York.[27]

What seems to be the Moulin de Chennevières, a different Giverny mill, figures in Robinson's *Père Trognon and His Daughter at the Bridge* (plate 78), a subject known also in a more abbreviated version, *The Watering Place* (Baltimore Museum of Art). The mill here is adjacent to the little stone bridge over the Ru, which also appears in one of Robinson's most beautiful pictures of 1892, *La Débâcle* (Scripps College, Claremont, California). That bridge is also a feature in an earlier painting by Wendel, *The Bridge, Giverny* (plate 87).

A mill in a neighboring community is featured in canvases by two other of the founding colonists, Bruce and Breck. One of Bruce's most monumental Giverny canvases, *The Bridge at Limetz* (plate 88), is a carefully structured rendering of the large mill in front of the bridge over the Bras de Limetz (a branch of the Epte), on what is known today as the chaussée Claude Monet, which leads to the village of Limetz. The bridge and the mill buildings are carefully defined in brilliant color and purple shadows. The same structure is seen beyond the bridge in Breck's more completely Impressionist *Mill Stream, Limetz* (plate 89). Somewhat obscured by the pattern of leaves that hang into the scene from both sides, the sunlit walls of the structures reflect in the shimmering water below. The two works offer a telling comparison in

89. John Leslie Breck
(1860–1899). *Mill Stream,
Limetz,* c. 1888–90. Oil on
canvas, 18 x 22 in. (45.7 x 55.9
cm). Private collection.

aesthetic approach between the two most avant-garde of the early colonists, though Breck's is a later canvas, painted after he had more fully absorbed the tenets of Impressionism.

The early colonists were attracted not only to depictions of the village buildings and its inhabitants but also to the local landscape. Almost all of these painters, like Monet himself, were fascinated by the quiet flow of the Epte through the bordering willow trees. In addition, the foreign artists (but not Monet) surveyed the broad expanse of the valley in which Giverny lay. In *A Bird's Eye View: Giverny* (plate 90) Robinson looked down toward the south on the farms and the field beyond. Moving farther east, he took a southwestward viewpoint in *Val d'Aconville* (plate 99), in which his friend and model, Marie, is shown seated on the hillside. This view is toward the valley of Aconville (also known as Arconville), situated across the Seine between Vernon and Port-Villez. This may be the earliest of Robinson's hillside panoramas; shown in the eleventh annual exhibition of the Society of American Artists, in 1889, it was one of the first American Impressionist pictures to appear in a New York show and had almost certainly been painted the previous year.

The geometric patterns in some of these landscapes—such as *A Bird's Eye View: Giverny; A Farm House in Giverny* (plate 62); and *Valley of the Seine, Giverny* (Spanierman Gallery, New York), a small, rare work of 1887—confirm Dawson-Watson's observation (evident in his own *Harvest Time,* plate 65) that the hillsides and pastures were under a communal system, divided into strips from the top of the hills to the flatlands below, for growing grapes, wheat, and so on.[28]

Robinson appears to have first chosen this panoramic landscape format in 1888. He may have been persuaded to adopt it by the series of landscapes painted the pre-

90. Theodore Robinson (1852–1896). *A Bird's Eye View: Giverny,* 1889. Oil on canvas, 25¾ x 32 in. (65.4 x 81.3 cm). The Metropolitan Museum of Art, New York; Gift of George A. Hearn.

91. William Blair Bruce
(1859–1906). *Untitled (Farm
Scene),* 1887. Oil on canvas,
10⅝ x 13⅝ in. (26.8 x 34.8 cm).
The Robert McLaughlin Gallery,
Oshawa, Canada.

vious year by his close friend William Blair Bruce. Bruce's much more Impressionist
Giverny, France (plate 43) of that year already utilizes the strong diagonal compositions
that Robinson would subsequently adopt, but the westward direction of his hillside
view is quite different. Bruce's *Untitled (Field and Farms)* and *Untitled (Farms)* (both,
Robert McLaughlin Gallery, Oshawa, Canada) offer an even closer comparison with
Robinson's later pictures, with their emphasis on the buildings of the village, though
Bruce incorporated decorative wildflower patterns while highlighting farming activity.
Such activity is the focus of his *Untitled (Farm Scene)* (plate 91), a more precipitous
view down on the rooftops of the buildings in Giverny, with a vast open field at the
center of the canvas, occupied by farmers and several grain stacks. Breck later took a
similar viewpoint, but on a much grander scale, in his monumental *In the Seine Valley
(Giverny Landscape)* (plate 92).

The most panoramic vista of all, and one that much more completely defined the
topography of the local landscape, was also one of the first major canvases by one of

the colonists, Louis Ritter's *Valley of the Seine from Giverny Heights* (1887; plate 23). This may have been a source for Robinson's Valley of the Seine series of 1892, though Ritter moved farther up the hillside to Les Grosses Pierres, the limestone cliffs above Vernonnet. As in Robinson's Valley of the Seine series, the view encompasses Vernon and the bridge over the river in the distance, but since Ritter had not absorbed the strategies of Impressionism, he defined the topography with great clarity and endowed it with considerable drama.

All in all, the early colonists evinced a tremendous interest in the landscape and the village where they took up residence—far more so than their putative mentor, Monet. They may have been attracted to the panoramic view partly because of its beauty and its picturesqueness, and partly to distinguish their art from that of the French master. But the predilection for such sweeping views by these North American painters may also have been an unconscious reflection of their own heritage. By the early 1880s the work of the older Hudson River School painters, who had favored such compositions in an often detailed, naturalistic mode, had been disparaged by critics and pretty well discarded by artists in favor of more personal and more poetic interpretations of nature.[29] But the landscape itself in which these foreign artists had originated had inevitably imprinted its breadth and distance on them, and they transferred that imprint to the valley of the Seine.

92. John Leslie Breck (1860–1899). *In the Seine Valley (Giverny Landscape),* c. 1890. Oil on canvas, 27½ x 51½ in. (69.9 x 130.8 cm). Private collection.

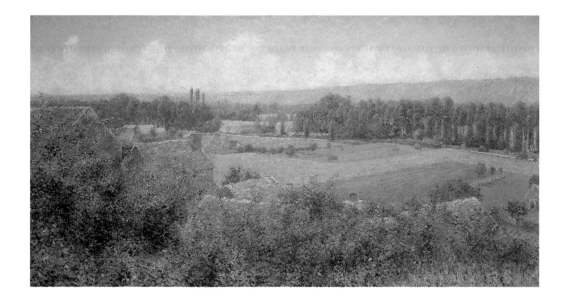

Provisions, Diversions, and Liaisons

Giverny served the artists not only as a base of operations for art making but also as a center for socializing and amusement. A major factor in the art colony's longevity was its congeniality to a diverse group of visitors from many nations—men and women, old and young, individuals and families—primarily artists but also others in the arts.

Since the early colonists were all English speaking and since they so rarely interacted with the villagers, other than to fill the most basic needs, language seems not to have been a significant barrier. The exception, of course, was Monet, and one factor in his reluctance to intermingle with the colonists may have been his inability to speak English and the inability of many of them to converse easily in French. This was certainly not a problem with Robinson, who corresponded with Monet in French when he was back in America and when he traveled in Italy during the winter of 1890–91.

Sharing the English language, as well as the Anglo-Saxon culture, may have been a significant factor in unifying a colony drawn primarily from the United States, Great Britain, Canada, and Australia. Isolated artists did occasionally join the colony from other countries, and a small group of Norwegians swelled the rolls at the Baudy in the 1890s. These included Bengt Gronvold and his wife, the German painter Hermine

93. Detail of Theodore Robinson, *Val d'Aconville,* 1887–89. See plate 99.

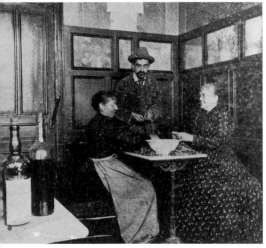

ABOVE, TOP

94. *The Hôtel Baudy,* c. 1900.
Vintage postcard.

ABOVE, BOTTOM

95. *Interior of the Hôtel Baudy,
Mme. Baudy Seated at Left, Mrs.
Meteyard Right, Thomas Buford
Meteyard Standing.*

Herrmann Gronvold, who made several short visits in the spring of 1890. Gudmund Stenersen was there several times in the spring of 1892; and Agnes Steineger, Sara Horneman, and Kristine Laache arrived together on May 20, 1893, a few weeks after the Norwegian writer, Erik Lie. The Norwegian-American painter Martin Borgord registered in May 1892.[1] French animosity toward the Germans, kindled by the Franco-Prussian War of 1870–71, still ran deep, and when some German and Austrian artists came to Giverny, Lucien Baudy paid their way out of town.[2]

Though a number of young peasant women served the early colonists as models, few of the artists seem to have socialized with any of the local inhabitants, except the Baudys, Abbé Anatole Toussaint, and the Monet-Hoschedé clan. Yet those who remained for long periods or frequently revisited Giverny naturally came to be known in the village. After his final return to Giverny in May 1892, Robinson wrote: "It seems like home, as the old ladies stop and ask me how I am and we talk about our ailments quite sociably. Having spent five summers here, I feel like one of them."[3] The attitude prevailing among the colonists toward the local population was probably best expressed, admittedly much later, by the American painter and illustrator Arthur B. Frost. Writing in 1908 to Augustus Daggy, a colleague in America, Frost reported:

> The peasants here are a good lot. They have been agreeable to us not cordial, but always civil and pleasant. They work very hard, from 4 A.M. till dark and they are certainly not *very* well to do, if outside appearances go for anything. And they live as all the peasants I have seen live, with the most abominable stinking barn yards right under their noses. They stink so that they choke Mrs. Frost and me as we pass them in the road. Claude Monet lives right on the road . . . and within forty feet of all of his windows is one of the most God awful stinking barn yards in Giverny or anywhere else. It isn't only manure. One can stand that, but everything rotten.[4]

For the artists Giverny was a community where they could not only paint but also develop their ideas and concepts about art—and about life, too. It was not usually a place where they could market their pictures, which were sent to exhibitions and galleries in Paris and back in the United States. Yet sales were occasionally made there. Robinson recorded on August 9, 1892, that Philip Leslie Hale had brought the railroad magnate Henry G. Marquand to see Robinson's work, noting that the collectors seemed to have particularly liked his figurative pieces. The following day Marquand returned and purchased Robinson's "little Layette" for his Boston partner.[5]

The center of community life for the colonists was the Hôtel Baudy—commemorated by John Leslie Breck in *M. Baudy behind His Desk at the Café of the Hôtel Baudy* (plate 96) and Robinson's *Portrait of Mme Baudy* (1888; location unknown). These depict the Baudys' son Gaston and his mother, Angélina Baudy, respectively. Lucien had made himself personally responsible for the artists after the secret police from Vernon kept a watch on the newcomers for six months.[6] The success of the colony encouraged Baudy to enlarge his original structure and to add some studios and outbuildings, including a separate studio in the center courtyard. One of the attractions of the hotel was its reasonable cost—five francs a day for room and board, with free red wine.[7] Rooms were not luxurious, but the hotel was well kept. Other villagers soon sensed the economic possibilities of this influx of foreigners. William Blair Bruce noted to his mother in the first season of the colony, "The natives are already begin-

96. John Leslie Breck (1860–1899). *M. Baudy behind His Desk at the Café of the Hôtel Baudy,* 1888. Oil on canvas, 13¾ x 17¾ in. (34.9 x 45.1 cm). Location unknown.

ning to build studios and we presume that the colony will soon be quite the thing to talk about just at present however we are very exclusive and daily letters arrive from fellows asking leave to visit us which we are obliged to refuse—on account of the lack of accommodation for them."[8]

Angélina Baudy presided over the hotel, assisted by Gaston and his wife, Clarisse, and by local girls serving as maids. In 1891 Robinson informed Thomas Sergeant Perry that a couple had been hired as cook and waiter and that a new trap, with a gigantic Norman horse, had been acquired, presumably to take guests to and from the railroad station at Vernon.[9] The great majority of the artists who stayed at the hotel were young men and women in their twenties. The youngest of all in the early days of the colony was the future painter and illustrator Frederick L. Pape, an eighteen-year-old art student from San Francisco, who registered on May 7, 1889; he was no doubt brought there from Paris, where he was studying, by Henry Prellwitz, who registered with him. Only a year or two older than Pape were the sisters Laura and Helen Glenn from New York, who arrived later the same year; Laura's portrait was painted by Breck (private collection, Ann Arbor, Michigan), almost surely at this time. A number of husband-and-wife artist teams stayed at the Baudy. The earliest were the American painters Jessie Leach France and his wife, the former Eurilda Q. Loomis, both students at the Académie Julian; and the sculptor Frederick MacMonnies and his wife, the former Mary Fairchild, a painter. Both couples had married in 1888, and they arrived together at the hotel on April 3, 1890; Loomis and Fairchild had roomed together in Paris during their student days. Another noteworthy pair was the English artist Adrian Stokes and his wife, the former Marianne Preindlsberger of Austria, who arrived on May 18, 1890, with Bengt and Hermine Gronvold. No Giverny pictures by any of these artists, except the MacMonnieses, have yet come to light.

The Hôtel Baudy was the residence of hundreds of artists in Giverny, and even more their source of food and drink. (And art supplies: when Mme Baudy became an agent for Lefevre et Foinet, paint, canvas, and other necessities became directly available in the hotel.[10]) Even some of the colonists who resided primarily in rented homes, such as Lilla Cabot Perry and her family, often took their meals at the Baudy. The dining table at the hotel could be extremely crowded; Robinson noted twenty-five people at the *table d'hôte* on July 3, 1892.[11] A Bohemian spirit reigned at the Baudy, where one Frenchman noted that it was like being dropped down *"en plein Middle-Ouest,"* with huge bearded men dressed like lumberjacks.[12]

In deference to the preponderance of American and British artists at the hotel, Mme Baudy prepared the native dishes of her guests. J. Stirling Dyce taught her how to prepare Welsh rarebit and the art of making tea—which she sold in her village store, along with other foreign products such as maple syrup, marshmallows, and Dundee marmalade. Thanksgiving was celebrated at the hotel, and Christmas puddings were served. Will Hickok Low, visiting Robinson in the summer of 1892, noted that "at the first meal of which I partook at Giverny, Boston baked beans were served! Poor patient Madame Baudy had concocted, under the direction of one of her guests,

97. J. Stirling Dyce (1853–?). *Winter in Normandy,* 1893. Oil on canvas, 18⅜ x 26¼ in. (46.5 x 66.5 cm). Private collection, France; Courtesy of Musée A. G. Poulain, Vernon, France.

a *version Française* of this dish."[13] Low noted, though, that Robinson had rented a room away from the hotel that summer and took his meals in a little café, perhaps the Rendezvous des Artistes.

The Baudy was much more than a hotel. Not long after the facility was expanded from a grocery and bar to full residence service, a billiard table was installed inside the hotel and tennis courts were established across the road from it. The courts offered the primary summer diversion for many of the visitors; Dawson Dawson-Watson and his wife were often joined in play by Thomas Sergeant Perry, the Perry's daughter Margaret, and Thomas Buford Meteyard—along with J. Carroll Beckwith, during his month-long stay in 1891, and Beckwith's former pupil the young painter Alice Beckington. In winter, tennis was replaced as the entertainment of choice by ice-skating and sledding on the frozen Marais. There were daytime races and evening festivals with the artists, their families, and friends drinking hot mulled wine; this was one activity in which even Monet participated.[14] In January 1888 Bruce noted to his mother that he had "had a jolly evening skate and such good ice. I have been quite turning the French peoples' heads with our Canadian fantastic skating."[15] In the winter of 1888, when the Seine flooded its banks and froze, the artists gave a Christmas party, with paper lanterns hanging from all the trees and skating that lasted until dawn.[16]

The artists and their families fished both for sport and for food, and boating was another common diversion. In 1892 Dawson-Watson built a fourteen-foot flat-bottomed boat out of the wood from the crates in which Theodore Butler's furniture had been sent to furnish his new house after he married Suzanne Hoschedé; the boat was Dawson-Watson's wedding present to the Butlers. Other forms of entertainment would pass through the village. Beckwith noted a sleight-of-hand performance on August 15, 1891,[17] and Dawson-Watson recalled strolling players who came to the village and performed off-color skits at the Baudy, standing on boxes with an old door used as a stage. They were rewarded with contributions collected by passing a hat. Ten of the players slept in one of the limestone caves up on the hill, after obtaining a permit from the mayor of the village.

On arriving at the Baudy, Beckwith noted, "It is all art or music rather more Boston than usual in art colonies."[18] In the evenings there were dances at the hotel, featuring quadrilles and waltzes. Some of the artists also played musical instruments: Butler was skilled with the mouth organ, Dyce played the trumpet, Breck's mother was an accomplished pianist, and her other son, Edward, was a violinist. He and his

98. Karl Anderson (1874–1956). *Tennis Court at the Hôtel Baudy, Giverny,* 1910. Oil on canvas, 21⅛ x 25 in. (53.7 x 63.5 cm). Terra Foundation for the Arts; Daniel J. Terra Collection.

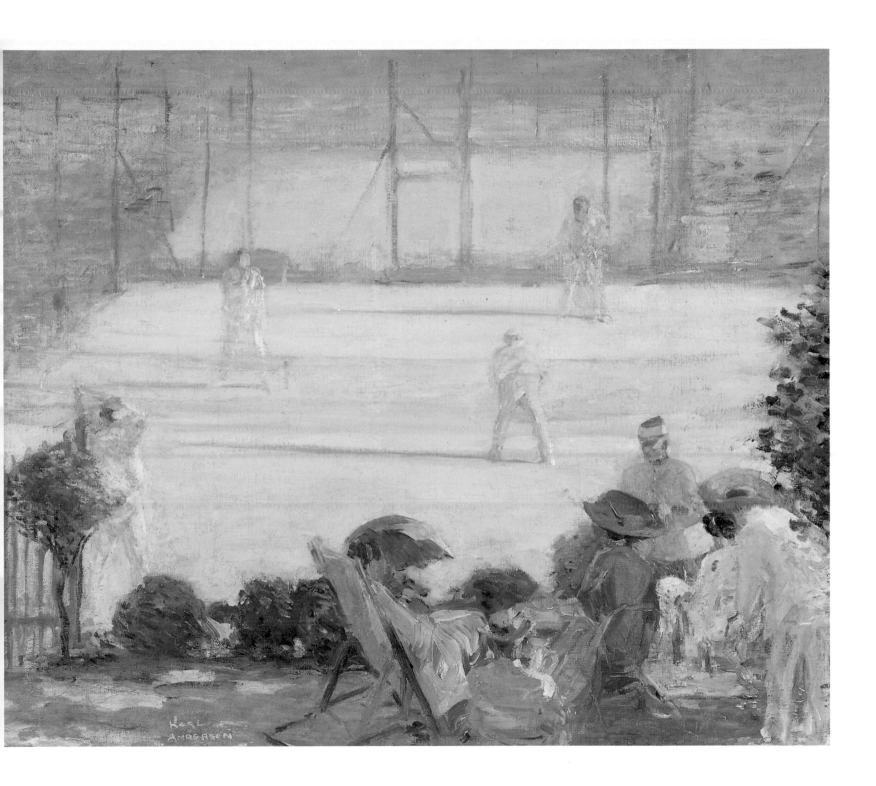

wife were also singers, and as Beckwith noted in his diary, they were "professionals and ultra Wagnerian."[19]

Occasionally the hotel held exhibitions of recent work by the colonists; these must have been fascinating displays, and one regrets the absence of catalogs, lists, or detailed reports of their contents. Dawson-Watson recalled that Meteyard's work, a group of about forty small watercolors, was seen for the first time in one of these shows. Many of the painters also adorned the walls of the hotel with their own work, painted directly on the plaster. William Rothenstein, there first in late 1889, noted: "The little cafe was fitted with panels, half of which were already filled by painters who had frequented the inn; and there was a billiard room whose white plastered walls had also tempted them. I, too, tried my first mural decoration on one of its walls, the subject forsooth! a man hanged on a gallows."[20]

Even some of the private rooms retained paintings by their occupants; when the poet Richard Hovey settled in at the Baudy in September 1891, he found his room frescoed by a former tenant; on the ceiling was a landscape and on the door, a Japanese girl.[21] Two decades later Mildred Giddings Burrage, another artist-guest, recalled

> the walls of the dining room and the little café . . . lined with pictures left by grateful artists to kind Monsieur and Madame Baudy, as souvenirs of delightful visits at their pleasant inn. Especially noteworthy are several pictures by Theodore Robinson, who, for many years, made Giverny his home. Here one sees a sketch by Willard Metcalf, there a gift from Philip Hale. In one corner a gay café chantant scene attracts the eye, and one reads the signature, "Robert W. Chambers," and, on inquiry, learns that the versatile Robert was a painter long before he began writing of the New York smart set.[22]

It was the interaction among the artists that proved the most enduring factor in the longevity of the art colony. Some friendships were formed, and others reinforced, by proximity in the village and especially at the hotel. In a roman à clef, "A Girl-Student's Year in Paris" (1891), the art-student heroine, visiting Giverny in June, noted:

> At the hotel, now full, are many students—a young Australian woman, cultivated and traveled, studying in a leisurely way—another from our West, in equally easy circumstances and most interested in her work—a Boston literary man with his wife, whom I knew at Julian's—a young painter or two of growing reputation. A little company of

individuals where similarity of pursuit make easy comradeship. Each goes his separate way in the morning, and again in the afternoon, some to where the stacks of grain are golden in the fields, or to the river bank where willows bend in rows, or long-stemmed trees reflect their silver green, or to lanes between grey walls where the green of garden trees looks over, or to the gardens themselves where blue-robed peasants bend and work.[23]

Although most of the young women who registered at the Baudy were accompanied by family members or female friends, the easygoing spirit of the hotel encouraged romantic liaisons. Elizabeth Chase and Emma Speed, both originally from Louisville, Kentucky, arrived at the Baudy from Paris on June 26, 1890; they had been preceded a week earlier by Charles Roswell Bacon. Chase and Bacon had previously known each while studying at New York's Art Students League, but their association in Giverny surely encouraged the relationship that culminated in their marriage; the twentieth-century painter Peggy Bacon was their daughter. A year later Meteyard was attracted to Alice Beckington, both on and off the tennis courts; she had first appeared at the Baudy in April 1891, also accompanied by Emma Speed. By August 1892 Robinson recorded that Beckington had refused Meteyard's offer of marriage but Meteyard was persisting, "aided and abetted by his mamma."[24] Though he was never successful, the two appear to have remained fast friends. Over the next three years Beckington often returned to the Baudy with her parents, and she later became a mainstay of the art colony that developed in Scituate, Massachusetts, in the mid-1890s, which centered on the Meteyard home.[25]

Emma Speed became involved with the young Stephen Codman, who had shared a studio in Paris with Philip Hale in 1890. At one point Codman appears to have at least considered involvement with both Chase and Speed.[26] Despite his entanglements Codman remained a part of the colony, purchasing a cottage in Giverny in 1893.[27]

Mariquita Gill became involved with a young artist from New York, Arthur Murray Cobb; both registered at the Baudy in September 1892. Robinson noted in his diary on October 9 that he had attended a "tea given by Miss Strasburg in honor of Cobb and Gill whose engagement is announced."[28] Butler wrote to Hale on February 1, 1893: "The Gill-cobbs are not yet married but are living a life of great engagedness. They flit once in a while [illegible] our horizon and are very gay and young."[29] By July 1894 the marriage seems to have taken place, as Gill was listed as "Mariquita-J. Cobb" in the seventh *Exposition de peintres impressionistes et symbolistes* at

If it be so, that Miss Beckington is engaged to Metyard [*sic*], would it not be called a good match for her? Not but that she is very nice, but I've somehow the impression that in a worldly way, the Metyards [*sic*] are fortunate. . . . Amusing about Bacon & Miss Chase, upon what are they to marry, if they both spend the summer without working; still if they are contented. It is safe to say that Miss Speed is idle—at any rate if there is a young man about. As she said to me she could not work she "liked people" so. It would hardly be fair for Codman to expect faithfulness from her. It is only just when it works both ways.

Katherine Kinsella to Philip Hale, October 26, 1892, Philip Leslie Hale Papers, Archives of American Art, Smithsonian Institution, Washington, D.C.

the gallery of Le Barc de Boutteville in Paris. On January 20, 1895, Butler reported to Hale that "Mrs. Cobb has gone to America to get a DIVORCE,"[30] and by the end of that year Arthur Murray Cobb was living in Boston and exhibiting at the Pennsylvania Academy of the Fine Arts.

In September 1890 Katherine Kinsella, an art student and Hale's inamorata, was staying at the Baudy. In a letter to Hale she noted that Robinson was there and had a model accompanied by her daughter, whom the model referred to as her niece.[31] Kinsella informed Hale that the child looked very much like Robinson and that he was generally believed to be the girl's father. Robinson, his model, and the daughter dined not with the other guests but with Mme Baudy, who was helpful to all her visitors but apparently had special affection for Dawson-Watson and Robinson. The model may have been the "Marie" who figures in Robinson's diary and appears in a number of his paintings, including *Val d'Aconville* (plate 99).

Robinson had presumably met Marie in Paris, but some of the colonists became involved with young women from the vicinity of Giverny and Vernon, a number of whom served as models. Indeed, gossip regarding the personal lives of the colonists was rife from the very beginning, when a housekeeper-model employed by Willard Metcalf in 1888 became pregnant and accused the young artist of the paternity, which he denied.[32] Beckwith was vexed by the rumors that circulated in the village, particularly when they were directed at his friends. In August 1891 he commented in his diary: "One of the objections to these places is the various stories people hatch up about others. Here is one this evening about poor [Carle John] Blenner who has been here for the day—quite too absurd to repeat and yet listened to by this disoeuvre crowd."[33] Some of the artists entered into legalized unions with local women. The most celebrated was the marriage of Butler and Suzanne Hoschedé in July 1892, but this was not the only one. The Boston painter Arthur George Collins first registered at the Baudy in July 1898 and thereafter occupied a house in Giverny owned by Mme Baudy, in which Robinson had previously lived.[34] Collins was a resident of the village on October 19, 1905, when he married Marie-Julia Etienne, a young woman from Vernon. The ceremony was held in the town hall, and Gaston Baudy was one of the witnesses.[35]

Probably the most significant of the diversions enjoyed by the early colonists in Giverny was the creation of the *Courrier innocent*. This was a handmade journal of which five issues appeared, probably over the years 1892–93; unfortunately, no copies of these have been located to date.[36] According to Dawson-Watson, who published a

99. Theodore Robinson (1852–1896). *Val d'Aconville,* 1887–89. Oil on canvas, 18 x 21⅞ in. (45.7 x 55.6 cm). Art Institute of Chicago; The Friends of American Art.

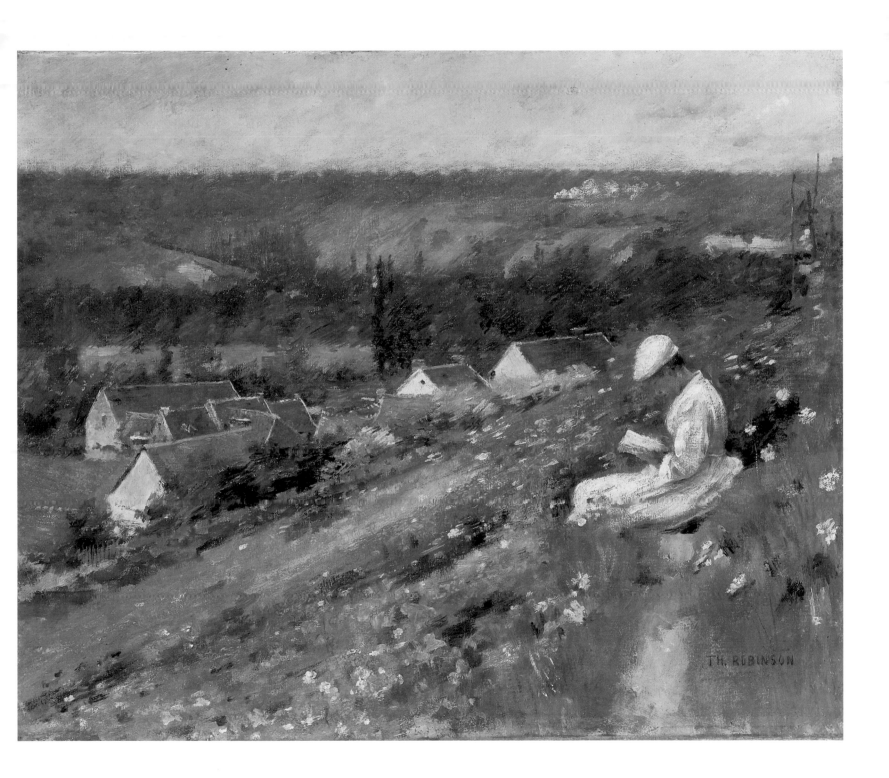

100. *Richard Hovey.*

short article on the *Courrier innocent,* the conception of the magazine was Butler's.[37] In the autumn of 1891 the primary figures involved—Butler, Dawson-Watson, Meteyard, and Richard Hovey—pooled their talents in order to produce the magazine; some of Hovey's poetry, later published in his Vagabondia series, first appeared in the early issues of the *Courrier innocent.*[38] The magazine was issued as a quarterly; the first issue appeared in May 1892 and publication continued through the spring of the following year.[39]

Dawson-Watson was the editor and printer of the magazine; drawings were made in transfer ink on manila paper, and Butler designed each cover. Each number had only a few pages, with poems, sketches, and an occasional prose selection; some of the texts were in French, revised and corrected by Lucien Baudy.[40] A tribute in verse to the pleasures of ice-skating in Giverny, written by the Hoschedé sisters and illustrated by Butler, appeared in the *Courrier innocent.* Mentioned in the poem are Blanche, Suzanne, and Germaine Hoschedé; Michel Monet; Gaston Baudy; Dawson-Watson and his wife; Butler; Meteyard; and possibly Alice Beckington ("Mam'selle que l'en traine Meteyard")—all skating on the Marais.[41] A Hovey poem appeared in all five of the numbers

printed in Giverny; "Hymnus Nuptialis" was included in the wedding number issued to celebrate the marriage of Butler and Suzanne Hoschedé in July 1892.[42]

In 1895, three years after returning to the United States, Meteyard built a house in Scituate, Massachusetts, on the South Shore of Massachusetts Bay. It became a center for artists and writers, and at least two more issues of the *Courrier innocent* were published there in the winter and spring of 1897, this time by Salt Marsh Press. The contributors now were listed as Butler; Hovey; Meteyard; Meteyard's mother, Marion Lunt Meteyard; Dawson-Watson; the poet and editor Bliss Carman; and Bertram Goodhue, a young architect from Boston. Giverny was not forgotten in the Scituate resurrection of the magazine. Hovey had returned to the Hôtel Baudy in 1895 to replenish his enthusiasm for the village. The sixth number of the *Courrier innocent* (Winter 1897) opened with his poem, in French, commemorating Giverny, from which the following stanzas are quoted:

> *OVER THERE*
>
>
>
> *I know a village*
> *Not too far from Paris*
> *Where no one behaves*
> *And everyone laughs.*
>
>
>
> *People do as they please*
> *Let destiny guide them*
> *They're gay and their smiles*
> *Are bright as the morning.*
>
> *Leave this silly world behind*
> *And come one come all*
> *To the place where God's do-nothings*
> *Frolic and stroll.*[43]

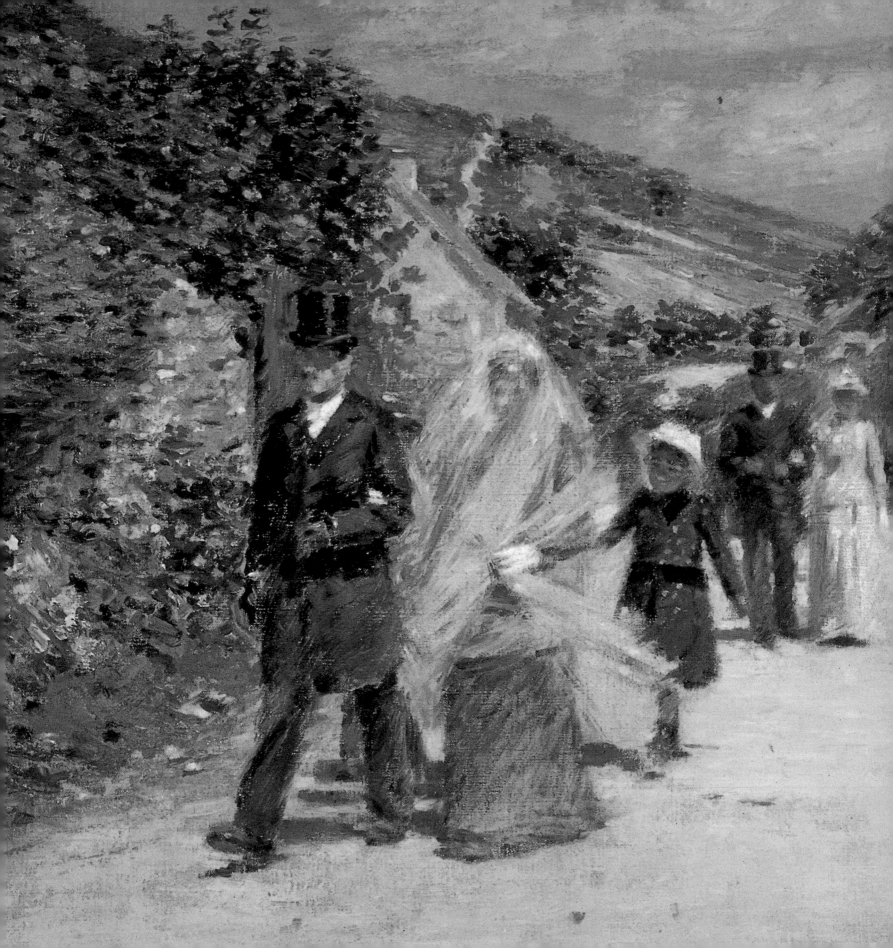

Giverny in the 1890s

Life in the Giverny art colony seemed to flow smoothly by, with a second generation of newcomers fresh from the ateliers and academies of Paris registering at the Baudy, with other artists renewing their association with the village, and with some departing for good.

The interpretations of the local scene inaugurated by the original colonists were emulated by their successors. George Albert Thompson's *View of Giverny, France* (plate 102) of 1897 seems a simulation and a synthesis of paintings created at the end of the previous decade by Theodore Robinson, William Blair Bruce, John Leslie Breck, and Theodore Wendel; in addition, his paint application suggests his understanding of Monet's canvases of the early 1890s.[1] Actually, the painting's title is a misnomer, for this is a view not of Giverny but of Vernon, seen from the hills above and just to the west of it.

Thompson had first registered at the Hôtel Baudy in June 1896. He seems to have painted many Normandy landscapes, but his interaction with any other colonists is undocumented. He was a graduate of the Yale School of the Fine Arts, which apparently developed a rather special association with the Giverny art colony during the 1890s.[2] And it was not only the men of the Yale art school who made their way to Giverny. Registering along with Thompson at the Baudy on June 4, 1896, were two

101. Detail of Theodore Robinson, *The Wedding March,* 1892. See plate 110.

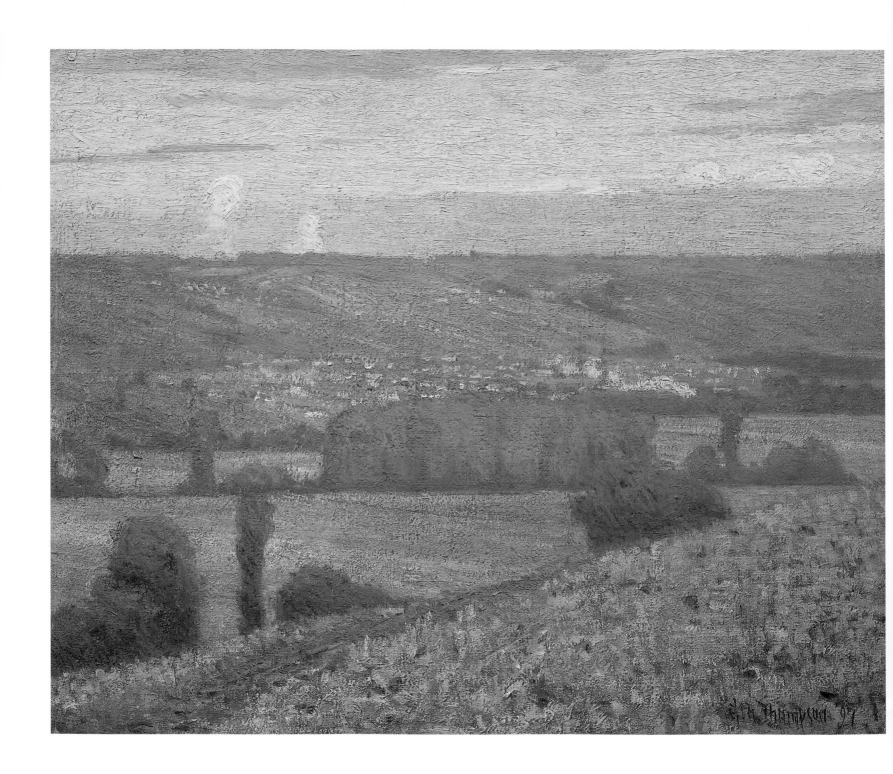

sisters who listed themselves as students: Matilda Lewis and Josephine Miles Lewis.[3] Josephine had graduated from the Yale School of the Fine Arts in 1887, and four years later she became the first person to receive a Bachelor of Fine Arts degree from the university and the first woman to receive any undergraduate degree from it.[4] She went to Paris in 1892 with her sister, Matilda, and their friend Alice Beckington; she is said to have studied with Amand-Edmond Jean, known as Aman-Jean, as well as with Frederick MacMonnies.[5]

Josephine Lewis apparently visited Giverny as early as 1892, since there are Giverny landscapes by her of that date, but she was not a guest at the Hôtel Baudy until March 1894. She was back at the hotel late in April of that year and again, with her sister, on October 3; they continued to visit Giverny through April 1897. In Giverny, Lewis painted both landscapes and figures in the landscape, such as her *Girl in Sunshine* (plate 103). She exhibited with the (old) Salon in 1893 and with the (new) Salon in 1896; the following year she returned to the United States, taking a

studio in New York and summering in Scituate, Massachusetts, which became her legal residence. Her long-time friendship with Beckington probably accounts for her presence there, but it reiterates the Giverny-Scituate connection.

When the Lewis sisters arrived at the Baudy on October 3, 1894, they were accompanied by two other women artists—Janet D. Pulsifer and G. Hutchinson. All four of them had just returned to France after traveling in the Netherlands. During the next month or so they were startled by two new arrivals. Václav Radimsky from Bohemia, then part of the Austro-Hungarian Monarchy, arrived the day after the Lewises; and on November 7 Paul Cézanne registered at the hotel. Both made a deep impression on their fellow guests, as reported in a letter from Matilda Lewis to her family in the United States:

> The circle has been increased by a celebrity in the person of the first Impressionist, Monsieur Cezanne—the inventor of Impressionism as Madame D. [probably a misreading of "B.," for Baudy] calls him. He is a friend of the Bohemian, and of Monet. Monsieur Cezanne is from Provence, and is like the man from the Midi whom Daudet describes. When I first saw him I thought he looked like a cutthroat with large red eyeballs standing out from his head in a most ferocious manner, a rather fierce looking pointed beard, quite gray, and an excited way of talking that positively made the dishes rattle. I found later on that I had misjudged his appearance, for far from being fierce or a cutthroat, he had the gentlest nature possible, "comme un enfant" as he would say. His manners at first rather startled me, he scrapes his soup plate, then lifts it and pours the remaining drops into the spoon; he even takes his chops in his fingers and pulls the meat from the bone. He eats with his knife and accompanies every gesture, every movement of his hand with that implement, which he grasps firmly when he commences the meal and never puts down until he leaves the table; yet in spite of the total disregard of the dictionary of manners he shows a politeness towards us which no other man here would have shown. He will not allow Louise to serve him before us in the usual order of succession at the table; he is even deferential to that stupid maid, and he pulls off the old tam-o'shanter, which he wears to protect his bald head, when he enters the room. I am gradually learning that appearances are not to be relied upon over here; the Bohemian, with his leather coat and corduroys which he wears to dinner, and in which he looks rather like a stable boy, speaks five languages, not [just] passibly [sic], but understanding all the idioms, all the shades of meaning; he even remembers his Latin and Greek, has read much of the literature of several countries, traveled tremendously, and with all this is a hard working artist; and I have despised him for wearing a leather coat to dinner!

The conversation at lunch and dinner is principally of art and cooking. The Bohemian talks about a dish which he calls "Soufflé des Anges," which we discover to be a cream of garlic and oil. The Impressionist praises the oil of Provence, he says that the people of his country who have an income of eight hundred francs have an oil which Napoleon could not have bought. Cezanne is one of the most liberal artists I have ever seen, he prefaces every remark with "Pour moi" it is so and so, but he grants that every one may be as honest and as true to nature from their convictions, he doesn't believe that every one should see alike.[6]

Cézanne was in Giverny at Monet's invitation, to join a group of Monet's close friends—including the politician Georges Clemenceau, the poet Octave Mirbeau, and the sculptor Auguste Rodin. Cézanne was so ill-at-ease that he departed abruptly after dining at Monet's with Auguste Renoir and Alfred Sisley, who were there especially to celebrate Cézanne's visit. He left several unfinished canvases at the Baudy, which Monet sent to him in Aix-en-Provence.[7] However, one unfinished work, *Winter Landscape, near Paris* (plate 104)—a view looking onto an enclosed orchard—remained with Mme Baudy. Although it is incomplete, Cézanne had already blocked in the ground plane, the trees, the wall, and the buildings beyond, leaving the white ground as an element in the pictorial structure. The blue wash in part of the sky and to the left side of the picture are not finished, but the rest of the composition seems totally comprehensible.[8]

Cézanne himself made quite an impression at the Baudy, but he was there less than a month and it is extremely unlikely that his art had any impact because of his visit; to Matilda Lewis he was obviously a visiting celebrity. Radimsky, "the Bohemian," had been there a month longer than Cézanne when Lewis wrote her letter, and she obviously had had more experience with him at the dining table and in the common rooms of the hotel.[9] Along with J. Stirling Dyce, Radimsky may have been the most picturesque member of the colony, and he was certainly one of the longer lasting, being associated with

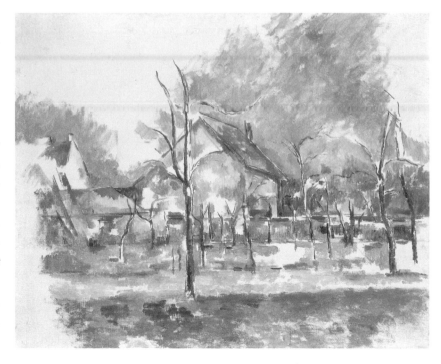

104. Paul Cézanne (1839–1906). *Winter Landscape, near Paris,* 1894. Oil on canvas, 21⅛ x 31⅞ in. (54.9 x 81 cm). Philadelphia Museum of Art; Given by Frank and Alice Osborn.

Giverny into the twentieth century. As late as 1911 Frederick MacMonnies wrote from Giverny to Arthur B. Frost, recommending that Frost's son, John, meet Radimsky—"a former Givernyite who lives in a village beyond, and is really an excellent landscape painter. . . . He has gone on & is a remarkable painter—Jack would greatly profit by his advice."[10] By 1899 Radimsky had rented the Maison Rose (Pink House), a property formerly occupied by William Howard Hart. Radimsky lived there with his mistress, Louise, an attractive young woman from Vernonnet who had posed for many of the painters. She and Radimsky had one of the earliest automobiles in the village and went driving all over the countryside.[11] At some point, Radimsky moved out of Giverny to a nearby village.

Critics wrote about Radimsky's work as they did about Monet's: "One feels that he is interested in the transformation of a landscape from the early hours of the morning until the last twilight."[12] No association with Monet himself is recorded, but Radimsky painted many pictures of the Seine, presumably influenced by Monet's Morning on the Seine series of 1896–97 and similar to it in both composition and especially in the pale blue-violet tones that predominate. Radimsky seems to be one of the few Giverny colonists who emulated this series.[13] His attraction to these more poetic pictures by Monet may reflect the two artists' shared appreciation of the lyric beauty of Barbizon art and Camille Corot's paintings; Lilla Cabot Perry, in Giverny in 1896–97, noted that Monet's pictures in this series had "a certain Corot-like effect."[14]

Radimsky was one of the painters who continued the same subjects favored by the founding members of the colony, from poppy fields to the local peasants to the regional topography. Radimsky's The Pig (plate 105) is a unique slaughtering scene, and the artist did not shy away from rendering the pool of blood dripping from the animal. In general the Giverny artists did not display particular interest in the farm livestock—cattle, sheep, horses, or pigs—and The Pig seems to be unusual even for Radimsky.

More often his paintings investigate the local landscape, as in Old Mill in Giverny (plate 106). It continues the earlier artists' concern for the working environment, with a group of felled trees in the foreground to indicate labor; the distinctive Giverny church is visible on the hill. Radimsky's panoramic Giverny: The Arrival of Spring (plate 107) is in some ways the quintessential image of the region, with the young peasant woman sewing by the stream, the bordering trees casting long shadows over the fields, the houses and farm buildings of the village in the distance, and behind, the

OPPOSITE, TOP

105. Václav Radimsky (1867–1946). *The Pig,* 1896. Oil on canvas, 18⅛ x 24 in. (46 x 61 cm). Private collection, France; Courtesy of Musée A. G. Poulain, Vernon, France.

OPPOSITE, BOTTOM

106. Václav Radimsky (1867–1946). *Old Mill in Giverny,* 1899. Oil on canvas, 35⅜ x 53⅛ in. (90 x 135 cm). National Gallery, Prague.

In my student days the young woman votary of art had made but a timid first appearance in Paris, and the leaf-embowered artistic haunts of Fontainebleau knew her not. In the interval that had elapsed since then . . . she had come in numbers so largely plural that the male contingent at Giverny was greatly in the minority. . . . [Robinson] contritely owned partial responsibility for the feminine invasion, as he had unguardedly recommended the place to one or two young women painters in Paris. . . .

In another year or two the sudden wave of popularity deserted Giverny, and the bevy of student-esses deserted the meadows, and the hill slope saw them no longer, though the village is by no means deserted by its artists.

Will Low, *A Chronicle of Friendships* (New York: Charles Scribner's Sons, 1908), pp. 446, 448, 450.

divided fields on Les Bruyères, the steeply sloping hillside. It is a picture worthy of Theodore Robinson a decade earlier.[15]

A number of visitors to Giverny in the 1890s discerned changes occurring in the colony. Will Hickok Low visited his friend Robinson in the summer of 1892 and found the town dominated by "the young woman votary of art."[16] In actuality, the colony was never overwhelmed by women artists, though their number certainly increased as the years went by, and their presence was undoubtedly more noticeable once they were taking instruction in outdoor painting in the village.

The women painters in Giverny came from throughout the United States as well as from England. Philip Leslie Hale's sister, Ellen Day Hale, appears to have been in the village at some unspecified time, when she painted the beautiful *Landscape in Giverny* (plate 108). In it she interpreted the town's distinctive topography in parallel brushstrokes of violet and chrome yellow; the result corresponds to the aesthetic her brother developed in his figure paintings of the 1890s.[17] M. Evelyn McCormick arrived at the Baudy with her fellow San Franciscan Guy Rose on July 4, 1890, and remained the rest of the year. She exhibited a Giverny garden picture in Paris at the (old) Salon in 1891, and another at the *Annual Exhibition of American Painting and Sculpture* held at the Art Institute of Chicago in 1894.

Guy Rose was in Giverny in 1890 and 1891, and he returned to the Hôtel Baudy in March 1894. He subsequently wrote a most informative article about Giverny, which concluded with some reflections on this last visit: "A few years later I went back,

and although it was certainly as beautiful, there was a difference. The English, with their tea-pots and their rum-and-water, had taken possession, and for me had changed it all. But I am thankful to have known it when I did, and to have received that impression which I shall never forget."[18]

British painters never really dominated the colony, but there was a gradual influx after the arrival of Dawson Dawson-Watson and William Rothenstein, with the Scotsman Dyce long remaining a formidable presence. The Australian artist Charles Conder went to England in 1890 and immediately made his way to Paris and the Académie Julian. It was probably at the recommendation of Rothenstein that Conder spent the springs and summers of 1891–94 painting landscapes in the Seine Valley. Early in 1892 he rented a small house on the river at Chantemesle; in his wanderings down the valley, he visited Giverny—hardly surprising, given its art colony and its pictorial attractions as well as Conder's need for company.[19] Works such as his *Scene on the Epte* (plate 109) certainly conform to the general topography of the region. Conder was involved at this time with Louise Kinsella, sister of Philip Hale's inamorata, Katherine Kinsella. The latter wrote to Hale from Giverny in February 1894, saying that she had heard Conder was not doing well and was down to his last sou; Louise had tried to assist him by purchasing a painting.[20]

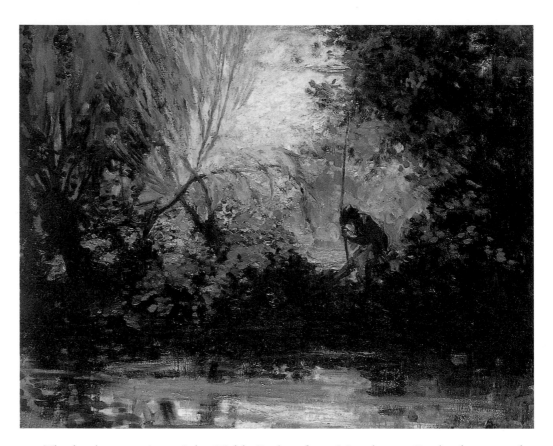

109. Charles Conder (1868–1909). *Scene on the Epte,* c. 1894. Oil on canvas, 18 x 21 in. (45.5 x 53.2 cm). Location unknown.

The landscape painter John Noble Barlow from Manchester, England, was at the Baudy in February 1890, before joining the Saint Ives art colony in Cornwall sometime after 1893. Ernest Parton, the Anglo-American landscapist, visited from London quite often at this time, and Alfred Dobson was a frequent guest at the Baudy in 1893 and 1894. Ellen Gertrude Cohen—like Barlow, a student from the Académie Julian—registered at the Baudy in July 1893 and again a year later; she returned to England to become a figure painter specializing in domestic scenes. Other British artists in Giverny who later achieved some reputation included William Wesley Manning and Harry B. Friswell, both Julian students in 1892, who were at the Báudy the following year—Manning in January, Friswell in April. Both later specialized in landscape work, and Manning was an etcher as well. Later visitors from the British Isles included the Irish painter Katherine McCausland, who had settled in Grèz around 1890 but made a visit to Giverny in 1898; and the landscape and seascape painter Hugh Blackden, a guest at the Baudy in April 1899.[21]

In some ways, the most important of the British painters to frequent Giverny in the 1890s was Wynford Dewhurst. His name first appears in the Baudy register in June 1895; he was back in October 1895 and again in April 1898. No British painter adhered to the tenets of Impressionism more faithfully than Dewhurst, and his allegiance to the movement and to Monet found its ultimate testimonial in Dewhurst's impressive study, *Impressionist Painting: Its Genesis and Development,* the first such book in the English language.[22] It is dedicated to Monet "as witness to his esteem and admiration," and in his chapter on Monet, Dewhurst indicates that they had developed a speaking acquaintance.[23] Many French landscapes by Dewhurst are known, but none so far can be documented as having been painted in Giverny. And strangely, although Dewhurst discusses Giverny extensively, no mention is made of the art colony in which he was a participant.

Although neither Low's nor Rose's perception of the feminization or anglicization of Giverny was correct, the colony really was changing in the 1890s, as was the nature of the art produced there. In some ways, the key picture in this alteration is Robinson's *Wedding March* (plate 110), of 1892. Here Monet himself is depicted as escorting Suzanne Hoschedé; behind them is the groom, Theodore Butler, escorting Alice Hoschedé-Monet, herself married to Monet only four days earlier. For many years this has been recognized as one of the artist's masterpieces, and so it is—a marvelous embodiment of the strategies of Impressionism, with its loose, flecked brushwork and its brilliant light and color. Capturing an important episode in the life of the Giverny art colony, the painting is the only pictorialization of a historical event ever painted by one of the colonists, and so it is an anomaly, even though appearing archetypally Impressionist.

And yet, it is not quite that either. Outward appearances aside, the painting is, at least in part, a studio production. It was begun on August 5, several weeks after the July 20 wedding, as the artist recorded in his diary: "Commenced my 'Wedding March' my model being the groom's silk hat, lent to me by Gaston."[24] Monet certainly did not pose for the painting, and very likely none of the other figures did either; presumably only the landscape setting was painted on site.

The wedding was certainly a great event for the Giverny art world, celebrating the alliance between one of the early colonists and the family of the great Impressionist. Dawson-Watson was stuck in Wales without funds to get to the wedding until Butler sent him passage money; he wrote and illustrated a charming, witty poem, "By Telephone," about the event.[25] On the wedding day Philip Hale and Courtland Butler,

I sdown here at Giverny in the same place with Robinson. . . . I don't know if he described to you Theodore Butler's marriage here—which was quite an event in such a quiet little hole as this, the whole thing had a strange, bizarre side to it: this Westerner's being married in an old Norman town was queer tnough [*sic*] of itself, and then the Breakfast in a Salle a Manger hung from top to bottom with Monet's pictures only increased the feeling of a bad dream—not that I mean that his pictures were nightmares—quite the reverse.

Philip Hale to Mr. [J. Alden] Weir, August 19, 1892, J. Alden Weir Papers, Archives of American Art, Smithsonian Institution, Washington, D.C.

along with Monet's brother Léon and Alice's brother-in-law Georges Pagny (both of whom had been witnesses at Monet's marriage four days earlier), served as witnesses for the civil service; the Abbé Toussaint officiated at the church. Robinson noted in his diary:

> A great day—the marriage of Butler and Mlle. Suzanne. Everybody nearly at the church—the peasants—many almost unrecognizable—Picard very fine. The wedding party in full dress—ceremony first at the Mairie—then at the church. Monet entering first with Suzanne. Then Butler and Mme. H—a considerable feeling on the part of the parents—a breakfast at the atelier—lasting most of the afternoon. . . . Champagne and gaiety—a pretty blonde—Mme. Baldini amusing Dyce and Courtland. Butler flirting with and kissing her. Dinner and evening at the Monets; bride and groom left at 7:30 for the Paris train. . . . Monet rather upset and apprehensive, which is natural enough. I had to reassure him.[26]

The painting of the wedding party—or at least the event it commemorated—signified to some degree the end of the era of discovery, independence, and individuality for the colony. In fact, of the seven original colonists of 1887, only Robinson returned to Giverny in 1892, and that visit constituted his last season there. Even though back in the United States he continued to anticipate returning in future summers, neither he nor any of his original colleagues ever rejoined the colony. Among the more significant artists who had arrived in the years immediately after 1887, Dawson-Watson remained in Giverny until 1893, and Philip Hale was there in the summers of 1892 and 1893 (he checked into the Baudy a couple of weeks after Butler's wedding). Hale would return only once more, in 1904, several years after his own wedding to the artist Lilian Westcott Hale.

Butler, however, became a full-time Giverny resident, and he served to some degree as a bridge between the Monet household and the Giverny colony. Monet had initially attempted to discourage the relationship between Butler and Suzanne, even considering selling his house and moving away from Giverny. The courtship seems to have commenced, or at least advanced, on the skating pond the previous winter and went undetected by Monet while it was encouraged by Dawson-Watson and other colonists.[27] To counter Monet's objections, Alice Hoschedé made inquiries regarding Butler's social and financial status, writing in 1892 both to Butler's mother and to the Beckwiths, whom Monet had admired on their brief visit to him the previous year; Robinson, too, added his support of Butler.[28] By June, Butler was gradually allowed to

110. Theodore Robinson (1852–1896). *The Wedding March,* 1892. Oil on canvas, 22⁵⁄₁₆ x 26½ in. (56.7 x 67.3 cm). Daniel J. Terra Collection.

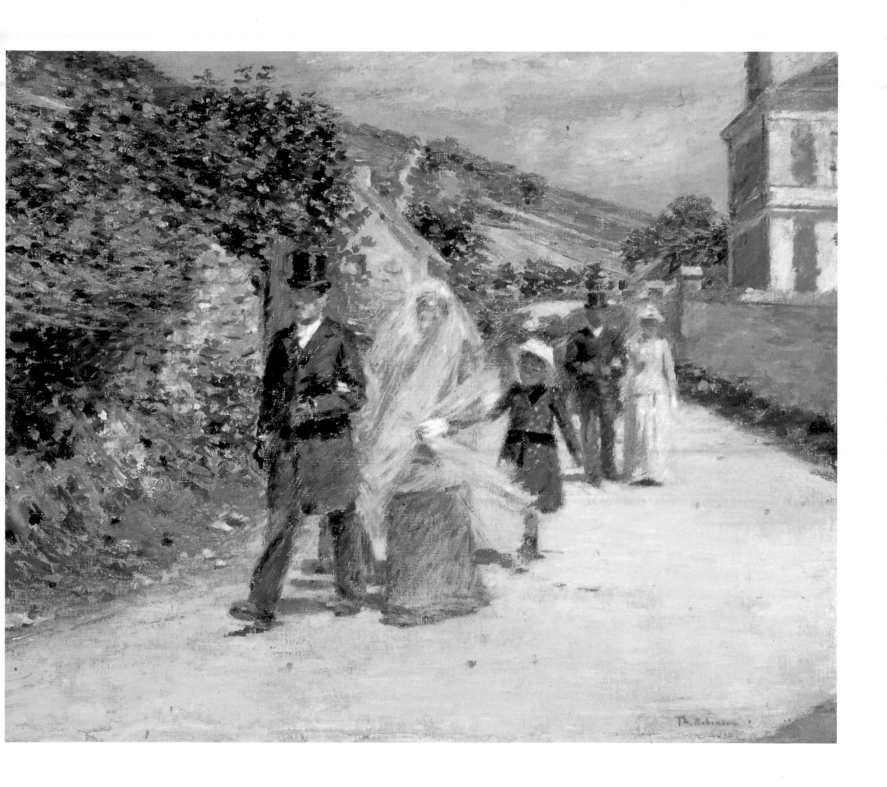

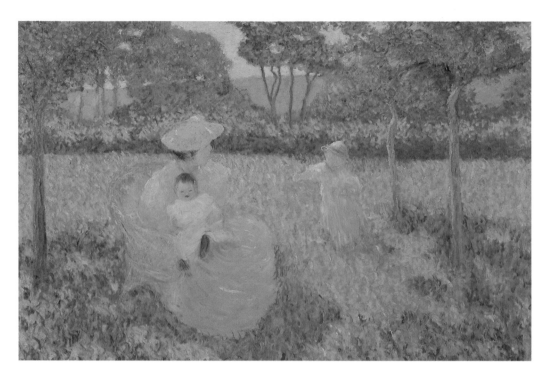

111. Theodore Butler (1861–1936). *The Artist's Family,* 1895. Oil on canvas, 34 x 50 in. (86.4 x 127 cm). Mr. and Mrs. Al Wilsey, San Francisco.

ease into the Monet-Hoschedé family life; Robinson recorded having dinner at Monet's with Butler several times before the wedding.[29]

Yet even after the marriage Monet appears to have accepted Butler only reluctantly. Monet's *Blanche Hoschedé Painting* (1892; private collection), painted either just before the marriage or shortly after the Butlers had returned from their honeymoon in Paris, shows Butler in the distance seated at an easel with Suzanne standing behind him, but they are both shadowy figures—Monet's concentration here is on Blanche.[30] Following their honeymoon, the Butlers moved into the Maison Baptiste, a small house near the Maison du Pressoir, where Butler cultivated a flower garden in emulation of his father-in-law. And it was in that house and garden that Butler developed his mature art.

During the rest of the 1890s Butler devoted himself not to the depiction of Giverny's landscape and inhabitants but to his own house, family, and garden. Many of these pictures were indoor scenes, conveying his pleasure in being at home with his wife and two children: James, born in 1893, and Alice (Lili), born the following year. Among Butler's most decorative canvases are outdoor pictures of them in bright sun-

light, such as *The Artist's Family* (plate 111), painted in the garden during the summer of 1895. Butler defined his life quite clearly and simply in a letter to Hale, written in February 1893: "We be a living and painting and sewing and working in the garden."[31]

Familial genre continued to be dominant in Butler's art after the family moved in the autumn of 1895 into a newly designed, more spacious house across from the Maison Baptiste on the rue Columbier; here, too, a luxurious flower garden was constructed. It was in this house that Suzanne's increasingly debilitating illness, which appears to have begun in 1895, shortly after the birth of Lili, led to her death in February 1899. After a trip back to the United States with his children in September of that year, Butler returned to Giverny and remained a part of the Monet-Hoschedé household. On October 31, 1900, he married Suzanne's sister, Marthe. Subsequently, without the inspiration of the attractive Suzanne and with the children growing up, Butler turned away from domestic genre and returned to painting scenes in and around the village; beginning in 1904 he spent much of his pictorial energy painting on the Normandy coast during long summer holidays.

During the 1890s Butler moved stylistically toward association with the Post-Impressionist Nabis, simplifying and dissolving forms, flattening space, and often adopting a strident chromatic scale that foretells Fauvism. At the same time, his avant-garde tendencies could not mask the inadequacies of his draftsmanship or his limited interpretive ability, and his letters written from Giverny to Hale in Boston are filled with his disappointment at rejections from the Paris Salons.[32]

Butler's close friend William Howard Hart seems to have remained in Paris and Giverny pretty steadily through 1895 and then continued as a summer visitor, but his life there is indistinctly recorded and, except for several portraits (see plate 178), his art is unknown. Early in 1893 Butler wrote that he wanted Hart (and Hale) to take the Maison Rose, the house next to the Maison Baptiste, that summer, which Hart did; Hale didn't stay there that summer but took his meals with Hart. Renowned for his gardening skills, Hart developed a garden at the Maison Rose and spent much time occupied with it.[33] He apparently kept that house for several years, but by 1899 it had been rented to Radimsky.[34] Hart remained very close to Butler, taking a keen interest in the children and comforting him in his grief over Suzanne's worsening condition and death. Hart seems to have functioned as part of the Butler-Hoschedé household rather than mingling to any great extent with the Baudy visitors.[35]

The other early visitor to Giverny who returned for a significant stay during the 1890s was Lilla Cabot Perry, who was back from Boston in 1894.[36] The Perry family registered at the Baudy early in June, remaining until mid-October; they then took another house, Le Hameau (The Hamlet), very near Monet's. (Increasingly in the late 1890s and after, those artists who stayed in Giverny for any length of time chose to rent houses rather than billet in the hotel; this was one more move away from the bohemian camaraderie of the Baudy toward a more self-contained and more bourgeois existence.) Like Monet's and Butler's houses, this too had a large garden, though painting flowers was not of great interest to Perry. She continued to paint Impressionist-derived landscapes in a manner influenced by Monet, and she was the colonist whose art remained the closest to his.

Le Hameau became something of a social center in Giverny during the mid-1890s. Bernard Berenson met Monet in Giverny through the Perrys late in the summer of 1895 and was "taken off his feet" when he saw the Rouen Cathedral series.[37] In 1896 the Philadelphia portrait and figure painter Cecilia Beaux visited the Perrys in Giverny, and Lilla took her to meet Monet—an experience Beaux long treasured. They "found him in the very centre of 'a Monet,' indeed; that is, in his garden at high noon, under a blazing sky, among his poppies and delphiniums." Monet showed Beaux and Perry works from his latest series, Morning on the Seine: "views, at differing hours and weather, of the river, announcing the full significance of summer, sun, heat, and quiet on the reedy shore."[38]

The Perrys returned to Boston in the autumn of 1897; that year Thomas was offered a position as professor of English language and literature at Keiogijiku University in Tokyo, and the family spent the next three years in Japan, where Lilla interpreted the Japanese landscape in Giverny Impressionist terms.

Though the Hôtel Baudy continued to receive dozens of artist-visitors each year and remained the heart of Giverny social life, many of the more long-standing visitors rented or even purchased homes as the decade progressed. In 1901 a writer pointed out that "the visitor can readily hire a furnished cottage with four or five rooms, garden, cellar and kitchen, for the season, for $80 or $90."[39] And a perusal of the Baudy register suggests that artists and art students remained in the majority but guests increasingly recorded other professions as well—journalists, teachers, or just *rentiers* (i.e., those living off investments).

When artists set up their own households they were often family affairs: husbands and wives with their children, like the Butlers and the Perrys; artists with their parents,

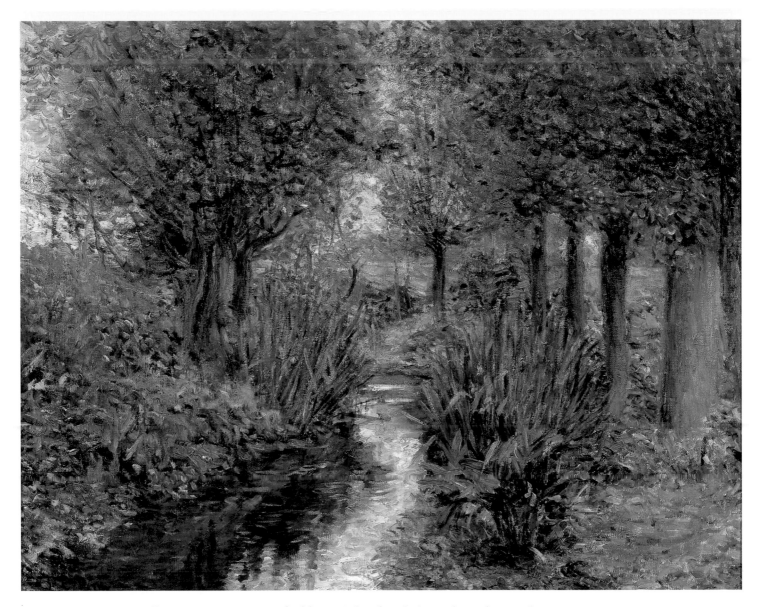

such as Mariquita Gill; or an assortment of siblings. This familial emphasis lessened the spirit of independence that had first prevailed in the colony, and it often directed the artists' concentration homeward, to the confines of hearth and garden. This more sedate environment was often depicted using less avant-garde strategies, even those verging on the academic and the classical. Those painters in Giverny who concentrated on figural work came increasingly to base their compositions either on family

112. Lilla Cabot Perry (1848–1933). *A Stream Beneath Poplars*, 1890–1900. Oil on canvas, 25¾ x 32 in. (65.4 x 81.3 cm). Hunter Museum of Art, Chattanooga, Tennessee; Gift of Mr. and Mrs. Stuart P. Feld.

members, or on professional models from Paris, rather than on local women and children. This reduced the number of contacts between the artists and the villagers, and it also resulted in more synthetic, less realistic images.

Many of the artists whose names can be recognized in the Baudy register visited for only a few days, which likely means that they were there to visit friends or to size up this increasingly publicized village, rather than to execute paintings. Several of the more distinguished of these visitors would not have been attracted to the imagery provided by the village or to the Impressionist aesthetic.

Among the more celebrated guests at the hotel was the expatriate American Thomas Alexander Harrison, known primarily for his panoramic marine paintings, who made frequent short visits to the village as early as January 1888 and continuing through April 1897. Kenyon Cox, a painter of classicized figures and a muralist, and his wife, the portrait and figure painter Louise Cox, were at the Baudy for several weeks late in the summer of 1893. The American Tonalist painter Thomas Wilmer Dewing and his wife, the flower painter Maria Oakey Dewing, took a house in Giverny in April and June 1895; William Howard Hart wrote to Philip Hale that the Dewings were homesick for Cornish, New Hampshire.[40] Thomas Dewing found the French language and people trying, and he appears not to have executed any paintings in Giverny. Other well-known artists who stayed at the Baudy during the 1890s included H. Siddons Mowbray and Alexander Harrison, as well as a number of women who would later achieve prominence, including the Richmond, Virginia, Impressionist Adele Williams and the printmakers Helen Hyde and Blanche Dillaye.

Two artists who did make a significant change in Giverny, however, were Frederick MacMonnies and Mary Fairchild MacMonnies. By the late 1890s—with Perry back in Boston and then in Japan, and with Butler preoccupied with his desperate family problems—they were the dominant figures in the colony. Frederick was a gifted young sculptor who had studied in Paris and exhibited in the Salon as well as back home. Mary was a painter who had trained first in Saint Louis and then in Paris, where she met her future husband late in 1887. They set up a communal studio in Paris before marrying in August 1888, and they first visited Giverny two years later, staying at the Baudy for a few days twice in early April. They were back again in early August 1893 and then returned for almost a month, starting on August 12. After a third visit at the beginning of October, they decided to settle in Giverny. In 1895 they took a three-year lease on the Villa Bêsche, a modern cottage where they developed a flower-filled garden, which Mary loved to paint, and where they summered for several seasons.

With increasing financial success, the MacMonnieses were able to move to a three-acre estate, Le Prieure (The Priory)—an abandoned three-century-old monastery, which was soon nicknamed the "MacMonastery." They first rented the property, then purchased it in 1901. Furnishing it elaborately, they made it into a showplace far more accessible to colonists and visitors than Monet's Maison du Pressoir.[41] Its luxuriousness is evident from Mildred Giddings Burrage's description of "the salon, with its wall coverings of blue-green tapestry, its yellow brocaded chairs, its black and white marble floor and its great overhanging fireplace."[42]

The MacMonnieses continued to maintain a presence in Paris during this period—Frederick kept his studios there—but much of their creative energies were expended in Giverny, and they were resident in the village for much of the time.[43] Frederick turned Le Prieure's principal barn into a sculpture studio, and in 1903 he made another of the old stone buildings into his painting studio. Models were imported from Paris, including the well-known Marcelle, who was posing for him in Giverny in 1897.[44] MacMonnies' 1902 statue of General Henry Slocum for Brooklyn was completed in his Giverny studio, and his monument to General George McClellan for Washington, D.C. (1903–7), and the *Pioneer Monument* for Denver (1907–10) were both sculpted there.[45] His nude portrait of ten-year-old Edith Gould (Gould family collection) was executed in Giverny in the summer of 1910.

The MacMonnieses developed the garden surrounding Le Prieure until it became the envy of their fellow colonists and a rival to Monet's in size and beauty. By 1901 Emma Bullet thought that in Giverny "the most beautiful, the most picturesque and artistic is the Macmonnies' [*sic*] garden."[46] Ten years later Burrage seems to have admired the MacMonnies garden even more than Monet's.

Mr. MacMonnies' garden is second in fame only to that of M. Monet. Here there is more than a tumult of color; there is rest and repose. The gravel paths bordered by tiny box-hedges lead underneath great trees and fresh shrubbery. The flowers are wonderful, indeed, but they are not the *raison d'être* of the garden; they are simply a feature. Along the low wall of the terrace overlooking the garden are placed little statues [see plate 128], Apollo, Dionysius and the great god Pan—all copies of the antique, however, and not the work of the sculptor himself. Mention should be made of the dainty little fountain, as well as of the great stone-lined pool, which in all probability was the bathing place of the monks. Everywhere are evidences of great thought and care, and, looking about, one may well wonder if there could be a more charming house, or a more delightful garden.[47]

113. Mary Fairchild MacMonnies (1858–1946). *Roses and Lilies,* 1897. Oil on canvas, 52⅓ x 69½ in. (133 x 176 cm). Musée des Beaux-Arts de Rouen, Rouen, France.

114. Mary Fairchild MacMonnies (1858–1946). *In the Nursery (Giverny Studio),* 1897–98. Oil on canvas, 32 x 17 in. (81.3 x 43.2 cm). Daniel J. Terra Collection.

The house and garden served as the subject and setting for numerous paintings. Like many of the other artists painting in Giverny during the 1890s, Mary MacMonnies focused not on the village or on the local landscape but on her own house.[48] *Roses and Lilies* (plate 113), painted in 1897 in the garden of the Villa Bêsche, is one of the largest and most elaborate of her Giverny pictures, showing her confident rendering of form and her mastery of free brushwork and vibrant color. She exhibited it in the (new) Salon in 1898, and it won a gold medal at the Exposition Universelle in Paris two years later. The picture proclaimed the new aesthetic and thematic concerns in turn-of-the-century Giverny: it is a self-portrait with the couple's youngest child, the two-year-old Berthe-Hélène, in an elaborate garden filled with lilies, an age-old symbol of purity. This subject of women and children in an enclosed garden would be a primary theme for Giverny painters during the next two decades.

A related subject, also centering on Berthe, was painted indoors at about the same time—*In the Nursery (Giverny Studio)* (plate 114), which surely depicts the room that

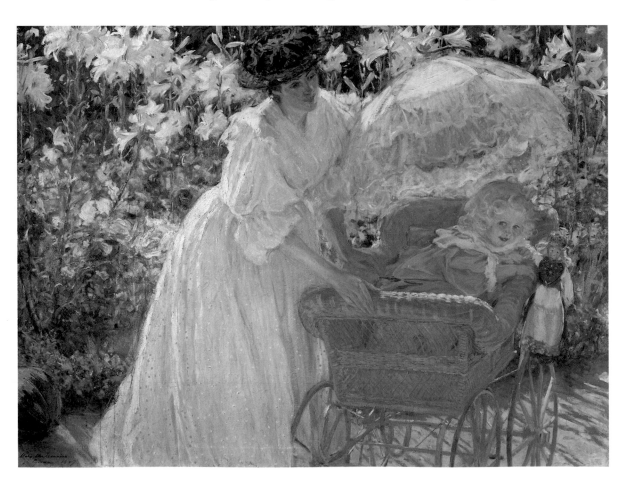

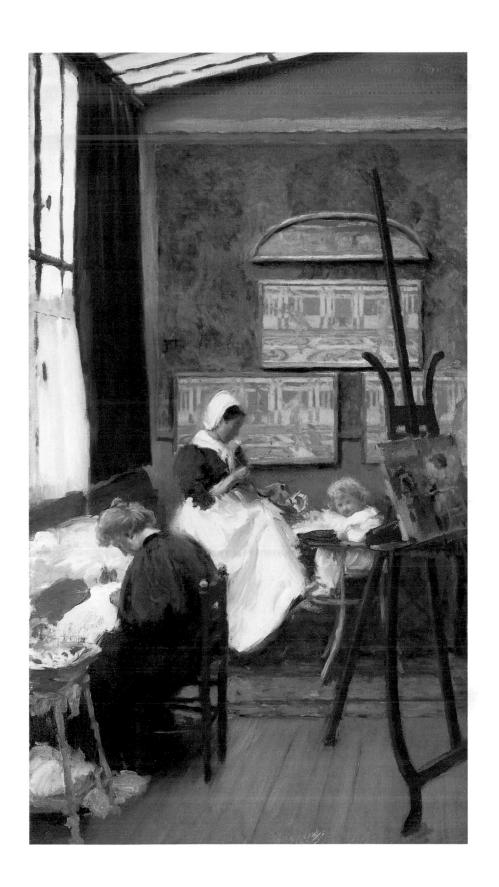

ABOVE

115. Mary Fairchild MacMonnies (1858–1946). *Blossoming Time,* 1901. Oil on canvas, 39 x 64 in. (137.2 x 162.6 cm). Union League Club of Chicago.

OPPOSITE

116. Mary Fairchild MacMonnies (1858–1946). *Winter Garden of Giverny,* c. 1902. Oil on canvas, 38⅜ x 64½ in. (97.5 x 163.8 cm). Musée A. G. Poulain, Vernon, France.

the artist utilized as both studio and nursery. Her copies of paintings by the much-admired Pierre Puvis de Chavannes hang on the back wall, against one of the large tapestries for which the MacMonnies homes were noted.[49]

Mary MacMonnies was as much a landscape as a figure painter, at least while she was in Giverny. Two of her most beautiful and monumental canvases, both painted in Le Prieure's garden, are *Blossoming Time* (plate 115) and *Winter Garden of Giverny* (plate 116). The former offers a springtime panorama of the terraced garden, with flowers, blossoming fruit trees, and rows of vegetables and other plants; a view of town buildings can be seen behind the high wall, with a glimpse of Sainte Radégonde's steeple at the far right. The colorful *Winter Garden of Giverny* shows a statue of Pan in the center of the pool, and beyond the walls is the Ajoux field, with the blue-tinted hills above Port-Villez on the other side of the Seine. The seasonal emphasis in these

two landscapes is certainly Impressionist, as are the chromatic strategies utilized in them. At the same time, however, these pictures are more carefully constructed and more detailed than those by most of the earlier Giverny colonists, and they conform more to academic methodology.

During the 1890s Frederick MacMonnies was primarily involved with executing sculpture, and so he spent much of each week in his Paris studios (at one time he had four of them), returning to Giverny for long weekends. By the late 1890s he was exhausted by his sculpture making and turned to painting, which had long attracted him; he and Mary had taken sketching holidays at Cernay and Barbizon, as well as Giverny, in the years immediately following their marriage.[50] Being in Giverny with his wife and other painters must have encouraged that career change.

When MacMonnies actually began painting in earnest is not documented. It was officially noted in the American press in the autumn of 1900—having been announced by the artist's brother Frank, who had just returned from France. Mac-Monnies' fame as a sculptor was so great that the press hailed the news as a major event.[51] But he had begun painting at least a year or two earlier, and several dated examples are known. MacMonnies was a technical perfectionist, preparing his own canvases and grinding and mixing his own colors in his Giverny studio.[52]

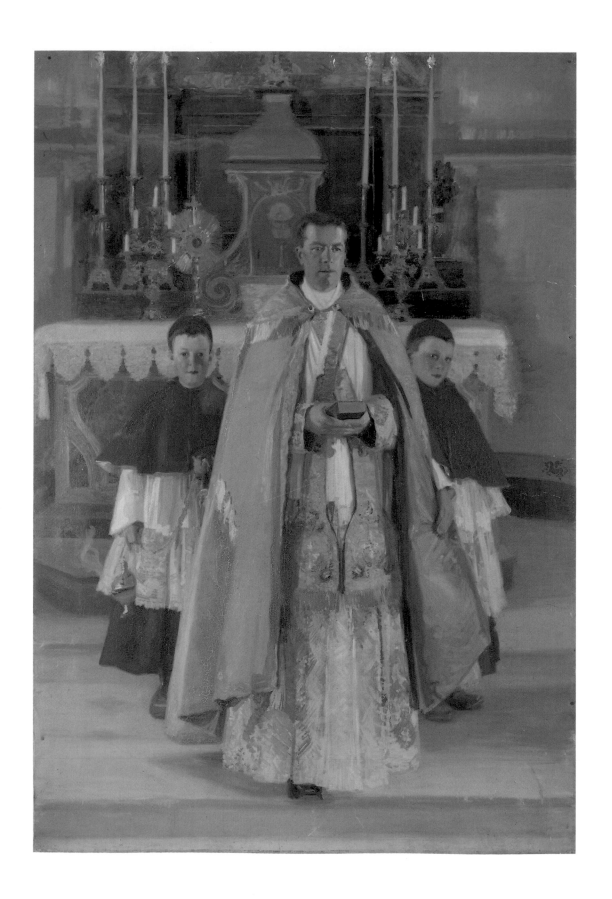

As a painter, MacMonnies concentrated on figures, painting portraits and family subjects in Giverny, portraits and nudes in Paris. His portraits included formal commissions as well as those of pupils and a number of self-portraits; in the example illustrated here (plate 179), it is significant that he portrayed himself as a painter, not a sculptor. One of MacMonnies' grandest portraits (which won a medal at the [old] Salon in 1904), and one that especially signifies Giverny, is *L'Abbé Toussaint* (plate 117). (The Abbé was a good friend of the MacMonnies family and usually alternated taking Sunday dinners with them and with the Monets.[53]) It is a stately image, undoubtedly inspired, as were his self-portraits, by the art of Diego Velázquez, which MacMonnies had studied on a trip to Spain in 1898. After a second trip to Spain, in 1904, MacMonnies painted another self-portrait, *As Velasquez Made Me See Myself* (location unknown). Religious imagery appears in a very different, more traditional form in MacMonnies' *Madonna of Giverny* (plate 118), a work reminiscent of compositions painted by contemporary American Renaissance artists such as Abbott Handerson Thayer and George de Forest Brush. MacMonnies' picture conflates established

OPPOSITE

117. Frederick MacMonnies (1863–1937). *L'Abbé Toussaint,* 1901. Oil on canvas, 88⅝ x 61 in. (225 x 155 cm). Musée A. G. Poulain, Vernon, France.

BELOW

118. Frederick MacMonnies (1863–1937). *Madonna of Giverny,* n.d. Oil on canvas, diameter: 48 in. (122 cm). Metropolitan Museum of Art, New York; Gift of Ira Spanierman.

religious imagery with portraits of his own family (including his third child and only son, who died at the age of two); the other children are those of one of Monet's gardeners. MacMonnies rendered this group in a very conservative, academic manner, even utilizing the traditional tondo shape.

MacMonnies' most monumental family composition is *Mrs. MacMonnies, Betty and Marjorie* (plate 119), painted at the time of Berthe's (Betty's) birthday in 1901. This work was painted concurrently with *L'Abbé Toussaint*—the former undertaken outdoors in the morning, the latter inside in the afternoon. MacMonnies' two daughters, with their mother and a nurse, are posed in a long allée in the family's extensive gardens. Like Mary's earlier *Roses and Lilies,* this is a plein-air work full of sunlight, but with forms and space quite precisely rendered.

MacMonnies had an exhibition of paintings in Durand-Ruel's New York gallery in January 1903; the pictures were almost all portraits—some painted in Giverny, some in Paris, and some elsewhere. His reviews were decidedly mixed: critics found the work "vulgarly commonplace" and "brilliant to the point of glitter."[54] Although MacMonnies continued to paint, the negative comments may have helped direct him back to sculpture, the medium in which he maintained a dazzling reputation. Also, having begun to concentrate professionally on portrait painting as a potentially lucrative practice, he discovered that sitters were difficult to deal with and vague about making commitments to pose; his focus on painting, primarily in Giverny, lasted only about three years.

There was a lot of interaction between the MacMonnies and Monet households, but Claude Monet and Frederick MacMonnies themselves, while cordial, were not especially friendly. MacMonnies recalled that "the few times I did see him, he was very charming."[55] The Hoschedé-Monet daughters were frequent visitors to Le Prieure, and the Butler children often came to play with the MacMonnies daughters.

MacMonnies and Le Prieure attracted increasing numbers of visitors to Giverny as the century drew to an end. Many of these were art students, primarily American, taking instruction from MacMonnies in Paris. A tremendously successful instructor, he taught privately at the Académie Vitti, founded by one of his models in 1895; and at the Académie Carmen, a school set up by his colleague James McNeill Whistler in 1898. Though MacMonnies' fame was based on his achievements as a sculptor, his teaching emphasized drawing and color.

Most of MacMonnies' pupils, both in Giverny and in Paris, were young women. Josephine Miles Lewis was one student who was in Giverny while the MacMonnieses

119. Frederick MacMonnies (1863–1937). *Mrs. MacMonnies, Betty and Marjorie,* 1901. Oil on canvas, 96½ x 88½ in. (245 x 225 cm). Musée des Beaux-Arts de Rouen, Rouen, France.

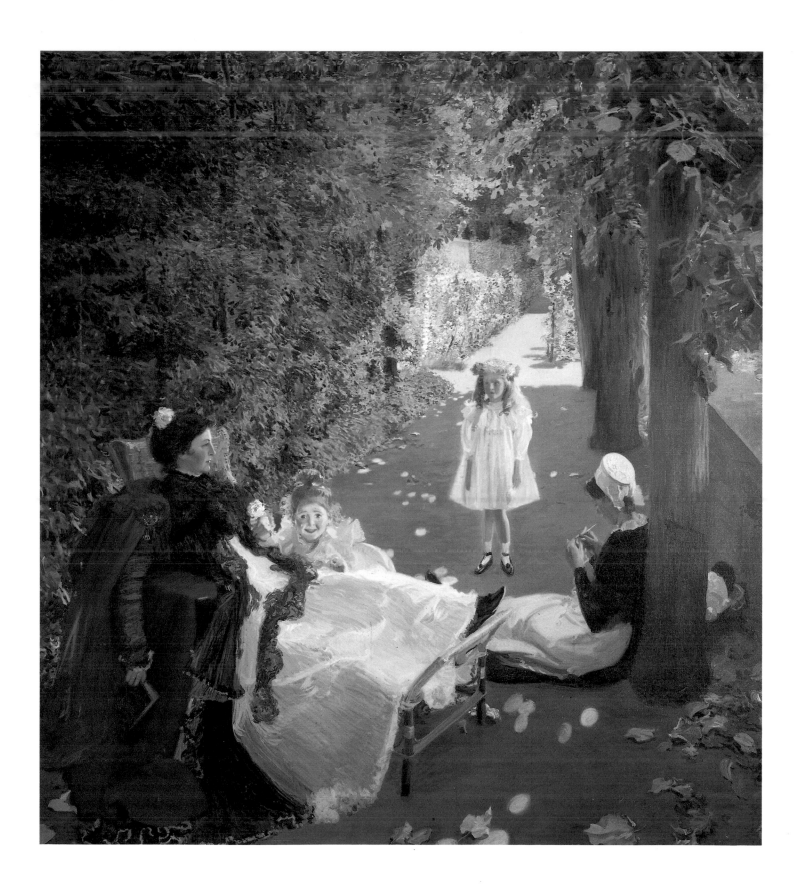

were inhabiting the Villa Bêsche, in the mid-1890s. Ellen Emmet (known as "Bay" and later Mrs. Blanchard Rand), her sister Rosina Hubley Emmet, and their cousin Jane all stayed with the MacMonnieses at the villa in the spring of 1897, just before they moved into Le Prieure.[56] Ellen, her sister (Edith) Leslie Emmet, and her cousin Lydia Field Emmet had all been students at the Académie Vitti the year before; Raphael Collin was the principal teacher there, but it was MacMonnies' instruction that they valued most. Ellen Emmet was the most devoted of these students of Mac-Monnies, and she worked with "the Patron" in his studio. Teacher and pupil painted each other's portraits.[57] It seems doubtful that MacMonnies conducted formal classes in Giverny, but he offered criticism to these young artists in 1899, just as he was turning to painting.

These young women, along with many others who visited and stayed in Giverny at the turn of the century, were constantly to be seen bicycling down the roads of Giverny, wandering through the landscape, picnicking on an island in the Seine, or rowing on the river. One writer noted in 1901, "An open air studio [at Le Prieure] is utilized by a number of young women art students, who add a note of gayety [sic] to Giverny, and whose leisure hours are occupied in playing lawn tennis or in cycling, or in driving in two wheeled pony carts."[58] Rosina Hubley Emmet wrote about plans for a big dinner party on the Fourth of July, 1899, at the MacMonnies home, with ice cream, strawberries, and fireworks, and visits expected from Whistler and Augustus Saint-Gaudens.[59]

Ellen, Leslie, and Rosina Hubley Emmet took a house outside of Giverny in June 1899, along with Jane Emmet, also an art student (later married to the English landscape painter Wilfred De Glehn). The house they rented was in Bois Jérôme, a community overlooking the village from the hills of Les Bruyères. Rosina described the house and garden as superior to anything in Giverny—larger than the Villa Bêsche and nicer than the MacMonnies' place because it was more unsophisticated. It was surrounded by a high stone wall, with a garden of trees, shrubs, and lilac bushes.

The only located painting surely done during the Emmets' stay in the region is Ellen's portrait of their landlady, *Madame de Laisemont* (plate 120), a quick, vibrant study of the elderly woman. It accords well with MacMonnies' own very painterly approach, although the still life on the table recalls the work of William Merritt Chase, with whom both Ellen and Lydia had earlier studied at the Shinnecock Summer School of Art on Long Island. Ellen recorded that MacMonnies had bicycled to their house in order to critique a painting done by Leslie in the vegetable garden.[60]

The girls . . . have taken a cottage at Giverny for $100 for a year. They then get a bonne to do all the work for I forget what paltry sum ($9 a month or 6) and then their food is the only extra expense and washing. McM is to be painting there for 2 months this summer, and Mrs. McM all the time. Then they won't need to spend anything on new clothes and they couldn't do anything so cheap or so profitable anywhere else.

Lydia Field Emmet to her mother, March 4, 1899, Emmet family papers; courtesy Debra Petke.

Ellen and Lydia Field Emmet would go on to distinguished careers as portraitists, with Lydia becoming a specialist in children's portraits.

The Emmet family papers detail the young women's admiration for MacMonnies. Indeed, probably no other Giverny painter, Monet included, ever received such adulation. During her 1897 stay with the MacMonnies family in the Villa Bêsche, Jane Emmet referred to Frederick as "the most remarkable person I've ever met by far. . . . the very wittiest, funniest, most penetrating person I've ever seen." To her sister Rosina Emmet Sherwood, she wrote that MacMonnies "is the very best teacher in the world," and she described him to Lydia as "a lambent flame of genius. He is much the most extraordinary person I know and I think the most attractive. He is so uncannily clever and penetrating and both witty and funny. . . . He is the most inspiring creature, you simply cringe with shame before his ideals of art."[61]

Rosina Hubley Emmet judged MacMonnies "without exception, one of the most brilliant creatures I have ever known—and the complexity of his nature is marvellous."[62] Lydia Field Emmet was more judicious in her estimation, finding MacMonnies to be "so completely and distinctly an artistic and sensitive sort of type . . . the youngest and the most ungreat seeming thing to have attained so much." But she noted that "he attains a dignity the minute he begins to talk of art and you can feel the voice of authority."[63]

Staying with the Emmet women in Giverny in 1899 was their close friend Mary Hubbard Foote, who graduated from Yale and won the first William Wirt Winchester Prize in 1897. This was a travel grant, which enabled her to go to Europe. Living in Paris in the same building as her friends Ellen, Lydia, Jane, and Leslie Emmet, she too enrolled in the Académie Vitti and received criticism from MacMonnies, becoming one of his most devoted pupils, in both Paris and Giverny.[64]

120. Ellen Gertrude Emmet Rand (1875–1941). *Madame de Laisemont*, 1899. Oil on canvas, 17¾ x 14½ in. (45.1 x 36.8 cm). Rosina Rand Rossire.

Like Ellen Emmet, Foote painted a portrait of MacMonnies (private collection), as well as numerous views of the MacMonnies garden (plates 121, 122). Her garden vistas, like those by both her mentor and his wife, often include young women, though whether these were models or fellow artists is not documented. Foote was in Giverny again in the summer of 1901, and she seems to have been expected by Mac-Monnies there in 1904.[65]

MacMonnies' sometimes mesmerizing appeal to his young women pupils has been interpreted by a number of recent art historians as a propensity for "womanizing."[66] In the case of Mary Foote, there certainly was intense mutual attraction, and it seems that she did expect him to divorce his wife and marry her. Their correspondence continued for years after she returned to New York in the fall of 1901. Foote established herself as a professional portraitist in New York, and she participated in Mabel Dodge's avant-garde circle there in the 1910s. After a nervous breakdown in the 1920s Foote became a patient and then a disciple of Carl Jung in Zurich, where she settled for many years.

121. Mary Hubbard Foote (1872–1968). *In the Garden, Giverny,* c. 1898–1901. Oil on canvas, 12½ x 16 in. (31.8 x 40.6 cm). Private collection.

Some of MacMonnies' sculpture assistants who had been his students in Paris visited Giverny and worked with him on sculpture projects there. Among the most significant of these were Mabel and Paul Conkling; MacMonnies painted Mabel's portrait in Giverny in 1904 (Terra Museum of American Art, Chicago). Two other student-assistants of MacMonnies who worked in Giverny were John Heywood Roudebush and Japanese-born Gozo Kawamura, probably the most exotic of the artists who visited him in Giverny. The best known was his earliest pupil, Janet Scudder, who had persuaded MacMonnies to offer criticism to a private class in Paris in 1894. Scudder became one of his principal assistants, and while working with him in his Giverny sculpture studio, she entered into the local social life. She was a

122. Mary Hubbard Foote (1872–1968). *View Through the Studio Window, Giverny,* c. 1899–1901. Oil on canvas, 25½ x 18 in. (64.8 x 45.7 cm). Courtesy of John Pence Gallery, San Francisco.

123. William de Leftwich Dodge (1867–1935). *In MacMonnies' Giverny Garden,* c. 1898–99. Oil on canvas, 50 x 33½ in. (127 x 85.1 cm). Mr. and Mrs. Martin Kodner, Saint Louis; Courtesy of Gallery of the Masters, Inc., Saint Louis.

frequent summer renter, often with groups of her friends, and as late as 1910 she was there with her own assistant, Malvina Hoffman. Scudder had rented a stone house from a local woman known as Mère Porchet, who cooked meals for the Americans. Hoffman recalled visiting MacMonnies often in his studio, where he "worked with nervous movements while his remarks fell like a shower of sparks, often singeing some of his listeners."[67]

Neither student nor assistant but already an established painter who went to Giverny as part of MacMonnies' circle in the last years of the century was William de Leftwich Dodge. He was already a significant muralist when he and his wife took a house near the MacMonnies property in the summer of 1898. Their temporary dwelling was a one-story building surrounded by a stone wall, with a garden in which Dodge could paint.[68] They may have decided that they did not need the expanse and expense of a house, for the next year they registered at the Baudy, and Leslie Emmet reported that they planned to stay through the winter.[69] The Dodges constituted a significant addition to the colony for three seasons, through 1900.

124. Mary Fairchild MacMonnies (1858–1946). *Nude by a Stream,* c. 1895–1900. Oil on canvas, 18 x 14½ in. (45.7 x 36.8 cm). Post Road Gallery, Larchmont, New York.

Dodge's most ambitious works were executed in the MacMonnies garden. The vantage point of his *In MacMonnies' Giverny Garden* (plate 123) is much the same as in Mary MacMonnies' later *Winter Garden of Giverny* (plate 116), though Dodge moved closer to the pool, as though enjoying the challenge of depicting the reflections in the clear water. He also reveled in the warm tones of summer sunlight, contrasting the golden glow with the bright red flowers in the foreground and the blue hills in the distance.

During the late 1890s Mary MacMonnies painted at least two female nudes posed outdoors in Giverny (plate 124 and private collection), and Frederick MacMonnies is said to have joined his wife one summer in painting "from a nude model in the sunshine against the aspen trees and a quiet little brook."[70] This probably occurred in 1899, when Ellen, Jane, Leslie,

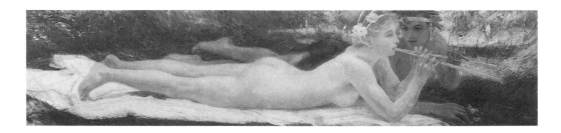

and Rosina Hubley Emmet rented their house in Bois Jérôme; Lydia Field Emmet wrote that "Mrs. McM has a garden and pond enclosed in a high wall, and a nude model engaged for all summer for them all to paint."[71]

It is Dodge who seems to have popularized the theme of the nude in the garden, establishing it in the repertory of the colony. *The Music Lesson, Giverny* (plate 125) and *Georgette in Giverny Garden* (plate 126) are companion pictures in which Dodge's mastery of the figure is clearly displayed. Both pictures bear the marks of tradition.

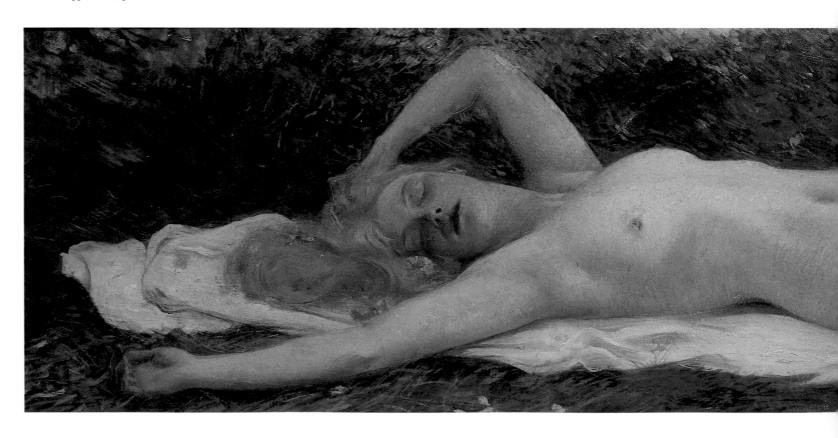

The former alludes to a pastoral Arcadia, as the young male instructs his fair companion on the pipes of Pan. The more sensual *Georgette* relates to the frankly naked Salon nudes immortalized by such nineteenth-century French academics as Alexandre Cabanel, William Bouguereau, and Jules Lefebvre. Dodge's method is equally academic, but what differs is the setting. We have here not a sea-born nymph or a cloud-backed goddess but a nubile young woman posed in the seclusion of MacMonnies' sun-filled garden. A third, more Impressionist painting by Dodge of Georgette, semi-nude in the garden (private collection), is also known.

Georgette's presence in Giverny that summer was not appreciated by Dodge's wife, Fanny, who had posed for his more sedate pictures. MacMonnies was amused when Georgette, fully naked, opened the garden gate for him. But the next visitor she greeted—a young Presbyterian minister from Virginia, who came with a letter of introduction from one of Dodge's maiden aunts—was scandalized, and the already jealous Fanny demanded that Georgette go. The model stayed only long enough for

OPPOSITE

125. William de Leftwich Dodge (1867–1935). *The Music Lesson, Giverny,* 1900. Oil on mahogany panel, 11¾ x 52 in. (29.8 x 132 cm). Private collection.

BELOW

126. William de Leftwich Dodge (1867–1935). *Georgette in Giverny Garden,* 1900. Oil on canvas, 12 x 52 in. (30.5 x 132.1 cm). Nella and Rufus Barkley, Charleston, South Carolina.

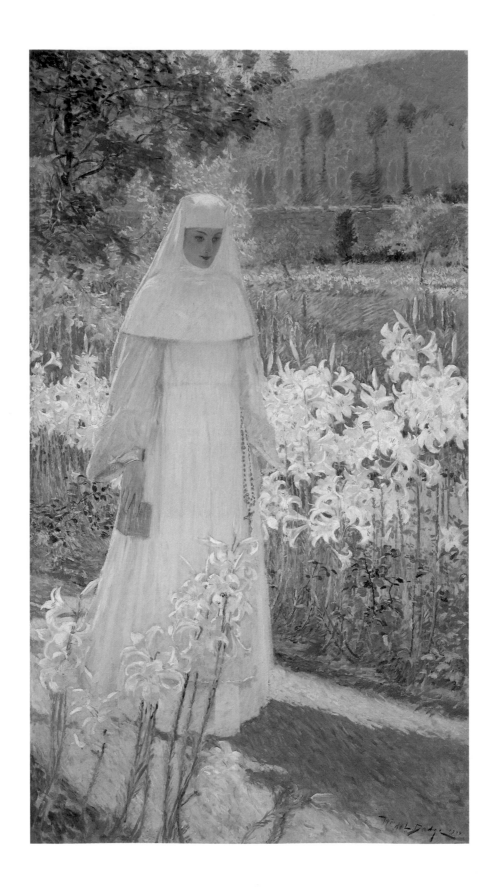

Dodge to complete a Salon picture, *Love's Awakening* (private collection), in which Georgette, nude to the waist, leans against a young shepherd, a young and very shy model from the local countryside.[72]

Symbolism, a feature of many of Dodge's murals, is also invoked in his *La Novice (Nun in Giverny Garden)* (plate 127), one of the most monumental and sun-filled of all of Dodge's Giverny canvases. It is believed that the model here was the artist Helen Bechtel, sister of Dodge's Philadelphia colleague B. Robert Bechtel[73]; the Bechtels had first registered at the Baudy late in July 1897, and they returned to the hotel over the next several years. The nun's figure is juxtaposed with white lilies, symbols of purity, in a religious image that suggests rejection of the sensuality evoked by Dodge's nude subjects. Indeed, with her head bowed and thus seemingly oblivious to the beauty of the flowers, the figure appears symbolic of total renunciation. Nevertheless, the setting is certainly the real MacMonnies garden, with the distant poplars and the blue hills above Port-Villez beyond.[74]

Dodge was one of the most active of the academically trained, classically oriented artists in Giverny at the turn of the century, but he was hardly the only one. Like Dodge, Walter MacEwen had painted murals for the 1893 World's Columbian Exposition and the Library of Congress; in the summer of 1901 he became the latest in the series of painters who leased the Maison Rose. There he was occupied with painting portraits, but no Giverny works by him have been identified.[75] Another mural painter in Giverny at this time—and one who would be far more significant for the Mac-Monnieses, if not for the colony in general—was Will Hickok Low. He and Mac-Monnies had become friends in the early 1880s, a relationship renewed the following decade in Paris and Giverny. Low and his wife, Berthe, were back in Giverny in 1895 when Berthe-Hélène MacMonnies was born, and she was named after Mrs. Low. In 1901 the Lows spent nine months living in a guest cottage on the MacMonnies estate.[76]

Low was very active in Giverny that year. He painted a series of pictures of the Mac-Monnies garden; some of these, such as the autumnal *The Terrace Walls* (plate 128), are fairly transcriptive works, similar to Mary MacMonnies' later *Winter Garden of Giverny* (plate 116). Featured in Low's depiction of the wall are the copies that MacMonnies had collected of antique statues in the museum in Naples; the bronze in the distance may be a reduced version of the *Diana* by MacMonnies' teacher, Alexandre Falguière.[77] Other garden pictures by Low are more fanciful and more overtly classical compositions, such as *Interlude: Macmonnies' Garden* (plate 129), in which two classically garbed women

iverny's] greatest charm lies in the atmospheric conditions over the lowlands, where the moisture from the rivers, imprisoned through the night by the valleys bordering hills, dissolve before the sun and bathe the landscape in an iridescent flood of vaporous hues, of which Monet . . . has portrayed the charm—a beauty which escaped most of the anxious neophytes who were . . . "camping on his trail" in the summer of 1892. . . . Later . . . when the first vogue of Giverny had departed, and the hamlet had resumed more of its material quiet, I have found the place to be pretty and peaceful, but at the time of my first visit, I own that I should have chosen other adjectives to describe it.

Will Low, *A Chronicle of Friendships* (New York: Charles Scribner's Sons, 1908), pp. 446–47.

127. William de Leftwich Dodge (1867–1935). *La Novice (Nun in Giverny Garden),* 1900. Oil on canvas, 71 x 39 in. (180.3 x 99.1 cm). Nella and Rufus Barkley, Charleston, South Carolina.

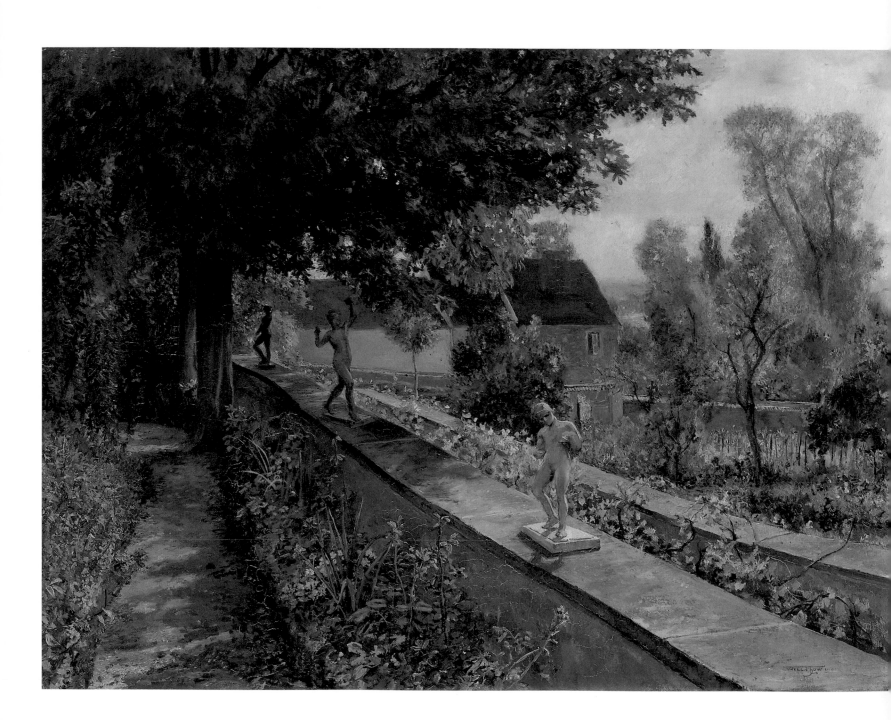

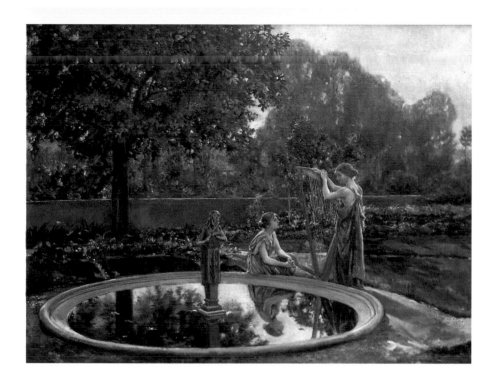

converse by the garden pool. This painting projects an image of tranquility totally removed from the contemporary village life just beyond the garden walls.

For Low the Giverny experience was experimental, extending his knowledge and practice of plein-air painting. His discussion of his paintings strangely parallels Dawson-Watson's nearly contemporaneous explanation of the principles of Impressionism (see pages 60–61). Low wrote, "An effort has been made throughout these works to give with some exactitude the varying color of light at different times of day, and at different times of year."[78] But even though the color range in these paintings reflects the innovations of Impressionism, and even though the pictures were painted outdoors,[79] the academic aesthetic so prominent here seems light years away from the art of Claude Monet, who was painting just at the other end of the village.

Low referred to his visit as a "golden summer . . . sheltered within garden walls in the gracious society of a châtelaine and two charming filleules."[80] He capitalized on his Giverny work not only with an exhibition of twenty paintings at the Avery Art Galleries in New York in February 1902,[81] but also in an article published that July in

Scribner's, with reproductions of thirteen pictures. The article constitutes an homage to the MacMonnies family, house, and garden, and to Mary MacMonnies in particular; both *The Terrace Walls* and *Interlude* (titled *By the Basin*) were illustrated. Described in the article is the cycle of painting undertaken by Low and the MacMonnieses that year; Frederick's *Mrs. MacMonnies, Betty and Marjorie* (plate 119) and Mary's *Blossoming Time* (plate 115) were painted alongside Low's garden pictures, and both are described in the article.[82]

Only one interior of Le Prieure was included in Low's exhibition—*The Spinet and the Harp* (plate 130), depicting Mary MacMonnies playing the harp and supposedly Berthe Low at the spinet. This painting gives a vivid view of how elegantly life was lived at Le Prieure, so unlike the impoverished conditions of the first Giverny colonists. What is striking about Low's piece in *Scribner's* is his confinement within the walls of Le Prieure. Neither the village nor the art colony of Giverny is ever even mentioned, and the only painting "excursion" described by Low was to portray the daughter of the family's washerwoman in her first-communion garb. But even she was posed in the garden of the MacMonnies housekeeper, which adjoined Le Prieure; a gate cut into the wall "permitted us to roam at will in the larger garden without going out to the village street."[83]

With the clarity of hindsight, the reader of the article quickly becomes aware of the tremendous affection that Low developed for his hostess, the "châtelaine." Presumably this affection was returned, for Low was back in Giverny in 1907. In early November 1908, Frederick MacMonnies left Giverny for New York; at the same time, his lawyer served Mary with divorce papers, and the divorce became final in late January 1909. The MacMonnies had been leading gradually more separate lives from the late 1890s on, with Frederick spending much of his time in Paris, where his mother and sister tended his needs, as well as in England and the United States. Letters exchanged among the Emmet sisters and cousins describe in detail the antipathy between the younger and the older Mrs. MacMonnies, as well as their growing belief in Mary's unsuitability for Frederick (one must take into account their own prejudices here). Mary was increasingly aware of the mutual attraction between her husband and a number of his students, and she may have justified her relationship with Will Low as consolation for Frederick's absences and indifference.

Mary MacMonnies and Low married in Paris on November 4, 1909 (Berthe Low had died either in 1908 or early 1909), and they left France with her daughters and her paintings the following January; the couple soon became an integral part of a very

Mrs. MacM is a fat curly little person with black ringlets, and a curly nature. . . . She is five or six years older than her husband, and I am afraid there is precious little sympathy between them. He is so much above her mentally and morally & is made of so much finer fibre, that it is absolutely impossible for her ever to meet him on his own ground—& he must come down to hers.

Rosina Hubley Emmet to Lydia Field Emmet, May 28, 1897, Emmet Family Papers, Archives of American Art, Smithsonian Institution, Washington, D.C.

different art colony, one that had developed in the Lawrence Park section of Bronxville, north of New York, where Low had kept a home since 1897.[84]

Frederick MacMonnies also remarried; his second wife was the former Alice Jones, daughter of a Nevada senator. She first attempted to make sculpture in MacMonnies' Giverny studio during the summer of 1904, and she took a house in the village so she could continue working with her teacher. She and MacMonnies married on March 23, 1910, in Lucerne, Switzerland. One of MacMonnies' finest portraits depicts his new wife (Terra Foundation for the Arts, Chicago), probably painted in Giverny soon after their honeymoon.

130. Will Hickok Low (1853–1932). *The Spinet and the Harp,* 1901. Oil on canvas, 21¼ x 28¾ in. (54 x 73 cm). Dr. and Mrs. Robert W. Lasky, Sr.

Into the Twentieth Century

In the early years of the twentieth century the Giverny colony became even more American dominated than it had been in the past. As Arthur B. Frost wrote in 1910, "Giverny is crowded with Americans, mostly painters and mostly women."[1] With many colonists establishing permanent residences and many more visitors renting houses for long stays, a "third generation" society developed that was increasingly separate from that of the local villagers. The tennis courts had now become a tennis club, and badminton became especially popular among the women colonists. A lot of entertaining took place in private homes, and there was also a "cinematograph" that the colonists attended.[2] A number of the resident artists drove around in private automobiles, and the colonists took trips together to Paris and elsewhere.

By this time Giverny had become expensive. Frost wrote in 1908 that "prices of everything have been adjusted to the American pocket," noting that milk and butter were more costly than in Paris and not as good. Chicken was as expensive as at home, and fruit was difficult to find; vegetables were often grown in the colonists' private gardens. Frost wrote that land prices, too, had risen "out of all reason because of the Americans," and Frederick MacMonnies had described to him the change in real-estate prices from when he had first arrived.[3]

131. Detail of Guy Rose, *The Blue Kimono*, c. 1909. See plate 140.

157

After Theodore Butler returned from America and married Marthe Hoschedé-Monet at the end of October 1900, he again settled into the Monet household and the Giverny colony. In 1911 he turned to mural painting, having accepted a commission to paint murals of famous Americans for the United States pavilion at the world's fair in Turin. He painted them in Giverny with the assistance of his son, James, and then installed them in Turin in the spring of 1912. Butler wrote to Philip Leslie Hale that the Italian architects referred to his style as *divisioniste* (divisionist)—an intriguing description, since this was the dominant mode of Italian Impressionism and an approach that Hale himself had adopted in the 1890s.[4] By 1913 Butler was back in America to install murals in William A. Paine's house, outside of New York City; the outbreak of World War I prevented Butler's return to Giverny until the spring of 1921.

Along with Monet himself, MacMonnies and Butler constituted the "old guard" within the colony; several early visitors came to see them in the middle of the century's first decade. Butler's close friend Philip Hale and his new wife, Lilian Westcott Hale, arrived for a month's stay at the Hôtel Baudy in August 1904. Hale had written to his father, "We shall enjoy seeing Theodore Butler and perhaps the Monets again."[5] Both Philip and Lilian Hale painted haystacks in the fields along with Butler, but the weather was so poor that they rarely worked outside. Though they painted continually, Lilian Hale opined years later that none of their Giverny paintings from that summer had survived.[6] Early in September they visited Monet, who showed them some of his latest paintings of London and the Thames River; Philip admired "their wonderful fog effects."[7]

In March 1906 Lilla Cabot Perry and her family returned to Giverny for their longest stay, renting the Villa Bêsche that season and then occupying a house at the west end of the village.[8] Perry renewed her friendship with Monet and continued to paint both the local landscape and figures. Her outdoor works were in a high, Impressionist key; some of her other pictures reflect her exposure to Japanese art during the three years the family had spent in Tokyo. Perry worked in both oils and pastels (see plate 132), having familiarized herself with the latter in Japan. The Perrys remained in Europe for more than three years, spending much of their time in Paris, though also touring Russia, Finland, and Bohemia in the summer of 1908. After a final summer in Giverny the next year, they returned to Boston in November 1909.[9]

Artists and other visitors to Giverny continued to fill the Hôtel Baudy, but the hotel's register for the twentieth century has not been located, and so our information about the guests there and elsewhere in the colony is fragmentary.[10] By and large, land-

132. Lilla Cabot Perry (1848–1933). *Bridge Willows— Early Spring,* c. 1905. Pastel on paper, 25¼ x 31¼ in. (64.1 x 79.4 cm). Private collection.

scape specialists, such as Eliot Clark and Allen Talcott, tended to make relatively brief visits to Giverny and to stay at the Baudy, while figural artists, who increasingly dominated the colony, remained longer and rented or even purchased houses.

The landscapes painted by Leon A. Makielski in 1909–11 are the most traditional of any by the colonists, many of them grain-stack pictures (plate 133) that emulate Monet's series from twenty years earlier. Judging by the impressive number of his Giverny pictures, Makielski must have been very prolific, concentrating on agrarian subjects, as had Theodore Robinson and others of the first generation. Other paintings done by Makielski in Giverny likewise repeat motifs the earlier artists had undertaken, such as stands of poplar trees, village roads, and views of the town with the terraced fields on the hills above.[11]

Young women artists and art students continued to find inspiration in Giverny. Blondelle Malone, who was one of several American artists to be dubbed the "Garden

133. Leon A. Makielski (1885–1974). *Straw Stacks, Giverny,* 1909. Oil on canvas, 10 x 14 in. (25.4 x 35.6 cm). Stan Mabry.

Painter of America," was in the village in 1904. Exuberantly ambitious, Malone actively sought out leaders in the French art world, including Auguste Rodin and Mary Cassatt. The latter advised her to live not in Paris but in some place away from the crowd of foreign students yet within reach of the French capital; this may have given Malone additional incentive to settle in Giverny for the year. She first stayed at the Baudy, probably registering that summer, and she described the village in some detail.

> The place is dotted with little farm houses in the midst of soft green fields which in the spring are covered with charming wild flowers. The atmosphere is soft and subtle. There is nothing glaring or coarse about Giverny and no modern houses. Many artists live here and have bought up the old houses and kept them quaint. I live at the inn, the dining room is the living room and very large. The walls are done in dull green and covered with paintings which distinguished artists have made, almost all unfinished sketches.[12]

Malone rented her own house, La Rainette (The Little Tree Frog), probably around the beginning of December. She became friendly with a number of the other artists in Giverny, including Václav Radimsky, Janet Scudder, and especially Alice Jones. This eased her into Frederick MacMonnies' circle as well as Butler's, but her

overriding ambition was to meet Monet. On December 20, 1904, she received a grudging invitation from the French painter, who wrote: "What you ask me for annoys me, I must confess. However, I will suggest to you to come to my home with some of your works." The next day she filled a wheelbarrow with a dozen pictures and knocked at his automobile gate; a gardener sent her to another entrance. Though Monet told her that he did not like to see people and that she was the only one he had received in years, he critiqued her pictures gently and then showed her his own paintings. Subsequently she visited Monet's garden on numerous occasions and executed her own series of water-lily paintings.[13]

Despite the predominance of Americans in the village during the twentieth century, artists from other countries also occasionally participated in the colony. One who was to become quite notable was the British painter Gerald Kelly, who established himself as one of England's leading portraitists and president of the Royal Academy. Like William Rothenstein before him, Kelly became a convert to Impressionism through the dealer Paul Durand-Ruel, and like his predecessor he followed up on this experience with a visit to Giverny.[14] Durand-Ruel offered to introduce Kelly to Monet when the latter's garden was in full flower, but only if the young man could discuss gardening. Kelly spent a ten-day holiday back in England studying up on the subject, but he found that his efforts had been unnecessary:

> [Monet's garden] was nice and large and it was entirely covered with rambling crimson roses which, you know, you get practically speaking in any suburban garden all over England. And there was a little piece of water where there were some common or garden water lilies, and there were some iris, and all my carefully acquired erudition was worth exactly nothing.
>
> But Monet was there, splendid creature. . . . I sort of tried to see into the studio . . . and Monet said, "No, no, come out into the garden. You must see my flowers, they are lovely." And it was one of those grey days which are not very interesting, at least I don't think so. And Monet said, "Le temps, c'est parfait"—"It is perfect for looking at flowers, grey day you know, the sun is the ruination of flowers, they look so bright you can't see them, but on a nice grey day like this you can really enjoy the flowers, so come along." And I started praying to Almighty God, and I said, "Send the sun, let the sun come out," and do you know, in a very short time it did, and Monet said, "Here's the sun, let's go back to the studio.[15]

Kelly and the others just mentioned were only visitors to the town. Much more central to the Giverny colony were those painters who settled in and associated with

the longtime resident artists. Many of these tended to be figure specialists, and some continued the academic traditions that had permeated their Parisian training. One of the most notable, and ultimately the most tragic, was James Wall Finn, who won an honorable mention the first time he exhibited at the (old) Salon, in 1896, with two works—one a portrait of MacMonnies' pupil and assistant, John Heywood Roudebush. Finn was one of MacMonnies' closest friends, from their early student days in Paris; Finn's wife was a cousin of Josephine Miles Lewis, another of MacMonnies' pupils.

Finn stayed at the Baudy before purchasing a house next door to MacMonnies in 1903, and the following year he built an adjoining studio larger than the house itself.[16] He was the first artist living in Giverny to become actively engaged in mural painting there; among his commissions were murals for the New York Public Library; the *Garden Scene* (1905) in the Flower Room of New York's Knickerbocker Hotel; and *The Seasons* (1910) for John Jacob Astor's Fifth Avenue residence. Finn's *Primavera,* or *Birth of Venus* (plate 134), painted in Giverny, is a large study for one of Astor's murals, inspired by the work of Botticelli and the Italian Renaissance.[17]

Much of Finn's time was necessarily spent in the United States, and he divided his time in France between Giverny and Paris.[18] When he lay mortally ill in the summer of 1913, MacMonnies offered to exchange homes with him, since Le Prieuré was far better equipped and had indoor plumbing. Finn refused, so MacMonnies told him that he was going off to Paris, while really moving back to the Villa Bêsche so that Finn would feel at ease moving into MacMonnies' palatial house. It was there that he died on August 28, 1913; MacMonnies and Butler witnessed the death certificate.[19]

One of the finest of the more traditional figure specialists to join the Giverny art colony in the early 1900s was Henry Salem Hubbell. He had produced some peasant genre paintings earlier in his career, but in the latter half of his French sojourn he specialized in close-toned paintings of attractively gowned women in elegant interiors. In 1907 Hubbell took a house in Giverny, where he painted *By the Fireside* (plate 135), which he showed in the Salon of 1909.[20] Probably no picture by Hubbell was more admired than this, especially for its distinctive color, in which later critics have detected the impact of Impressionism. The writer for *L'Art et les artistes* found it "quite beyond comparison . . . so delicate, so delightful to look at and so completely satisfying." In Vienna, Max Nordau described the work as outstanding in "its warm, distinguished color quality, like a flower among ordinary foliage."[21]

134. James Wall Finn (1867–1913). *Birth of Venus,* c. 1910–13. Oil on canvas, dimensions not available. David and Michael Madigan.

Such paintings reflect the more conservative artistic tendencies already evident in such Giverny works as Will Hickok Low's *The Spinet and the Harp* (plate 130), but the predilection for images of beautiful, passive women in tasteful interiors also reveals the influence of contemporary painting in America. Hubbell had returned to the United States in mid-1904, when many of the group known as the Ten American Painters (The Ten) had redirected their art toward just this form of imagery, induced by the Vermeer revival in America. The annual exhibitions of this group received accolades from both critics and patrons at this time, with Edmund Tarbell's *A Girl Crocheting* (1904; Canajoharie Library and Art Gallery, Canajoharie, New York) judged as one of the finest of all contemporary American paintings. That picture was on view in the annual show of work by The Ten held in March 1905 in New York and in Boston in May, before Hubbell returned to France, and it is inconceivable that he would not have made an effort to see the display.[22] *By the Fireplace* may be the ultimate expression by a Giverny artist of genteel aestheticism, as filtered through the work of The Ten.

The colony in Giverny became increasingly heterogeneous during the first decade of the century. Ernest Blumenschein, best known as a leading figure in Taos, New Mexico, spent 1903 to 1909 in France, attempting to establish himself as a painter while making a living as an illustrator. Although based in Paris, he was a visitor to Giverny, probably sometime in 1906–7.[23] Blumenschein was there not just to enjoy the village and to socialize; at least one of his illustrations, for an early story by Willa Cather, was executed in Frederick MacMonnies' Giverny studio, and it appears to depict a gathering of artists there.[24]

Blumenschein was at most an occasional visitor to Giverny; on the other hand, Arthur B. Frost, one of America's most renowned illustrators, took a house in Giverny in 1908 and returned for two succeeding summers, becoming an integral part of the colony. Mrs. Frost gave teas, and Frost developed a close friendship with MacMonnies. Although he was an enormously successful illustrator, Frost periodically chafed under the limitations of the genre and sought to establish himself as a "pure" painter. This was one motivation that had led him and his family to Paris in 1906; another was his ambition to provide professional training for his two sons, John (known as Jack) and Arthur, Jr., both of whom he enrolled in the Académie Julian at the beginning of January 1907. His sons were frequent visitors to Giverny from Paris, and Jack became especially close to James Butler, son of Theodore and Suzanne.

Complying with his father's wishes, Jack took instruction for a year at the Académie Julian and then studied with the American expatriate Richard Miller—

135. Henry Salem Hubbell (1870–1949). *By the Fireside,* 1909. Oil on canvas, 74 x 50 in. (188 x 127 cm). Central Junior High School, Lawrence, Kansas; Gift of the artist.

Matisse] is a charlatan and a fake and a pretty dirty one, too. He sold Arthur a little panel about 10 inches long that he painted in an hour for $80.00. I think a man who would sell one of his pupils, and a boy at that, such a thing for such a price, is a dirty mean cuss.

Arthur B. Frost to Augustus Daggy, July 22, 1909; courtesy of Henry M. Reed.

both in Paris at the Académie Colarossi and during summers in Giverny. Much to the elder Frost's horror and disgust, Arthur, Jr., abandoned the Académie after one month, having met a fellow American, Patrick Henry Bruce, who induced him to join a class started by Henri Matisse. Young Frost became an ardent disciple of French modernism, even acquiring a work by Matisse. His father's letters from Giverny to Augustus Daggy (an old classmate from his days studying under Thomas Eakins) detail Frost's pain and disillusionment over his son's course of action.[25]

Frost did not make the progress he had desired with his own painting, though his *French Landscape (Giverny Scene)* (plate 136) testifies to his involvement with Impressionist strategies of light and color—this in spite of his color blindness. He had earlier denounced Impressionism, but in 1909 he wrote, "Everyone is influenced more or less, by the way Monet has seen color and many try and copy him slavishly."[26] *French Landscape* is typical of Frost's interest in the appearance of the village and the surrounding landscape; much of his artistic energy was spent on drawings, watercolors, and occasional oils of the stone walls, the barns, the church, and the flower-lined roads and paths.[27] By July 1909 Frost had come to recognize his limitations, writing: "I've given up the idea of being a painter, I've too big a handicap: color blindness enters into everything. I don't want to be a third rater, and I *can't* be a first rater."[28]

Frost's outstanding achievements in Giverny were his graphic renderings. A number of his finest sketchbook drawings of Giverny appeared in *Scribner's,* in one of the most revelatory articles ever produced about the village—oddly enough, the piece was not published until 1924, over a decade after Frost had left the village.[29] Peasants and donkey carts, mills and bridges, roads and houses (plate 137), pollarded willows, and Sainte Radégonde all appear in Frost's pictorial panorama.

Frost was not as productive as he had planned, in part due to diversions such as hunting and fishing. As soon as the fishing season began in June, he and Jack would be out catching perch, pike, and chubs, not only in the streams around Giverny but throughout Normandy.[30] Frost combined his sporting interests and his illustration talents in a series of articles on shooting and fishing in France, concentrating on Normandy. The first two articles, published in 1911 and 1913, appeared while Frost was still living in France; the third came out in 1922. They were written by the author and illustrator Ethel Rose, wife of the painter Guy Rose. Guy also collaborated with Frost on the illustrations for the articles; his illustrations seem to range throughout Normandy, while Frost's seem to concentrate more in and around Giverny.[31]

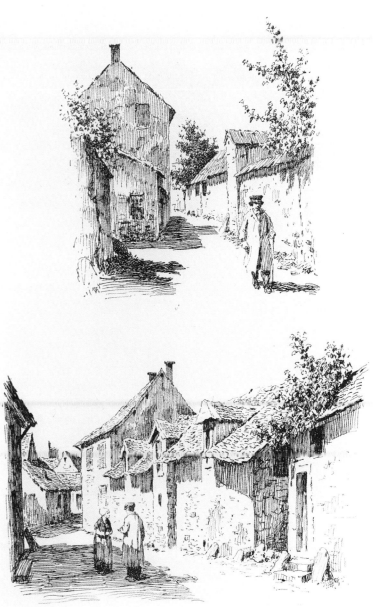

Guy Rose became one of the leading artists among the "third generation" of Giverny painters, and he was not only a great friend of Frost's but also a considerable influence, stylistically and professionally, on the young Jack Frost, who followed Rose back to Pasadena. There the younger Frost developed his mature career as a landscape painter, and there his father spent his last years.[32]

Guy Rose formed a bridge of sorts among the three generations of Giverny painters. Urged by Theodore Robinson to visit the village as early as 1890, Rose then developed a friendship with Theodore Butler that continued into the twentieth century. The Roses registered at the Baudy in May 1899, and then in 1904 they took a house in Giverny, where they remained in residence for eight years.[33] The California-born and -trained Rose began a very promising career in France with successful entries of imposing peasant genre, religious, and Symbolist subjects in the (old) Salon in 1890, 1891, and 1894. But the ill effects of lead

poisoning, suffered on a trip to Greece in the summer of 1894, forced him to abandon painting for a time, and he returned to America the following winter. He seems to have resumed painting, at least occasionally, about 1897, painting pure landscapes, probably in upstate New York, before returning to France in 1899. Even then he could not paint for sustained periods, but after he settled year-round in Giverny in 1904 the congenial country life improved his health enough so that he could resume his career; some of Rose's finest work was done during these Giverny years.[34]

The Roses remodeled and added a studio to an old stone peasant cottage at the west end of the village, adjacent to the property that Lilla Cabot Perry and her family would occupy a few years later. They developed a sloping hillside garden behind the house, where Ethel Rose served notable afternoon teas.[35] Like Frost, Rose was an avid sportsman, enjoying the local hunting and fishing and playing tennis on the courts across from the Baudy.

Both Guy and Ethel Rose wrote short but informative articles about Giverny.[36] Guy Rose continued to produce illustrations in France, even joining his wife in rendering fashion designs for *Harper's Bazar;* but painting was his primary vocation in Giverny, and his work there spans the varied interests of the three generations. He continued to paint pure landscapes of the region, concentrating on panoramic scenes not unlike those painted by his friend Robinson a decade and a half earlier. In *La Grosse Pierre, Giverny* (location unknown) he depicted the limestone cliffs overlooking the village, which Louis Ritter had painted in 1887 (plate 23). Rose also painted more-concentrated views, including several each of the Giverny church and the bridge at Vernon, plus winter and spring views of the Maison Bleue, where Monet kept his kitchen garden,[37] as well as poppy fields and streamside willow trees, as in *Untitled (River Epte, Giverny)* (plate 138).

This last picture is remarkably similar thematically to Rose's own *Willows, Giverny* (plate 139), painted during his first visits to the village in the early 1890s. But in place of the rather straightforward naturalism of the early view, the later painting glows with an almost iridescent luminosity, and its color range is in an intensely high key. One writer contrasted these "willows by the river at midsummer" with Rose's winter snow, spring greenery, and bare fall fields, reflecting the artist's fascination with rendering the seasons in Giverny—"with a magic touch that is purely lyric in its beauty and depth of feeling."[38] These are the hallmarks of Rose's vastly increased involvement with Impressionism, surely caused in part by his awareness of Monet's achievements and by his close association with the new generation of artists in the village. We have no docu-

When I first saw the French country at Giverny, it seemed so queer and strange, and above all so wonderfully beautiful, that the first impression still lasts; so that whenever I think of France that is the way I always see it.

Guy Rose, "At Giverny,"
Pratt Institute Monthly 6
(December 1897): 81.

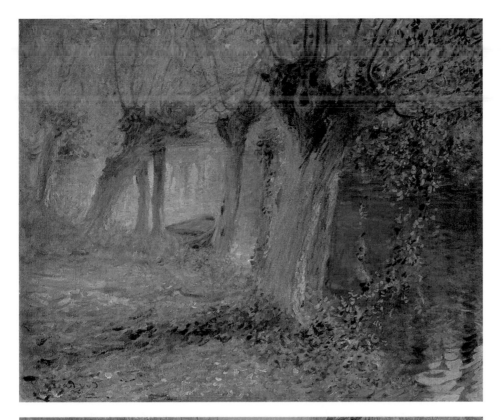

138. Guy Rose (1867–1925). *Untitled (River Epte, Giverny)*, c. 1904–12. Oil on canvas, 23 x 28½ in. (58.4 x 72.4 cm). James and Linda Ries.

139. Guy Rose (1867–1925). *Willows, Giverny,* c. 1890. Oil on canvas, 15 x 18 in. (38.1 x 45.7 cm). Rose Family Collection.

mentation of any interaction between Rose and Monet, although Rose was certainly friendly with the Butlers, but by the early twentieth century Monet's art was ubiquitous both in Paris and in New York.

In Giverny, Rose was equally involved with figure painting, a genre that epitomized the work of the third-generation Givernyites but owed relatively little to Monet.[39] Rose's *Blue Kimono* (plate 140) is characteristic of the genre, which featured lovely young female models painted in secluded flower gardens under brilliant sunlight. A popular variant on this theme was the female isolated not in a garden but in a boat on the Epte, as in Rose's *On the River* (plate 141). Here the figure is alone except for the artist who has painted her (and presumably rowed the boat out from shore). The woman is fashionably garbed, and though the garden setting has been eliminated, the floral reference is still present in her modish hat.

In this case, the subject is not a hired model but Sarah (known as Sadie) Frieseke, wife of Frederick Frieseke. Rose and Frieseke were fishing and tennis companions, and Sadie posed for at least two other pictures by Rose, further testimonial to the close friendship between the two couples. Frieseke was the dominant figure among the third generation of artists in Giverny—a group of painters whose manner has been defined as "decorative Impressionism." Younger than those of the Robinson and MacMonnies generations, this group of painters comprised primarily Midwesterners, including Karl Anderson, Karl Albert Buehr, Alson Skinner Clark, Frieseke, Richard Miller, Lawton S. Parker, and Louis Ritman.

Frieseke went to Paris in 1898, studying both at the Académie Julian and with Whistler at the Académie Carmen. His time with Whistler was probably very brief—no more than a week, according to one report.[40] Frieseke first appeared in Giverny in 1900, but during the next few years he spent time at Le Pouldu, Brittany, and at the artists' colony in Moret. He married Sarah O'Bryan of Philadelphia in

1905, and the couple settled in Giverny the next year, renting a small, rustic two-story cottage. The house was surrounded by high walls and described as having a beautiful old garden, running riot with flowers.[41] A second description pinpointed a "crooked old apple tree at one end" of the garden,[42] suggesting that this was the house formerly occupied by Mariquita Gill, where Robinson had executed his figure paintings in which that tree was prominent.

It was on this property that Frieseke developed the elements that would mark the work of the third-generation Givernyites—monumental images of women, single or in pairs, clothed or nude, and posed either in domestic interiors or in garden settings. They were often dressed in brightly colored, richly patterned gowns that both complemented and contrasted with the blossoms surrounding the figure. The woman—whether standing, seated, or reclining—is usually passive and meditative; the garden itself is a *hortus conclusus,* a safe haven for the purity of womanhood. Of course, not all the artists in the coterie surrounding Frieseke used all of these motifs; the nude, for instance, was of only marginal concern to Rose, and the floral setting was far less prevalent in his work than in Frieseke's.

Flowers per se were not Frieseke's real interest, and Sadie Frieseke was the gardener, not he. As he himself stated: "I know nothing about the different kinds of gardens, nor do I ever make studies of flowers. . . . If you are looking at a mass of flowers in the sunlight out of doors you see a sparkle of spots of different colors; then paint them in that way."[43] From Impressionism, Frieseke adopted a high color key and a fascination with effects of intense sunlight, which even infused many of his interior scenes. Color saturates his pictures, not only in the variegated blooms that constitute his floral settings but also in the man-made objects that are featured—lawn furniture, garden umbrellas (see plate 142), and even the architecture of his house. The building was painted bright yellow with green shutters and covered by trellises of roses, clematis, and passion vines. The living-room walls were lemon yellow; the kitchen, a deep blue. Strong color fields dominate such works as Frieseke's *Yellow Room* (plate 143).

It was Frieseke who introduced into the repertory of Giverny painting the concern for rich, decorative patterns, related to the art of Edouard Vuillard, Pierre Bonnard, and the other Nabi painters. There are patterns of furniture, patterns of parasols, patterns of fabric and wall coverings, patterns of light and shade, and patterns of flowers, all played off one against another in bright sunshine, as in *Lady in a Garden* (plate 144).

142. Frederick Frieseke (1874–1939). *The Garden Parasol,* c. 1909. Oil on canvas, 57 x 76⅝ in. (144.8 x 194.6 cm). North Carolina Museum of Art, Raleigh.

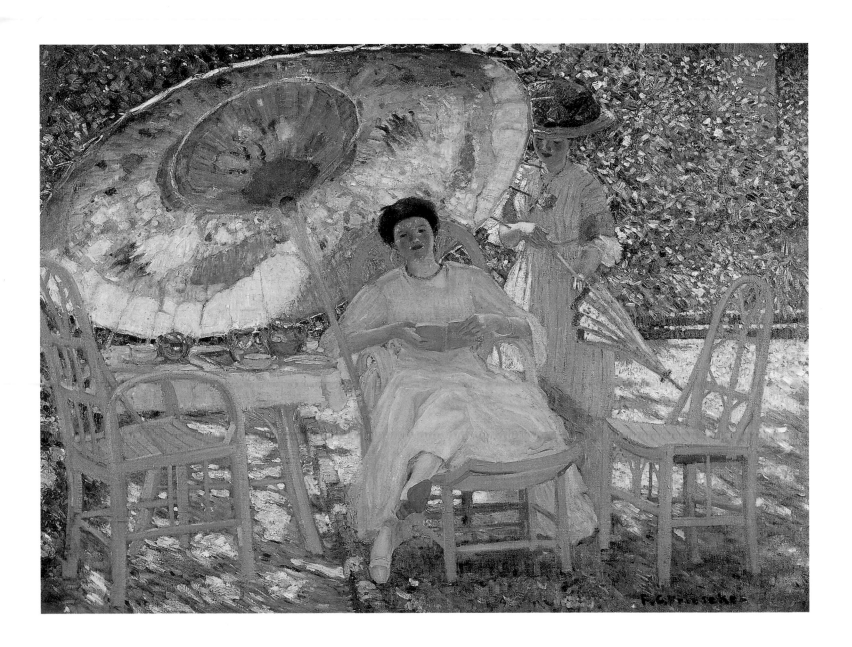

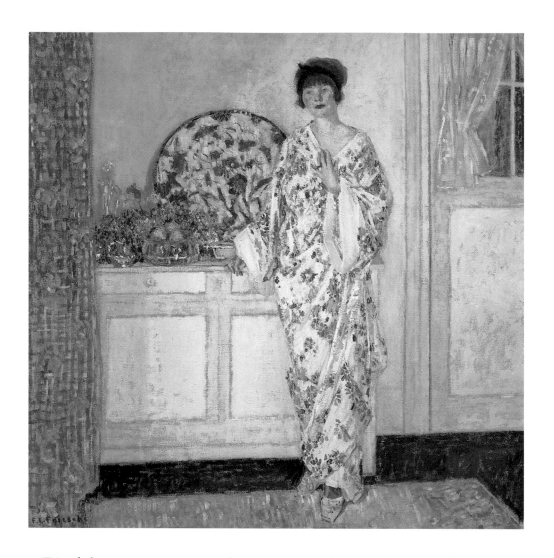

143. Frederick Frieseke (1874–1939). *The Yellow Room,* 1902(?). Oil on canvas, 32¼ x 32¼ in. (81.9 x 81.9 cm). Museum of Fine Arts, Boston; Bequest of John T. Spaulding.

144. Frederick Frieseke (1874–1939). *Lady in a Garden,* c. 1912. Oil on canvas, 31⅞ x 25¾ in. (81 x 65.4 cm). Daniel J. Terra Collection.

Frieseke's major concern may have been sunlight, but it is an artificial sunlight, and his art is a synthetic construct, divorced from the reality of both orthodox French Impressionism and the version of it adapted by earlier American practitioners such as Robinson. Phyllis Derfner has recognized that Frieseke's "light hardly seems to be *plein air* light at all. In fact it seems entirely artificial. . . . a stunning concoction of blues and magentas frosted with early summer green and flecks of white."[44] Likewise, Frieseke's use of flat, interlocking patterns to achieve two-dimensional effects allies his art to French Post-Impressionism; this nonnaturalistic aspect of Frieseke's paintings— and to a lesser degree those by his fellow colonists—distinguishes that work from perception-based Impressionism and reflects the "Art for Art's and not for Nature's-sake" creed of Whistler.[45]

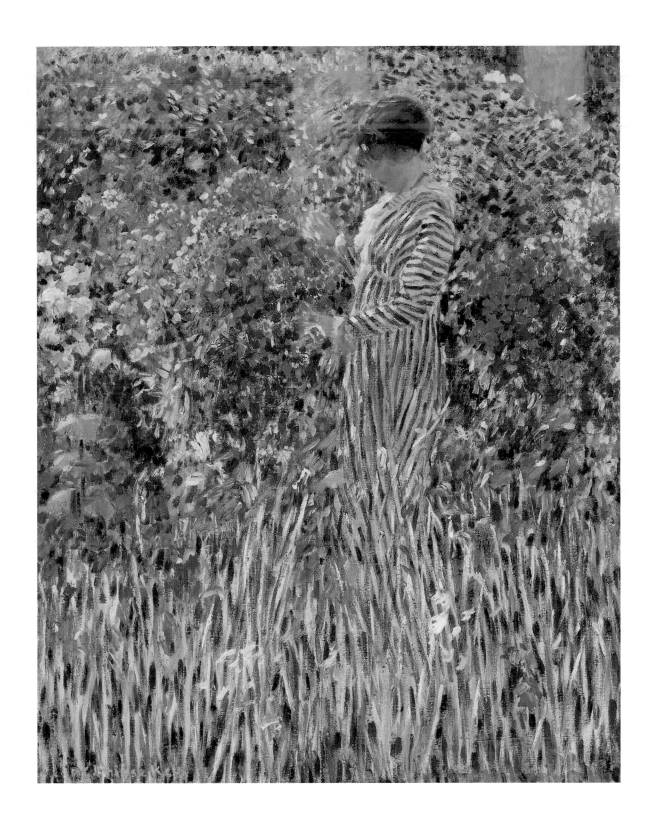

145. Frederick Frieseke
(1874–1939). *Autumn,* 1914. Oil
on canvas, 38 x 51½ in. (97 x 131
cm). Museo d'Arte Moderna di
Ca'Pesaro-Venezia, Venice

Many of Frieseke's nudes were painted outside his second studio, where the Ru
flowed after passing through Monet's water garden; Frieseke's section had once
belonged to a monastery and was referred to as "the fish pond."[46] Frieseke's preference
for the garden setting allies his art to that of Monet, but he and his generation of
colonists seem to have had even less direct contact with the French painter than their
predecessors. Frieseke acknowledged his own particular admiration for the art of
Auguste Renoir. Indeed, the swelling proportions, sensuous colors, and caressing sun-
light that characterize such pictures as Frieseke's *Venus in the Sunlight* (plate 146) and
Autumn (plate 145) have no correlation in Monet's oeuvre but are clearly related to
Renoir's nudes. Identical in general theme, size, and shape, but portraying different
seasons and contrasting moods of arousal and torpor, these two paintings appear to
have been conceived as pendants.[47]

Nudes by Frieseke such as these have an element of grandeur that, for all their aes-
thetic modernity, relates them to the majestic nudes from the era of Titian and
Velázquez. They are far more sensual than those by any of Frieseke's fellow colonists.

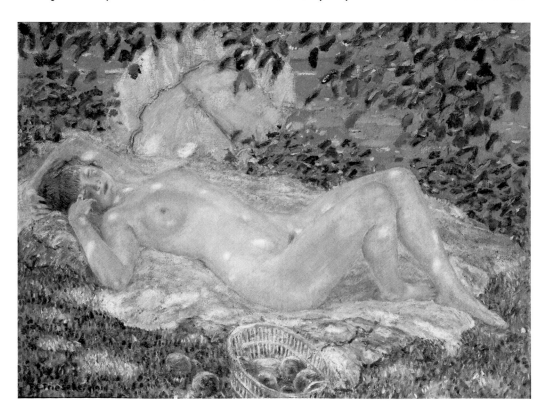

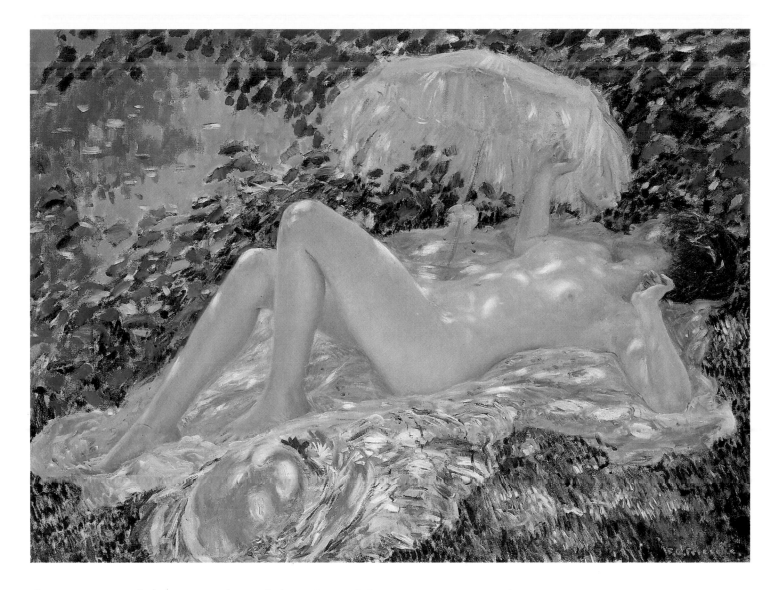

One writer regarded *Venus in the Sunlight* as "one of the greatest examples of flesh painting in sunlight I have ever seen." It was acclaimed when it was shown at the (new) Salon in the spring of 1914, and it was reported that the directors of the Musée du Luxembourg attempted in vain to negotiate its purchase.[48]

The opportunity to depict the nude constituted one of Frieseke's reasons for his expatriation. "I am more free and there are not the Puritanical restrictions which prevail in America. Not only can I paint the nude here out of doors, but I can have a

146. Frederick Frieseke (1874–1939). *Venus in the Sunlight*, 1913. Oil on canvas, 38 x 51½ in. (96.5 x 130.8 cm). Manoogian Collection

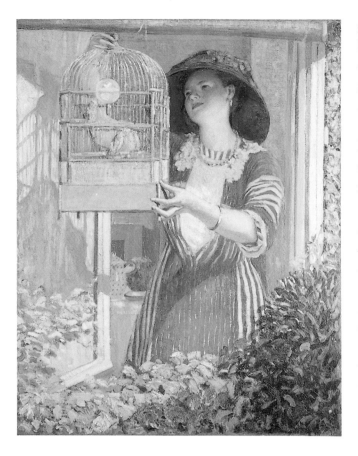

147. Frederick Frieseke (1874–1939). *Open Window,* c. 1900. Oil on canvas, 51½ x 40 in. (130.8 x 101.6 cm). Randolph J. and Judith A. Agley Art Collection.

148. Frederick Frieseke (1874–1939). *Lady with a Parasol,* c. 1908. Oil on canvas, 25½ x 32 in. (64.8 x 81.3 cm). Cornelia and Meredith Long.

greater choice of subjects."[49] Frieseke had painted the nude before 1913—an indoor nude was shown in the (new) Salon as early as 1903—but his series of outdoor nudes apparently commenced with *Nude with Second Woman* (also known as *The Bathers;* formerly Abraham M. Adler collection), painted in 1910. Then, during a winter vacation on Corsica early in 1913, Frieseke painted a number of images of the unclothed female on the beach, and he followed this up with the series of at least four Giverny images of monumental dimensions, including *Venus in the Sunlight;* a variant of it called *Summer* (Metropolitan Museum of Art, New York), also painted in 1913; *Autumn;* and *Nude in Dappled Sunlight* (1915; New York art market).

Woman herself is the dominant image in Frieseke's art; as in Rose's figural work, she functions as an object of beauty, encased in color and sunlight. Frieseke's *Open Window* (plate 147) is a modern equivalent of the traditional presentation of woman as confined in the world of shaded domesticity, akin to the caged bird with which she is often juxtaposed, and contrasted with the freedom of the limitless, sun-drenched outdoors. Like Rose, Frieseke also occasionally chose to portray the alternative matrix of isolation, woman alone in a boat. His *Lady with a Parasol* (plate 148) is really a companion picture to Rose's *On the River* (plate 141), both depicting Sadie Frieseke on the Epte.

Although most of Frieseke's Giverny canvases were painted in his house, his garden, or at the edge of the Epte, a number of his images portray specific elements of the Giverny landscape. These more traditional subjects sometimes involved less avant-garde strategies. Frieseke's *Misty Morn* (plate 149) features the pollarded willows along the Epte, painted with a very Tonalist palette. This is almost surely the picture singled out by a writer commenting on Frieseke's entries in the 1909 Salon. "One in particular is remembered with great pleasure. It shows the willow-bordered Epte enveloped in a soft haze, the pale grays and greens relieved only by the faint whiteness of a woman's figure."[50] His *Early Winter Landscape* (plate 150), a comparatively rare pure Giverny landscape, harks back to the panoramic vistas of the valley painted by Theodore Robinson and his contemporaries—even featuring the seasonal

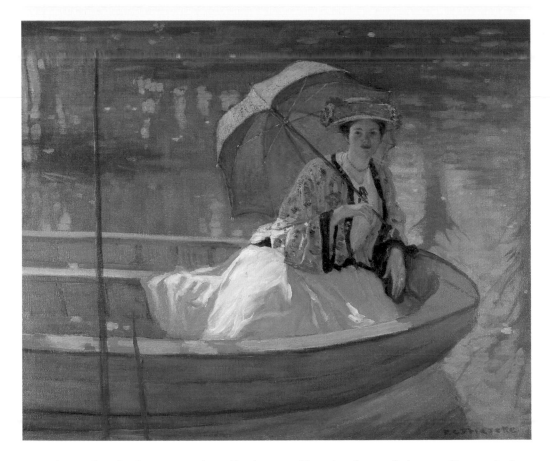

specificity that had interested Willard Metcalf and others of that earlier period, as well as Monet himself.

Frieseke lived in Giverny for a decade and a half, longer than any of his contemporaries there. In 1920 he bought a summer home in Le Mesnil-sur-Blangy in Normandy and left Giverny, though he remained an expatriate until his death twenty years later. Before leaving Giverny he had set the artistic course for numerous other painters there—and none more so than Lawton S. Parker. After moving back and forth between France and America, first as a student and then as a teacher, Parker settled in Giverny in 1903 and remained for a decade. He painted both academic formal portraits (plate 153) and, in Giverny, Impressionist outdoor figures. Emulating Frieseke in both subject and style, Parker eventually shared a walled garden with him, and like Frieseke he maintained two studios. Judging by his exhibition record, Parker did not produce many outdoor subjects

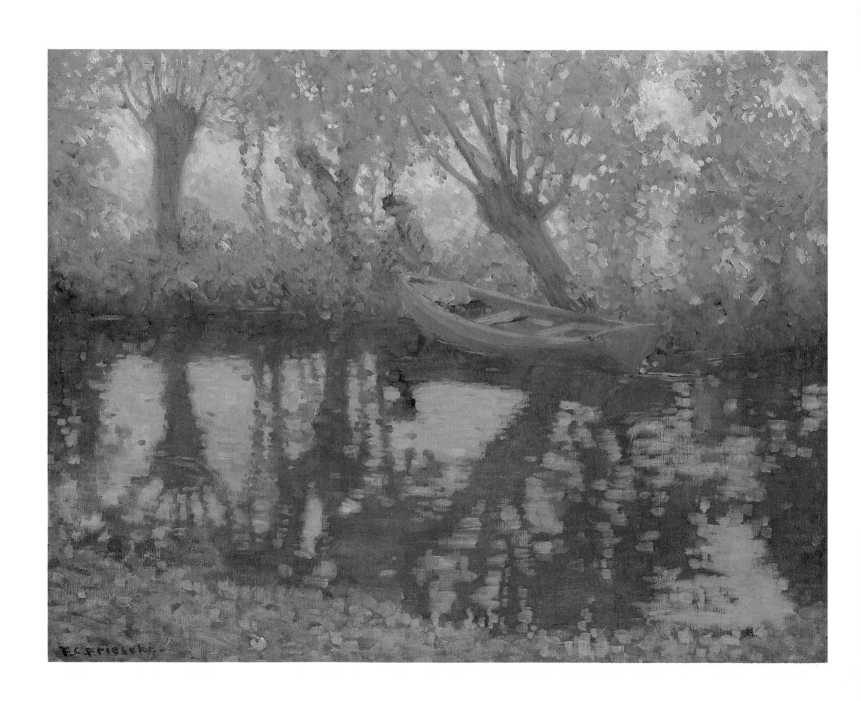

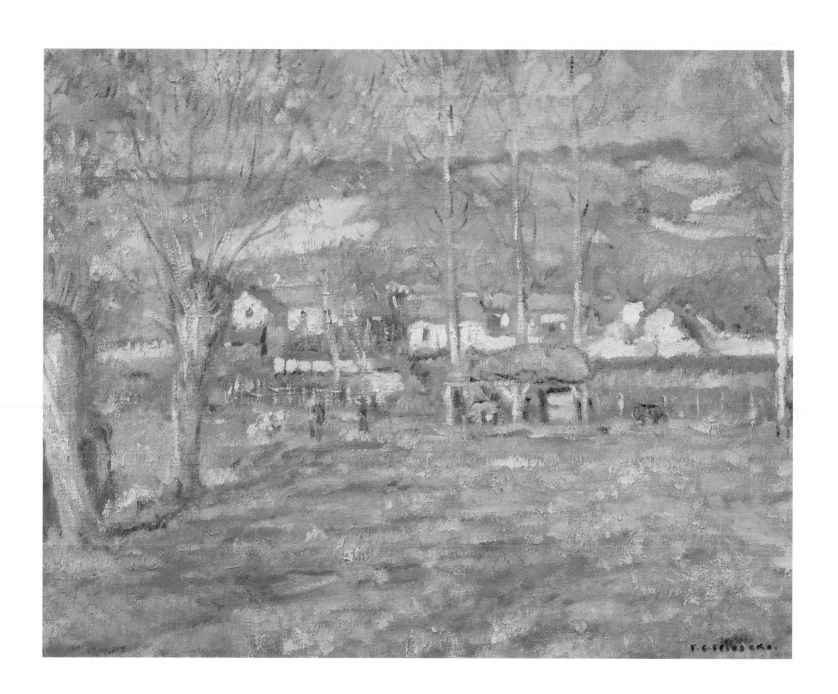

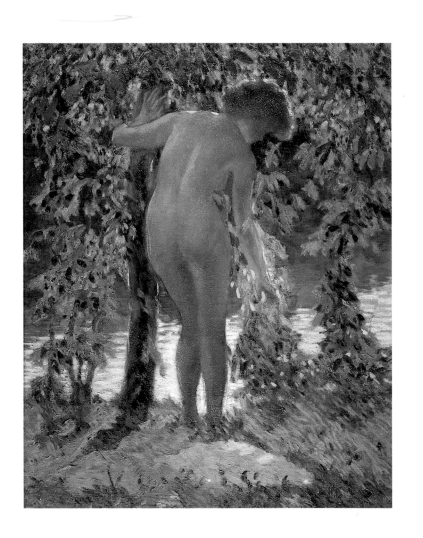 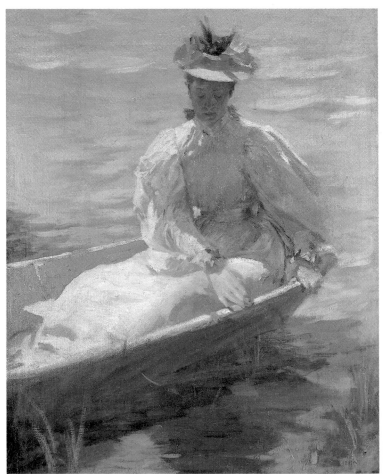

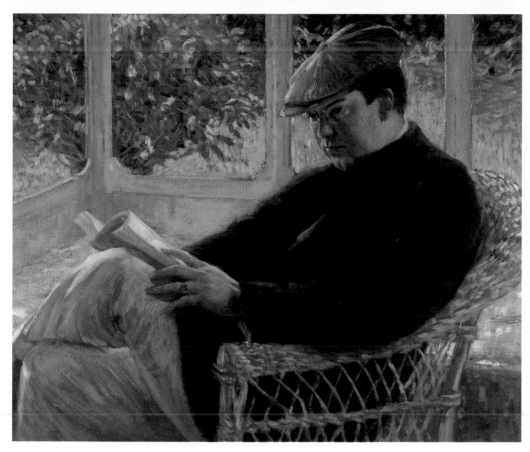

until about 1909; until then he showed, and presumably painted, predominantly portraits.[51]

Parker painted many nudes in sunlight in his Giverny water garden, including *Youth and Sunshine* (plate 151).[52] He also painted women at tea tables and numerous women in gardens, often with parasols; among his finest Giverny pictures are several adaptations of the woman-in-a-boat motif. In plate 152 the stress on colored patterns is not as insistent as in Parker's flower-garden settings, and his juxtaposition of soft pinks and pale blues displays a subtle color sense. A touching melancholy is projected by the isolated figure silhouetted against the seemingly endless watery expanse. In 1913 Parker became the first American to win a gold medal at the (old) Salon, for his *Paresse,* or *Idleness* (location unknown), painted in Giverny the year before. He had engaged a model from Paris but was forced by continuing rains to work indoors. The accidental pose assumed by the model while resting suggested the composition.

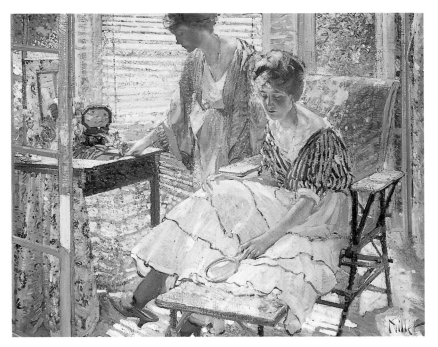

Parker taught extensively during his career, but there is no record of his having conducted classes in Giverny. It was his colleague Richard Miller who may have offered the most formal instruction in Giverny. About 1904 Miller turned to decorative compositions of young women in robes or kimonos at their dressing tables, having previously concentrated on figures of older women. Such compositions were painted, initially at least, in Paris; he may have turned to outdoor work when he started to summer in Giverny about 1906.[53] There Miller adopted many of the subjects for which Frieseke became renowned—women in sunlit interiors, garden scenes, and the nude. But although he and Frieseke were frequently paired in critical assessments and their work was often shown together, Miller almost always stressed drawing and structure more than his colleague. The models he chose were quite distinct from Frieseke's, more poignant and lovely, less in the Renoir mode. All of these qualities can be seen in *Sunlight* (plate 154).

Miller seems to have been less eager than Frieseke to portray his figures out of doors, often posing them instead on a sunlit porch or veranda. And even in his outdoor subjects, such as *The Pool* (plate 155), the parasol serves as a true sunshade, blocking the light, and Miller's firm draftsmanship in defining the figure remains paramount. The parasol even reinforces the sense of confinement established by the high wall surrounding the garden, with the young woman locked between the sunshade and the pool below. Miller's work, like that by his Giverny associates, was regarded as sensuously ornamental; he himself declared to a student, "Art's mission is not literary, the telling of a story, but decorative, the conveying of a pleasant optical sensation."[54]

Some of Miller's students in Giverny worked with him in Paris during the rest of the year and spent their summers painting outdoors under his tutelage in Giverny; one such student was Arthur B. Frost's son Jack.[55] Soon after the Frosts returned to Giverny for the summer in 1909, Arthur wrote to his friend Augustus Daggy: "The man Jack worked with last winter, Richard Miller, is here and I want

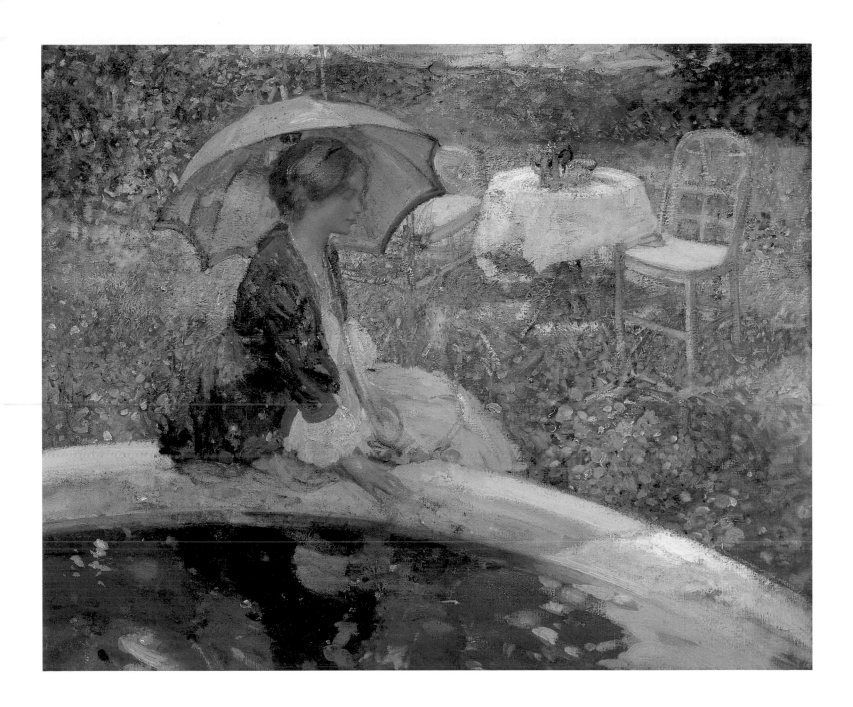

Jack to work with him down here. . . . I want him to work on the figure out of doors with Miller."[56] A month later Frost confirmed: "Jack is working away and doing excellent work. He is at work with Miller at *last*, painting the model out of doors."[57]

Leon A. Makielski studied with Miller for a month in the summer of 1911; another of Miller's students was Pauline Palmer, who joined the colony in the summer of 1910. Although Palmer's later figure paintings of women in domestic interiors strongly emulate Miller's imagery, her Giverny paintings are traditional agrarian landscapes. *The North Country, Giverny, France* (plate 156), with its farm and its grain stacks, harks back to Monet and Robinson, though the intense sunlight suggests the manner of the twentieth-century Givernyites. Miller also instructed the students who went to Giverny with their teacher, Mary Wheeler of Providence, Rhode Island. Wheeler, herself a painter, had started an art school in Providence in 1883 and began taking her classes to France in 1894. She conducted a summer school for two seasons in Lyme, Connecticut, but the lure of France was strong, and she reestablished her

156. Pauline Palmer (1867–1938). *The North Country, Giverny, France,* c. 1910. Oil on canvas, 22½ x 30 in. (57.2 x 76.2 cm). Private collection; Courtesy of Vose Galleries of Boston, Inc.

summer school in Giverny, probably beginning in 1906. Settling in a tiny house with a charming garden near Monet, she arranged for her young women to work under Miller's direction; Frieseke is also said to have been an instructor.[58]

Harriette Adams, Miller's future wife, was one of these students, and another was Mildred Giddings Burrage, from Portland, Maine, who was first in Giverny in June 1909, where she began by painting small landscapes.[59] Burrage also wrote one of the most important articles on the Giverny art colony, in which she described her own experience: "Fortunate, indeed, is the girl who goes to Giverny with Miss Wheeler, living in the quaint gray houses covered by trailing rose-vines, and painting through the far too short summer days, with the lovely garden for an outdoor studio."[60]

Miller did not remain associated with Giverny for nearly as long as Frieseke. In 1911 he moved his summer base of operations to Saint-Jean-du-Doigt in Brittany, conducting his school there. Many of his finest paintings, including some that have hitherto been attributed to his Giverny period, may actually have been painted in Brittany. Miller seldom dated his work, and since his style and subject matter seem not to have changed perceptibly from Giverny to Saint-Jean-du-Doigt—though he may have become more receptive to higher-keyed color and richer effects of sunlight—the parameters of his Giverny achievement remain undefined.[61] With the outbreak of World War I, Miller returned to America, and two years later he joined his Giverny colleague Guy Rose at the Stickney Memorial School of Art in Pasadena, where the precepts of the latest Giverny manner were transferred to Southern California.

The next artist to enter Frieseke's orbit in Giverny was Edmund W. Greacen, the one major figure of this generation who hailed not from the Midwest but from New York. In 1907, two years after he married Ethol Booth, a fellow art student, Greacen rented an old stone house across from the Giverny railroad station. During their two-year residence the Greacens became very much a part of the art colony; their daughter, Nan, was born in that house in March 1908.[62] The Greacens were especially close to Theodore and Marthe Butler but met Monet himself only once.

Unlike Frieseke and Miller, Greacen eschewed the nude and concentrated instead on outdoor domestic and garden scenes, such as *Tea Time, Giverny* (plate 158) and *Ethol with Roses* (plate 159); the latter composition, depicting his wife close up and enveloped by blooms, was a tribute to her that he repeated many times. Greacen's pictorial world was more intimate than those of his colleagues, characterized by more-muted tonalities and by softer brushwork that blended together figures, accessories, and background.

157. *Edmund W. Greacen and Teddy, Giverny.*

BELOW

158. Edmund W. Greacen
(1876–1949). *Tea Time, Giverny,*
1907–9. Oil on canvas, 24 x 28
in. (61 x 71.1 cm). Private collec-
tion, courtesy of Grand Central
Art Galleries, New York.

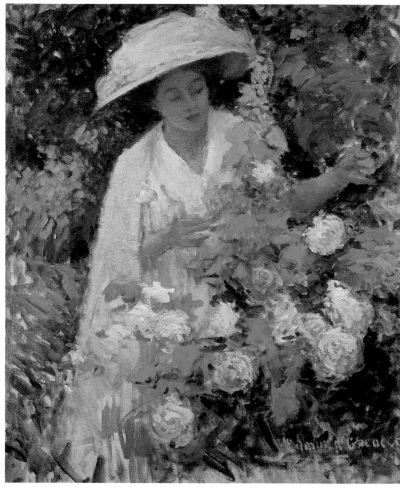

ABOVE, RIGHT

159. Edmund W. Greacen
(1876–1949). *Ethol with Roses,*
1907. Oil on canvas, 25¾ x 21 in.
(65.4 x 53.3 cm). John M.
Strange, Houston.

Greacen's palette became more lively and his paint application more vibrant in his many
landscapes of the region, including *River Epte* (plate 160). He chose traditional subjects
such as river views and stands of poplar trees, as well as more unusual panoramic views
of the town and of the cliffs above Vernonnet, painted from across the Epte.[63] Though
Greacen showed a view of Vernon at the National Academy as late as 1944, his Giverny
experience was comparatively brief, and soon after he returned to America in 1909 he
joined the Impressionist art colony in Old Lyme, Connecticut.

Karl Anderson, brother of the playwright Sherwood Anderson, was more a visitor
than a resident in Giverny, but his stay in the village in 1909–10 was significant to his
maturation. He was invited there by Frieseke, with whom he had been a student at the

LEFT

160. Edmund W. Greacen (1876–1949). *River Epte,* 1907. Oil on canvas, 26 x 32 in. (66 x 81.3 cm). Private collection; Courtesy of Spanierman Gallery, New York.

PAGE 190

161. Karl Anderson (1874–1956). *The Idlers, August,* 1910. Oil on canvas, 49¾ x 51⅛ in. (126.4 x 131.1 cm). Valparaiso University Museum of Art, Valparaiso, Indiana; Sloan Collection.

PAGE 191

162. Karl Anderson (1874–1956). *Portrait of Frieseke,* 1910. Oil on canvas, 36 x 29¾ in. (91.4 x 75.6 cm). Nicholas Kilmer.

Art Institute of Chicago, and like Frieseke he painted nudes in the sunshine. Anderson's *The Idlers, August* (plate 161) is similar to many of Frieseke's canvases—complete with blazing sunlight, garden setting, and parasol. Probably Anderson's most famous picture, it won him a silver medal at the Carnegie International in Pittsburgh in 1910. In his *Portrait of Frieseke* (plate 162), painted in that artist's walled garden, Anderson not only adopted Frieseke's manner but also paid tribute to his fascination with the nude and to their preference for painting outdoors.

Anderson met Hubbell, Greacen, and Frost in the village and became friendly with Frederick MacMonnies, in part, as he admitted, because they were the only ones who played tennis badly and thus became regular opponents at the courts each

G iverney [*sic*] is a quaint little peasant village an hour out of Paris. The houses are all on one road, with a great hill, very decoratively laid out in small fields, banking one side of the road, and the beautiful country of Eure, through which flows the Seine, on the other side.

[Karl Anderson], "Anderson's Impressions," *Bellman* 8 (March 5, 1910): 292.

evening.[64] Despite his deficiencies at the sport, Anderson memorialized the activity in a vivid sketch (plate 98), with the players casting long blue shadows on the white court, contrasting with the bright parasols of the women onlookers—"a charming glimpse of an afternoon holiday in Giverny."[65] Anderson later related an amusing experience that he and his wife had—or rather did *not* have—with Monet, who continued to distance himself from the thriving art colony:

> One Sunday morning, before the rest of the village was awake, Helen and I walked down the road which separated his garden from the famed lily pond and Japanese bridge. There is a stone wall guarding both sides coming to one's chin and a bit too high for Helen to see over. That she might view the newly bloomed masses of purple iris, I lifted her up to the level of the wall, and at the same time, on the inside, rose the monumental figure of the long-bearded Monet, seventy years of age. He had a somewhat condescending, amused expression on his full, red face. I had but a glimpse of him, but I saw that he wore the habitual suit of corduroys, very large at the hips and tight around the ankle, the coat short and of military cut. What left the deepest impression on us was his shirt; a brilliant purple, with frills in front like a woman's shirt-waist and frilled cuffs coming over the hands.
>
> We were told by one who knew him that with a stronger spirit on our part the circumstances might have appealed to Monet, and he would have invited us into his domain—but we hurried away like children stealing flowers.[66]

It was in 1910, while Anderson was still in Giverny, that the colony, now composed almost completely of American artists, enjoyed its greatest recognition back home, with New York critics taking note of the relatively homogeneous style of the latest generation of figure painters active in the village. A certain poetic justice applies here, for their venue was the Madison Gallery—which was founded in 1909 and managed by Henry Fitch Taylor, one of the original colonists of 1887. Early in 1910 Anderson and Greacen, who had just recently returned to America from Giverny, were given a two-artist show there, and that December works by Frieseke, Miller, Parker, and Rose were shown together; the critics identified the six painters as "the Giverny Group."

In the earlier exhibition, held in January, Anderson's *The Idlers, August* received the greatest attention, while the critics recognized the relative delicacy of Greacen's works. One writer concluded, "The pictures of both Mr. Anderson and Mr. Greacen are a sensuous delight to the eye, being full of the joy of abundant, sensitively felt and beautiful color, and painted broadly and skillfully."[67]

The December exhibition garnered even greater praise. The writer for the *New York Morning Telegraph* explained:

A group of Americans living abroad (who call themselves the Giverny Group) are having an exhibition. . . . These intensely modern young men are better known abroad than in their own country. They paint sunshine and shadows that are luminous, and they are not afraid to put a figure right out in the glaring light and paint it. . . . These men are impressionistic painters of the very best sort.[68]

Sunlight was the key to the critics' admiration; the writer for the *New York American* admired the "paintings of sunlight, of summer, of brilliancy and warmth. . . . They are impressionistic: they are of the new movement, the new movement whose search for light is ever mobile."[69] The artists were also praised for having avoided the extremes of modernity: "It is noticeable through this exhibition that in the experiments with color juxtaposition, efforts have been made in a sane and intelligent direction which is a relief in these days of new departures."[70] Most of the critics acknowledged the stylistic homogeneity of the four painters in the December show; surprisingly, it was Parker whose pictures were most often singled out for special attention, while Rose's work was acknowledged as "a little softer, a little mellower than the others, but lack[ing] somewhat in strength."[71] James Huneker perceived the greatest distinctions among the artists, recognizing Frieseke as a trailblazer—"the frankest sun worshiper we have encountered for many years. . . . unafraid of the scorching sunshine."

He has youth, audacity, talent, science and the shrill scarlet trumpets of high noon sound in the majority of his canvases. . . . Mr. Miller possesses a more harmonious temperament. He is less flamboyant, he feels the modulating edges of things. His interiors are cool and graceful, his women delicate and mysterious.[72]

One critic concluded, "In this country nothing much stronger has been done from the 'impressionist' standpoint."[73]

The 1910 exhibitions of the Giverny Group in New York did not signal the culmination of decorative figure painting in Giverny. Chicago continued to supply the colony with painters of superior ability, who joined Frieseke and his colleagues in depicting intimate domestic subjects, garden scenes, and the nude outdoors. German-born Karl Albert Buehr was listing himself as a Giverny resident by the time the Madison Gallery held its December 1910 exhibition; early in 1911 he was identified as "a comparatively new comer to Giverny, yet . . . already as devoted to the little village

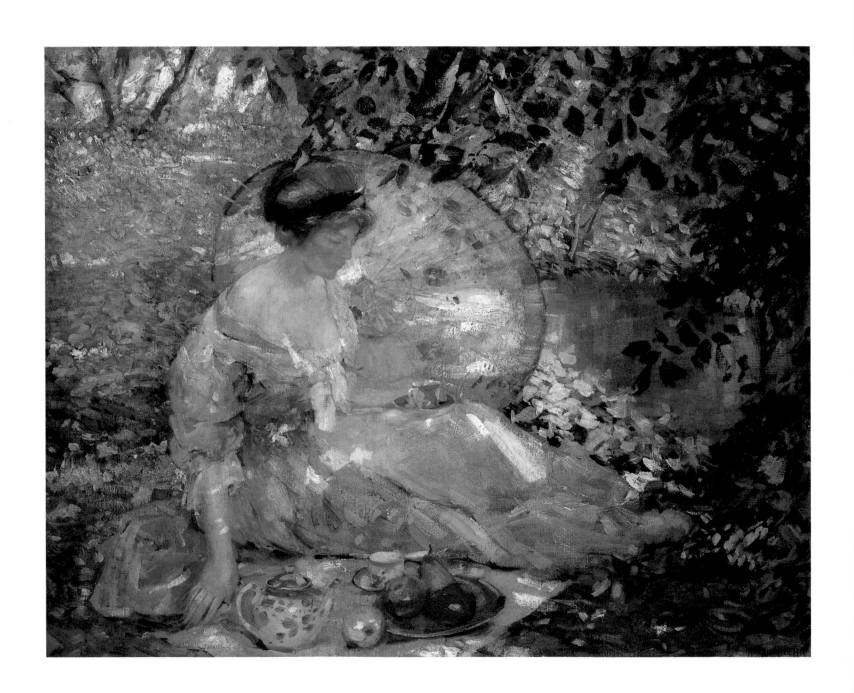

as its older inhabitants."[74] Starting in the spring of 1909, Buehr and his family inhabited an old peasant house with a garden of lilies for a year, then moved into a studio next door, rented from Lawton Parker until 1911. In 1912 they moved to Sainte-Geneviève, the town just beyond Giverny, and summered there again in 1913, returning to Paris each fall. The Buehrs became close to the Friesekes, the Millers, and the Butlers, and their children occasionally visited Le Pressoir to play with Monet's grandchildren—a privilege their parents envied. It was in Giverny that Buehr turned away from his previous landscapes—port scenes and peasant subjects painted in muted tonalities—and became an adherent of decorative Impressionism.

When Buehr's pictures were exhibited at the (old) Salon, critics found them similar to, even inspired by, Miller's paintings.[75] *Picnic on the Grass* (plate 163) is one of these. It depicts a girl seated on the grass with a picnic, next to a quiet pool, and shaded by branches through which the sun dapples patterns of light. The soft violets of the dress contrast with the brilliant orange of the parasol, while the dress is pulled back to reveal the young woman's soft flesh. The paint rests on the picture's surface, even more independent of

spatial illusion than in works by Buehr's Giverny colleagues. *The Flower Girl* (plate 164) is based on a similar or possibly the same model, who wears a green jacket that contrasts effectively with the brilliant red flowers surrounding her. Again the space is ambiguously defined, and the blue-and-purple environment of vibrant brushstrokes divorces the scene from the relative realism of comparable works by Frieseke and others.

Buehr sometimes used his wife as a model, but otherwise he hired young women in Paris who came down to the village to stay for a while. He reported that some artists competed for models, offering higher wages to lure them away. Buehr's model for these two pictures may have been Gaby, whom he was using in the spring of 1912.

OPPOSITE

163. Karl Albert Buehr (1866–1952). *Picnic on the Grass*, 1911–12. Oil on canvas, 31½ x 39 in. (80 x 99.1 cm). Private collection; Courtesy of Mongerson-Wunderlich Galleries, Chicago.

ABOVE

164. Karl Albert Buehr (1866–1952). *The Flower Girl*, 1912. Oil on canvas, 39½ x 32 in. (100.3 x 81.3 cm). Pfeil Collection.

She came from Paris and took her room and board at the house next door to the property he was renting. Gaby's husband insisted on accompanying her to the modeling sessions, and Buehr found it unnerving to have the husband constantly standing behind him, conversing with his wife while she posed. Propriety was an issue when the artists dealt with the villagers as well. When Buehr's wife (the talented miniature painter Mary Hess Buehr) was in America visiting her parents, the artist could not get respectable servants to come to the house despite the presence of the Buehr children.[76]

The last significant figure painter from Chicago to work within the aesthetic parameters of the Giverny Group was Ukrainian-born Louis Ritman, who grew up and studied in Chicago. Following Parker's advice, he moved to Paris, where he very likely met Frieseke and Miller; two years later, in 1911, he visited Giverny for the first time.[77] Ritman spent the next eighteen summers in Giverny and the winters in Paris, a schedule altered only briefly by World War I, during which he returned to Chicago for a short while in 1914–15.

Ritman only occasionally dated his pictures, and it is difficult to determine when he began to paint decorative Impressionist work, but the summer of 1913 was certainly a productive one for him. His repertory was like those of Frieseke, Miller, and the other Giverny figure painters, and Frieseke acted as Ritman's mentor. Ritman seems to have had access not only to Frieseke's garden and studio but also to the Frieseke house; several of his paintings, such as *The Yellow Room* and *The Blue Room* (location unknown), look as though they were painted in the Friesekes' unique environment.[78] On his first visits to the village Ritman stayed at the Baudy, but he eventually rented his own cottage, and it is possible that he painted his rooms in bright colors in emulation of Frieseke. Critics back in the United States recognized the connection: "[Ritman] paints in the same style and coloring as F. C. Frieseke, with whom he has worked in Frieseke's delightful old garden. . . . Ritman's aim, like that of his teacher, is to depict foliage in brilliant sunlight. Figures, flowers and garden furniture take their place as spots of color."[79]

A favorite motif of Ritman's was a boudoir interior with a figure silhouetted at the window, as in *Early Morning Sunshine* (plate 165), allowing for contrast between a shaded interior and a colorful, sun-drenched garden. Ritman also mastered the unclothed figure: his *Sun-Kissed Nude* (plate 166), posed by the Ru, is caressed by sunlight every bit as sensually as Frieseke's contemporaneous figures, and is equally inviting. In such pictures Ritman's brushwork is softer than that by his Giverny colleagues; it is even closer to Renoir's than the strokes of Frieseke, who may have communicated his

165. Louis Ritman (1889–1963). *Early Morning Sunshine,* 1912–14. Oil on canvas, 36 x 29¼ in. (91.4 x 74.3 cm). Private collection, Pennsylvania; Courtesy of Spanierman Gallery, New York.

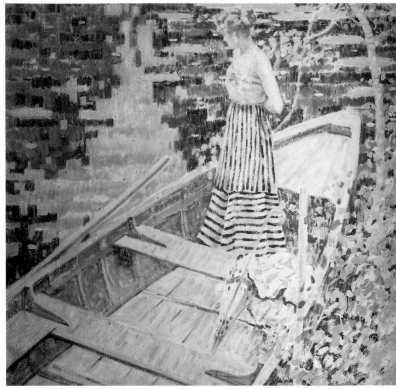

enthusiasm for the French master to Ritman. Ritman's color range, too, is the closest to Renoir's. At the same time, he maintained in these pictures a stronger academic stance in the modeling of figures with light and shadow, and in the rendering of accessories such as the tables in *Early Morning Sunshine* and *Dormitory Breakfast* (plates 165, 168).

There is, however, another and somewhat more advanced aesthetic at work in some of Ritman's interiors, figures, and depictions of boats on the Epte, such as *A Day in July* (plate 167). In these pictures space is tilted up sharply, emphasizing the two-dimensional surface of the picture plane. The paint is applied in large, often rectangular strokes, with alternating blocks of lighter and darker paint used to build up a geometric design that often contrasts with Frieseke-like patterns of garments and foliage. It is unlikely that this work reflects any impact of Cubism on decorative Impressionism, but it is probable that Ritman was trying to emulate Cézanne's way of structuring a picture—common currency by now among all artists working in France.[80] This more radical aesthetic does not appear to be a later variation developed by Ritman, for his *Rowing* (Spanierman Gallery, New York) of 1913 is painted in a similar manner and is a relatively early Giverny picture. Rather, he seems to have used the two modes concurrently, perhaps dictated by subject and mood.

L. RITMAN 1915

ABOVE

169. Alson Skinner Clark
(1876–1949). *Medora Clark and
the Friesekes in Giverny,* 1910.
Photograph. Alson Clark III.

OPPOSITE

170. Alson Skinner Clark
(1876–1949). *Summer, Giverny,*
1910. Oil on canvas, 25⅝ x 31⅞
in. (65.1 x 81 cm). Mr. and Mrs.
Thomas B. Stiles II.

Although only a visitor, the Chicago-trained landscape painter Alson Skinner Clark produced pictures painted in a style consonant with that of the Chicagoans resident in Giverny. After first traveling abroad to study late in 1898, Clark enrolled in Whistler's Académie Carmen, where he might have come into contact with MacMonnies, Hubbell, and Frieseke. Extremely peripatetic, Clark was back in France almost every year thereafter until World War I. Clark and his wife, Medora, made a day visit to Giverny on July 3, 1910, but not until the latter half of that August did Clark paint his best-known landscapes in Giverny—panoramic views from high on the hillside above the village. In format these works, such as *Summer, Giverny* (plate 170), are strikingly similar to Robinson's landscape compositions such as *A Bird's Eye View: Giverny* (plate 90) and *Val d'Aconville* (plate 99). But in place of Robinson's restrained brushwork and muted Impressionist palette is Clark's Pointillist confetti of multicolored dots and brushstrokes. Clark also painted several "Monet haystacks," and at one point he and Frieseke collaborated on a single painting, each doing half.[81]

Clark and his wife stayed with Parker in Giverny, and she posed for a number of Parker's paintings. The couple also socialized with the Friesekes, the Millers, the Roses, and the Butlers; like several of his colleagues, Alson was an avid tennis player. The Clarks were back in Paris by the end of August, and although they returned to Giverny late in October, their stay was again relatively brief, in part because of weather too unpleasant for outdoor painting and in part because Clark was put off by the backbiting competition he found rampant in the community. He was disturbed, too, by the similarity of the work being executed there by the various artists.[82]

A short-lived rival colony of American landscape painters emerged in Vernon, the larger town across the Seine from Giverny. They may have preferred Vernon for its amenities as well as for its freshness as a town that had not been turned into an artists' haunt; they may also have been repelled by the reports of the gossiping and rivalry in Giverny. Certainly no real "Vernon school" or "Vernon manner" evolved during the several years of activity there. The painters were united simply by friendship and by the desire to record, in a generally Impressionist manner, the local landscape and such distinctive structures as the town's imposing church and its stone bridge over the Seine.

The best description of the activities in Vernon was written by the Cleveland painter Abel G. Warshawsky, who went to Europe in 1908. At the end of July 1909 Warshawsky and his fellow student Samuel Halpert took the train to Saint-Germain-

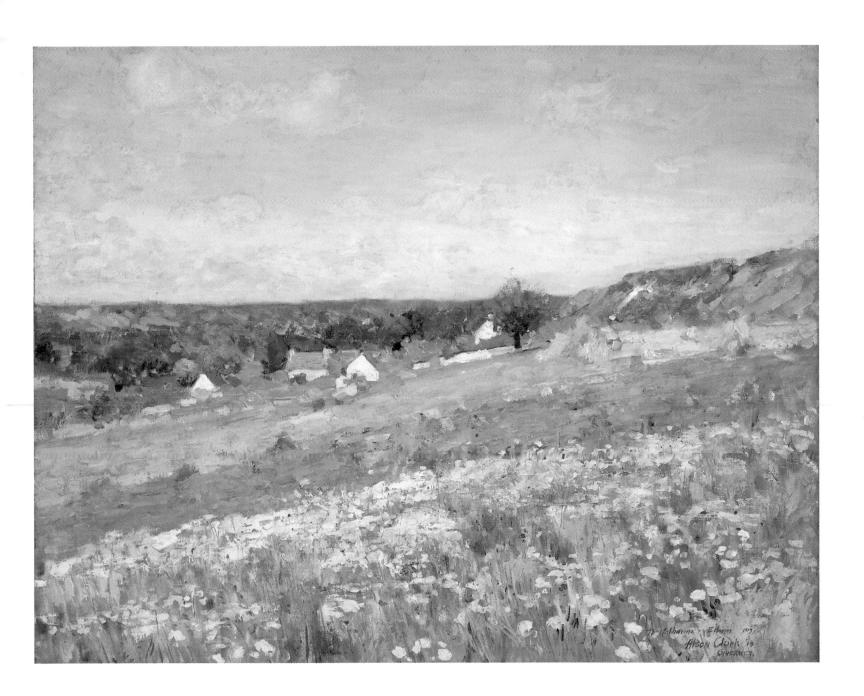

Charming and picturesque as Giverny was, we did not hesitate in our preference for Vernon. . . . Vernon had a spacious and unspoiled air, with its wide river, lovely old moss-covered bridge on graceful arches, distant hills with white chalk cliffs showing through at happy intervals, its quaint streets with remnants of Norman and Gothic architecture, its fine old fourteenth-century cathedral, and its lovely paintable gardens. . . .

At Giverny the majority of the American artists worked from the model, and I dare say they found the enclosed gardens and tiny river more conducive for figure work outdoors. Richard Miller had a summer class there, and Frederick Frieseke was painting some of his most delightful little nudes in his garden, through which the little Epte stream flowed. Sometimes he would do his figures standing in the shallows, or again it would be a gaily dressed girl in a boat, sheltered from the sun under a Japanese umbrella.

Abel G. Warshawsky, *The Memories of an American Impressionist*, edited and with an introduction by Ben L. Bassham (Kent, Ohio: Kent State University Press, 1980), p. 97.

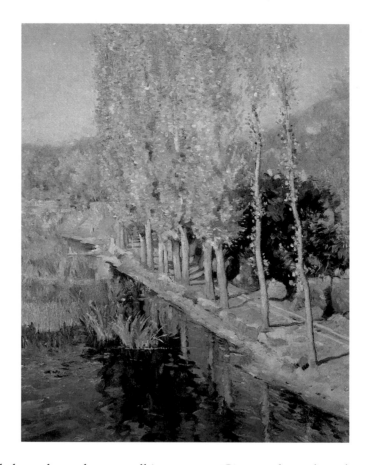

en-Laye and then planned on a walking tour to Giverny; but when they caught sight of Vernon, with its old bridge and quaint buildings, they decided it was an ideal spot for painters. They took rooms at the Hôtel du Soleil d'Or, and when they discovered that pension rates made a two-month stay there affordable, they decided to remain.

The next day they explored Giverny, but by then the village had become very expensive, and it also seemed cramped and overcultivated compared to the spacious, unspoiled charm of Vernon. Still another element in their decision to remain in Vernon was the fact that the Giverny colonists worked primarily from the model, whereas these new visitors were concerned with landscape.[83] Although Warshawsky and Halpert were admirers of Frieseke and Miller, after returning to Paris to stock up on painting material, they went back to stay in Vernon.

On occasional visits to Giverny in 1909, Warshawsky and Halpert became particularly friendly with the two Frost sons, and Arthur, Jr., frequently stayed with them at

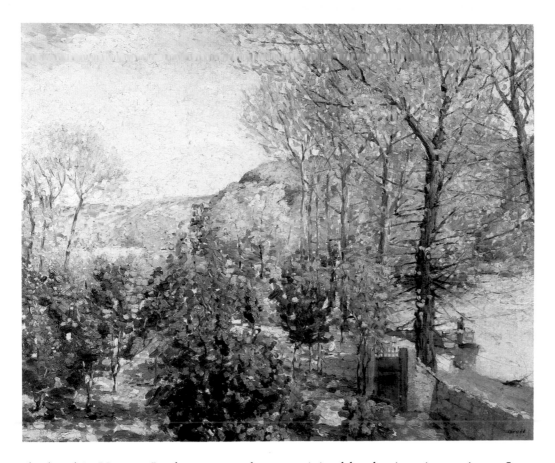

the hotel in Vernon. In the autumn they were joined by the American painters Leon Kroll and Ivan Olinsky.[84] After working outdoors, all of them would meet for sumptuous and festive meals at the hotel, followed by coffee at the Café des Trois Marchands. At the beginning of November the weather grew chilly; Olinsky and Kroll returned to Paris, but Halpert and Warshawsky stayed on. The latter was fascinated by the leaves remaining on the trees, with their tints of old rose, russet, and gold, which he recorded in such works as *Poplars near Vernon, Fall* (plate 171). Only when the autumn rains set in and the river became turbulent did Warshawsky return to Paris to share a studio with Arthur Frost, Jr.[85]

Warshawsky and Halpert were back in Vernon in the spring of 1910, staying at the same hotel and continuing to paint the surrounding landscape. Olinsky visited again for a few weeks, but more for a rest than to paint, since he was primarily a figure specialist. It was probably Halpert who encouraged the Chicago painter Jerome Blum

to visit Vernon, in either 1909 or 1910. Blum, one of the leaders of modernism in Chicago, subsequently exhibited a number of Vernon landscapes back home, including *Bridge at Vernon,* which was shown in 1912 at the Art Institute's Annual Exhibition of Works by Artists of Chicago and Vicinity.[86]

Perhaps the most lovely landscapes painted by the artists staying in Vernon were those by Leon Kroll. He ultimately became renowned for his monumental figure compositions of the 1920s and 1930s, but while in France from 1908 to 1910 he painted landscapes.[87] In 1910 Kroll executed a series of sparkling, sun-filled Impressionist scenes such as *Vernon, France* (plate 172), quite distinct from the paintings by the colonists across the Seine, though he also visited and worked in Giverny. Kroll later related an incident that occurred during his stay in Vernon: "One time I was painting a picture, still in my Impressionist manner, and a big limousine drove up nearby. Monet stepped out of it. He lived right near there. He watched me paint for a while, smiled, and got back into his car. I knew it was Monet—he had a big beard. He didn't say a word."[88]

With the exception of Monet and his stepdaughter Blanche Hoschedé-Monet, the Giverny art colony was, for the most part, made up of foreign artists. Monet occasionally entertained French colleagues, but visits such as the one Cézanne made to the Hôtel Baudy in November 1894 were exceptional. Other French artists of note stopped there briefly—Gustave Loiseau registered on March 2, 1899—but these were few. Their rarity made even more notable the move by Pierre Bonnard, one of the leading Post-Impressionist French painters, to Vernonnet, the small community across the bridge from Vernon and just downriver from Giverny.

Bonnard purchased a small house there, Ma Roulotte (My Caravan), in 1912, and from then on he divided his time between the Seine Valley and the south. He established a friendship with Monet, who was often driven in his automobile up the road to Ma Roulotte, and Bonnard was a frequent luncheon guest at Le Pressoir. In December 1926, Bonnard served as one of Monet's pallbearers.

In the domestic scenes that Bonnard painted at Ma Roulette, whether interiors such as *Dining Room in the Country* (plate 173) or garden pictures such as *The Nap in the Garden* (c. 1914; National Gallery, Oslo), he introduced a high-keyed and variegated colorism. Along with brightening his palette, Bonnard paid increased attention to landscape elements: flat planes of bright color on walls, doors, and furniture contrast with patterns of broken brushwork that define the flowers and trees of the garden. Such works have strong parallels to Frieseke's painting of the time, not only in

173. Pierre Bonnard (1867–1947). *Dining Room in the Country,* 1913. Oil on linen, 64¾ x 81 in. (164.5 x 205.7 cm). The Minneapolis Institute of Arts.

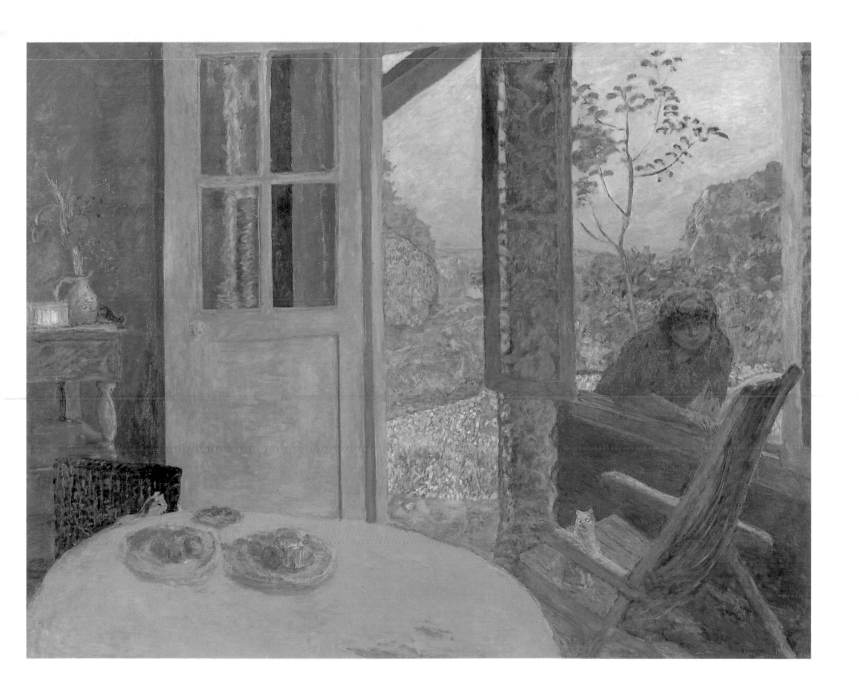

their derivation from Impressionist precepts but also in their departure from them: their emphatic geometry, their arbitrary spatial flattening, and their artificial chromatic brilliance. However, no documentation has yet been found that the two artists had any contact with each other. Frieseke had established his mature manner before Bonnard arrived in Vernonnet, and it seems unlikely that the latter was influenced by his American near-neighbor.

Bonnard's newly established residence aside, the art colony in and around Giverny was diminishing in the early 1900s. Mary MacMonnies left on December 1, 1908, after the breakup of her marriage with Frederick, and Lilla Cabot Perry never returned to the village after 1909. That year Edmund W. Greacen, too, returned to the United States, followed by Karl Anderson and Henry Salem Hubbell in 1910—the only year that Alson Clark was in Giverny and the final year of American activity in nearby Vernon; that year seems also to have been Arthur B. Frost's last in Giverny. Richard Miller left for Brittany in 1911; Guy Rose went back to America in 1912. James Wall Finn died in 1913, the same year that both Theodore Butler and Karl Buehr returned to America. Germany declared war on France early in August 1914, and Ritman left Giverny the next month, though he would be back in Giverny the next several summers. The movements of the peripatetic Lawton S. Parker are more difficult to trace, since he moved back and forth between Chicago and Giverny, but he was back in Chicago in the fall of 1914, if not before; Ritman had a show of his pictures in Parker's studio there that December. Parker's appointment to Chicago's Municipal Art Commission in 1915 suggests that he may not have continued his summers in Giverny thereafter.

Among the major art colonists, only MacMonnies and Frieseke remained in Giverny by the autumn of 1914, and MacMonnies returned to America the following year.[89] During World War I the German army drew so close that cannon fire was heard in the village, and wounded soldiers were hospitalized there. Having buried their silver to keep it safe, Frieseke and his wife were determined to stay unless the army itself retreated through the village, and he continued to paint while she maintained the garden.[90]

Although Giverny ultimately escaped damage, few foreign artists were able to travel to France during the conflict, and fewer still made their way to the village. Probably the most talented artist to visit during the war was the American George Biddle, who spent two summers there in 1915–16, getting to know Frieseke and Ritman. He

painted a series of ravishing figural works there, one of the most striking of which is *Back of a Nude with Parasol* (plate 174). Biddle's later fame, based on his Social Realist casel paintings and murals, scarcely prepares us for the beauty of his Giverny pictures. The subject recalls Frieseke, whom Biddle acknowledged as his mentor in Giverny and as the first to teach him "the difference between the sincere, individual and the Academic-Yale-Art-School approach to drawing."[91]

The clarity of Biddle's forms and the subtle precision of his line also suggest the influence of Degas, transmitted through their mutual friend Mary Cassatt, whom Biddle had first met in 1912. Biddle acknowledged that Cassatt had influenced his work "more than any other artist whom I had known. . . . From the very beginning I had been directly and consciously influenced by Degas; and quite naturally, then, by Mary Cassatt, who not only reflected through her own sharp and colorful personality the fine tradition of his masterful drawing and free, bold design, but who also for me became the living word and the authorized commentator on the master's work."[92]

Concerning *Back of a Nude with Parasol*, Biddle remarked to Frieseke, "This nude of mine with the black stockings looks nearly as good as a Degas." Frieseke replied: "No it does not. It looks—almost—like a Biddle."[93] The Degas parallel is sound, however, not only in formal terms but also in the sense of reality projected by this work. Biddle's *Nude* maintained more traditional decorum than is found in many of Frieseke's nudes, but the awkward naturalness of the pose, the scrunched buttocks, and the contrast of bare flesh with black stockings all suggest a realism distinct from the sparkling artifice of the Giverny Group's paintings.

Not only did the last generation of art colonists in Giverny produce images quite distinct in subject and style from their predecessors', but those images also elicited a different critical reception. When Theodore Robinson exhibited his Monet-inspired Impressionist paintings at New York's Society of American Artists in 1889, and John Leslie Breck did the same at the St. Botolph Club in Boston in 1890, they were misunderstood pioneers who had difficulty selling their works. Twenty years later Frederick Frieseke and Richard Miller were honored with special shows of their work at the Venice Biennale in 1909, and they were the subjects of articles published in Italian journals as well as American ones.[94] When Butler was painting his murals for the Turin world's fair in 1912, he also arranged for a display in the reception room of the United States pavilion there of paintings from the Giverny colony—work by himself, Frieseke, Rose, and others.[95]

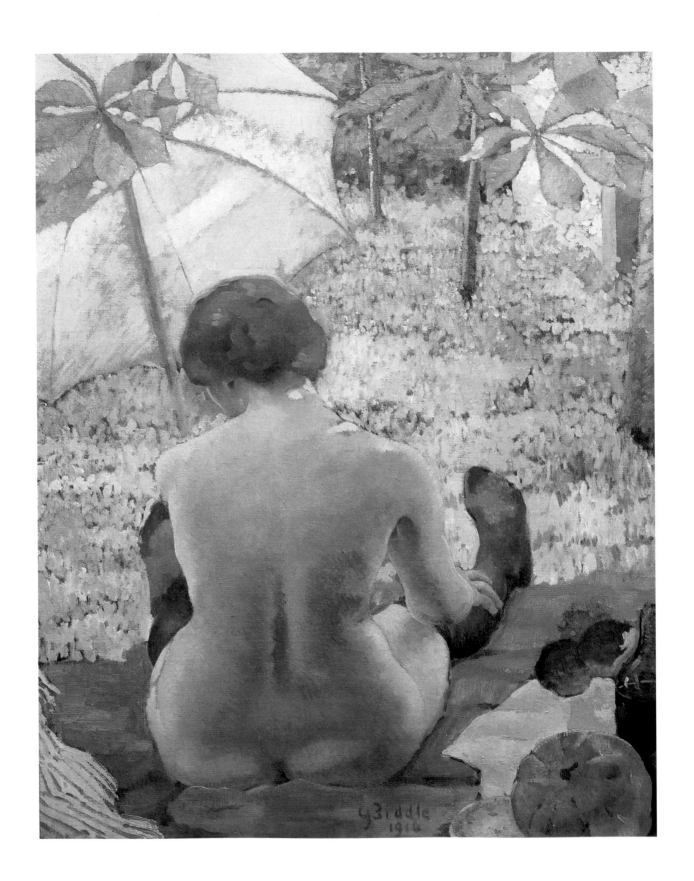

Though Frieseke and his colleagues won international plaudits, their market was primarily American. The previous year the Giverny "Luminists" had been lauded by critics when they exhibited together in New York, while the Chicago Art Institute honored its adopted sons with one-artist and group exhibitions. Critics and patrons eagerly awaited Frieseke's latest triumphs at his exhibitions held at New York's Macbeth Gallery from 1912, and he remained one of the most successful American painters of his generation, even after the innovations of Ashcan School realism and the ground-breaking presentation of European modernism at the Armory Show of 1913 in New York.

The success of the late Giverny works by Frieseke and his colleagues was due not to their stylistic innovations but rather to their combination of reassuring images of lovely, passive women with a sensuality of color and paint handling. These pictures were concerned with woman in her "rightful" place—sheltered, even locked into pleasant interiors and walled gardens, protected by the ubiquitous parasol, or isolated (and thus inviolable) on a small boat. An article of beauty, the object of a gaze, such women became objects to be possessed. The painting became a simulacrum of woman—as in contemporaneous work being done in Boston and New York by artists such as Edmund Tarbell, Frank Benson, Robert Reid, and Thomas Wilmer Dewing. The achievement of the Giverny artists was to present such imagery using the color and sunlight of modern Impressionism.[96]

174. George Biddle (1885–1973). *Back of a Nude with Parasol,* 1916. Oil on canvas, 32 x 25 in. (81.3 x 63.5 cm). D. Wigmore Fine Art, Inc., New York.

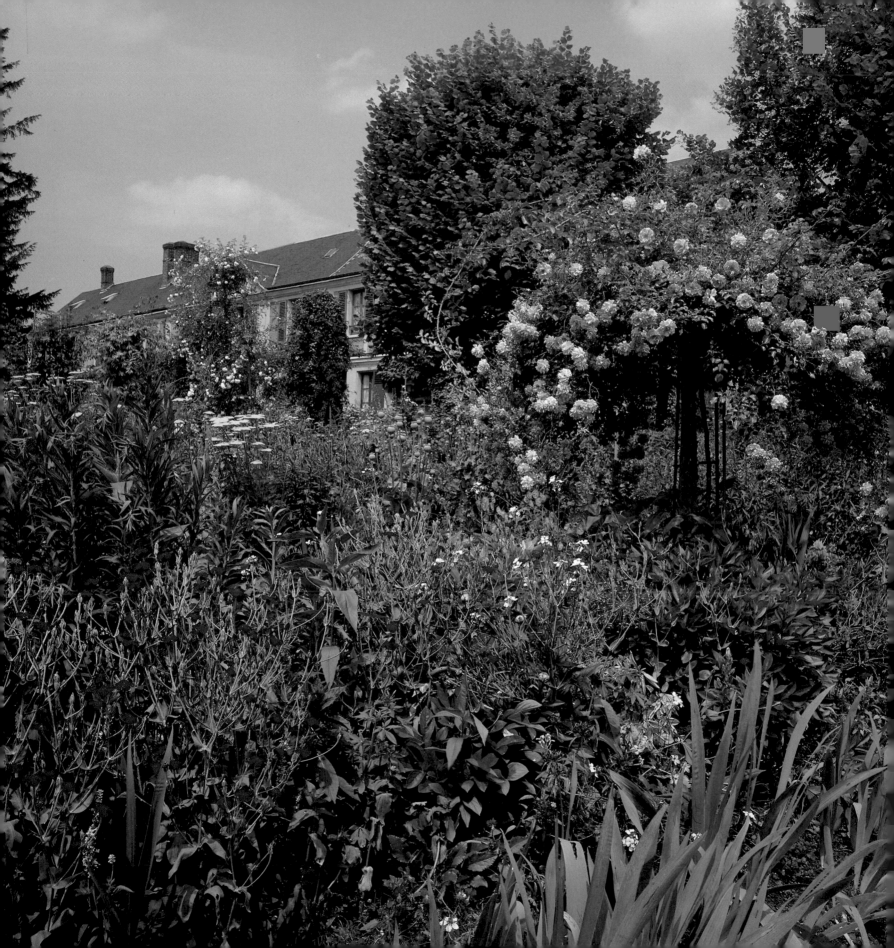

Postlude

With the resumption of tourism after World War I, Giverny enjoyed a new influx of visitors. Frieseke's departure from the village in 1920 essentially marked the end of the art colony, though artists continued to make the pilgrimage to the esteemed village. Indeed, that very year, Isadore Levy, from Scranton, Pennsylvania, joined his fellow Americans Clarence Johnson and Abraham Rattner at the Ferme de la Dîme; Levy stayed in Giverny for a year. Monet resided there until his death in 1926, cared for by Blanche Hoschedé-Monet. In 1921 Theodore Butler returned from America to live the rest of his life in Giverny, and his son James, also a painter, returned for a time to Giverny. Gaston Baudy, who had run the hotel with his mother after his father died in 1896, passed away in 1920, and the hotel was sold; Angélina Baudy died in 1942.[1] The Hôtel Baudy never regained the celebrity it had known in the previous decades, and it finally closed in 1960.

In the 1920s Giverny reemerged as a hub for a new avant-garde, attracting French and American Dadaists and Dada admirers: Louis Aragon, Tristan Tzara, and André Breton, along with Matthew Josephson and Harold Loeb, the publisher and editor, respectively, of the little magazine *Broom*. Some of them resided at the Ferme de la Dîme; Malcolm Cowley settled over the blacksmith's shop during the winter of 1922.[2] These newcomers were aware of the village's earlier culture, and Cowley came to know

175. *Monet's House, Giverny.*
Photograph by Allen Rokach.

That summer, 1926 . . . I revisited Vernon . . . hardly anything had changed. . . . But, alas, it was no longer possible to work by the roadside as in former times on account of the steady flow of motor traffic, which sent clouds of dust and sprinkled gravel over the easel. . . . Giverny . . . had undergone considerable changes. It had been rediscovered by a new group of Americans, very different from the old crowd, who had gone there to work. To cater to these new pleasure-seekers, and their weekend parties, several swagger hotels had been erected.

Abel G. Warshawsky, *The Memories of an American Impressionist*, edited and with an introduction by Ben L. Bassham (Kent, Ohio: Kent State University Press, 1980), p. 224.

the Butlers, developing a particular friendship with James.[3] But this was a very different world from the one discovered thirty-five years earlier by Theodore Robinson and his colleagues.

Foreign painters continued to visit and paint in Giverny, and the town has continued to attract artists to the present day. The activity sponsored there in recent years through the artist-in-residency grants offered by Reader's Digest Foundation merits its own study, as does the contemporary work being created in the village and in Monet's gardens by other painters from all over the world. The Monet house and gardens were restored in the early 1980s—an undertaking financed largely by American contribu-

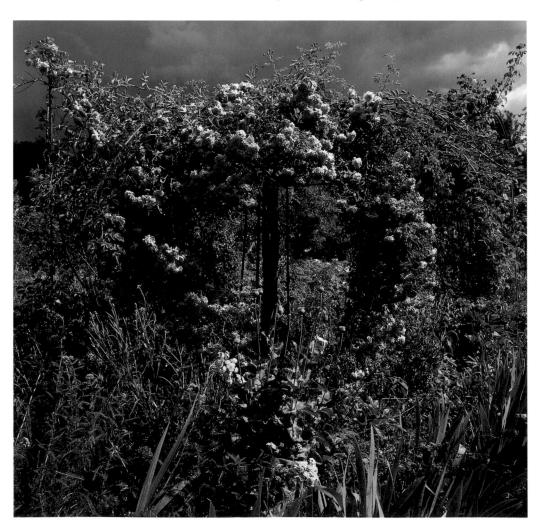

176. *Roses, Giverny*. Photograph by Allen Rokach.

tions—and the number of visitors to the town in the last decades must now be well into the millions, a quantity that will be increased by visitors to the recently opened Musée Américain Giverny, just down the road from Monet's house. The heritage of that "little band of artists who first went thither in 1887" is still alive and far from being embalmed as history.

Is Giverny itself so very special? Not everyone has thought so. On the one hand, J. Carroll Beckwith found much to praise during his relatively short one-month visit in late summer of 1891: "This place is certainly excellent for a painter in summer. It is a most picturesque region—accommodating people and cheap with good air—I am more than delighted with it and wish my time were longer."[4] And Mildred Giddings Burrage noted in 1911:

> The country is charming; quite one's ideal of what French country should be in fact. On the left, the hills rise up steep and high; on the right, the meadows stretch out to the Seine. Beyond the river the distant hills lie blue and purple in the summer air. The wheat fields beside the road are full of vivid scarlet poppies, with here and there a dash of blue cornflowers. Everywhere there is a stillness, a calm, a perfect peace. . . . Giverny itself is a little village lying in this happy valley.[5]

On the other hand, that ardent midwestern nationalist Hamlin Garland visited Frederick MacMonnies in Giverny about 1906 and came to an estimation very different from the praise generally lavished on the region in paint, prose, and poetry.

> When I walked out into the meadows, down past the pollarded willows, I discovered (what I might have inferred) that Monet had glorified a sadly commonplace little valley. He and his gifted associates had haloed every object, lifting it to a higher quality than it actually possessed. They aureoled every haystack. It was not as beautiful as the Wisconsin Valley in which I was born, but it had been loved and studied by men of genius for centuries.

> While in Giverny, Garland met with his old friend Thomas Sergeant Perry, who took him to see Monet's home. Garland found it "an uninspiring spot. His dwelling was ordinary and his garden formal without being tasteful. The more I studied this village, the more I marveled at the transforming power of art. Precisely as James Whitcomb Riley had translated his flat Indiana farmlands into poetry, so these . . . painters had transformed their commonplace Giverny into a wonderland of art."[6]

And so they had.

It is possible to live in a spot where you are not always conscious that there is such a thing as atmosphere (and I am not speaking now of artistic atmosphere), where the enveloping ether is a necessity of life but not an ever-present aesthetic joy. But in Giverny there was no possibility of forgetting it. It was a Presence. It was almost The Presence.

J.I.H.D. [John Ireland Howe Downes], *Mariquita Gill* ([New Haven, Conn.?]: Tuttle, Morehouse and Taylor, [1915?]), p. 20.

177. *Fields near Giverny.*
Photograph by Diane Burko.

ARTISTS' BIOGRAPHIES

CAROL LOWREY

Karl Anderson
Born 1874, Morning Sun, Ohio
Died 1956, Westport, Connecticut

Figure, portrait, and still-life painter, illustrator. Brother of novelist-playwright Sherwood Anderson. Studied at Art Institute of Chicago, 1893–97. Met Frederick Frieseke. Worked as an illustrator for women's magazines. Studied in Paris at Académie Julian, at Académie Colarossi, and privately with Alphonse Mucha, 1900–1901. Worked under George Hitchcock in Egmond, the Netherlands, summer 1901. Visited France—including Giverny—Spain, and Italy, 1909–10. Settled permanently in Westport, Connecticut, 1912. Exhibited regularly in New York, Chicago, and elsewhere in the U.S. Belonged to many art societies, including National Academy of Design and National Arts Club. Taught at Grand Central School of Art, New York.

J. Carroll Beckwith
Born 1852, Hannibal, Missouri
Died 1917, New York, New York

Portrait, figure, and mural painter. Studied with Walter Shirlaw in Chicago, 1868, and at National Academy of Design, New York, 1871–73. Studied in Paris at Ecole des Beaux-Arts and privately with Carolus-Duran and Léon Bonnat, 1873–78. Settled in New York, 1878, and became an influential figure on the local art scene. Taught at Art Students League, 1878–82, 1886–97. Visited Giverny, August 8–September 7, 1891. Designed murals for World's Columbian Exposition, Chicago, 1893. Spent summers in Onteora, New York. Active in Italy, 1910–14. Exhibited widely, including Paris Salons, Society of American Artists, and National Academy of Design.

George Biddle
Born 1885, Philadelphia, Pennsylvania
Died 1973, Croton-on-Hudson, New York

Painter, sculptor, lithographer, and muralist. Studied at Pennsylvania Academy of the Fine Arts, Philadelphia, 1908; at Académie Julian, Paris, 1911; and in Munich, 1911–14. Spent summers of 1915 and 1916 in Giverny. Fought in France during World War I, 1917–18. Active in Tahiti, France, and Italy, 1920s. Returned permanently to the U.S. in 1932. Became involved with social causes and the promotion of mural painting; later turned to satirical genre subjects. Taught at Columbia University and at the University of California, Berkeley. Artist-in-residence at the American Academy in Rome. Wrote autobiography, *An American Artist's Story* (1939), and numerous books and articles.

Pierre Bonnard
Born 1867, Fontenay-aux-Roses, France
Died 1947, Le Cannet, France

Painter, illustrator, and graphic artist. Studied at Académie Julian and at Ecole des Beaux-Arts, Paris, late 1880s. Met Paul Sérusier, Maurice Denis, and other future members of the Nabis. Established a close friendship with Edouard Vuillard. Specialized in domestic genre scenes, which were described as "Intimiste." Also painted nudes and ornamental screens. Made several lithographic posters for *La Revue blanche,* 1891–94. Participated in Nabi exhibitions. Also exhibited at Salon des Indépendants and Salon d'Automne. Moved to Vernonnet, 1912; spent World War I in Saint-Germain-en-Laye. Traveled extensively between 1912 and 1920. Made frequent visits to the south of France. Settled in Le Cannet, 1944.

John Leslie Breck
Born 1860, at sea, near Guam
Died 1899, Boston, Massachusetts

Landscape, garden, and figure painter. Son of a merchant-marine captain. Raised in Newtown, Massachusetts. Studied at the Royal Academy, Munich, 1879–81, and in Antwerp, under C. Verlat, 1882. Painted landscapes in Massachusetts, 1883–86. Studied at Académie Julian, Paris, 1886–87. Made first visit to Giverny, summer 1887, and subsequent visits until 1891. Became friendly with Claude Monet and was influenced by his work. Exhibited Impressionist canvases at St. Botolph Club, Boston, 1890. Returned to U.S. in 1892 and thereafter divided time between Boston and Auburn, Massachusetts. Active in California, 1890; England, 1892; and Venice, 1896.

William Blair Bruce
Born 1859, Hamilton, Canada
Died 1906, Stockholm, Sweden

Landscape, figure, and marine painter. Studied law and worked as an architectural draftsman before turning to art. Studied at Hamilton Mechanics Institute, 1877, and at Académie Julian, Paris, 1881. Active in Paris and Barbizon, 1881–85. Returned to Hamilton, late 1885, following loss of two hundred paintings in a shipwreck and a nervous breakdown. Returned to Paris, January 1887. Active in Giverny, summer 1887 and winter 1888. Married Caroline Benedicks, a Swedish sculptor, 1888, and thereafter spent majority of time in Paris and Grèz-sur-Loing, with intermittent visits to Hamilton, Stockholm, Italy, Lapland, and Corsica. Exhibited in Paris Salons and in London, Toronto, Munich, and Stockholm. Settled permanently in Visby, Gotland Island, Sweden, 1899.

Karl Albert Buehr

Born 1866, Feverbach, Germany
Died 1952, Chicago, Illinois

Landscape and figure painter. Studied at Art Institute of Chicago, 1888–93, and with Frank Duveneck, 1899. Also studied at Académie Julian, Paris, 1902, and at the London Art School, 1903–7(?). Active in Giverny, 1909–11, and in Sainte-Geneviève, 1912–13. Painted female figures in outdoor settings. Work influenced by Impressionism and Post-Impressionism. Returned to U.S. in 1913 and settled in Chicago. Taught for many years at the Art Institute. Spent summers in Wyoming, New York. Exhibited widely throughout the U.S. and won many medals.

Theodore Earl Butler

Born 1861, Columbus, Ohio
Died 1936, Giverny, France

Landscape and genre painter, muralist. Studied at Art Students League, New York, 1883–85, and in Paris, at Académie Julian, Académie Colarossi, Académie de la Grande Chaumière, and with Carolus-Duran, 1887. Active in Giverny, 1888, 1890, 1891. Married Suzanne Hoschedé, Monet's stepdaughter, 1892, and settled in Giverny. Friendly with Philip Leslie Hale and William Howard Hart. Work influenced by Impressionism and, later, Post-Impressionism. Had first solo exhibition

178. William Howard Hart (1863–1934?). *Theodore Butler*, c. 1897. Oil on canvas, 22 x 18 in. (55.9 x 45.7 cm). Private collection.

at Galerie Vollard, Paris, 1897; exhibited regularly in Paris thereafter. Married Marthe Hoschedé, 1900, following Suzanne's death in 1899. Lived in New York, 1913–21. Executed mural commissions for Cornelius Vanderbilt III and others. Founding member, Society of Independent Artists, 1917. Returned to Giverny permanently in 1921.

Paul Cézanne

Born 1839, Aix-en-Provence, France
Died 1906, Aix-en-Provence, France

Landscape, portrait, figure, and still-life painter. Studied at Académie de Dessin, Aix, 1859–61, and at Académie Suisse, Paris. Met Camille Pissarro, Claude Monet, and Alfred Sisley. Early work inspired by Gustave Courbet and Edouard Manet. Later influenced by Impressionism. Settled in Auvers-sur-Oise, 1872. Worked closely with Pissarro at Pontoise and Auvers, 1870s–early 1880s. Participated in Impressionist exhibitions, 1874, 1877. Lived mainly in Aix after 1886. In Giverny, November 1894. Became disenchanted with Impressionism and its emphasis on atmospheric effects. A major Post-Impressionist, he played a vital role in the development of early twentieth-century art, especially Cubism.

Emma Richardson Cherry

Born 1859, Aurora, Illinois
Died 1954, Houston, Texas(?)

Portrait, landscape, and still-life painter. Studied at Art Institute of Chicago and at Art Students League, New York. Taught at University of Nebraska, 1880s. Also active in Kansas City. Studied at Académie Julian, Paris, c. 1888–89, and in Venice and Rome. Settled in Denver by 1889. Founding member, Denver Art Association. Moved to Houston, late 1890s, and assumed a prominent role in local and regional art life. Helped organize Houston Art League and San Antonio Art League. Painted portraits of leading Houstonians. Taught at Yupon School of Art and Crafts. Exhibited throughout U.S. and belonged to many art societies.

Alson Skinner Clark

Born 1876, Chicago, Illinois
Died 1949, Pasadena, California

Landscape, figure, and portrait painter, muralist, lithographer. Studied at Art Institute of Chicago, 1895–96, and with William Merritt Chase in New York and Shinnecock, Long Island, 1896–98. Studied in Paris with James McNeill Whistler, 1898, and at Académie Delecluse, 1900–1901. Based in Chicago, 1900s–early 1910s, but traveled extensively throughout Europe. In Giverny, summer 1910. Also active in Watertown, New York; Quebec; and Panama. Returned to the U.S., 1914. Active in Chicago and the Saint Lawrence region. Settled in Pasadena, 1920, and became associated with the Southern California landscape school. Taught at Stickney Memorial School of Art, Pasadena, and at Occidental College, Los Angeles.

Charles Conder

Born 1868, London, England
Died 1909, London, England

Landscape painter, designer. Lived in Australia, 1885–90. Active in Melbourne, Eaglemont, Mentone, and elsewhere. Associated with Tom Roberts and Arthur Streeton and with them influenced the development of Impressionism in Australia. Lived primarily in Paris, 1890–94. Studied at Académie Julian, 1890, and with F. Cormon. Became friendly with Henri de Toulouse-Lautrec, D. S. McColl, and William Rothenstein. Spent springs and summers in Normandy. Painted landscapes and beach scenes. Settled in London, 1894, but continued to make frequent visits to France. Became known for his fan designs, mid-1890s. Painted decorations for Siegfried Bing's Maison de l'Art Nouveau, 1895. Exhibited regularly at New English Art Club. Painted less frequently after 1906.

Dawson Dawson-Watson

Born 1864, London, England
Died 1939, San Antonio, Texas

Landscape, portrait, and figure painter. Studied with Mark Fisher in London, early 1880s, and

in Paris with Carolus-Duran, Léon Glaize, and others, 1886–88. Lived in Giverny, 1888–93. Painted Impressionist-inspired scenes of rural life. Moved to Hartford, Connecticut, 1893. Director of the Hartford Art Society, 1893–97. Active in England, 1897–1901; Quebec, 1901–2; and Woodstock, New York, 1903. Taught at Saint Louis School of Fine Arts, 1904–15. Established the Dawson-Watson Summer School of Painting and Handicraft, Brandesville, Missouri, 1912. Began visiting San Antonio in 1917; settled there permanently in 1927. Became known as a painter of Texas wildflowers.

Louis Paul Dessar
Born 1867, Indianapolis, Indiana
Died 1952, Preston, Connecticut

Landscape and portrait painter. Studied at National Academy of Design, New York, 1883–86, and in Paris at Académie Julian, 1886–89, and Ecole des Beaux-Arts, 1889–90. Took summer sketching trips to Fontainebleau, Brittany, England, and Spain, 1887–91. Work influenced by Jean-François Millet and the French Barbizon tradition. Spent eight months in Giverny, 1891–92. Lived in Etaples after 1892. Spent winters, 1894–97, painting portraits in New York. Settled permanently in Lyme, Connecticut, 1901. Specialized in views of rural Connecticut. Affiliated with numerous art societies, including National Academy of Design, Lotos Club, and the Lyme Art Association.

William de Leftwich Dodge
Born 1867, Liberty, Virginia
Died 1935, New York, New York

Muralist, figure and landscape painter, illustrator. Studied in Paris at Académie Colarossi, 1881; at Ecole des Beaux-Arts, 1883, 1885; and at Académie Julian, 1889. Also studied at Kaiserliche und Koenigliche Kunst Akademie, Berlin, 1883. Became friendly with Frederick MacMonnies, George Grey Barnard, and George Bridgman, mid-1880s. Exhibited in Paris Salons and in U.S. Rose to prominence as a mural painter, mid-1890s. Decorated numerous public buildings, hotels, and the-aters, including the dome of the Administrative Building, World's Columbian Exposition, Chicago, 1893. Lived in France, 1894–95, 1897–1900. Settled in New York, 1900. After 1906 divided time between Manhattan and Setauket, Long Island. Taught at Cooper Union School of Art and Art Students League. Visited Sicily, 1926, and Mexico, 1930.

J. Stirling Dyce
Born 1853, Aberdeen, Scotland
Died [?]

Landscape and portrait painter. Active in London and in Grèz-sur-Loing and Rochefort-en-Terre, France, mid-late 1880s. Made periodic visits to Giverny, 1891–96 (and possibly earlier). Exhibited at Royal Academy, London. Member of the Ridley Art Group.

James Wall Finn
Born 1867, New York, New York
Died 1913, Giverny, France

Muralist and figure painter. Studied at Cooper Union School of Art, New York. Began career as an architectural draftsman. Traveled to Europe, 1887. Visited Venice and was inspired by Italian Renaissance art. Studied under Jean-Léon Gérôme at Ecole des Beaux-Arts, Paris, 1892. Friend of Frederick MacMonnies, John Singer Sargent, Augustus Saint-Gaudens. Active in New York; Cornish, New Hampshire; Paris; and Giverny. Designed murals for many public and private buildings in Manhattan, including Lyceum Theatre and Knickerbocker Hotel. Gilded Saint-Gaudens's Sherman monument (New York). Died in MacMonnies' house in Giverny.

Mary Hubbard Foote
Born 1872, Guilford, Connecticut
Died 1968, West Hartford, Connecticut

Portrait and figure painter. Studied at Yale School of the Fine Arts, 1890–97. Also studied at Académie Vitti and Académie Colarossi, Paris, and privately with Frederick MacMonnies in Paris and Giverny, 1897–1901. Settled in New York, 1901. Established reputation as a portrait painter. Associated with John Singer Sargent, Henry James, Mabel Dodge Luhan, and other artistic and literary figures. Exhibited at National Academy of Design, 1903–20. Made frequent trips to Europe. Active in Taos, New Mexico, 1917. Abandoned her artistic career in 1928 and moved to Zurich, where she became an assistant to Carl Jung. Returned permanently to the U.S., 1958.

Frederick Frieseke
Born 1874, Owosso, Michigan
Died 1939, Le Mesnil-sur-Blangy, France

Figure, portrait, and landscape painter, muralist. Studied at Art Institute of Chicago, 1893–95; at Art Students League, New York, 1896–97; at Académie Julian, Paris, 1897–98; and with James McNeill Whistler. First visited Giverny in 1900; settled there, 1906–20. Work influenced by Impressionism and Post-Impressionism. Exhibited regularly at Paris Salons and in U.S. Won international acclaim for his depictions of women in interior and outdoor settings. Received numerous awards and honors, including Grand Prize, Panama-Pacific International Exposition, San Francisco, 1915. Moved to Le Mesnil-sur-Blangy, 1920, and concentrated on portraiture.

Arthur Burdett Frost
Born 1851, Philadelphia, Pennsylvania
Died 1928, Pasadena, California

Illustrator, painter. Spent early career as a wood engraver and lithographer. Active as a book and magazine illustrator from the mid-1870s, specializing in wildlife and rural subjects. Established reputation as one of America's leading illustrators. Studied painting with Thomas Eakins at Pennsylvania Academy of the Fine Arts, Philadelphia, 1878–81, and with William Merritt Chase in New York and Shinnecock, Long Island, 1891. Lived primarily in Convent Station, New Jersey, 1890–1906, 1916–19; France, 1906–14; and Pasadena, 1919–28. Stayed in Giverny in 1908, 1909, and 1910. Suffered from color blindness and impaired vision throughout career. His wife, Emily, and sons, Arthur, Jr., and John, were also painters.

Mariquita Gill
Born 1865, Montevideo, Uruguay, or New York, New York
Died 1915

Landscape, garden, and still-life painter. Studied in New England with Ross Turner and at Art Students League, New York, mid-1880s. Lived in France, late 1880s–1890s. Spent most of that time in Paris and Giverny, first visiting Giverny in October 1889. Studied at Académie Julian, 1887. Also studied with Louis-Jules Dumoulin in Paris and Auvers-sur-Oise, c. 1888–89. Work influenced by Claude Monet and Camille Pissarro. Also active in Saint Ives, England; Grèz-sur-Loing, France; Italy; and Switzerland. Returned to U.S. late 1897. Spent several months in Scituate, Massachusetts, before settling permanently in Salem, Massachusetts. Exhibited periodically at Boston Art Club and Copley Society. Traveled to Bermuda and Mexico.

Edmund W. Greacen
Born 1876, New York, New York
Died 1949, White Plains, New York

Landscape, figure, and portrait painter. Studied at Art Students League, New York, 1899, and at Chase School of Art, New York, 1900–c. 1905. Traveled in Spain, the Netherlands, Belgium, and England, 1905–6. Lived in Paris, 1906, and in Giverny, 1907–9. Specialized in Impressionist garden scenes. Lived in New York after 1909. Spent summers in Old Lyme, Connecticut, 1910–17. Founding member, Painters and Sculptors Gallery Association, New York, 1922, and Grand Central School of Art, New York, 1923. Active in Florida, mid-late 1940s.

Ellen Day Hale
Born 1855, Worcester, Massachusetts
Died 1940, Brookline, Massachusetts

Figure, portrait, landscape, and still-life painter; etcher; muralist. Daughter of Rev. Edward Everett Hale and sister of Philip Leslie Hale. Studied in Boston with William Rimmer, 1873, and William Morris Hunt, 1874–79. Studied in Paris at Académie Julian, 1882–85, and with Carolus-Duran. Also studied with Anna Lea Merritt in London. Wrote articles on Paris art life for *Boston Traveler.* Taught art in Boston, late 1880s. Lived in Washington, D.C., 1904–9. Spent summers in Rockport, Massachusetts, where she experimented with etching techniques. Also active in California, South Carolina, Syria, and Palestine. Author of *History of Art* (1888).

Philip Leslie Hale
Born 1865, Boston, Massachusetts
Died 1931, Boston, Massachusetts

Portrait, landscape, and figure painter. Son of Rev. Edward Everett Hale and brother of Ellen Day Hale. Studied at Boston Museum School, 1883, and privately with William Merritt Chase, 1883. Studied at Art Students League, New York, 1884. Associated with Theodore Butler and William Howard Hart. Lived in Paris, 1887–92. Studied at Académie Julian and at Ecole des Beaux-Arts. Spent summers in Giverny. Returned permanently to Boston, late 1892. Spent summers in Matunuck, Rhode Island, mid-late 1890s, where he investigated Neo-Impressionist techniques and taught outdoor painting classes. Turned to a more conservative style after 1900. Became an important member of the Boston school of figure painters. Exhibited regularly in Boston, New York, Philadelphia, and elsewhere in the U.S. Wrote articles and reviews for art journals and local newspapers. Author of numerous books, including two influential studies on Jan Vermeer. Taught at Museum School, 1893–31, and at Pennsylvania Academy of the Fine Arts, 1913–28. His wife, Lilian Westcott Hale, was also a painter.

William Howard Hart
Born 1863, Fishkill-on-Hudson, New York
Died 1934 (or 1937?)

Portrait, still-life, and landscape painter; designer. Studied at Art Students League, New York, mid-1880s. Became friendly with Philip Leslie Hale and Theodore Butler. Studied at Académie Julian, Paris, 1886–90. Lived primarily in Giverny, 1890–95. Also active in New York, early 1890s, and Cornish, New Hampshire, 1892. Settled permanently in New York, 1896, and thereafter divided time between Manhattan and Cazenovia, New York. Spent several summers in Matunuck, Rhode Island, late 1890s. Returned to Giverny for summer visits in 1905, 1906, 1909, and 1912. Established a summer residence in Cornish, 1907. Exhibited at Pennsylvania Academy of the Fine Arts and elsewhere. Belonged to Century Association, American Federation of Arts, and Salmagundi Club.

Blanche Hoschedé-Monet
Born 1865, Paris, France
Died 1947, Nice, France

Landscape and still-life painter. Lived in Vétheuil, 1879–81; Poissy, 1881–83; and Giverny, 1883–97. Met Claude Monet at age eleven; later became his assistant and pupil; his stepdaughter, 1892; and married his son Jean, 1897. Lived in Rouen, 1897–1911, and Beaumont-le-Roger, 1911–13. Returned permanently to Giverny, 1913. Tended to Monet during his old age. Exhibited at Salon des Indépendants, Paris; at Salon de la Société des Artistes Rouennais; and at Salon de Vernon. Had solo exhibitions in Paris, 1927, 1931, 1942, and 1947.

Henry Salem Hubbell
Born 1870, Paolo, Kansas
Died 1949, Miami, Florida

Portrait, figure, and genre painter; illustrator. Studied at Art Institute of Chicago, early 1890s, then worked as an illustrator in Chicago and Springfield, Illinois. Moved to Paris, 1898. Studied at Académie Julian, 1898–99, and with James McNeill Whistler at Académie Carmen, 1901. Exhibited in Paris Salons and in the U.S. Work purchased by Baron Edmond de Rothschild, William Merritt Chase, and others. Active in Giverny, 1909, and became a friend of Frederick MacMonnies. Lived in New York, 1911, and in Silvermine, Connecticut, 1912–16. Taught at Carnegie Institute, Pittsburgh, 1918–21. Settled in Miami, 1924. Member of the founding Board of Regents, University of Miami, 1925.

Leon Kroll
Born 1884, New York, New York
Died 1974, Gloucester, Massachusetts

Portrait, figure, and landscape painter, muralist. Studied at Art Students League, New York, 1899; at National Academy of Design, New York, 1904–7; and at Académie Julian, Paris, 1908–9. Visited Vernon and Giverny, 1909, 1910. Influenced by Paul Cézanne and Impressionism. Settled in New York, 1910. Painted urban landscapes and associated with members of The Eight. Taught at National Academy, 1910–18, 1931–38, 1959–68, and elsewhere in the U.S. Lived abroad for extended periods throughout the 1920s. Turned to mural painting, late 1930s. Spent summers on Cape Ann, Massachusetts, after 1923. Exhibited widely and received numerous awards and honors.

Josephine Miles Lewis
Born 1865, New Haven, Connecticut
Died 1959, Scituate, Massachusetts

Figure, portrait, and landscape painter. Studied at Yale School of the Fine Arts under John Ferguson Weir and John Henry Niemeyer, where she was the first woman awarded an undergraduate degree (B.F.A., 1891). Lived in France 1892–97. Stayed in Giverny, intermittently, from 1892 to 1897. Studied with Frederick MacMonnies in Paris and Giverny. Returned to the U.S., 1897. Established studio in New York. Spent summers in Scituate, Massachusetts. Exhibited widely and belonged to many art societies, including National Association of Women Artists and New Haven Paint and Clay Club. Moved permanently to Scituate, 1943.

Mary Fairchild MacMonnies Low
Born 1858, New Haven, Connecticut
Died 1946, Bronxville, New York

Figure and landscape painter, muralist, miniaturist. Studied at Saint Louis School of Fine Arts, early 1880s, and at Académie Julian, Paris, 1885–88. Also studied under Carolus-Duran. Married the sculptor Frederick MacMonnies, 1888. Lived in Paris and exhibited in salons. Painted mural, *Primitive Woman,* for Women's Pavilion, World's Columbian Exposition, Chicago, 1893. Spent several summers in Giverny before settling there in 1897. Exhibited throughout Europe and the U.S. Won several gold medals. Divorced by MacMonnies, 1909. Married the painter Will Hickok Low, 1909, and settled in Bronxville, New York, 1910. Spent summers in Gloucester, Massachusetts.

Will Hickok Low
Born 1853, Albany, New York
Died 1932, Bronxville, New York

Figure painter, muralist, illustrator. Active as an illustrator in New York, early 1870s. Lived in Paris, 1873–77. Studied under Jean-Léon Gérôme at the Ecole des Beaux-Arts and with Carolus-Duran. Spent summers in Barbizon, mid-1870s. Influenced by Jean-François Millet. Also active in Grèz-sur-Loing. Returned to New York, 1877, and established reputation as a decorative painter and illustrator. Taught at Cooper Union School of Art and at National Academy of Design. Affiliated with many art societies. Concentrated on mural painting after early 1890s. Visited Giverny in 1892 and 1895. Settled in Bronxville, New York, 1897. Active in Giverny, 1901, 1907–9. Married the painter Mary Fairchild MacMonnies, 1909; they returned to Bronxville. Author of *A Chronicle of Friendships* (1908), *A Painter's Progress* (1910), and numerous articles and reviews.

Frederick William MacMonnies
Born 1863, Brooklyn, New York
Died 1937, New York, New York

Sculptor, portrait and figure painter. Apprenticed to sculptor Augustus Saint-Gaudens, 1880–84. Studied at Cooper Union School of Art and National Academy of Design, New York, early 1880s. Traveled to Paris, 1884. Studied at Académie Colarossi, at Ecole des Beaux-Arts under Alexandre Falguière, and privately with Antonin Mercie. Married the painter Mary Fairchild, 1888. Established studio in Paris and executed many important public monuments for American patrons. Exhibited in Salons and in the U.S. Won

179. Frederick MacMonnies (1863–1937). *Self-Portrait,* 1896. Oil on canvas, 32 x 21⅜ in. (81.3 x 54.3 cm). Terra Foundation for the Arts; Daniel J. Terra Collection.

international acclaim as a Beaux-Arts sculptor. After brief visit in 1890, spent several summers in Giverny before settling there in 1897. Turned increasingly to painting until about 1905. Taught at Académie Vitti, Paris, 1895; at Académie Carmen, Paris, 1898; and privately in Paris and Giverny. Returned permanently to New York, 1915. Also active in Cornish, New Hampshire.

Leon A. Makielski
Born 1885, Morris Run, Pennsylvania
Died 1974, Ann Arbor, Michigan

Portrait and landscape painter. Studied at Art Institute of Chicago, 1903–4, 1905–9; awarded a traveling fellowship in 1908. Active in Fox River region, near Oregon, Illinois, middle of first decade. Based in Paris, 1909–13. Studied at Académie Julian and at Académie de la Grande Chaumière. Active in Giverny, 1909–11. Exhibited at 1910 and 1911 Salons. Visited England, Italy, Germany, Poland, Belgium, and the Netherlands. Returned to U.S., 1913. Was active in South Bend, Indiana, before settling in Ann Arbor, 1915. Taught at University of Michigan, 1915–27, and in Detroit. Exhibited throughout the Midwest and won many prizes. Member of Scarab Club, Detroit.

Willard Leroy Metcalf
Born 1858, Lowell, Massachusetts
Died 1925, New York, New York

Landscape and figure painter, illustrator. Studied at Massachusetts Normal Art School,

Boston, 1874; apprenticed under George Loring Brown, Boston, 1875; at the Lowell Institute, Boston, 1875; and at the Boston Museum School, 1877–78. Active in New England and New Mexico, late 1870s–early 1880s. Studied at Académie Julian, Paris, 1883–89. Spent summers in Brittany and Normandy; possibly visited Giverny in 1885 and 1886. Worked as an illustrator in New York, 1890s. Taught at Art Students League, 1890–91, and at Cooper Union School of Art, 1893–1903. Founding member, Ten American Painters, 1897. Active in Boothbay Harbor, Maine, 1903–4; Old Lyme, Connecticut, 1905–7; northwestern Connecticut, 1910–25; and Cornish, New Hampshire, 1909–20. Nationally acclaimed for his views of rural New England.

Thomas Buford Meteyard
Born 1865, Rock Island, Illinois
Died 1928, Territet, Switzerland

Landscape painter, illustrator, and book designer. Studied at Harvard University, 1885–87. Became friendly with poets Bliss Carman and Richard Hovey. Based in Paris, 1888–93. Studied with Léon Bonnat, Alfred-Philippe Roll, Auguste-Joseph Delecluse, and possibly Pierre Puvis de Chavannes. Associated with a circle of avant-garde artists and literati that included Edvard Munch and Stéphane Mallarmé. Active in Giverny, early 1890s. Landscape work inspired by Claude Monet and Impressionism. Book designs and illustrations influenced by Aesthetic movement and by Post-Impressionism. Lived in Scituate, Massachusetts, 1894–1910, but made several extended trips abroad. Settled permanently in England, 1911. Exhibited in Paris, London, and the U.S. Illustrated numerous publications, including Carman and Hovey's *Songs from Vagabondia* (1894).

Richard Miller
Born 1875, Saint Louis, Missouri
Died 1943, Saint Augustine, Florida

Figure and marine painter, muralist. Studied at Saint Louis School of Fine Arts, mid-1890s, and at Académie Julian, Paris, 1898–99. Spent several years in Paris. Exhibited at Salons and in the U.S. Taught at Académie Colarossi, early 1900s. Started to summer in Giverny, c. 1906. Taught summer classes in Saint-Jean-du-Doigt, starting in 1911. Recognized internationally for his portrayals of women in gardens and interiors. Returned to the U.S., late 1914. Settled in Pasadena, California, by 1916. Taught at Stickney Memorial School of Art, Pasadena. Influenced development of Impressionism in Southern California. Resided in Provincetown, Massachusetts, after 1918. Designed murals for State Capitol, Jefferson City, Missouri, 1919–23.

Claude Monet
Born 1840, Paris, France
Died 1926, Giverny, France

Landscape and figure painter. Spent youth in Le Havre, France, where he established a local reputation as a caricaturist. Met Eugène Boudin, c. 1856, who inspired him to paint *en plein air*. Studied in Paris at Académie Suisse, 1859. Met the Dutch painter Johan Barthold Jongkind, 1862, and was influenced by his work. Studied in the atelier of Charles Gleyre, 1862–c. 1864. Met Auguste Renoir, Frédéric Bazille, and Alfred Sisley. Active in Fontainebleau and along Channel coast, 1860s. Resided in London, 1870–71. Influenced by John Constable and Joseph Mallord William Turner. Painted views of London parks and the Thames. Began experimenting with broken-color technique associated with Impressionism. Exhibited in Impressionist group exhibitions, 1874, 1876, 1877, 1879, 1882. Lived in Argenteuil, 1871–78; Vétheuil, 1878–81; and Poissy, 1881–83. Settled permanently in Giverny, 1883. Concentrated on serial paintings from late 1880s. Continued to travel and paint throughout France. Also active in the Netherlands, London, Venice, and Norway. Painted until the end of his life, despite failing eyesight.

Pauline Lennards Palmer
Born 1867, McHenry, Illinois
Died 1938, Trondheim, Norway

Landscape, figure, and portrait painter. Studied at Art Institute of Chicago, 1890s, and in New York with William Merritt Chase. Also studied in Paris at Académie de la Grande Chaumière and Académie Colarossi, early 1900s. Work influenced by Richard Miller. Active in Brittany and Normandy. Settled in Chicago, 1906, and became a prominent figure in local art circles. Was supervisor of art for Chicago Public Schools. Joined Giverny colony, summer of 1910. Spent summers in Provincetown, Massachusetts, 1910s, studying under Charles Hawthorne. After 1920 painted seascapes and dunescapes in Cape Cod, Massachusetts. Exhibited throughout the U.S. and won many awards. Affiliated with numerous societies, including the Chicago Women's Salon, the Chicago Society of Artists, and the Provincetown Art Association.

Lawton S. Parker
Born 1868, Fairfield, Michigan
Died 1954, Pasadena, California

Portrait, figure, and landscape painter. Studied at Art Institute of Chicago, 1886–88; at Académie Julian, Paris, 1889–90, 1896–98; at National Academy of Design, New York, 1895–96; and at Ecole des Beaux-Arts, Paris, 1897. Also studied with Paul Besnard and possibly James McNeill Whistler. Lived primarily in Giverny, 1903–13. Associated with Frederick Frieseke, Richard Miller, and Frederick MacMonnies. Painted figures and nudes in sunlit gardens. Active in Chicago and New York after 1913. Moved to New York, 1917; then to Pailly-sur-Oise, France, 1920s. Settled in Pasadena, 1942. Exhibited in Paris Salons and in U.S. Taught at Saint Louis School of Fine Arts, 1892; Beloit College, Beloit, Michigan, 1893; New York School of Art, 1898–99; and Art Institute of Chicago, 1901–2. Operated the Parker Academy of Art, Paris, 1900.

Ernest Clifford Peixotto
Born 1868, San Francisco, California
Died 1940, New York, New York

Landscape and figure painter, muralist, illustrator. Studied at San Francisco School of Design, early 1880s, and at Académie Julian, Paris, 1888–90, 1891–93. In Giverny fre-

quently, 1889–95. Exhibited in Paris Salons and in the U.S. Gained wide reputation as a muralist and illustrator. Active primarily in New York; Fontainebleau, France; and Cornish, New Hampshire. Official artist for American Expeditionary Force, 1918. Director of mural painting, Beaux-Arts Institute, New York, 1919–26. Affiliated with many art organizations, including Art Commission of the City of New York, Fontainebleau School of Fine Arts, National Society of Mural Painters, and Society of Illustrators. Author of numerous travel books.

Lilla Cabot Perry
Born 1848, Boston, Massachusetts
Died 1933, Hancock, New Hampshire

Portrait, figure, and landscape painter. Married writer-scholar Thomas Sergeant Perry, 1874. Studied in Boston with Alfred Q. Collins, 1884; with Robert Vonnoh, 1885; and with Dennis Miller Bunker. Continued training at Académie Colarossi and Académie Julian, Paris, 1887–89. Studied briefly in Munich with Fritz von Uhde, 1888. Resided primarily in Boston but spent intermittent summers in Giverny, 1889–1909, and three years in Europe, 1906–9. Befriended Monet and was inspired by his style. An influential figure in Boston art circles, she promoted the work of Monet and many American Impressionists. Exhibited widely in the U.S. and abroad. Lived in Japan, 1898–1901. Founder and secretary of Guild of Boston Artists. Spent summers in Hancock, New Hampshire, after 1910. Author of "Reminiscences of Claude Monet from 1889 to 1909" (1927) and four books of poetry.

Václav Radimsky
Born 1867, Kolín, Bohemia [Czechoslovakia]
Died 1946, [Czechoslovakia?]

Landscape painter. Studied in Prague and in Vienna, late 1880s. Lived in France, 1889–1918. Worked in Paris and Barbizon, late 1880s–early 1890s. Active in Giverny and environs from mid-1890s to c. 1918. Specialized in views of the Seine and the local coun-

tryside. Work influenced by Claude Monet and Impressionism. Exhibited at Paris Salons and in Vienna, Hamburg, and Berlin. Awarded bronze medal at Exposition Universelle in Paris, 1900. Had solo exhibition at Galerie Bernheim-Jeune, Paris, 1910.

Ellen Gertrude Emmet Rand
Born 1875, San Francisco, California
Died 1941, Salisbury, Connecticut

Portrait painter, illustrator. Studied under Dennis Miller Bunker in Boston, late 1880s; at Art Students League, New York, 1889–93; and with William Merritt Chase at Shinnecock, Long Island, 1892. Worked as an illustrator, 1893–94. Met John Singer Sargent in England, 1896, and was influenced by his work. Studied with Frederick MacMonnies at Académie Vitti, Paris, 1896, and in Giverny, 1897–99. Settled in New York, 1900, and became a successful portraitist. Solo exhibitions at Durand-Ruel, New York, 1902; Copley Hall, Boston, 1906; and Macbeth Gallery, New York, 1907. Married William Blanchard Rand, 1911. Spent summers in Salisbury, Connecticut. Continued to exhibit regularly in New York and Philadelphia. Awarded a Gold Medal, Panama-Pacific Exposition, 1915, and National Arts Club Prize, 1925.

Louis Ritman
Born 1889, Kamenets-Podolski, Russia
Died 1963, Winona, Minnesota

Figure and landscape painter. Studied at Chicago Academy of the Fine Arts, 1907; at Pennsylvania Academy of the Fine Arts, Philadelphia, 1908; at Art Institute of Chicago, 1909; and at Ecole des Beaux-Arts, Paris, 1909–11; first visited Giverny in 1911. Lived in France, 1910s and 1920s, dividing time between Paris and Giverny. Known for Impressionist-inspired portrayals of women in flower gardens and interiors. Exhibited regularly in Paris Salons and in the U.S. Had many solo exhibitions in Chicago, New York, and elsewhere. Settled in Chicago, 1930. Taught at the School of the Art Institute of Chicago. Continued to make periodic visits to

France. Painted landscapes in southeastern Michigan, summers 1951–63.

Louis Ritter
Born 1854, Poughkeepsie, New York
Died 1892, Boston, Massachusetts

Landscape, portrait, and still-life painter. Studied at McMicken School of Design, Cincinnati, 1873–74. Worked as a lithographer, mid-1870s. Studied at Royal Academy, Munich, 1878. Associated with Frank Duveneck and his circle in Polling, Bavaria; Florence; and Venice, 1878–80. Lived in Cincinnati, 1881–83, and in Boston, 1883–85. Spent part of 1885 in Barbizon. Active in Giverny, 1887, and in Florence, with Duveneck, 1888. Returned to Boston, 1889, where he painted landscapes. Taught at Wellesley College. Exhibited regularly at St. Botolph Club, Boston, and at Boston Water-Color Society.

Theodore Robinson
Born 1852, Irasburg, Vermont
Died 1896, New York, New York

Landscape and figure painter. Studied at Chicago Academy of Design, 1869–70; at National Academy of Design, New York, 1874; and at Art Students League, New York, 1875. Went to Paris, 1876. Studied with Carolus-Duran, and at Ecole des Beaux-Arts with Jean-Léon Gérôme. Active in New York, Boston, and Nantucket, 1879–84. Lived in France, 1884–92, with frequent visits to the U.S. Active in Paris, Barbizon, Cernay-la-ville, and Grèz-sur-Loing. Visited Giverny, 1885. Resided primarily in Giverny, 1888–92. Became friendly with Claude Monet and was influenced by his work. Specialized in peasant themes and views of the Seine Valley. Exhibited in Paris Salons and in New York and Boston. Returned to New York, 1892, and thereafter painted landscapes in Connecticut, New York, New Jersey, and Vermont. Taught outdoor summer classes at Brooklyn Art School; at Napanoch, New York; and at Evelyn College, Princeton, N.J. Played a key role in the dissemination of Impressionism in the U.S.

Guy Rose
Born 1867, San Gabriel, California
Died 1925, Pasadena, California

Landscape and figure painter, illustrator. Studied at School of Design, San Francisco Art Association, 1886–87, and at Académie Julian, Paris, 1888–89. Lived in France, 1888–91; visited Giverny, July 4, 1890–January 1891 and returned in May 1891. Returned to U.S., 1891, and became a successful illustrator in New York. Lived in Paris, 1893–94, 1899–1904; Giverny, summer 1899 and 1904–12; New York, 1895–99, 1912–14. Settled in Pasadena, 1914, and thereafter painted coastal views in and around the Monterey Peninsula. Taught at Pratt Institute, Brooklyn, and at Stickney Memorial School of Art, Pasadena. Exhibited in New York, California, and elsewhere in U.S. Won numerous medals. Influential in disseminating Impressionism in Southern California.

John Singer Sargent
Born 1856, Florence, Italy
Died 1925, London, England

Portrait, figure, landscape, and mural painter. Studied at Accademia di Belle Arti, Florence, 1870–73, and in Paris with Carolus-Duran, 1874. Traveled throughout Europe and England, early 1880s, with intermittent stays in Venice. Settled in London, 1885, following the controversy surrounding his *Madame X* (Metropolitan Museum of Art, New York), shown at the 1884 Salon. Explored Impressionism, summers 1885–89, at Broadway, Henley-on-Thames, Calcot, and Fladbury, England, and in Giverny. Became a friend of Claude Monet and collected his work. Active in Boston and New York, 1887–88, 1890. Established reputation as the leading society portraitist in England and the U.S. Exhibited internationally and won many honors. After 1900 concentrated on mural commissions in Boston and worked increasingly in watercolor.

Henry Fitch Taylor
Born 1853, Cincinnati, Ohio
Died 1925, Cornish, New Hampshire

Painter. Studied in Cincinnati with Joseph Jefferson, late 1870s, and at Académie Julian, Paris, 1880–86(?). Active in Barbizon and Giverny, mid-late 1880s. Settled in New York, 1888. Specialized in Impressionist-inspired landscapes. Moved to Cos Cob, Connecticut, 1898. Became manager (with Clara Potter Davidge) of Madison Gallery, New York, 1909. Founding member of Association of American Painters and Sculptors, 1912. Participated in organization of the Armory Show, 1913. After 1914, work influenced by Paul Cézanne, Cubism, and other progressive movements. Founding member of Modern Artists of America, 1922, and Salons of America, 1923. Spent later years in Cornish, New Hampshire.

George Albert Thompson
Born 1868, New Haven, Connecticut
Died 1938, Mystic, Connecticut

Landscape and portrait painter. Studied at Yale School of the Fine Arts, New Haven, Connecticut, 1886–92 (B.F.A., 1898), and with John La Farge in New York. Also studied with Luc-Olivier Merson and others in Paris, 1893–97. First registered at the Hôtel Baudy in June 1896. Landscape work influenced by James McNeill Whistler and later, by Impressionism. Taught at Yale School of the Fine Arts, 1900–1910. Director, Norwich (Connecticut) Art School, 1910–12. Painted and taught in Mystic, Connecticut, 1912–38. Supervisor of Art for Groton (Connecticut) Public Schools, 1921–30. Founding member of New Haven Paint and Clay Club, 1900, and Mystic Art Association, 1914. Exhibited in New York, Chicago, Philadelphia, and elsewhere in the U.S.

Abel George Warshawsky
Born 1883, Sharon, Pennsylvania
Died 1962, Monterey, California

Landscape, figure, and portrait painter. Studied at Cleveland School of Art, c. 1900; Art Students League, New York, 1905; National Academy of Design, New York, 1906; and Académie Julian, Paris, c. 1908. First visited Vernon, July 1909. Lived primarily in France, 1910–38, with intermittent periods of activity in Cleveland. Friendly with Leon Kroll, Samuel Halpert, and other members of the Franco-American art community in Paris. Best known for his Impressionist views of Paris and rural France. Also active in Italy, Switzerland, and Majorca. Exhibited in Paris Salons and in the U.S. Returned to America, 1938. Settled in Monterey, California. Specialized in coastal scenes. Made occasional visits to Mexico.

Theodore Wendel
Born 1859, Midway, Ohio
Died 1932, Ipswich, Massachusetts

Landscape painter. Studied at McMicken School of Design, Cincinnati, 1876–77, and at Royal Academy, Munich, 1878. Worked with Frank Duveneck in Polling, Bavaria, 1879, and in Florence and Venice, 1879–80. Studied at Académie Julian, Paris, 1886–87. Active in Giverny, 1886(?), 1887, 1888. Returned to U.S., 1888. Exhibited Impressionist landscapes in Boston, 1889. Lived in Boston, 1892–97. Taught at Cowles Art School, Boston, and at Wellesley College. Moved to farm in Ipswich, Massachusetts, 1898, and thereafter specialized in views of Ipswich and Gloucester. Exhibited regularly in Boston, New York, and Philadelphia. Painting activity restricted after illness in 1917.

HOTEL BAUDY
GUEST REGISTER

CAROL LOWREY

Source: "Registre pour inscrire les voyageurs," Department of Prints, Drawings, and Photographs, Philadelphia Museum of Art. The register can be consulted on microfilm (roll 4236) at the Archives of American Art, Smithsonian Institution, Washington, D.C., and at its regional offices.

This list consists of information extracted from the "Registre pour inscrire les voyageurs," commonly known as the Hôtel Baudy Guest Register. Issued to Madame Baudy by the *mairie* (town hall) of Giverny, the register lists the guests who stayed at the inn from June 1887 to July 1899. (The hotel continued in business until 1960, but the location of the twentieth-century register is unknown.) In most of the approximately seven hundred entries in the register, visitors described themselves as "artiste," "artiste-peintre," or "peintre." The compilation presented here includes individuals listed as such, plus entries for sculptors, architects, art students, one model, one art dealer, and any family members who registered separately.

Names were frequently spelled differently in different entries; birthdates and places of birth were often inconsistent or omitted altogether. Similarly, register numbers were sometimes lacking or were repeated. For the sake of clarity, the form, spelling, and punctuation of the registration dates has been regularized. In transcribing entries, I have retained the original spellings of names, professions, and places of birth. Expanded or corrected forms of artists' names have been inserted in square brackets.

The order of each entry is as follows: registration number; name of guest; age; profession (if other than artist or painter); place of birth; duration of stay.

2. Jaime Vilallonga, 25 ans, Barcelona (Espagna), 6–12 juillet 1887

3. Robinson, Theodore, 35 ans, Irasburg (Etats Unis),18 septembre–4 janvier 1888

6. Carrey, 30 ans, Etats Unis, 10–15 janvier 1888

7. Harrison [Alexander Harrison], 35 ans, Etats Unis, 10–12 janvier 1888

9. John L. Breck [John Leslie Breck], 28 ans, Hong Kong, China, 4 avril 1888–30 octobre 1889

10. Dawson Watson [Dawson Dawson-Watson], 23 ans, Londres (Angleterre), 12 mai–15 septembre 1888

11. The E Butler [Theodore Butler], 26 ans, Etats Unis, Columbus, Ohio, 20 mai–11 septembre 1888

12. T. M. Wendel [Theodore Wendel], 29 ans, Washington, 20 mai–7 septembre 1888

13. J. N. Barlow [John Noble Barlow], Angleterre, 25 mai–15 juin 1888

14. William M. Ellicott, Jr. [William B. Ellicott?], architect, 25 mai–15 juin 1888

15. P. L. Hale [Philip Leslie Hale], 1 juin–1 octobre 1888

17. Schiaffino Edouardo [Edward Schiaffino], 27 ans, Bueyno Aires, 12 juin–25 octobre 1888

18. Macpherson, Mme., 24 ans, Melbourne, 15 juin–30 juin 1888

21. P. L. Hale [Philip Leslie Hale], 27 ans, Boston, 5–7 octobre 1888

22. Robert Naki [Maki?], 50 ans, New York, 15–20 janvier 1889

23. Pullecorty [?], 23 ans, New York, 28 février–2 mars 1889

25. Fred Richardson [Frederick Richardson], 26 ans, New York, 16 mars–25 mars 1889

26. Harry Russ, 23 ans, New York, 16 mars–25 mars 1889

27. F——— Luques [Frank A. Luques], 25 ans, New York, 16–25 mars 1889

28. Prellwitz [Henry Prellwitz], 23 ans, New York, 7–10 mai 1889

29. F. L. Pape [Frederick L. Pape], 18, San Francisco, 7–10 mai 1889

31. Robinson[,] Theodore, 36 ans, Etats Unis, 12 mai–12 décembre 1889

32. Schiaffino Edouardo [Edward Schiaffino], 27 ans, Buenos Ayrs, 2 juin–2 août 1889

33. Richardson [Frederick Richardson], 26 ans, Chicago, America, 20 juin–27 septembre 1889

34. Prellwitz [Henry Prellwitz], 23 ans, New York, 20 juin–26 août 1889

35. Perry et sa famille [Lilla Cabot Perry], Boston, 20 juin–29 octobre 1889

36. A. B. Job [Alice E. Job], 23 ans, Alton, Illinois, Etats-Unis, 20 juin–11 octobre 1889

37. G. P. Fidler, 25 ans, Australia, 27 juin–29 juillet 1889

38. C. E. Young, Angleterre, 5 juillet–7 septembre 1889

39. Cohen, New York, 10–29 juillet 1889

[35?] L. C. Perry [Lilla Cabot Perry], Boston, 20 juin–29 octobre 1889

36. Codman [Stephen Codman], 22 ans, architecte, Boston, 31 juillet–22 septembre 1889

37. Wheelwright [Edmund M. Wheelwright], architecte, Boston, 31 juillet–5 août 1889

38. H. D. Hale [Herbert Dudley Hale], architecte, Boston, 31 juillet–5 août 1889

39. Dawson Watson et sa dame [Dawson Dawson-Watson and Mary Hoyt Sellars], Londres/Angleterre, 20–26 août 1889

41. Lugues [Frank A. Luques], 25 ans, Maine Amérique, 10–29 septembre 1889

42. Peixotto [Ernest Clifford Peixotto], 23 ans, Califournie, 10–29 septembre

43. Bacon [Charles Roswell Bacon], New York, 10–24 septembre 1889

44. M. W. Webster, 52 ans, Boston, 10 septembre–22 octobre 1889

45. Laura F. Glenn, 19 ans, New York, 10–19 septembre 1889

46. Helen Glenn, 27 ans, New York, 10–19 septembre 1889

47. Rood [Roland Rood], 23 ans, New York, 11 septembre–13 octobre 1889

48. Ellen F. Rice, 45 ans, Boston, 16 septembre–30 octobre 1889

49. Ernest Parton, 40 ans, London, 17–19 septembre 1889

50. Stewardson, E. A. [Edmond Austin Stewardson], 24 ans, sculpteur, Etats-Unis, 17–29 septembre 1889

51. Prellwitz, Henry, 23 ans, New York, 21–26 septembre 1889

52. Hart Wm. H. [William Howard Hart], 25 ans, New York, 21–26 septembre 1889

53. Brady [Mary C. Brady], 21 ans, San Francisco, 23 septembre–3 décembre 1889

54. Ernest Parton, 40 ans, Londres, 12–25 octobre 1889

55. Dr. George Gill, 45 ans, M.D., St. Louis, 17–23 octobre 1889

56. Madame Gill, 35 ans, Boston, 17–23 octobre 1889

57. Mme Mary Gill, 45 ans, Boston, 17–23 octobre 1889

58. Mariquita Gill, 24 ans, Boston, 17–23 octobre 1889

59. Codman [Stephen Codman], 22 ans, architecte, Boston, 19–24 octobre 1889

60. Bigelow [Henry Forbes Bigelow], architecte, Boston, 19–24 octobre 1889

61. Mauran [John Lawrence Mauran], architecte, Boston, 19–24 octobre 1889

62. Laura F. Glenn, 27 ans, New York, 20–30 octobre 1889

63. Helene Glenn, 19 ans, New York, 20–30 octobre 1889

64. Prellwitz[,] Henry, 23 ans, New York, 22–29 décembre 1889

65. Rothenstein [William Rothenstein], Angleterre, 22 décembre 1889–4 janvier 1890

66. Richardson [Francis Henry Richardson?], 25 ans, Maine Amerique, 28 décembre 1889–5 janvier 1890

67. Luques [Frank A. Luques], 23 ans, Californie, 28 décembre 1889–5 janvier 1890

68. Peixotto [Ernest Clifford Peixotto], 26 ans, Chicago, 28 décembre 1889–5 janvier 1890

69. Hofmann Louis [Ludwig von Hofmann], 28 ans, Darmstadt, 24 janvier–2 février 1890

70. Rothenstein [William Rothenstein], Angleterre, 24 janvier–2 février 1890

71. Luques Franck [Frank A. Luques], 23 ans, Maine (Amerique), 7 février–1 mars 1890

72. J. N. Barlow [John Noble Barlow], 28 ans, Angleterre, 11–15 février 1890

73. R. B. Mayfield [Robert Bledsoe Mayfield], 21 ans, Carlinville, 11–15 février 1890

74. Rob. Rands Naltes [?], 24 ans, U.S.A., 11–15 février 1890

76. M. et Mme. J. L. France [Jessie Leach France and Eurilda Q. Loomis France], U.S. d'Amerique, 3–6 avril 1890

77. M. et Mme. MacMonnies [Frederick MacMonnies and Mary Fairchild MacMonnies], sculpteur et artiste peintre, Etats Unis d'Amerique, 3–6 avril 1890

78. M. et Mme. Gronvold [Bengt Gronvold and Hermine Hermann Gronvold], Norvege, 4–6 avril 1890

79. Rothenstein [William Rothenstein], 18 ans, Bradford, Angleterre, 10 avril–13 mai 1890

80. Ernest Parton, 41 ans, Londres, 6–18 mai 1890

81. Prelwitz Henri [Henry Prellwitz], 24 ans, New York, 7–10 mai 1890

82. Grey, New York, 7–10 mai 1890

83. M. et Mme. MacMonnies [Frederick MacMonnies and Mary Fairchild MacMonnies], sculpteur et artiste, Etats Unis Amerique, 9–13 mai 1890

84. Mr. et Mme. Clements [George Henry Clements], Etats Unis Amerique, 11–13 mai 1890

85. W. H. Hyde [William Henry Hyde], Etats Unis Amerique, 11–13 mai 1890

86. Harison, Etats Unis Amerique, 11–12 mai 1890

87. M. et Mme. Gronvold [Bengt Gronvold and Hermine Hermann Gronvold], Norvege, 18 mai 1890

88. Mr. and Mrs. Adrian Stokes [Adrian Stokes and Marianne Preindlsberger], 0 ans, England-Austria, 18 mai 1890

89. Th Robinson [Theodore Robinson], 37 ans, Etats Unis, 19 mai–3 novembre 1890

90. Grey, New York, 23–31 mai 1890

91. H. D. Hale [Herbert Dudley Hale], 23 ans, architecte, Boston, 23–31 mai 1890

92. Wheelwright [Edmund M. Wheelwright], architecte, Boston, 23–26 mai 1890

94. Brady [Mary C. Brady], 21 ans, San Francisco, 25 mai–29 juin 1890

95. Job Alice [Alice E. Job], 23 ans, Etats Unis, 27 mai–16 juin 1890

96. Grey, 25 ans, New York, 19 juin–3 juillet 1890

97. Bacon Ch. [Charles Roswell Bacon], 23 ans, New York, 19 juin–20 octobre

98. M. et Mme. J. L. France [Jessie Leach France and Eurilda Q. Loomis France], U.S. Amerique, 20 juin–4 octobre 1890

99. Elizabeth Alb. Chase [Elizabeth Chase], 22 ans, Louisville, 26 juin–1 octobre 1890

100. Emma Speed, 22 ans, Louisville, 26 juin–25 septembre 1890

101. Hale, H. D. [Herbert Dudley Hale], 23 ans, architecte, Boston, 28 juin–1 juillet 1890

102. Willeright [Edmund M. Wheelwright], 24 ans, architecte, Boston, 28 juin–2 juillet 1890

103. Codman [Stephen Codman], 23 ans, architecte, Boston, 28 juin–3 juillet 1890

104. Dr. [?] Gerrdorff, 23 ans architecte, Boston, 28 juin–1 juillet 1890

105. Gertrude Frye, 24 ans, U.S. Amerique, 1 juillet–25 août 1890

106. Kinsella Catherine [Katherine Kinsella], Brooklyn, U.S.A., 1 juillet–26 octobre 1890

107. Kinsella[,] Louise, Brooklyn, U.S.A., 1 juillet–26 octobre 1890

108. Rose Guy et le famille [Guy and Ethel Rose], 23 ans, U.S. Amerique, 4 juillet 1890–27 janvier 1891

109. Mlle. McCormick [M. Evelyn McCormick], U.S. Amerique, 4 juillet–25 décembre 1890

112. Mr. and Mrs. F. J. Wiley [Frederick J. Wiley], New York, 25 juillet–13 septembre 1890

113. Grey, 25, New York, 26 juillet–4 août 1890

116. Robert W. Chambers, 25 ans, Brooklyn, N.Y., 4 août–8 septembre 1890

117. Aguessi [?], 30 ans, Brooklyn, N.Y., 4–15 août 1890

118. Rafflin [Louis-Emile Rafflin?], 40 ans, Paris, 8–18 août 1890

119. Willeregiht [Edmund M. Wheelwright], 24 ans, Boston, architecte, 11–19 août 1890

120. Codman [Stephen Codman], 23 ans, architecte, Boston, 11–19 août 1890

121. Gerdorff, 20 ans, architecte, Boston, 11–19 août 1890

123. Mathews [Charles T. Mathews?], 22 ans, architecte, New York, 27–31 août 1890

124. E. C. Peixotto [Ernest Clifford Peixotto], 20 ans, San Francisco, 28 août–20 octobre 1890

126. Dawson Watson et sa dame [Dawson Dawson-Watson and Mary Hoyt Sellars], 25, Londres, Angleterre, 10 septembre 1890–12 février 1891

127. Codman [Stephen Codman], 23 ans, architecte, Boston, 12–23 septembre 1890

128. Grey, 25 ans, New York, 12–20 septembre 1890

129. Robert Chambers [Robert W. Chambers], 25 ans, Brooklyn, N.Y., 16 septembre–30 octobre 1890

131. Richardson [Francis Henry Richardson?], Maine, 1–18 octobre 1890

132. Gerdorff, 20 ans, architecte, Boston, 3–6 octobre 1890

133. Willeregiht [Edmund M. Wheelwright], 24 ans, architecte, Boston, 3–6 octobre 1890

134. H. Hale [Herbert Dudley Hale], 23 ans, architecte, Boston, 3–6 octobre 1890

136. Rothenstein [William Rothenstein], 19 ans, Bradford, 6–19 décembre 1890

M M Longstoff [John Longstaff], Angleterre, 6–19 décembre 1890

137. Richardson [Francis Henry Richardson?], 26 ans, Maine, U.S.A., 23 février–2 mars 1891

138. Peixotto, E. C. [Ernest Clifford Peixotto], 20 ans, San Francisco, 23 février–2 mars 1891

139. Peixotto, A, 22 ans, San Francisco, 23 février–2 mars 1891

140. Richardson [Frederick Richardson], 27 ans, Chicago (Amerique), 5–29 avril 1891

141. Mackenzie [Roderick D. Mackenzie], 26 ans, Londres, 5–28 avril 1891

142. Robinson [Theodore Robinson], 38 ans, New York (Irasburg), 6 avril–20 novembre 1891

143. Bacon Ch. [Charles Roswell Bacon], 24 ans, New York, 7–10 avril 1891

144. Emma Speed, 22 ans, Louisville, 11–25 avril 1891

145. Beckington[,] Alice, 22 ans, St. Charles (U.S.A.), 11–25 avril 1891

146. Peixotto E C [Ernest Clifford Peixotto], 20 ans, San Francisco, 14–28 avril 1891

147. Peixotto A., 22 ans, San Francisco, 14–28 avril 1891

148. Willergiht [Edmund M. Wheelwright], 24 ans, architecte, Boston, 15–17 avril 1891

149. Codman [Stephen Codman], 23 ans, architecte, Boston, 18–21 avril 1891

151. Hale [Herbert Dudley Hale], 23 ans, architecte, Boston, 25–27 avril 1891

152. M. et Mme. Mondy, 33, 30, Boston, 27–29 avril 1891

153. Richardson [Frederick Richardson], 27 ans, Chicago, 4–11 mai 1891

154. Candwell, Amerique, 4–11 mai 1891

155. Guy Rose, 23 ans, U.S. Amerique, 6 mai–1 juillet 1891

157. M. McCorminck [M. Evelyn McCormick], U.S. Amerique, San Francisco, 1 juin–1 juillet 1891

158. M.C.J. Collins, 27 ans, Boston, 11–13 juin 1891

159. J. Frusdel, 26 ans, Boston, 11–13 juin 1891

160. Balsch, 32 ans, Boston, 11–13 juin 1891

161. Jeanne Laurent, 25 ans, Boston, 13–19 juin 1891

162. Les 3 Dlles Perry L C [Lilla Cabot Perry], Boston, 13–19 juin 1891

165. Dumond [Frederick Melville Dumond], 23 ans, U.A. Amerique, 25 juin–28 juillet 1891

166. John L. Breck [John Leslie Breck], Boston, 9 juillet–21 novembre 1891

168. A. Cobb [Arthur Murray Cobb], 20 ans, Boston, 9 juillet–19 novembre 1891

170. J. Eastman Chase, Marchand de Tableaux, Boston, 9–10 juillet 1891

171. Roland Rood, New York, 9 juillet 1891–[?]

172. Opdycke [?], 31 ans, Boston, 12–15 juillet 1891

173. M. et Mme. Gay [Walter Gay], 32, Boston, 14–16 juillet 1891

174. L. C. Perry et sa famille [Lilla Cabot Perry], Boston, 14 juillet–20 octobre 1891

176. Edward Breck et sa dame, 33, Boston, 20 juillet–10 octobre 1891

177. Meteyard H. [Thomas Buford Meteyard], 27 ans, Boston, 21–31 juillet 1891

178. Galbrith [Clara E. Galbraith?], 27 ans, Toronto, Canada, 27–30 juillet 1891

179. Mlle. Lewis, 23 ans, Toronto, Canada, 28 juillet–6 août 1891

180. Mlle. Cotes, 23 ans, Angleterre, 28 juillet–2 août 1891

181. Mlle. Sarah El Olivet, 25 ans, Canada, 28 juillet–30 août 1891

182. Mlle. Gardner, 22 ans, Canada, 28 juillet–28 août 1891

183. Mr. Maynard, Amerique, 2 août–8 octobre 1891

186. Mr. Ertz [Edward Frederick Ertz], Amerique, 3–4 août 1891

187. Mr. Newell [George Glenn Newell?], Amerique, 3–4 août 1891

188. Carrol Beckwith [J. Carroll Beckwith], New York, 8 août–8 septembre 1891

189. Mme. Beckwith, New York, 8 août–8 septembre 1891

190. Mlle. Mariquita Gill, New York, 8–30 août 1891

191. Mlle. L. Gill, Boston, 8 août–5 octobre 1891

192. Mlle. Lewis, Canada, 12 août–10 septembre 1891

193. Watson Dawson et sa dame [Dawson Dawson-Watson and Mary Hoyt Sellars], 26 ans, Londres, 19 août 1891–25 février 1892

197. Meteyard [Thomas Buford Meteyard], Boston, 5 septembre 1891–20 février 1892

198. R. Hovey [Richard Hovey], Boston, 5–14 septembre 1891

199. Scherer [Baptist Scherer], Hambourg, 14 septembre–4 décembre 1891

200. Beckington, Miss [Alice Beckington], St. Charles, U.S.A., 27 septembre–26 octobre 1891

201. Beckington, M. M., St. Charles, U.S.A., 27 septembre–19 octobre 1892 [1891?]

203. Herford [Oliver Herford], 24 ans, New York, 15 octobre–24 décembre 1891

204. Fox, New York, 1 décembre 1891–26 mai 1892

205. Peters et sa dame [DeWitt Clinton Peters?], Etats Unis, 21 novembre–4 décembre 1891

207. Elisabeth Robin, 22 ans, Londres, 21–31 décembre 1891

208. Florence Strasburg, 40 [or 20?] ans, Amerique, Cincinnati, Ohio, 31 décembre 1891–9 janvier 1893 [?]

209. Dyce Stirling [J. Stirling Dyce], 28 ans, Ecosse, 30 décembre 1891–11 [?] janvier 1892

210. Patterson H S [Stirling Patterson?], 21 ans, Ecosse, 5–11 janvier 1892

213. Dyce Stirling [J. Stirling Dyce], 28 ans, Ecosse, 3 avril–2 mai 1892

214. Darent Harrison, Londres, 8–11 avril 1892

216. M. Meteyard [Thomas Buford Meteyard], 26 ans, Boston, 20 avril–8 septembre 1892

217. M. Dawson Watson [Dawson Dawson-Watson], 26 ans, Londres, 23 avril 1892–15 mai 1893

218. Mme. W. Scelard, 21 ans, Ecosse, 23 avril–25 mai 1892

219. Hovey R [Richard Hovey], Boston, 24 avril–5 mai 1892

221. Scherer [Baptist Scherer], 22 ans, Hambourg, 3 mai–31 août 1892

222. Hale, M. M. [?], 27 ans, architecte, New York, 8–14 mai 1892

224. Ad. Robbi, 24 ans, Suisse, 20 mai–4 novembre 1892

225. R. S. Robbins [Richard Smith Robbins], 29 ans, Chicago, 19 mai 1892–16 février 1893

226. M. Borgord [Martin Borgord], 26 ans, Norvege, 19 mai–3 juin 1892

227. H. A. Coobb [H. Cobb?], 20 ans, New York, 19 mai–28 août 1892

228. W. W. Manning [William Leslie Manning?], Londres, 22 mai–19 juin 1892

229. M——— [?], Australie, 29 mai–4 juin 1892

230. M et M [?] Harrison, Londres, 2 juin–4 juillet 1892

231. Mme. Gill, 25 ans, 11 juin–29 août 1892

232. Mme. Mariquita Gill, 50 ans, New York, 11 juin–29 août 1892

233. M. Wood, 35 ans, London, 12–15 juin 1892

234. Oberliant F. Fux, 30 ans, Moravie, 16 juin–7 juillet 1892

235. Macdonald, 30 ans, New York, 25 juin–1 juillet 1892

238. G. P. Fidler, 27 ans, Australie, 29 juin–1 août 1892

240. Mlle. Greland, New York, 1–22 juillet 1892

242. Beckington[,] Alice, 23 ans, S. Charles U.S.A., 10 juillet–9 septembre 1892

243. M. et Mme. Mowbray [H. Siddons Mowbray], New York, 11 juillet–1 août 1892

244. Mlle. Rutmels [?], Etats Unis, 18–26 juillet 1892

245. Mme. [?] et Mlle. Edson, 45 [?], 20 ans, Etats Unis, 18–26 juillet 1892

248. M. Chambers [Coutts L. Chambers], 32 ans, Londres, 23 juillet–13 août 1892

249. Mme. Souby-Darque, 28 ans, Paris, 23–25 juillet 1892

250. Mlle. Fontaine, 21 ans, Paris, 23–25 juillet 1892

252. M. Philippe Hale [Philip Leslie Hale], 27 ans, Boston, 6–30 août 1892

253. M. et Mme. Hale pere [Rev. Edward Everett Hale], homme des lettres, Boston, 6–12 août 1892

255. Mlles. Williams [Adele Williams], 20, 22 ans, Richmond, Virginia, 10–27 août 1892

256. M. et Mme. Beckington rentier, 50 ans, Etats Unis, S. Charles U.S.A., 10 août–9 septembre 1892

257. M. Burlangt, 21 ans, 18 août–29 septembre 1892

258. Nicoll, 24 ans, 20 août–24 septembre 1892

259. H. Cobb, 22 ans, New York, 13 septembre 1892–3 mars 1893

260. Mme. Gill, rentier, New York, 13–16 septembre 1892

261. Mme. Mariquita Gill, 25 ans, New York, 13–16 septembre 1892

263. Mlle. Fidler [G. P. Fidler], 27 ans, Australie, 4–15 octobre 1892

265. Brady [Mary C. Brady], 23 ans, San Francisco, 6–10 octobre 1892

266. Bernard Pie, 20 ans, Londres, 13–27 octobre 1892

267. Dyce Stirling [J. Stirling Dyce], 30 ans, (Ecosse), 13 octobre–25 décembre 1892

288. Mme. Beckington, 48, rentier, S. Charles (U.S.A.), 22–29 octobre 1892

289. Mme. Alice Beckington, 23 ans, S. Charles (U.S.A.), 22–29 octobre 1892

290. Manning [William Leslie Manning], Londres, 22 octobre–23 novembre 1892

291. Chambers [Coutts L. Chambers], 32 ans, Londres, 3 novembre 1892–15 mai 1893

292. Dyce Stirling [J. Stirling Dyce], 40 ans, Ecosse, 14 janvier–15 mai 1893

293. Manning [William Leslie Manning], 27 [?] ans, Londres, 15 janvier–15 mars 1893

294. Carrido, 25 ans, Amerique, 24–27 février 1893

295. M. et Mme. Dessart [Louis Paul Dessar], Amerique, 8–20 mars 1893

296. J. Macdonald, 31 ans, Canada, 24 mars–12 avril 1893

297. M. et Mme. G. Obis, 30 ans, architecte, St. Claring Clos [?], 24–30 mars 1893

298. M. et Mme. Friswell [Harry B. Friswell], 32 ans, 31 mars–2 avril 1893

299. Dardel Rene [René Dardel], 22 ans, Paris, 31 mars–5 avril 1893

300. Hunt, 26 ans, Londres, 1–28 avril 1893

301. M. et Mme. Friswell [Harry B. Friswell], 32 ans, Londres, 13 avril, mai 1893

302. Dobson [Alfred Dobson], 30 ans, Londres, 13–22 avril 1893

303. M. Meteyard [Thomas Buford Meteyard], Amerique, 22 avril–23 juin 1893

306. Stenersen [Gudmund Stenersen], Norvege, 22 avril–15 mai 1893

307. J. Macdonald, 31, Canada, 24 avril–7 mai 1893

308. Hunt J, 30 ans, Angleterre, 25 avril–13 mai 1893

310. Steineger[,] Agnes, 30 ans, Bergen, Norvege, 20–28 mai 1893

311. Laache[,] Kristine, 32 ans, Trondhjein, Norvege, 20–28 mai 1893

312. Horneman[,] Sara, 32 ans, Norvege, 20–28 mai 1893

313. Chambers [Coutts L. Chambers], 37 ans, Angleterre, 20 mai–4 juillet 1893

314. Shenerioy [?] [Gudmund Stenersen?], 27 ans, Norvege, 22–26 mai 1893

315. Aguartiz [?], 31 ans, Brooklyn, N.Y., 1–3 juin 1893

317. Dardel[,] Rene, 22 ans, Paris, 12 juin–5 juillet 1893

321. Alf. Dobson [Alfred Dobson], 21 ans, Amerique, 27 juin–24 juillet 1893

312. Mr. [?] Kinsella, Amerique, 27 juin–24 juillet 1893

313. Mme. Morcrette, 30 ans, Paris, 27 juin–8 juillet 1893

314. M. et Mme. Luntley, 30 ans, Londres et Paris, 6–15 juillet 1893

315. Ellen Cohen [Ellen Gertrude Cohen], 25 ans, Londres, 10 juillet 1893–27 avril 1894

316. Mlle. Hall, Ecosse, 18–21 juillet 1893

317. Mlle. Greenfield, Ecosse, 18–21 juillet 1893

318. Wilhem Hyorth, Suede, 19 juillet–2 août 1893

319. Polly King, New York, 20 juillet–15 août 1893

320. Horsfall Charles [Charles M. Horsfall], 26 ans, Angleterre, 30 juillet–2 août 1893

323. M. et Mme. MacMonnies [Frederick MacMonnies and Mary Fairchild MacMonnies], 25 ans, sculpteurs, Etats Unis Amerique, 3–6 août 1893

324. Mme. Ibriglia [?], Paris, 3–12 août 1893

330. M. et Mme. MacMonnies [Frederick MacMonnies and Mary Fairchild MacMonnies], sculpteur et peintre, Etats Unis Amerique, 12 août–4 septembre 1893

331. M. et Mme. Kenyon Cox [Kenyon and Louise Cox], Etats Unis Amerique, 29 août–10 septembre 1893

332. Mr. [?] Kinsella, 28 ans, Amerique, 29 août–5 septembre 1893

333. M. Dobson Alf. [Alfred Dobson], 21 ans, Londres, 20 août–3 octobre 1893

336. M. Laflin, architecte, Etats Unis, 11–20 septembre 1893

337. M. et Mme. Beckington, 40, rentier, S. Charles U.S.A., 11–25 septembre 1893

338. Mme. Beckington [Alice Beckington], 22 ans, S. Charles U.S.A., 11 septembre–15 octobre 1893

339. Chambers [Coutts L. Chambers], 33 ans, London, 12 septembre 1893–20 avril 1894

341. MacMonnies [Frederick MacMonnies], sculpteur, Etats Unis, 1–5 octobre 1893

342. Harrison [?], 19 ans, Londres, 1–7 octobre 1893

343. Jules Girardet, 37 ans, Paris, 13–17 octobre 1893

344. Mlle. Wrihgt [Wright?], Amerique, 17 octobre–15 novembre 1893

345. M. Dobson Alf. [Alfred Dobson], 21 ans, Londres, 8–14 novembre 1893

346. Dyce Stirling [J. Stirling Dyce], 40 Aberdeenshire (Ecosse), 12 novembre 1893–2 mai 1894

351. René Dardel, 23 ans, Paris, 17 février–6 avril 1894

352. Josephine M. Lewis [Josephine Miles Lewis], 25 ans, student, Etats Unis Amerique, [5?]–20 mars 1894

353. Bella Johnson [Belle Johnson], 20 ans, student, Amerique, [?] 16 mars 1894

354. Jeanie D. Pulsifer [Janet D. Pulsifer], 21 ans, student, Amerique, 5–21 mars 1894

355. Helen Hyde, 21 ans, student, Amerique, 5–[?] mars 1894

356. Peixotto, J. S., 21 ans, San Francisco, 8 mars–12 juin 1894

357. Rose[,] Guy, 24 ans, Amerique, 5 mars–1 juin 1894

359. Mlle. G——— [?], 22 ans, Amerique, 27 mars–12 juin 1894

360. Mlle. B. Wardanay [?], 22 ans, Providence, Amerique, 27 mars–1 juin 1894

363. Helen Hyde, 25 ans, student, 19 [?]–27 mars 1894

364. Dobson [Alfred Dobson], 28 ans, Londres, 27 mars–25 avril 1894

365. Mlle. G. Hutchinson, 28 ans, student, Londres, 8–25 avril 1894

368. Josephine Lewis [Josephine Miles Lewis], 21 ans, student, Etats Unis Amerique, 23 avril–2 juillet 1894

369. D. Pulsifer [Janet D. Pulsifer], 21 ans, student, Amerique, 23 avril–2 juillet 1894

370. Helen Hyde, 25 ans, student, Amerique, 23 avril–2 mai 1894

379. Chambers [Coutts L. Chambers], 33 ans, London, 18 mai–29 octobre 1894

380. Mlle. Hutchinson, 28 ans, student, Londres, 18 mai–11 juin 1894

382. M. et Mme. Bekington [Beckington], 40 ans, rentier, St. Charles, MO., 19 mai–11 juin 1894

383. Mlle. Alice Bekington [Alice Beckington], 22 ans, St. Charles, MO., 19 mai–15 juin 1894

384. René Dardel, 23 ans, Paris, 19 mai–5 juillet 1894

385. T. S. Perry et famille [Thomas Sergeant Perry and Lilla Cabot Perry], homme de lettres, 8 juin–18 octobre 1894

386. Dyce Stirling [J. Stirling Dyce], Ecosse, 8 juin–15 juillet 1894

387. Mary Flearew [?], 28 ans, U.S.A., 12–29 juin 1894

388. Henrietta Weaver, 23 ans, California, U.S.A., 12 juin–6 août 1894

389. Ernest Peixotto [Ernest Clifford Peixotto], 21 ans, Californie, 28 [?] juin–8 juillet 1894

390. Mlle. Gill [Mariquita Gill], New York, 25 juin–29 août 1894

393. Mlle. Blaky [Margaret Blakely?], Boston, 9–23 juillet 1894

394. Helene William, Moscou, 24 juillet–7 août 1894

395. Marguerite Klein, Moscou, 24 juillet–7 août 1894

396. G. Neymark, Poitiers, 1 août–5 octobre 1894

400. M——— [?] Boardman, New York, 25 août–15 octobre 1894

401. [?], New York, 27 août–4 octobre 1894

402. Morin [?] Goustiano, architecte, Paris, 4–18 septembre 1894

403. Peixotto, J. S., 21 ans, San Francisco, 30 septembre–25 octobre 1894

404. Mlles. Lewis [Josephine Miles Lewis], Etudiant, Etats Unis Amerique, 3 octobre–10 novembre 1894

405. Mlle. Pulsifer D. [Janet D. Pulsifer], 21 ans, Etudiant, Etats Unis Amerique, 3 octobre–10 novembre 1894

406. Mlle. G. Hutchinson, 28 ans, Etudiant, Etats Unis Amerique, 3–15 octobre 1894

407. M. Radimsky [Václav Radimsky], Etudiant, Autriche (a Kolin), 4 octobre–19 décembre 1894

408. M. F. Peixotto [Florian Peixotto], Etudiant, 4–16 [?] octobre 1894

409. M. Jones, Etudiant, 4 octobre–1 novembre 1894

410. M. Cezanne P. [Paul Cézanne], 57 ans, Aix, 7–30 novembre 1894

411. M. Dyce Stirling [J. Stirling Dyce], [?] ans, Ecosse, 10 novembre–21 décembre 1894

415. M. Dyce Stirling [J. Stirling Dyce], Ecosse, 5 février 10 mai 1895

416. Allen B. Talcott, Etats Unis d'Amerique, 5–28 mars 1895

417. E. Peixotto [Ernest Clifford Peixotto], Etats Unis d'Amerique, 5 avril 1894–21 mai 1894

418. Mlle. Hutchinson [G. Hutchinson], 28 ans, Etats Unis d'Amerique, 6 avril 1894–20 mai 1894

419. Lorb Louis [Louis Loeb], 28 ans, Etats Unis d'Amerique, 7–16 avril 1895

420. D. Pulsifer [Janet D. Pulsifer], 22 ans, Maine, 8 avril–27 juillet 1895

421. Mlle. Lewis [Josephine Miles Lewis], Maine, 8 avril 1895–en loge a Giverny

425. Dlle [?] Cohen Ellen [Ellen Gertrude Cohen], Londres, 16 avril–23 mai 1895

426. Mme. Cohen, Londres, 16 avril–24 avril 1895

427. Harris Wm. L. [William L. Harris], 25 ans, New York, 16–28 avril 1895

428. Blackwell S. E. [S. E. Blackwell], 16–28 avril 1895

429. Hopkinson, M. et Mme. [Charles S. Hopkinson], Etats Unis, 3–10 mai 1895

430. Eyre Mlle. [Louise Eyre?], Etats Unis, 4–10 mai 1895

432. M. Cout Chambers [Coutts L. Chambers], Londres, 13 mai 1895–7 janvier 1896

434. Mr. Dardel Renie [René Dardel], Paris, 17–21 mai 1895

435. Mr. Olbert et son dame, Paris, 19–31 mai 1895

436. Mme. Nelly [?] Driver, Boston, 22 mai–12 juillet 1895

446. Mr. and Mrs. Wynford Dewhurst, Manchester, 14–18 juin 1895

447. Newmann M. et Mme. [Carl Newman], 30 ans, Philadelphia, 14 juin–27 octobre 1895

448. Blenner [Carle John Blenner?], 29 [?], New York, 14 juin–3 juillet 1895

449. Mr. J. W. Nicoll, 26 ans, Etats Unis Amerique, 25 juin–4 septembre 1895

451. Mellou, 27 ans, Angoulems, 25–30 juin 1895

458. M. John Doures [?], 25 ans, Etats Unis, 6 juillet–15 octobre 1895

461. Augustus Vincent Tack, 25 ans, Etudiant, Pittsburgh, E.U., 15 juillet–27 août 1895

462. Geo. W. Breck [George W. Breck], 32 ans, Etudiant, Washington, 15 juillet–1 septembre 1895

464. Albert Thompson [George Albert Thompson], 23 ans, Washington, 24 juillet–15 octobre 1895

465. M. et Mme. Hovey [Richard Hovey], litterateurs, New York, 24 juillet–10 août 1895

469. Mme. Stephanie Nantas, 20 ans, modele, Paris, 30 juillet–25 septembre 1895

470. Mr. Forbes, 35 ans, New York, 30 juillet–15 août 1895

474. Mme. Gill, 40 ans, rentier, New York, 14 août–30 septembre 1895

475. Roland Rood, 25 ans, New York, 18–28 août 1895

476. Mon. Mme. Hovey [Richard Hovey], poete, New York, 20 août–21 décembre 1895

479. M. Mme. Loob [Louis Loeb], 40 ans, New York, 28 août–8 octobre 1895

483. Radimsky [Václav Radimsky], 30 ans, Koln, Autriche, 1–12 octobre 1895

485. M. Dewhurst [Wynford Dewhurst], 24 ans, Manchester, 8–12 octobre 1895

486. Mlle. Wolff, 25 ans, Hambourg, 24–26 octobre 1895

487. Mlle. Rosen, 25 ans, Hambourg, 24–26 octobre 1895

489. M. Dyce Stirling [J. Stirling Dyce], Ecosse, 20 octobre–21 décembre 1895

490. M. Dyce Stirling [J. Stirling Dyce], Ecosse, 2 mars–5 mai 1896

492. Ch. Psotta [Charles Psotta], Etats Unis, 5–19 avril 1896

493. Canfield, Birtley K. [Birtley King Canfield], Etats Unis, 5–19 avril 1896

494. Coutts Chambers [Coutts L. Chambers], Londres, 9 avril–20 juin 1896

495. Alexander Harrison, 43 ans, Etats Unis, 15–18 avril 1896

496. Alonzo St. George Huntington, 28 ans, Etats Unis, 15 avril 1896–14 avril 1897

497. Harrisson Alexandre [Alexander Harrison], 40 ans, Etats Unis, 15–18 avril 1896

498. Geo. H. Leonard, Jr. [George H. Leonard, Jr.], Etats Unis, 16–17 avril 1896

499. Leandro R. Garrido, 25 ans, Etats Unis, 25–26 avril 1896

500. H. Anthony Dyer, Etats Unis, 9–13 mai 1896

501. M. et Mme. Richardson, 25 ans, Amerique, 11–17 mai 1896

502. Mlle. Simpson, 21 ans, Amerique, 18 mai–27 juin 1896

504. M. Gro. Leonard, Jr. [George H. Leonard, Jr.], 25 ans, Amerique, 21–28 mai 1896

506. M. et Mme. A. S. Calder [Alexander Stirling Calder], 22 ans, etudiant, 27 mai–8 juin 1896

508. Wright[,] Anna, 25 ans, Amerique, 27–31 mai 1896

509. L. R. Garrido [Leandro R. Garrido], 25 ans, Amerique, 30 mai–1 octobre 1896

510. John D. Downes [John Ireland Howe Downes], 32 ans, Amerique, 30 mai–14 septembre 1896

512. Mlle Bougton Dreigh [?], Boston, 1 juin–27 août 1896

514. Albert Thompson [George Albert Thompson], 24 ans, Washington, 4 juin–2 octobre 1896

515. Matilda Lewis, 24 ans, etudiante, Boston, 4–13 juin 1896

516. Josephine Lewis [Josephine Miles Lewis], 24 ans, etudiante, Boston, 4–13 juin 1896

517. Mlle Williams, 20 ans, Amerique, 10–13 juin 1896

518. Mlle Blake, 18 ans, Amerique, 10–17 juin 1896

519. M. et Mme. DeKnatal, 25 ans, Chicago, 12–18 juin 1896

520. Miss A. Stackpole [Alice Stackpole], 22 ans, Boston, 13–26 juin 1896

521. Miss A. P. Hogood [?], 20 ans, Boston, 13–26 juin 1896

524. Carette, 30 ans, Paris, 19–21 juin 1896

526. Hunldengtoo [?], Douglas, 22 ans, Etats Unis Amerique, 21 juin–4 août 1896

528. Blanche Dillaye, 1–21 juillet 1896

529. M. et Mme. E. D. Connell [Edwin D. Connell], 33 ans, Amerique, 11 juillet–29 août 1896

530. Laura Glenn, 23 ans, New York, 20 juillet–11 août 1896

531. Helene Glenn, 26 ans, New York, 20 juillet–11 août 1896

532. Mlle. Baumes, 25 ans, New York, 21 juillet–3 septembre 1896

535. M. Reykert, 25 ans, Amerique, 8–13 août 1896

536. Sfoane, 25 ans, Amerique, 8–13 août 1896

539. M. et Mme. A. S. Calder [Alexander Stirling Calder], Amerique, 17–25 août 1896

540. A. Lonsot, 25 ans, architecte, Paris, 17–25 août 1896

541. Fill [Till?], 30 ans, Amerique, 24–28 août 1896

543. Mlle. Chester [Minnie Edna Chester?], 25 ans, Amerique, 7 septembre–5 octobre 1896

545. Mlle. Ellen Glenn, 22 ans, New York, 24 septembre–4 octobre 1896

547. Poulain, 45 ans, Paris, 25 octobre–5 décembre 1896

555. Charles Psotta, 31 ans, Philadelphie, 29 mars–3 avril 1897

556. Mlle. Josephine Lewis [Josephine Miles Lewis], etudiante, Boston, 13–20 avril 1897

557. Mlle. Matilda Lewis, etudiante, Boston, 13–20 avril 1897

558. Mlle. Carou, 21 ans, Etats Unis, 15–21 avril 1897

559. Mr. Carou, 21 ans, Etats Unis, 15–21 avril 1897

560. Mr. Psotta [Charles Psotta], 31 ans, Philadelphie, 15–22 avril 1897

561. Mlle. Taft, 25 ans, New York, 16–22 avril 1897

568. Mr. St. George Huntington [Alonzo St. George Huntington], Etats Unis, 14–16 mai 1897

570. M. G. Melidion, Paris, 6–25 mai 1897

571. Mme. Underwood et sa fille, Etats-Unis, 10–29 mai 1897

572. M. et Mme. Callender, Etats-Unis, 13 mai–23 juin 1897

573. M. M. Lauvraq, Paris, 4–20 juillet 1897

574. Frank Colfax, New York City, 17 juillet–30 août 1897

575. Mon. Thompson [George Albert Thompson], Etats Unis, 20 juillet–21 août 1897

578. Florian Peixotto, San Francisco, 21–28 juillet 1897

579. B. Robert Bechtel, Pensylvannie, 21–28 juillet 1897

580. Mlle. Helen Bechtel, Pensylvannie, 21–28 juillet 1897

581. Mlle. Margery Childs, Pensylvannie, 21–28 juillet 1897

591. Mlle. Bull, New York, 19–20 août 1897

592. Mme. Maudbuch [?], sculteur, Boston, 22 août–10 septembre 1897

608. Mr. Lesimple, 47 ans, St. Lubain des Ouche [?], 14–15 décembre 1897

609. A. Duclos [Adolph Duclos], 32 ans, Ste. Barbe Eure, 14–18 décembre 1897

614. O. H. Root [Orville Hoyt Root], 30 ans, Etats Unis, 2–14 mars 1898

615. Louis Loeb, 30 ans Etats Unis, 2–14 mars 1898

618. Monsieur St. George [Alonzo St. George Huntington?], Etats Unis, 16–20 mars 1898

619. Wynford Dewhurst, Engleterre, 21–30 avril 1898

620. Didier-Pouget, Toulouse, 21–22 avril 1898

622. Alice M. Curtis [Alice Marian Curtis], Boston, U.S.A., 4–21 mai 1898

626. B. R. Bechtel [B. Robert Bechtel], U.S.A., 29 mai–4 novembre 1898

628. Emmanuel Potes, 37 ans, Rouen, 26–29 juin 1898

630. A. G. Collins [Arthur George Collins], 32 ans, Boston, U.S.A., 13–20 juillet 1898

631. C. S. Rocheau [?], architecte, Etats Unis, 13–15 juillet 1898

632. M. Psotta [Charles Psotta], Philadelphie, 14–15 juillet 1898

634. K. McCausland [Katherine McCausland], Irlande, 7 juillet–9 novembre 1898

635. Mary Lusk [Marie Koupal Lusk?], New York, 21–28 juillet 1898

636. Anna Lusk, New York, 21–28 juillet 1898

640. Mr. Pope [John Russell Pope?], architecte, Boston, 22–24 juillet 1898

643. Miss G. Rosenberg, 25 juillet–4 octobre 1898

647. E. W. Brown [Ethelbert W. Brown?], Arizona, 26 juillet–27 octobre 1898

649. Mr. Van Vorsht, 21 août–10 septembre 1898

653. Mme. Rouvray [?], 26 ans, Brest, 26 août–5 novembre 1898

654. Abrams [?] [Lucien Abrams?] New York, 10–20 septembre 1898

655. Mlle. A. Haferdt [?], Silesie, 10 septembre–17 novembre 1898

657. J. R. Pape [John Russell Pope?], 42, architecte, New York, 12–14 novembre 1898

658. F. C. Lee, 24 ans, architecte, New York, 10–15 novembre 1898

659. ———— [?] McR. Wyett [?] 20 ans, architecte, New York, 10–15 novembre 1898

[661.] G. Loiseau [Gustave Loiseau], 34 ans, Paris, 2–3 mars 1899

666. L. Gimett [Louis Ginnett], 23 ans, Leamington, 23–30 avril 1899

667. M. M. Mauvaring [?], England, 23 avril–5 mai 1899

668. H. C. Blackden [Hugh Blackden], 27 ans, Folkestone, 23 avril–5 mai 1899

670. Mr. et Mme. Albert Joseph, 31 et 25, Paris, 5–21 mai 1899

671. M. et Mme. Rose Guy [Guy and Ethel Rose], 32 ans, New York, 24 mai 1899

674. Juliana MacMonnies, 55 ans, New York, 4–17 juin 1899

681. B. R. Bechtel [B. Robert Bechtel], Philadelphie, 21 juin–10 juillet 1899

682. Mlle. Bechtel [Helen Bechtel], Philadelphie, 21 juin–10 juillet 1899

693. Mr. et Mme. Doodge [William de Leftwich Dodge], New York

ACKNOWLEDGMENTS

The genesis of this book lies in my previous studies of American Impressionism—above all, the volume published by Abbeville Press in 1984. Writing those histories brought about the realization that the Giverny art colony was both a part of that history and yet also something unique. I was encouraged by Abbeville to pursue this subject, and it became a fascinating topic to consider as I worked on the study of regional American painting that became the three-volume *Art Across America* (Abbeville, 1990). That work deals with painters throughout the United States; this one is concerned with artists, primarily from America, working abroad.

Studying the evolution of an artists' colony, at least one with the longevity of Giverny, proved to be a dynamic and intriguing process. The only major disappointment was our inability to locate works painted in Giverny by so many of the non-American artists, including a few, such as the English painter William Rothenstein, who are well known and well regarded in their native lands. Perhaps the present volume will encourage the emergence of such works and thus yield additional rewards.

Many individuals have assisted me in the preparation of this volume. Among the many to whom I owe a debt of gratitude, I want to single out especially Nancy S. Allen, David Bahssin, James Ballinger, Ben L. Bassham, Michael Borghi, Katherine Emmet Bramwell, Richard B. Brettell, Alson Clark, Charles T. Clark, Mrs. Timothy Coggeshall, Elizabeth de Veer, Peter Hastings Falk, Nan Greacen Faure, Ilene Susan Fort, Sophie Fourny-Dargère, Ross Fox, Helen K. Fusscas, Ruth Nickerson Greacen, Mrs. Sherry L. Hamilton, Bev Harrington, Erica Hirshler, Susan Hobbes, Martha Hoppin, Raymond Inbona, Marie Louise Kane, Robert J. Killie, Nicholas Kilmer, Leftwich D. Kimbrough, William Kloss, Marit Lange, Richard H. Love, Kenneth McConkey, Alan B. Macnee, David Madigan, Sally E. Mansfield, Edward Morris, Priscilla Muller, Joan Murray, Lin Nelson-Mayson, Natasa Nikitinova, Debra Petke, Alena Pomajzlová, Lewis Hoyer Rabbage, John Rewald, Joseph J. Rishel, Beverly Rood, Roy C. Rose, Martha R. Severens, Jean Stern, Lise C. Swensson, Theodore C. Taylor, Diane Tepfer, Elaine C. Tillinger, Bruce Weber, Deedee Wigmore, and Laura Wortley.

There was a smaller group of scholars who were always at the ready to satisfy my constant importuning for assistance, information, and opinion, though I expect I often drove them to distraction. Special gratitude, then, goes to Shanon Aaron, Jeffrey Brown, Tara Collins, Kathryn Corbin, Betsy Fahlman, Sona Johnston, Merl M. Moore, Jr., Henry M. Reed, and Mary Smart. And as always, Christine Hennessey and her colleagues at the Inventories of American Painting and Sculpture of the Smithsonian Institution generously and speedily answered my every request for information concerning the works of artists who painted, who possibly painted, and a few who, it turned out, never painted, in Giverny.

Several colleagues among my graduate students and assistants made yeoman's efforts in researching and retrieving material, often from obscure sources on obscure artists. I want to acknowledge especially David Dearinger, Lorraine Kuczek, and Mary Elizabeth Boone. Carol Lowrey, my associate on this project, provided countless insights, corrected errors of fact and judgment, and has been a joy to work with. A special debt of gratitude is due Ira Spanierman, who supported this project with both faith and funding—the material provided in this book would not be as rich as it is without his backing. Finally, my heartfelt appreciation to the two individuals whose support and guidance have, in the long run, made this publication possible—my editor, now as heretofore, Nancy Grubb, and, as always, my wife, Abigail.

NOTES

Abbreviations for Frequently Cited Sources

AAA Archives of American Art, Smithsonian Institution, Washington, D.C.

Burrage Mildred Giddings Burrage, "Arts and Artists at Giverny." *World To-Day* 20 (March 1911): 344–51.

PLH Philip Leslie Hale Papers, Archives of American Art, Smithsonian Institution, Washington, D.C.

DDW Dawson Dawson-Watson, "Things Remembered," unpaginated manuscript, Dawson-Watson family archives.

Low Will Low, *A Chronicle of Friendships, 1873–1900* (New York: Charles Scribner's Sons, 1908).

Perry Lilla Cabot Perry, "Reminiscences of Claude Monet from 1889 to 1909," *American Magazine of Art* 18 (March 1927): 119–25.

TR Theodore Robinson, diaries, March 1892–March 1896, Frick Art Reference Library, New York.

Sellin David Sellin, *Americans in Brittany and Normandy, 1860–1910* (Phoenix: Phoenix Art Museum, 1982).

Claude Monet in Giverny (pages 7–19)

1. Charlotte Warton, "A Girl-Student's Year in Paris," *Jenness Miller Magazine* 5 (March 1891): 453.

2. Burrage, p. 348.

3. Ibid., p. 347.

4. Abbé Anatole Toussaint and Jean-Pierre Hoschedé, *Flore de Vernon et de la Roche-Guyon* (Rouen, France: Julien LeCerf, 1898).

5. Butler to Hale, n.d., PLH.

6. Monsieur Monet, que l'hiver ni
 L'été sa vision ne leurre,
 Habite en peignant, Giverny,
 Sis auprès de Vernon, dans l'Eure.

(Mallarmé, in Wynford Dewhurst, *Impressionist Painting: Its Genesis and Development* [London: George Newnes; New York: Charles Scribner's Sons, 1904], p. 45.) Translation by Carol Volk.

The First Generation (pages 21–61)

1. Copley to Henry Pelham, September 2, 1774, in "Letters and Papers of John Singleton Copley and Henry Pelham, 1739–1776," *Collections of the Massachusetts Historical Society* 71 (1914): 243.

2. Evan Charteris, *John Sargent* (New York: Charles Scribner's Sons, 1927), p. 130.

3. René Gimpel, *Diary of an Art Dealer* (New York: Farrar, Straus and Giroux, 1966), p. 75.

4. Monet noted Sargent's presence in Giverny in a letter to Auguste Rodin written on June 5, 1887. See Daniel Wildenstein, *Claude Monet: Biographie et catalogue raisonné*, 4 vols. (Lausanne, Switzerland: Bibliothèque des Arts, 1974–85), 3: 223. For Sargent's visits in 1888 and 1889, see Stanley Olsen, *John Singer Sargent: His Portrait* (New York: St. Martin's Press, 1986), p. 150.

5. See Trevor J. Fairbrother, *The Bostonians: Painters of an Elegant Age, 1870–1930* (Boston: Museum of Fine Arts, 1986), p. 50. Robert Herbert has also made this identification; see John House, *Monet: Nature into Art* (New Haven, Conn.: Yale University Press, 1986), p. 233 n. 16.

6. Sargent to James Wall Finn, June 6, 1891, courtesy of David Madigan.

7. Paulette Howard-Johnston, "Une Visite à Giverny en 1924," *L'Oeil* 171 (March 1969): 28–33, 76.

8. Metcalf collected birds' eggs, a popular hobby of the period; one of these, a blackbird's egg, is marked "May, 1885" and listed in his bird-nesting records as having been found in Giverny. See Elizabeth de Veer, "The Life," in de Veer and Richard J. Boyle, *Sunlight and Shadow: The Life and Art of Willard L. Metcalf* (New York: Abbeville Press, 1987), pp. 37 and 256 n. 13.

9. Pierre Toulgouat, "Skylights in Normandy," *Holiday* 4 (August 1948): 67.

10. Ibid.

11. Claire Joyes, *Monet at Giverny* (New York: Mayflower, 1975), p. 25. Metcalf's presence in Giverny in May and June 1886 is again confirmed by annotated birds' eggs; see Joyes's n. 2. She states that Metcalf returned to Giverny with two friends; Toulgouat, "Skylights in Normandy," enlarges the number to "four friends from the Académie" Julian, but this may be a confusion with the seven artists who arrived in 1887.

12. A rough drawing for Metcalf's *Sunny Morning in September* appears in his sketchbook (Willard L. Metcalf Papers, AAA) enumerating the works to be shown in his second one-artist show, held at the St. Botolph Club in Boston in March 1889. The sketch is annotated "Giverny in Sept." and its dimensions correspond to those of the oil painting.

13. Edward Breck, "Something More of Giverny," *Boston Evening Transcript*, March 9, 1895, p. 13.

14. Dawson Dawson-Watson, "The Real Story of Giverny," in Eliot Clark, *Theodore Robinson: His Life and Art* (Chicago: R. H. Love Galleries, 1979), pp. 65–67.

15. See Joan Murray, ed., *Letters Home: 1859–1906: The Letters of William Blair Bruce* (Moonbeam, Canada: Penumbra, 1982), pp. 123–63.

16. Greta [pseud.], "Boston Art and Artists," *Art Amateur* 17 (October 1887): 93. As Greta indicated, Metcalf, Breck, Ritter, and Wendel were all identified with Boston, though none had been born there. The paintings of Wendel and Ritter were judged to be similar, and their friendship led them, after Ritter's death at age thirty-eight in 1892, to be considered as having jointly "discovered Claude Monet." ("Art Notes," *Boston Evening Transcript,* April 21, 1885, p. 6; H.M.K. [Helen M. Knowlton], "The Discoverer of Monet," *Boston Evening Transcript,* May 9, 1893, p. 4. I am grateful to Merl M. Moore, Jr., for these citations and for many other Boston newspaper references.)

17. J. F. Ráfols, *Diccionario de artistas de Cataluña, Valencia y Baleares* (Barcelona-Bilbao: Edicions Catalanes and La Gran Enciclopedia Vasca, 1981), 5: 1369. I am grateful to Dr. Priscilla Muller of the Hispanic Society, New York, for locating this reference.

18. Bruce to Janet Bruce, June 24, 1887; in Murray, ed., *Letters Home,* p. 123.

19. DDW. Dawson-Watson's most ambitious picture done in Great Britain was a depiction of his wife picking flowers in an old Welsh garden (Boston art market). The painting was denigrated as a sentimental, commercial, "Kiss-Mammy" image, and Dawson-Watson was advised to return to France and to his Impressionist work, which he did.

20. Dawson-Watson, in Emily Grant Hutchings, "Art and Artists," *St. Louis Globe-Dispatch,* July 12, 1925.

21. "Sad news for you my dear boy—not only your dear old land-lord Mister Singeot is dead—but also the calf." Butler to Hale, March 8, 1894, PLH.

22. William Howard Hart, interview with Gertrude Hanna, for Arthur J. Kennedy's proposed biography of Hale, February 1932, p. 8, PLH.

23. Henry Prellwitz, interview with DeWitt Lockman, January 10, 1927, DeWitt Lockman Papers, New-York Historical Society. Both Prellwitz and Hart await modern scholarly study.

24. William Rothenstein, *Men and Memories: Recollections of William Rothenstein, 1872–1900* (London: Faber and Faber, 1931), pp. 49–50. See also Robert Speaight, *William Rothenstein: The Portrait of an Artist in His Time* (London: Eyre and Spottiswoode, 1962), pp. 27–31. I am grateful to my colleagues Kenneth McConkey, of the University of Northumbria at Newcastle, and Edward Morris, of the Walker Art Gallery in Liverpool, for their assistance regarding the British artists in Giverny.

25. "Obituary Notes," *Studio* 7 (August 20, 1892): 308.

26. Cherry exhibited in December 1889 with the Denver Paint and Clay Club, showing several Normandy—and therefore very possibly Giverny—landscapes. See Denver Paint and Clay Club, *First Annual Exhibition,* December 1889, Bromwell Scrapbook, Collection no. 79, Stephen H. Hart Library, Colorado Historical Society, Denver. I am tremendously grateful to Sally E. Mansfield of the Denver Art Museum for her assistance in regard to Cherry.

27. Margaret Perry, interview with Thomas N. Maytham of the Museum of Fine Arts, Boston, October 31, 1966 (Perry Papers, Library of the Museum of Fine Arts, Boston); in Meredith Martindale, *Lilla Cabot Perry: An American Impressionist* (Washington, D.C.: National Museum of Women in the Arts, 1990), p. 22. My thanks for this reference to Nancy S. Allen, chief librarian of the Museum of Fine Arts, and to Sona Johnston.

28. Theodore Robinson wrote from Giverny to Thomas Sergeant Perry in Paris to inform him that everything was ready for their arrival at the hotel. He told him that the town was very quiet, with only two "pensionnaires" in residence beside himself. (Robinson to Perry, June 9, 1891, Perry Papers, Museum of Fine Arts, Boston.)

29. Virginia Harlow, *Thomas Sergeant Perry: A Biography* (Durham, N.C.: Duke University Press, 1950), p. 110.

30. See Florence Lewison, "Theodore Robinson and Claude Monet," *Apollo* 78 (September 1963): 208–11.

31. TR, May 22, 1892.

32. Daniel Wildenstein, *Claude Monet: Biographie et catalogue raisonné,* 4 vols. (Lausanne and Paris: La Bibliothèque des Arts, 1974–85), 3: 47, taken from the *Registre d'état civil de Giverny, 1891–1900, année 1892,* n. 3. Of course, Monet and Alice could not have married prior to the death of her husband, Ernest Hoschedé, in 1891.

33. Kimball's essay appeared as an introduction to the catalog for the *Memorial Exhibition of Paintings by John Leslie Breck* (Boston: St. Botolph Club, 1899). Kimball's authorship was not acknowledged there, but it was given when the essay was reprinted at the time the *Memorial Exhibition* was reassembled, with some changes, and shown at the National Arts Club in New York the following February.

34. *Boston Sunday Globe,* March 19, 1899; in Kathryn Corbin, "John Leslie Breck, American Impressionist," *Antiques* 134 (November 1988): 1145. This article is the most significant published writing on Breck. I am tremendously indebted to Ms. Corbin and to Jeffrey Brown for their assistance on this project, particularly in regard to Breck's life and art.

35. Harlow, *Thomas Sergeant Perry,* pp. 110–11.

36. Perry, p. 119.

37. T. Perry, in Harlow, *Thomas Sergeant Perry,* pp. 110–11.

38. Perry, p. 119. There seems to be some confusion about when the Perrys took the first of the several houses they occupied in Giverny. Martindale (*Lilla Cabot Perry,* p. 25) states that this occurred during their first summer, in 1889, but the Hôtel Baudy

register seems quite clear that the family remained at the hotel for that summer.

39. A thorough study of the Impressionist techniques developed by some of the leading American painters working at Giverny can be found in "Claude Monet and the American Coterie in Giverny," in Laura L. Meixner, *An International Episode: Millet, Monet and Their North American Counterparts* (Memphis, Tenn.: Dixon Gallery and Gardens, 1982), pp. 123–61.

40. "Monthly Record of American Art," *Magazine of Art* 12 (June 1889): xxv.

41. When teaching at his summer school in Matunuck, Rhode Island, Hale advised his students to bring "plenty of chrome yellow no. 1. It is well to anticipate the yellow fever." Cited in Erica E. Hirshler, "Philip Leslie Hale," in Fairbrother, *Bostonians,* p. 211.

Even though *Girl with Birds* is annotated "Giverny 1894," it seems unlikely that Hale was in Giverny that year. On May 8, 1894, Butler wrote to him from Giverny that he "had hoped that you might be over here this summer [but] that we have lost said hope." And Butler wrote to Hale again on July 14, with no suggestion that he was expecting his friend to visit Giverny that summer. (Both letters, PLH.) It is possible that the picture was postdated, with the recollection that it was painted in Giverny but the date incorrectly recalled.

42. That Hale was familiar with the art of Martin and Segantini is established in his art reviews for the Montreal-based art magazine *Arcadia.* See Philip Hale, "Art in Paris," *Arcadia* 1 (January 1, 1893): 375; see also Fairbrother, *Bostonians,* p. 59.

43. The Hale correspondence put together by Kennedy is now part of PLH. Carol Lowrey, "The Art of Philip Leslie Hale," in *Philip Leslie Hale, A.N.A.* (Boston: Vose Galleries, 1988), pp. 3–11.

The Boston artist William MacGregor Paxton insisted that Hale came under the influence of Impressionism and started experimenting in that mode in the summer of 1889 or 1890. (Paxton, in A.W.K., "The Philip L.

Hale Memorial Exhibition," *Bulletin of the Museum of Fine Arts* [Boston] 29 [December 1931]: 116.) Paxton gave the year as 1889 but stated that it was the same year that Hale first showed with the (new) Salon, and the (new) Salon did not begin until 1890.

44. "Mr. Metcalf's Exhibition in the Gallery of the St. Botolph Club," *Boston Evening Transcript,* March 21, 1889, p. 4.

45. "Fine Arts," *Boston Sunday Herald,* March 24, 1889, p. 13.

46. One critic wrote on March 21, 1889, that Wendel had returned to Boston "about two months since"; Metcalf had gone back in December 1888. ("The Breakfast Table," *Boston Daily Advertiser,* March 21, 1889, p. 4.)

47. Ibid.

48. "Fine Arts," p. 13.

49. "Metcalf's Exhibition," p. 4.

50. Wendel's chronology is complicated by the appearance of *Flowering Fields, Giverny* (plate 57), which is dated 1889. This hardly seems to be a winter scene, yet the picture appears to be a plein-air composition rather than one painted from memory. No documentation has been found of a return trip to Giverny that year, but by the end of April, Wendel was teaching in Newport, Rhode Island, as noted by Anna Hunter (Hunter Family Diaries, Newport Historical Society). The painting therefore may have been incorrectly postdated.

51. Pamela Moffat, one of the curators of the 1990 Lilla Cabot Perry exhibition at the National Museum of Women in the Arts, has identified the figure in this picture as the artist's daughter Edith. If this is correct, then the age of the sitter probably dates the painting to 1889, the Perrys' first season in Giverny. (Ira S. Carlin to author, October 22, 1991.)

52. Perry, p. 120.

53. Murray, ed., *Letters Home,* p. 20. Dr. Ross Fox, who is currently working on Bruce, concurs with my belief that Bruce was the pacesetter among the original colonists, and that, if there was any transmitted influence, it would

have been Bruce's upon Robinson. (Fox to author, July 29, 1992.)

54. I am indebted to Dr. Fox for bringing this work to my attention.

55. *November* is also a touching depiction of a fellow Giverny artist, Mary Brady. Robinson's diary for 1892 is full of references to Brady's role in the evolution of the painting. November 9: "Lovely, quiet mild day. The leaves are almost all gone and rains have darkened things, especially the pretty carpet of yellow leaves, alas always very fugitive. Still the landscape has plenty of charm. Began one by the brook with figure in cloak (Miss Brady)—took two photos yesterday." November 10: "Beautiful grey day and mild. . . . Worked all day near the brook on my 'garden' and landscape with Miss Brady." November 16: "Miss Brady posed for me at the little brook. . . ."

The subject here is presumably the landscape and still-life painter Mary C. Brady, an artist from San Francisco and one of the first women to stay at the Hôtel Baudy, registered there September 23–December 3, 1889; May 29–June 20, 1890; and October 6–10, 1892. Presumably, she was residing elsewhere in the village when Robinson painted *November.*

56. TR, January 9, 1893: "I must do differently—and for the next exhibition make some from nature, instead of using photos and studies." On January 1, 1895, he complained about "too much photo, too little model, time, etc.," and on February 2 he noted "using (and trusting too much) on photographs."

57. Twachtman, quoted from the Breck family archives in Kathryn Corbin, "John Leslie Breck, American Impressionist," *Antiques* 134 (November 1988): 1142.

58. A show of Breck's paintings at the St. Botolph Club in November 1890 was the art sensation of the season, though the critics were generally negative, recognizing that the inroads of Impressionism were far greater in Breck's work than in the shows by Wendel and Metcalf they had reviewed the previous year.

59. Although the entire series was shown in *Paintings by John Leslie Breck,* Chase's Gallery, Boston, 1893, nos. 25–39, the three now-missing examples had become separated from the rest by the time the twelve known works were shown in the *Memorial Exhibition of Paintings by John Leslie Breck,* National Arts Club, New York, 1900, nos. 42–53. (See Corbin, "Breck," p. 1149 n. 16.) Edward Breck wrote a poem, "The Day (On Seeing John Leslie Breck's 'Studies of an Autumn Day')." (Typescript in Breck family archives.)

60. Louisa Trumbull Cogswell, "Art in Boston," *Arcadia* 1 (February 1, 1893): 404.

61. Robinson originally had considered painting only two contrasting pictures. He began the first on June 4, "charming in morning sunlight," and planned a second "with cloud shadows." (TR, June 4, 1892.) He began the third, "the gray day one" on June 9, noting that the "effect changed little in 2½–3 hours."

62. [Lilla Cabot Perry], *Informal Talk Given by Mrs. T. S. Perry to the Boston Art Students' Association in the Life Class Room at the Museum of Fine Arts, Wednesday, Jan. 24, 1894* (Boston: Boston Art Students' Association, 1894).

63. TR, November 21, 1894.

64. Dawson Dawson-Watson, "Impressionism," manuscript, 1894, Dawson-Watson family archives.

Painting the Town (pages 63–99)

1. "I weathered two or three showers on the side hill this morning and then gave up the study as a bad job—pure landscape is too hard for me. I know too well how it should look to be satisfied with what I do." (J. Carroll Beckwith, diaries, August 19, 1891, Archives of the National Academy of Design, New York.) I have been greatly assisted in regard to Beckwith by Beverly Rood, the authority on the artist, and I am tremendously grateful for her transcription of the Giverny entries from these diaries.

In his "Record of Pictures" (James Carroll Beckwith Papers, AAA), Beckwith lists "6 can-

vases at Giverny 20x24." In the 1910 Beckwith collection sale, three of these six works—*Sewing in the Garden (Giverny),* no. 37; *Josephine in the Garden,* no. 49; and *Weeding the Garden,* no. 116—were offered, but none has yet resurfaced. (*The Collection of Carroll Beckwith, N.A.,* sale held at American Art Galleries, New York, April 14 and 15, 1910.)

2. Guy Rose, "At Giverny," *Pratt Institute Monthly* 6 (December 1897): 81–82. (This article was discovered by Ilene Susan Fort.)

3. A twenty-page pamphlet by Celin Sabbrin [Helen Cecilia De Silver Abbott], *Science and Philosophy in Art* (Philadelphia: Wm. F. Fell, 1886), offers an analysis of Impressionism based primarily on these two pictures; it was immediately translated into French and published in the short-lived avant-garde review, *La Vogue.*

4. Perry's *Haystacks, Giverny* is undated, but in 1933 it was given the date "1896?" in the *Memorial Exhibition of Paintings by Lilla Cabot Perry* held at the Boston Art Club.

5. John House, *Monet: Nature into Art* (New Haven, Conn.: Yale University Press, 1986), pp. 197–98.

6. See especially Robert Herbert, "Method and Meaning in Monet," *Art in America* 67 (September 1979): 106; and Paul Hayes Tucker, *Monet in the '90s* (Boston: Museum of Fine Arts; New Haven, Conn.: Yale University Press, 1989), pp. 65–99.

7. See Julia Rowland Myers, "The American Expatriate Painters of the French Peasantry, 1863–1893" (Ph.D. diss., College Park, University of Maryland, 1989).

8. Beckwith, diaries, August 29, 1891.

9. Peter Robertson, "Peixotto and His Work," *Out West* 19 (August 1903): 134–37.

10. In Metcalf's diagrammatic sketches of the pictures included in his one-one-man show held in March 1889, at the St. Botolph Club (Willard L. Metcalf Papers, AAA), he put quotation marks around the word "Auberge." This may have been to distinguish the French word from the rest of the title written in English, or it may have been an indication that the

building was only referred to as an inn or that it had served that role in the past but was not functioning as such in 1887–88. Above the inscription on the sketchbook sheet he had crossed out an alternative title: "The Hillside farm from below," and below the drawing, again crossed out, appears "St. Genevieve," referring to Saint-Geneviève-les-Gasny, a very small community, with a mill on the Epte, between Giverny and Gasny.

11. In *Les Artistes américains à Giverny* (Vernon, France: Musée Municipal A.-G. Poulain, 1984), p. 15, it is suggested that Dyce arrived in Giverny earlier, around 1887.

12. TR, October 12 and October 25, 1892.

13. TR, September 5, 1892. Historians have long acknowledged the similarities between the work of Robinson and Pissarro, both thematically and formally. See, most recently, William Kloss, introduction to *The Figural Images of Theodore Robinson, American Impressionist* (Oshkosh, Wis.: Paine Art Center and Arboretum, 1987), pp. 26–27.

14. Richard R. Brettell to author, June 1, 1992. Brettell believes that Pissarro and Monet met more often in Paris than in Giverny.

15. Hart to Hale, February 17, 1894, PLH.

16. Hamlin Garland, *Roadside Meetings* (New York: Macmillan Co., 1930), pp. 30–31.

17. TR, October 30, 1892.

18. Robinson, in Sona Johnston, *Theodore Robinson, 1852–1896* (Baltimore: Baltimore Museum of Art, 1973), p. 49.

19. J. Carroll Beckwith noted in his diary of August 8, 1891, that, on being met at the train station in Vernon by John Leslie Breck, "we drove over with the two Miss Gills who came also." (Beckwith, diaries.)

20. J.I.H.D. [John Ireland Howe Downes], *Mariquita Gill* ([New Haven, Conn.?]: Tuttle, Morehouse and Taylor, [1915?]), p. 17.

21. Downes's pamphlet (ibid.) is the only significant source for information on Gill. In the Baudy register, Gill consistently listed her place of birth as New York (City); the cita-

tion to Montevideo is from Downes, who presumably received his information from Gill's mother. I am grateful to my friend and colleague Dr. Betsy Fahlman for bringing these references to my attention and for information on Downes, brother of the noted Boston critic and art historian William Howe Downes. Rose O'Connor, of Comenos Fine Arts, Boston, has been studying Gill's life and art.

22. Information received through the kindness of Raymond Inbona, Giverny, courtesy of my associate Carol Lowrey.

23. Meteyard to Hovey, April 20, 1890, Richard Hovey Papers, Dartmouth College, Hanover, New Hampshire; in Nicholas Kilmer, *Thomas Buford Meteyard (1865–1928): Paintings and Watercolors* (New York: Berry-Hill Galleries, 1989), p. 16.

24. In the retrospective exhibition of his work held at the school of the Misses Kelly in Cambridge, Massachusetts, in April 1905, Meteyard showed eight Giverny-area pictures, three of which were moonlight scenes. The manuscript for his catalog (ibid.) and additional information courtesy of Nicholas Kilmer.

25. Polly King, "Paris Letter," *Art Interchange* 31 (September 1893): 65.

26. Robert J. Killie has identified at least ten pictures by Robinson in which the mill is prominent, and it also appears in his *Père Trognon and His Daughter at the Bridge* (plate 78). (Robert J. Killie, "A New Look at Theodore Robinson's Giverny Mill Views," manuscript courtesy of the author.) Only the five I have mentioned in my text, however, can be considered a series, since they depict the mill from nearly identical vantage points. The pictures considered in Killie's paper are, I believe, representations of more than one Giverny mill.

27. TR, September 5, September 15, November 14, November 17, and November 29, 1892; in Johnston, *Robinson*, p. 48, and discussed by Killie in "A New Look at Theodore Robinson's Giverny Mill Views." Both Deconchy's and Monet's criticisms must refer

to plate 86, since only this example includes bright green and the other known versions are figureless.

28. DDW.

29. See, for instance, William Crary Brownell, "The Younger Painters of America: First Paper," *Scribner's Monthly* 20 (May 1880): 1–15; Sylvester Rosa Koehler, *American Art* (New York: Cassell and Company, 1886).

Provisions, Diversions, and Liaisons (pages 101–13)

1. I am very grateful to Marit Lange, Keeper of Paintings, National Gallery, Oslo, for her help in identifying some of the Norwegian artists listed in the Hôtel Baudy register. Borgord registered at the Baudy with Richard Smith Robbins from Chicago, his classmate from the Académie Julian; Borgord stayed only a week, but Robbins remained nearly a year and exhibited Giverny pictures in 1895 at the annual exhibition at the Art Institute of Chicago.

2. This, like much of my information about the early artistic community, comes from Dawson-Watson's manuscript, "Things Remembered," courtesy of his descendants.

3. Robinson, in R. J. Antes, "Artist's Biography Is Written by Niece," *Evansville (Wisconsin) Review*, February 4, 1943, p. 3.

4. Frost to Daggy, September 19, 1908, courtesy of Henry M. Reed.

5. TR, August 9 and 10, 1892.

6. DDW.

7. Henry Prellwitz, interview with DeWitt Lockman, January 10, 1927, DeWitt Lockman Papers, New-York Historical Society.

8. Bruce to Janet Bruce, October 3, 1887; in Joan Murray, ed., *Letters Home, 1859–1906: The Letters of William Blair Bruce* (Moonbeam, Canada: Penumbra, 1982), p. 125.

9. Robinson to Perry, June 9, 1891, Perry Papers, Museum of Fine Arts, Boston, courtesy of Sona Johnston.

10. Claire Joyes, "Giverny's Meeting House, the Hôtel Baudy," in Sellin, p. 101.

11. TR, July 3, 1892.

12. Pierre Toulgouat, "Skylights in Normandy," *Holiday* 4 (August 1948): 68.

13. Low, p. 446.

14. DDW.

15. Bruce to Janet Bruce, January 22, 1888; in Murray, ed., *Letters Home*, p. 162.

16. Toulgouat, "Skylights in Normandy," p. 68.

17. Beckwith, diaries, August 15, 1891, Archives of the National Academy of Design, New York.

18. Ibid., August 8, 1891.

19. Ibid., August 9, 1891. There may be a play on words intended here, since Mrs. Edward Breck's maiden and stage name was Antonie Wagner.

20. William Rothenstein, *Men and Memories: Recollections of William Rothenstein, 1872–1900* (London: Faber and Faber, 1931), pp. 49–50.

21. Allan Houston Macdonald, *Richard Hovey: Man and Craftsman* (Durham, N.C.: Duke University Press, 1957), pp. 103, 166. Hovey and his lover, Mrs. Edmund Russell, had a child that Hovey named Radegund, after the namesake of the Giverny church, Sainte Radégonde.

22. Burrage, p. 351.

23. Charlotte Warton, "A Girl-Student's Year in Paris," *Jenness Miller Magazine* 5 (June 1891): 609.

24. TR, August 9, 1892.

25. Beckington had studied with J. Carroll Beckwith at the Art Students League in New York, and then with Jean-Joseph Benjamin-Constant at the Académie Julian. There she became interested in miniature painting, and she went on to become one of the leaders of the miniature-painting revival in the United States and a founder in 1899 of the American Society of Miniature Painters, which she served as president for several years. See Elizabeth Lounsbery, "American Miniature Painters," *Mentor* 4 (January 15, 1917): n.p.

26. "I am glad that Codman's work was so good—he must have felt pleased that you really liked his things. What do you think Cod meant by saying that he would not care to marry either Miss Chase or Miss Speed?" Kinsella to Hale, November 1, 1892, PLH. "Codman" was probably the architect Stephen Codman, who registered at the Baudy as early as July 1889 and who corresponded with Hale, signing his letters "Cod." However, there was also an American painter, Stephen R. H. Codman, who exhibited at the (new) Salon in Paris, in 1893. The architect Stephen Codman, a member of one of Boston's most aristocratic families, scandalized his native city when he married a Boston model, Mary Sullivan, in 1905.

27. Rob Leith, "Philip Leslie Hale: His Life," typescript, 1986, p. 18.

28. TR, October 9, 1892.

29. Butler to Hale, February 1, 1893, PLH. Trying to identify Cobb in the pages of the Baudy register is extremely confusing. H. I. Cobb, born in Boston, age twenty-three, registered at the Baudy on October 3, 1890, giving his profession as "architect." This is surely the architect Henry Ives Cobb, born 1859 in Brookline, Massachusetts, who had married Emma Martin Smith as early as 1882. "A." or "H." Cobb (probably Arthur Murray Cobb), born in Boston, age twenty, registered at the Baudy on July 9, 1891, as an "artiste-peintre." H. A. Coobb (misspelling?), born in New York, age twenty, registered on May 19, 1892, as an "artiste-peintre." H. Cobb, born in New York, age twenty-two, registered on July 13, 1892, as an "artiste-peintre"; judging by his year of birth, this is almost surely Arthur Murray Cobb. Citations to the Cobb in Giverny who was associated with Mariquita Gill in producing the Giverny-based publication *Courrier innocent* refer to him as "Murray" Cobb.

Arthur Murray Cobb was born in Boston and spent the latter part of his life engaged in arts and crafts work in Florence, Italy, where he died at the age of thirty-six on January 30, 1907. (Obituary, *Boston Evening Transcript,*

February 4, 1907; courtesy of Janice Chadbourne, curator of fine arts, Boston Public Library, and Vose Archives, Brookline Village, Massachusetts.)

A later, presumably second, Mrs. Arthur Murray Cobb was a painter in Plainfield, New Jersey, and a member of the National Association of Women Artists. (Peter Hastings Falk, ed., *Who Was Who in American Art* [Madison, Conn.: Sound View, 1985], p. 120.)

30. Butler to Hale, January 20, 1895, PLH. The divorce was also discussed by William Howard Hart in an undated letter to Hale, probably from Paris, also PLH.

31. Kinsella to Hale, September 23, 1890, PLH. Kinsella exhibited her work professionally, including Giverny subjects at the annual exhibitions of the Art Institute of Chicago in 1894 and the Pennsylvania Academy of the Fine Arts in 1895.

32. Elizabeth de Veer, in de Veer and Richard J. Boyle, *Sunlight and Shadow: The Life and Art of Willard L. Metcalf* (New York: Abbeville Press, 1987), p. 49.

33. Beckwith, diaries, August 20, 1891. Blenner, who became well known in America both for portraits of society women and for still lifes and gardens, seems from this reference to have been only a day visitor to Giverny, and I have found no indication of a stay by him at the Hôtel Baudy. Nevertheless, he exhibited *A Peasant Girl at Giverny* at Yale University in 1901. I am grateful to Dr. Betsy Fahlman for bringing this reference to my attention.

34. Robinson had previously lived in this house. Joyes, "Giverny's Meeting House," in Sellin, p. 102.

35. *Giverny, France, Mairie, Etat Civil, Département de L'Eure: Naissances, mariages, divorces et décès,* October 19, 1905, pp. 649–52.

36. Nevertheless, a good deal is known about the periodical, and subsequent copies produced in the United States have been located. The Union List of Serials gives the library at Princeton University as the only source for a

complete run of this publication, but there is no record there of the journal, and the reference may be a misprint. Investigation into the papers of some of those involved with its production—the Richard Hovey Papers at Dartmouth College and the Dawson-Watson family archives—have yielded no copies of the issues produced in Giverny. The Toulgouat family in Giverny, descendants of Theodore Butler and the most likely holders of the magazine, have failed to respond to inquiries. Henry Leffert, who prepared a dissertation on Richard Hovey for New York University in 1929, noted that he had seen a complete file of all seven numbers of the magazine but did not indicate a source.

I am tremendously grateful to my student Tara Collins, who put in long hours researching the *Courrier innocent;* much of the information given here is from her summation.

37. Dawson Dawson-Watson, "The Rolling-Pin in Art," *Literary Review* 1 (May 1897): 70.

38. Hovey is perhaps best remembered for the three Vagabondia collections of poetry, written and published in collaboration with his friend and colleague Bliss Carman, with decorations by Meteyard. These consisted of *Songs from Vagabondia* (Boston: Copeland and Day, 1894); *More Songs from Vagabondia* (Boston: Copeland and Day, 1896); and *Last Songs from Vagabondia* (Boston: Small, Maynard and Company, 1903)—the last was in part a memorial to Hovey, who died in 1900.

39. Nicholas Kilmer, *Thomas Buford Meteyard (1865–1928)* (New York: Berry-Hill Galleries, 1989), p. 18.

40. DDW.

41. Manuscript in the Dawson-Watson family archives.

42. Henry Leffert, "Richard Hovey: An American Poet" (Ph.D. diss., New York University, 1929), pp. 205–8. A printed copy of the seven-stanza Latin poem, overlying a drawing of leafy boughs, is in the Dawson-Watson family archives.

43. Courtesy of Dartmouth College Library, Dartmouth College, Hanover, New Hampshire. Translation by Carol Volk.

LA-BAS

.

Je connais un village,
Pas trop loin de Paris,
Ou personne n'est sage
Et tout le monde rit.

.

Ils font ce qu'ils désirent,
Ils suivent leurs destins,
Ils sont gais et leurs rires
Sont comme le matin.

Laissez ce bête monde
Et venez donc mes vieux,
Où vant et vagabondent
Les vauriens du bon Dieu.

Giverny in the 1890s (pages 115–55)

1. For more information about Thompson's *View of Giverny, France,* see the entry by Carol Lowrey in *Holidays 1989* (New York: Spanierman Gallery, 1989), no. 9.

2. Carle John Blenner may have been the first Yale art school graduate there, visiting Giverny in 1891, and John Ireland Howe Downes was at the Baudy in 1895–96. Indeed, Thompson arrived only a week after Downes made his second appearance at the Baudy (on May 30, 1896), and he may well have been encouraged to join the colony by Downes. The associations among these Yale art school graduates appear to have endured. Blenner, Thompson, and Downes all later lived in New Haven. Downes was librarian of the Yale School of the Fine Arts; and Thompson and Downes cofounded the New Haven Paint and Clay Club in 1900, with Thompson as president. For the club, see Jane Allison, "The New Haven Paint and Clay Club," *Journal of the New Haven Colony Historical Society* 34 (Fall 1987): 23–32.

3. Josephine Lewis's presence in Giverny—along with that of Downes, Thompson, and many other artists—was noted in the American press: "Among the American artists at

Giverny this summer are Albert Sterner, Frederick MacMonnies, Carl Newman, Mrs. Lilla Cabot Perry, Miss Josephine Lewis, Miss Bain, Miss Nelson, John I. H. Downes and Bert Thompson." ("Art Notes," *New York Evening Sun,* June 29, 1896, p. 4.)

4. For Lewis in the context of Yale University, see Betsy Fahlman, "Women Art Students at Yale," *Woman's Art Journal* 12 (Spring–Summer 1991): 18–19.

5. Fahlman (ibid.) states that Lewis studied with Aman-Jean at the Académie Julian; however, Aman-Jean was not a teacher there, and Lewis is not listed as taking instruction at the school, although the records of women students there are, admittedly, incomplete. See Catherine Fehrer, *The Julian Academy, Paris, 1868–1939* (New York: Shepherd Gallery, 1989). Lewis may have studied privately with Aman-Jean.

6. Matilda Lewis to her family, 1894, typescript in the archives of the Yale University Art Gallery, given by Mrs. James A. Finn on May 28, 1955, at the time she donated *Portrait of a Woman,* by Josephine Lewis, to the gallery. (Mrs. Finn was a second cousin of the Lewis sisters.)

This letter has a peculiar history. It has often been reproduced, in part, as written by Mary Cassatt while she was staying at the Hôtel Baudy along with Cézanne. I find this first, without a source, in John Rewald, *Paul Cézanne: A Biography* (New York: Simon and Schuster, 1948), pp. 165–66. However, there is no record that Cassatt was ever a guest at the Baudy, and I have found no documentation of any visit by her to Giverny. Furthermore, Rewald has voiced his agreement with my conclusions that the letter's description of Cézanne seems much more appropriate for a young woman fresh from the United States rather than a seasoned painter in middle years, who was already very familiar with the French Impressionists.

7. For Cézanne's visit and his abrupt departure, see Rewald, ibid., pp. 165–67; and Claire Joyes, *Monet at Giverny* (New York: Mayflower, 1975), pp. 27–28.

8. See the perceptive analysis of this work by Joseph J. Rishel, *Cézanne in Philadelphia Collections* (Philadelphia: Philadelphia Museum of Art, 1983), pp. 38–39. Rishel reads the Baudy entry for Cézanne as *September 7–30, 1894*—incorrect but understandable, given the idiosyncratic method of abbreviating the dates in the register. He points out that one other painting, *House and Trees* (Barnes Foundation, Merion, Pennsylvania), may also have been executed in Giverny; Rewald has mentioned his belief to me that an unfinished *Self-Portrait,* possibly done in Giverny, may now be in a Japanese museum.

9. When I first read Lewis's letter I thought that she was using "Bohemian" in the Georges du Maurier sense of a participant in "la vie de Bohème"; du Maurier's *Trilby,* in fact, was published that very year, 1894. She was, however, more likely using it in a geographic sense: Radimsky was born in the Bohemian town of Kolín, though he quite properly registered the country of his birth as Austria.

10. MacMonnies to Frost, June 12, 1911, courtesy of Henry M. Reed.

11. Hart to Hale, July 13, [1899], PLH. I am very grateful to Natasa Nikitinova of Slovart, Bratislava, Czechoslovakia, for her help, and to my student Mary Elizabeth Boone, for unearthing material on Radimsky. The literature on the artist is, not surprisingly, all in Czech. See Karel B. Mádl, "Václav Radimsky," *Volné smery* 3 (1899): 278–88. The most recent study is by Ludvík Sevecek in the exhibition catalog *Václav Radimsky vyber z malírského díla* (Gottwaldov [now Zlín], Czechoslovakia: Oblastni Galerie, 1985).

12. "Exposition Wenceslas Radimsky," *L'Art et les artistes* 11 (1910): 83.

13. I am grateful to Dr. Alena Pomajzlová of the National Gallery in Prague for showing me both the large collection of works by Radimsky held there and the files of other works by the artist in public collections in Czechoslovakia.

14. Perry, p. 120.

15. Radimsky at one time lived in a house in Giverny previously inhabited by Robinson.

(Claire Joyes, "Giverny's Meeting House, the Hôtel Baudy," in Sellin, p. 102.)

16. Low, p. 446.

17. Hale's career and travels are not securely documented. She was in France in 1882 and again in 1885, presumably too early to have been drawn to Giverny, though she did visit Normandy on this journey; she etched *A Woman from Normandy* in 1889. She was back in Europe in 1895, certainly an acceptable date for her *Landscape in Giverny*, but her movements are pretty well documented on that trip: Algiers to Florence to Paris. Accepting that this picture was, in fact, painted in Giverny, its date remains speculative.

I am tremendously grateful to my good friend and colleague Dr. Martha J. Hoppin for researching the Hale Family Papers in the Sophia Smith Collection at Smith College, Northampton, Massachusetts, for me.

18. Guy Rose, "At Giverny," *Pratt Institute Monthly* 6 (December 1897): 82.

19. John Rothenstein, *The Life and Death of Charles Conder* (London: Dent, 1938), p. 96; Conder's presence in Giverny is also mentioned in Frank Gibson, *Charles Conder: His Life and Work* (London: John Lane, Bodley Head, 1914), p. 44. For Conder in France, see also Ursula Hoff, *Charles Conder* (Melbourne: Lansdowne Press, Lansdowne Australian Art Library, 1972), pp. 51–57.

20. Kinsella to Hale, February 13, 1894, PLH.

21. I am grateful to Kenneth McConkey for information on the British artists in Giverny during the 1890s.

22. Wynford Dewhurst, *Impressionist Painting: Its Genesis and Development* (London: George Newnes; New York: Charles Scribner's Sons, 1904).

23. Ibid., p. 47. I know of no monographic study of Dewhurst, but see Kenneth McConkey, *British Impressionism* (Oxford: Phaidon, 1989), pp. 140–44.

24. TR, August 5, 1892.

25. Dawson-Watson (signed, "The Exile"), "By Telephone," Dawson-Watson family

archives. Its six stanzas begin: "As far away I sit to-day / I sit to-day, / And muse of things chez Baudy"; and end: "So here's a health, / Long life & wealth, / And love & joy & kisses, / A future heir, / And lack of Care, / To Butler & his Mrs."

26. TR, July 20, 1892.

27. A charming love poem, surely acclaiming the relationship of Suzanne and Butler, is decorated with a drawing of a winged Cupid wearing ice skates and sitting on a bare branch over a flat landscape. (Dawson-Watson family archives.)

28. Monet's apprehensions were voiced in letters written to Alice Hoschedé from Rouen (where he was engaged in painting the cathedral) on March 10 and April 9, 1892; in Daniel Wildenstein, *Claude Monet: Biographie et catalogue raisonné,* 4 vols. (Lausanne, Switzerland: Bibliothèque des Arts, 1974–85), 3: 165–66 (English translations appear in Sellin, p. 103).

29. TR, June 10 and July 3, 1892.

30. Richard H. Love interprets this picture as proof of Monet's rejection of Suzanne, with his diminution of her "a kind of punishment." (Love, *Theodore Earl Butler: Emergence from Monet's Shadow* [Chicago: Haase-Mumm Publishing Co., 1985], pp. 110–11.) This surely overstates the case. The picture is, after all, one of a series of paintings by Monet (and by other Impressionists, such as Sargent) that document the essentials of out-of-door painting. Suzanne was not an artist and Blanche was. Blanche is also the "featured" sister in Monet's earlier version of the same subject (plate 19), naturally without Butler's presence.

31. Butler to Hale, February 22, 1893, PLH.

32. For example: "You knew that I sent to the Salon but was left to gnash my teeth. Damn me I don't see why I was fired when the others got in." (Butler to Hale, July 14, 1894, PLH.)

33. "We . . . wish that you and Peggy [William Howard Hart] would take the little pink house next to us." (Butler to Hale, February 22, 1893, PLH.) "Gardening is about to

commence. Oh that Peggy were here to warm himself up with the spade." (Butler to Hale, February 1, 1893, PLH.) By the fall of 1909 the Maison Rose had become a hotel.

34. Hart to Hale, July 13, [1899]; and Hart, interview with Gertrude Hanna, for Arthur J. Kennedy's proposed biography, February 1932, p. 8. (Both PLH.)

35. Hart appears to have stayed with Butler during the summer of 1899 and to have returned to America with him, his children, and Marthe on the S.S. *Touraine* that September. (Butler to Hale, [summer 1899], PLH.)

36. Earlier that year she had lectured on Monet to the Boston Art Students' Association and participated in an Impressionist-oriented group show at the St. Botolph Club. ([Lilla Cabot Perry], *Informal Talk Given by Mrs. T. S. Perry to the Boston Art Students' Association in the Life Class Room of the Museum of Fine Arts, Wednesday, Jan. 24, 1894* [Boston: Boston Art Students' Association, 1894].)

37. According to Thomas Sergeant Perry, in Meredith Martindale, *Lilla Cabot Perry: An American Impressionist* (Washington, D.C.: National Museum of Women in the Arts, 1990), p. 44.

38. Cecilia Beaux, *Background with Figures* (Boston: Houghton Mifflin Co., 1930), pp. 201–2.

39. C.I.B., "Monet and Giverny," *New York Tribune,* September 8, 1901, pt. 2, p. 1.

40. Hart to Hale, June 7, [1895], PLH. My thanks to Dr. Susan Hobbes, the authority on Dewing, for sharing her information on his brief appearance in Giverny.

41. For Le Prieure, see Raymond Inbona, "The MacMonnies' House at Giverny," in E. Adina Gordon and Sophie Fourny-Dargère, *Frederick William MacMonnies (1863–1937), Mary Fairchild MacMonnies (1858–1946): Deux Artistes américains à Giverny* (Vernon: Musée Municipal A. G. Poulain, 1988), p. 85; and "Frederick MacMonnies' Home near Paris," *Town and Country* 60 (February 3,

1906): 16. Mary Smart confirms the purchase date of 1901; Inbona gives the alternative date of 1906, but it seems unlikely that MacMonnies would have undertaken his extensive changes and additions to the property in 1903 if he had still been only renting at that date.

42. Burrage, p. 349.

43. I am tremendously grateful to Mary Smart for sharing with me relevant pages from Mary MacMonnies' unpublished "Memoirs."

44. Theodore Dreiser, "The Art of MacMonnies and Morgan," *Metropolitan* 7 (February 1898): 151.

45. Christian Brinton, "Frederick MacMonnies," *Munsey's Magazine* 34 (January 1906): 421.

46. Emma Bullet, "MacMonnies, the Sculptor, Working Hard as a Painter," *Brooklyn Daily Eagle,* September 8, 1901, sec. 1, p. 2.

47. Burrage, p. 349.

48. Mary Smart, "Sunshine and Shade: Mary Fairchild MacMonnies Low," *Woman's Art Journal* 4 (Fall 1983–Winter 1984): 20–25.

Ms. Smart, the leading authority on Frederick MacMonnies, is writing a biography of the sculptor, authorized by his descendants. She has been tremendously helpful to me on this project, in regard both to Frederick and Mary MacMonnies and to their large circle of artist associates in Giverny. Ms. Smart shared with me much of the material used here and directed me to other sources as well. I am also grateful to Leftwich D. Kimbrough for allowing me to read the unpublished biography of MacMonnies written by his mother, Sara Dodge Kimbrough.

49. E. Adina Gordon designated this work—and its companion piece, *C'est la fête à bébé* (formerly, *Bébé Berthe dans sa chaise avec ses jouets*)—as by Frederick MacMonnies in the catalog of the exhibition *Frederick William MacMonnies (1863–1937), Mary Fairchild MacMonnies (1858–1946): Deux Artistes américains à Giverny,* pp. 97–98. However, Frederick seems not to have started painting

seriously by 1897. Furthermore, these two works seem to correspond to the titles of pictures that Mary exhibited in the (new) Salon in Paris in 1899. And finally, Mary Smart has noted that there was a precise inventory of Frederick's paintings that were still in Giverny in 1927; these were not listed among them. Mary took her own works with her to Bronxville, New York, in 1909; these ended up with her daughter Marjorie in California, as did Frederick's pictures from Giverny; hence the mix-up.

Mary MacMonnies is also known to have painted more traditional agrarian subjects in Giverny, but these have not yet resurfaced. At the 1902 annual exhibition of the Pennsylvania Academy of the Fine Arts, she exhibited a *Normandy Barn-yard,* and the following year she showed there *The Giverny Thresher at Work;* in 1904 she exhibited *Threshing at Giverny* at the Annual Exhibition of American Painting and Sculpture held at the Art Institute of Chicago.

50. David Bahssin, "The Paintings of Frederick MacMonnies and His Life in Giverny," typescript, 1984, author's collection.

51. "MacMonnies Takes to Paint," *New York Times;* "MacMonnies to Paint," *New York Tribune;* "MacMonnies Abandons Sculpture for Painting," *New York Evening Journal;* "MacMonnies a Painter, Too," *Brooklyn Times;* "MacMonnies May Substitute Picture Painting for Sculpture," *Philadelphia Bulletin;* all, October 15, 1900.

52. Edith Pettit, "Frederick MacMonnies, Portrait Painter," *International Studio* 29 (October 1906): 322–24.

53. Sara Dodge Kimbrough, *Drawn from Life* (Jackson: University of Mississippi Press, 1976), p. 67.

54. "Exhibition Notes," *Art Interchange* 50 (March 1903): 64; "Art Exhibitions," *New York Daily Tribune,* January 21, 1903, p. 9.

55. Frederick MacMonnies, interview with DeWitt Lockman, February 15, 1927, typescript, DeWitt Lockman Papers, New-York Historical Society.

56. There is much confusion here, since there were two Rosina Emmets. Referred to here is Rosina Hubley Emmet, sister of the painters Ellen and Leslie Emmet; the other Rosina (Posie) Emmet was the sister of Lydia and Jane Emmet; all three were cousins of Ellen, Leslie, and the other Rosina. Rosina (Posie) Emmet was much the oldest of the six and had married Arthur Murray Sherwood in 1887; she does not figure in the Giverny story. Rosina Hubley Emmet never married.

The most important published study of the Emmets is Martha J. Hoppin and Lydia Sherwood McClean, *The Emmets: A Family of Women Painters* (Pittsfield, Mass.: Berkshire Museum, 1982). Vast quantities of the Emmet papers are on deposit with the AAA; see David B. Dearinger, comp., "The Emmet Family Papers: An Inventory," typescript, summer 1990, New York Regional Office, AAA. I am also grateful to Debra Petke and Michael Borghi of Borghi Fine Arts, New York, for sharing with me their material on the Emmet family; and to Katherine Emmet Bramwell for her assistance in locating pertinent material in the Emmet family papers.

57. Hildegard Cummings, *Good Company: Portraits by Ellen Emmet Rand* (Storrs: William Benton Museum of Art, University of Connecticut, 1984).

58. C.I.B., "Monet and Giverny," pt. 2, p. 1.

59. Rosina Hubley Emmet to Mary Foote, June 1899, Mary Foote Papers, Beinecke Rare Book and Manuscript Library, Yale University, New Haven, Connecticut.

60. Ellen Emmet to Mary Foote, July 9, 1899, Foote Papers.

61. Jane Emmet to her mother, Giverny, May 20, 1897, Emmet family papers; generously shared with me by Debra Petke. Jane Emmet to Rosina Emmet Sherwood, [1897], Emmet Family Papers, AAA. Jane Emmet to Lydia Field Emmet, May 24, 1897, Emmet family papers; courtesy Debra Petke.

62. Rosina Hubley Emmet to Lydia Field Emmet, May 28, 1897, Emmet Family Papers, AAA.

63. Lydia Field Emmet to her mother, 1898(?), Emmet family papers; courtesy Debra Petke.

64. Fahlman, "Women Art Students at Yale," pp. 19–20. Edward Foote, "A Report on Mary Foote," *Yale University Library Gazette* 49 (October 1974): 225–30.

65. MacMonnies to Foote, March 1904, Foote Papers.

66. The term "womanizing" is used in reference to MacMonnies by Sellin, p. 80. E. Adina Gordon (in Gordon and Fourny-Dargère, *Deux Artistes américains*, pp. 25, 53) has offered a particularly inflamed account of MacMonnies' liaisons, claiming without evidence that "flirtations and indiscretions were the norm in MacMonnies' relations with his students." Gordon refers to Ellen Emmet as "one of a tight circle of young women who were at first students, then friends, and sometimes lovers," finding her source in such letters as those quoted above.

It is true that all the Emmet women admired MacMonnies greatly; but only Ellen seems to have been truly infatuated with him and possibly eager for his marriage to dissolve. In a letter to her cousin Lydia, written in September 1898, she spoke admiringly of Mac-Monnies' mother and sister, who were visiting Giverny, and then wrote: "I don't know how everything will end up or how he will bow to the inevitable for his life is cut out now in a kind of inevitable pattern. Now when I see how utterly weird & diverse the characters & way of life, of his wife, & his mother are—I realize what an impossible marriage he has made. Don't let what I have said get about although it is an open secret." (Emmet Family Papers, AAA.)

The most questionable of Gordon's deductions targets *Half-Length Portrait of a Nude Woman* (private collection), which was found behind another painting, *Portrait of a Man with a Large Hat,* a work discovered on Mac-Monnies' Giverny property. Gordon identifies the subject as Mary Foote and concludes that the picture was "hidden" because of its "disquieting air of guilt after passion," noting the figure's "startlingly hot flushed face and the

wild unkempt sweep of red hair." The idea of MacMonnies' rushing to his easel immediately after a moment of illicit passion in order to record his lover's disheveled appearance is improbable. Moreover, there is no reason to accept this amateur, or at best student, work as being by MacMonnies; it is far more likely to be a study left at Le Prieure by one of his students. Finally, the model bears only a generic resemblance to Foote, as recorded in her likeness by Ellen Emmet (private collection), in which her hair is not red.

67. Malvina Hoffman, *Yesterday Is Tomorrow* (New York: Crown Publishers, 1965), p. 110.

68. Kimbrough, *Drawn from Life,* pp. 60–61.

69. Leslie Emmet to Mary Foote, August 6, 1899, Foote Papers.

70. Kimbrough, *Drawn from Life,* p. 66.

71. Fragment of a letter written by Lydia Field Emmet from Paris (addressee unidentified, but probably Lydia's mother), [1899], Emmet Family Papers, AAA.

72. Kimbrough, *Drawn from Life,* p. 69. The painting was exhibited at the (old) Salon in 1901.

73. Ibid., p. 63.

74. Dodge returned to New York in December 1900, and that month many of his Giverny canvases were displayed in a one-artist show at the American Art Galleries. The exhibition engendered much publicity; *La Novice (Nun in Giverny Garden)* (plate 127) was discussed in Georgia Fraser Arkell, "The Paintings of William de Leftwich Dodge," *Art Education* 7 (February 1901): 242–46.

75. Bullet, "MacMonnies, the Sculptor," p. 2.

76. Information courtesy of Mary Smart; see also Bullet, ibid.

77. The sculptures in the garden, including the *Diana,* are identified by Bullet, ibid.; Burrage (p. 349) offers a somewhat different list.

78. Low, in *A Painter's Garden of Pictures Painted from Early Spring until Late in the Autumn of 1901 at Giverny in France by Will H. Low* (New York: Avery Art Galleries, 1902), n.p.

79. Low to Kenyon Cox, July 20, 1901, Kenyon Cox Papers, Avery Library, Columbia University, New York. See the discussion of Low's Giverny experience in Douglas S. Dreishpoon, "Will H. Low: American Muralist (1853–1932)" (M.A. thesis, Tufts University, Boston, 1979), pp. 85–91.

80. Low, p. 450.

81. *A Painter's Garden of Pictures,* n.p. Most of these works were also included in *Special Exhibition of Pictures and Original Designs for Mural Paintings by Will H. Low,* Detroit Museum of Art, December 1902.

82. Will H. Low, "In an Old French Garden," *Scribner's Magazine* 32 (July 1902): 3–19.

83. Ibid., p. 14.

84. Smart, "Mary Fairchild MacMonnies Low," pp. 24–25. Ironically, Low had earlier written an adulatory biography of MacMonnies; see Will H. Low, "Frederick MacMonnies," *Scribner's Magazine* 18 (November 1895): 617–28. I am indebted to Mary Smart for the specifics on the divorce and remarriage of both Mary and Frederick MacMonnies.

Unlike Mary MacMonnies, Alice Jones MacMonnies appears to have abandoned her professional career immediately after her marriage.

Into the Twentieth Century (pages 157–209)

1. Frost to Augustus Daggy, August 17, 1910, courtesy of Henry M. Reed.

For the logistics of moving from Paris to Giverny and back for the season, see Arthur B. Frost's "agenda" book for 1908 (his first season in the village). The process of getting settled included a preliminary search for a Giverny residence (the Moulin Hoan) on March 13; the move from Paris and the purchase of supplies in Vernon on April 15; trips to the Baudy to purchase canvas and whiskey, to attend dances, and to see an art show; and occasional day trips to Paris as well as walks to Vernon not only for food and furnishing shopping but also for visits to the dentist, the doctor, and the barber. In mid-November the Frosts started to pack up for the season and

left on November 28, after a stay of eight months. (I am grateful to Henry M. Reed for providing me with a copy of this document.)

2. For the interest in badminton, see Medora Clark's diary for August 1910, courtesy of Alson Clark; for the cinematograph, see her entry for August 27, 1910.

3. Frost to Daggy, September 19, 1908, courtesy of Henry M. Reed.

4. Richard H. Love, *Theodore Earl Butler: Emergence from Monet's Shadow* (Chicago: Haase-Mumm Publishing Co., 1985), pp. 350–52, 360. Butler to Philip and Lilian Hale, April 14, 1912, PLH.

5. Hale to Edward Everett Hale, August 12, 1904, Hale Family Papers, Sophia Smith Collection, Smith College, Northampton, Massachusetts; in Erica Eve Hirshler, "Lilian Westcott Hale (1880–1963): A Woman Painter of the Boston School" (Ph.D. diss., Boston University, 1992), p. 61. I am tremendously grateful to Dr. Hirshler for her assistance regarding the Hales' Giverny visit in 1904.

6. Lilian Hale, interview with Gertrude Hanna, February 27, 1932, typescript, p. 8, PLH.

7. Philip Hale to Edward Everett Hale, September 5, 1904, Hale Family Papers; quoted in Hirshler, "Lilian Westcott Hale," p. 62.

8. Thomas Sergeant Perry to Philip Hale, February 10, 1906, PLH, and other letters from Perry to Hale, written from Paris and from Giverny.

9. Meredith Martindale, *Lilla Cabot Perry: An American Impressionist* (Washington, D.C.: National Museum of Women in the Arts, 1990), p. 66.

10. This lacuna is filled to some degree by published accounts of Giverny by writers such as Ethel Rose and Mildred Giddings Burrage, who listed artist-visitors to the village.

11. I am tremendously grateful to the artist's son-in-law, Theodore C. Taylor, for his generosity in sharing information on Makielski. See also Mary Q. Burnet, *Art and Artists of Indiana* (New York: Century Co., 1921), pp. 295–97.

12. Louise Jones DuBose, *Enigma! The Career of Blondelle Malone in Art and Society, 1879–1951* (Columbia: University of South Carolina Press, 1963), p. 54. I am grateful to Lin Nelson-Mayson, curator at the Columbia Museum of Art, and to Lise C. Swensson, chief curator of art at the South Carolina State Museum, for their assistance in regard to Malone.

13. Ibid., pp. 60–65.

14. *Young Will and Young Gerald: Early Work by Sir William Rothenstein (1872–1945), Drawings 1889–1891, and Sir Gerald Kelly (1879–1972), Paintings 1900–1909* (London: Parkin Gallery, 1978).

15. Kelly, in Derek Hudson, *For Love of Painting: The Life of Sir Gerald Kelly, K.C.V.O., P.R.A.* (London: Peter Davies, 1975), pp. 14–15.

16. Mary Fairchild MacMonnies Low, unpublished "Memoirs," p. 154, courtesy of Mary Smart.

17. Finn's devotion to the art of the Italian Renaissance is a key motif in Royal Cortissoz's touching tribute to Finn in Cortissoz, *American Artists* (New York: Charles Scribner's Sons, 1923), pp. 255–59.

18. Finn leased his house while he was out of the village, and MacMonnies collected the rent money for him. MacMonnies wrote to Finn on October 2, 1907, "I wouldn't sell my home here yet," while informing Finn that he was holding the rent money for him. (Letter courtesy of David Madigan.)

19. "Décès James Wall Finn 28 Août 1913," *Giverny, France, Mairie, Etat Civil, Département de L'Eure: Naissances, mariages, divorces et décès,* pp. 810–11.

20. *Henry Salem Hubbell: A Retrospective* (Coral Gables, Fla.: Lowe Art Museum, 1975), p. 17. This is the most extensive publication of recent date on Hubbell, but some of the information included is not accurate. *By the Fireside,* for instance, is listed as having been shown in the Paris Salon in 1907, rather than 1909. Jay Williams, curator of the gallery at Edison Community College, Fort Myers,

Florida, is preparing a catalogue raisonné of Hubbell's work.

21. See these and other commentaries in *Catalogue of an Exhibition of Paintings by Henry Salem Hubbell* (Godfrey, Ill.: Wade Memorial Fine Arts Building, Monticello Seminary, c. 1920).

22. For the art and impact of The Ten, see my essay in *Ten American Painters* (New York: Spanierman Gallery, 1990); for the 1905 exhibition, see pp. 26–31.

23. Ethel Rose, "Giverny," *For Art Sake* 1 (November 8, 1923): 4; Charles Morris Young, "Nature Was My Mistress: My Life and Some Comments," unpublished autobiography, pp. 134–144, courtesy of Charles T. Clark.

24. The title of Blumenschein's illustration in the March 1907 issue of *McClure's Magazine* (opposite p. 492) is "Despite the dullness of light, We instantly recognized the boy of Hartwell's 'Color Sergeant.'" It was used to illustrate Cather's story "The Namesake." (Ernest L. Blumenschein Papers, AAA.)

25. "Arthur is now working in a school just started by Henri Matisse. He has reached the bottom, he can't degrade his talent any further. His studies are silly and affected and utterly worthless. He will come to his senses too late, I'm afraid." Frost to Daggy, March 1908, courtesy of Henry M. Reed; in Reed, *The A. B. Frost Book* (Rutland, Vt.: Charles Tuttle & Co., 1967), p. 115. I am tremendously grateful to Henry Reed for his extensive assistance in regard to Frost. For Frost in Giverny, see also Burrage, p. 350.

26. Frost to Daggy, July 22, 1909, courtesy of Henry M. Reed.

27. Reed, *A. B. Frost Book,* p. 108.

28. Frost to Daggy, July 22, 1909, courtesy of Henry M. Reed.

29. A. B. Frost, "From a French Sketch-Book," *Scribner's Magazine* 75 (March 1924): 263–70. Frost was best known for his illustrations for Joel Chandler Harris's Uncle Remus stories.

30. Frost to Daggy, June 21, 1909, courtesy of Henry M. Reed.

31. All by Ethel Rose: "Shooting in France (Normandy)," *Scribner's Magazine* 49 (March 1911): 399–409; "Trout Fishing in Normandy," *Scribner's Magazine* 54 (October 1913): 455–70; "Coarse Fishing in Normandy," *Scribner's Magazine* 72 (September 1922): 281–92.

32. John Frost is almost completely unstudied. See Reed, *A. B. Frost Book,* pp. 127–40; "Blue Mountains and the Art of John Frost," *California Southland* 6 (March 1924): 10–11. The latter notes, "Like the French, he loves a screen of pollard willows," p. 11.

33. Butler to Philip and Lilian Hale, September 15, 1904, PLH.

34. See Ilene Susan Fort, "The Cosmopolitan Guy Rose," in Patricia Trenton and William H. Gerdts, *California Light, 1900–1930* (Laguna Beach, Calif.: Laguna Beach Art Museum, 1990), pp. 93–111, for a full discussion of Rose's career, including his years in Giverny. See also Anthony Anderson and Earl Stendahl, *Guy Rose* (Los Angeles: Stendahl Art Galleries, 1922), p. 7. For Rose as an illustrator, see Will South, "The Painterly Pen," *Antiques and Fine Arts* 10 (April 1992): 120. Rose's *An Anxious Moment* (for *Harper's Weekly,* October 3, 1896, p. 980) prefigures his Normandy sporting illustrations done in collaboration with Arthur B. Frost. I want also to thank the artist's great-nephew, Roy C. Rose, director of the Guy Rose Research Center, Avalon, California, for his splendid cooperation in this project.

35. Burrage, p. 350. For a description of one such tea, see L.A.C.W., "Chicago Notes," *Wyoming (New York) Reporter,* January 19, 1910, p. 4.

36. Guy Rose, "At Giverny," *Pratt Institute Monthly* 6 (December 1897): 81–82; Rose, "Giverny," p. 4.

37. The Maison Bleue was probably the Roses' own house in Giverny, though it was described as the home of "Claude Monet's daughter" when one of the paintings was on view at the Stendahl Art Galleries. (Peyton Boswell and Anthony Anderson, *Catalogue of the Guy Rose Memorial* [Los Angeles: Stendahl Art Galleries, 1926], p. 19.) The only Monet daughter (actually stepdaughter) resident in Giverny during Rose's tenure there was Marthe Butler. The Butlers' house was a newly built residence near Monet's, whereas the Maison Bleue was at the other end of the village.

38. Burrage, p. 350.

39. See Ilene Susan Fort, "The Figure Paintings of Guy Rose," *Art of California* 4 (January 1991): 46–50.

40. Charles H. Caffin, "New American Painters in Paris," *Harper's New Monthly Magazine* 118 (January 1909): 295.

41. Clara T. MacChesney, "Frederick Carl Frieseke: His Work and Suggestions for Painting from Nature," *Arts and Decoration* 3 (November 1912): 14.

42. Clara T. MacChesney, "Frieseke Tells Some of the Secrets of His Art," *New York Times,* June 7, 1914, sec. 6, p. 7.

43. Frieseke, ibid.

44. Phyllis Derfner, "New York Letter," *Art International* 19 (February 20, 1975): 41.

45. See Bruce W. Chambers, *Frederick C. Frieseke: Women in Repose* (New York: Berry-Hill Galleries, 1990), p. 8.

46. MacChesney, "Frieseke Tells," p. 7.

47. For a more detailed examination of *Venus in the Sunlight* and *Autumn,* see my essay in *Masterworks of American Impressionism* (Einsiedeln, Switzerland: Thyssen-Bornemisza Foundation and Eidolon, 1990), pp. 148–51.

48. Clara T. MacChesney, "American Artists in Paris," *International Studio* 54 (November 1914): xxiv.

49. Frieseke, in MacChesney, "Frieseke Tells," p. 7.

50. Burrage, p. 350.

51. In March 1912 the writer of the introduction to Parker's one-artist show noted that his Impressionist canvases presented him "in a new and interesting light for they show the departure of one hitherto known as a portrait painter into an impressionism of rather a new sort." (*Paintings by Lawton Parker* [Chicago: Art Institute of Chicago, 1912], n.p.) The show consisted of twenty-seven Impressionist outdoor paintings and six portraits.

52. An extended discussion of this painting can be found in George Breed Zug, "The Art of Lawton Parker," *International Studio* 57 (December 1915): xlii. Parker's water garden is mentioned in Lena M. McCauley, "Lawton S. Parker," *Art Student* 1 (October 1915): 7.

53. Miller's life in Giverny is not nearly so well documented as Frieseke's. In November 1907 he is known to have married Harriette Adams of Providence, Rhode Island, and they had a daughter, Elsbeth, born in Giverny in June 1909; the record of her birth was witnessed by Frieseke. (Frost to Daggy, June 21, 1909, courtesy of Henry M. Reed; *Giverny, France, Mairie, Etat Civil, Département de L'Eure: Naissances, mariages, divorces et décès,* June 18, 1909, pp. 714–16.)

54. Miller, in Wallace Thompson, "Richard Miller—A Parisian-American Artist," *Fine Arts Journal* 27 (November 1912): 712.

55. Burrage, p. 349.

56. Frost to Daggy, June 21, 1909, courtesy of Henry M. Reed.

57. Frost to Daggy, July 22, 1909, courtesy of Henry M. Reed.

58. Blanche E. Wheeler Williams, *Mary C. Wheeler: Leader in Art and Education* (Boston: Marshall Jones Company, 1934), pp. 231–32.

59. In 1981 Burrage donated nearly one thousand of her paintings, sculptures, and drawings to the Portland Museum of Art, Portland, Maine, including some Giverny landscapes. I am very grateful to my good friend Martha R. Severens, former curator of collections at that institution, for bringing the Burrage collection to my attention.

60. Burrage, p. 351.

61. Marie Louise Kane is currently studying Miller's career and art, and she is the leading authority on his painting. I am grateful to Ms. Kane for her willingness to share some of her material.

62. *Giverny, France, Mairie, Etat Civil, Département de L'Eure: Naissances, mariages, divorces et décès,* March 6, 1908, no. 3, pp. 697–98. I would like to thank the artist's daughter, Nan Greacen Faure; his daughter-in-law, Ruth Nickerson Greacen; and Helen K. Fusscas, for their assistance and advice.

63. These pictures, variously entitled *La Roche* and *Les Roches* (all in private collections) depict the limestone formations above the area known as Près de Vernonnet, between Vernonnet and Giverny—not the estate Les Roches, at the entrance to Falaise, east of Giverny.

64. Karl Anderson, "Anderson's Impressions," *Bellman* 8 (March 5, 1910): 292.

65. Burrage, p. 351.

66. Anderson, "Anderson's Impressions," p. 293.

67. "Bright Picture Seen in the Galleries," *New York Evening Mail,* January 22, 1910, p. 14.

68. Florence B. Ruthrauff, "Art Notes," *New York Morning Telegraph,* December 21, 1910, p. 4.

69. Guy Pène du Bois, "Over 300 Pictures in Corcoran Art Show," *New York American,* December 26, 1910, p. 9.

70. "Art and Artists," *New York Globe and Commercial Advertiser,* December 23, 1910, p. 7.

71. Ruthrauff, "Art Notes," p. 4.

72. [James Huneker], "Seen in the World of Art," *New York Sun,* January 8, 1911, sec. 3, p. 4.

73. "News and Notes of the Art World," *New York Times,* December 25, 1910, p. 15.

74. Burrage, p. 351.

75. Reviewing the (old) Salon exhibition of 1912, Jean-Louis Vaudoyer in *Excelsior,* May 2, 1912; *Cleveland Ledger,* May 12, 1912; and *New York Herald,* May 26, 1912, all suggest Buehr's derivation from Miller.

76. Buehr to his wife, May 27, 1912, Karl Buehr Papers, AAA.

77. Richard H. Love, *Louis Ritman: From Chicago to Giverny* (Chicago: Haase-Mumm Publishing Co., 1989), pp. 125ff.

78. Love suggests Ritman's activity in Frieseke's walled garden; see ibid., pp. 164, 178.

79. *Indianapolis News,* April 24, 1915; ibid., p. 209.

80. These affinities were recognized by critics at the time. C. H. Waterman noted that "Frieseke knows his Monet, but seems totally unaware of Cézanne. Ritman is always plastic." (Waterman, "Louis Ritman," *International Studio* 67 [April 1919]: 64.)

81. For the haystack pictures, see Medora Clark's diary for August 28 and October 31, 1910; for the collaborative effort, see the diary for October 26, 1910. Alson Clark, the artist's descendant, has been most generous in sharing with me Medora Clark's 1910 Giverny diary and her biography of her husband.

82. See Medora Clark's diary for October 27, 1910, courtesy of Alson Clark. Other noted Chicago landscape painters who were attracted to Giverny in the early twentieth century included Charles Francis Browne, Charles Dahlgreen, and Lawrence Mazzanovich.

83. Abel G. Warshawsky, *The Memories of an American Impressionist* (Kent, Ohio: Kent State University Press, 1980), pp. 96–97.
 Diane Tepfer confirms that no works painted by Halpert in Vernon have been located, but she points out that he did exhibit *Le Pont, Vernon* in the 1910 Salon d'Automne. (Tepfer to author, June 13, 1991.) I am very grateful to Dr. Tepfer for sharing her information on Halpert.

84. Warshawsky and Halpert had met the Russian-born Olinsky earlier that year in Rome. Olinsky had grown up and studied in New York before becoming an assistant to John La Farge in 1900; he went abroad in 1908 for a stay of three years in Italy and France. It is possible that Warshawsky was confused about the date of Kroll's visit; no Vernon paintings by Kroll are known from 1909, and the artist himself recalled working

in Vernon in 1910. (Interview with Leon Kroll, November 16, 1956, p. 44, Leon Kroll Papers, AAA.)

85. Warshawsky, *Memories,* p. 106.

86. Kenneth Hey has written that Blum "departed the city [Paris] for a visit to the Halpert country home." (Kenneth Robert Hey, "Five Artists and the Chicago Modernist Movement, 1909–1928" [Ph.D. diss., Emory University, 1973], p. 83.) Halpert, of course, did not have a "country home" but was staying at the hotel in Vernon. No Vernon works by Blum have been located.

87. Nancy Hale and Fredson Bowers, eds., *Leon Kroll: A Spoken Memoir* (Charlottesville: University Press of Virginia, 1983), p. 20; based on the Kroll interview of November 16, 1956 (see n. 84). On his return to New York in 1910, Kroll exhibited eighty-five of his French pictures in his studio; besides general Normandy references, titles of five of the paintings referred specifically to Vernon and two to Giverny.

88. Ibid., p. 24.

89. Even after he had settled in New York, MacMonnies still retained Le Prieuré; he visited Giverny in 1920, 1925–26, and in 1927, during trips to France in connection with his Marne Memorial sculpture. (Mary Smart to the author, July 19, 1991.) His house, maintained by caretakers, was not sold by the family until 1963. (David Bahssin, "The Paintings of Frederick MacMonnies and His Life in Giverny," typescript, 1984, pp. 19–21; based in part on interviews in January 1985 with Marjorie MacMonnies Young, the artist's granddaughter, and with Willard Clerk—a Malden Bridge, New York, art dealer, who had been sent to Giverny by Alice Jones MacMonnies in the 1950s.)

90. Frances Frieseke, "It's Only the Cannon," manuscript, Frederick Frieseke Papers, AAA.

91. George Biddle, *An American Artist's Story* (Boston: Little, Brown and Co., 1939), p. 124.

92. Ibid., p. 218.

93. Ibid., p. 149.

94. Pier Ludovico Occhini, "Karl Frédéric Frieseke," *Vita d'arte* 7 (February 1911): 58–68; Vittorio Pica, "Artisti contemporanei: Frederick Carl Frieseke," *Emporium* 38 (November 1913): 323–27; Pica, "Artisti contemporanei: Richard Emile [*sic*] Miller," *Emporium* 39 (March 1914): 162–77.

95. Butler to Philip and Lilian Hale, April 14, 1912, PLH.

96. For further discussion, see the writings of Bram Dijkstra, especially "The High Cost of Parasols: Images of Women in Impressionist Art," in Patricia Trenton and William H. Gerdts, *California Light, 1900–1930* (Laguna Beach, Calif.: Laguna Art Museum, 1990), pp. 33–52.

Postlude (pages 211–13)

1. Pierre Toulgouat, "Peintres américains à Giverny," *Rapports: France—Etats-Unis,* no. 62 (May 1952): 71–72.

2. Malcolm Cowley, *Exile's Return* (New York: W. W. Norton, 1934), pp. 142–43; Pierre Toulgouat, "Skylights in Normandy," *Holiday* 4 (August 1948): 69.

3. Malcolm Cowley, "The Butlers of Giverny," in *Claude Monet and the Giverny Artists* (New York: Charles E. Slatkin Galleries, 1960), n.p.

4. J. Carroll Beckwith, diaries, August 18, 1891, Archives of the National Academy of Design, New York.

5. Burrage, p. 346.

6. Hamlin Garland, *Companions of the Trail* (New York: Macmillan Co., 1931), pp. 301–2.

SELECTED BIBLIOGRAPHY

CAROL LOWREY

A ★ indicates a source of particular significance.

General Books and Exhibition Catalogs

Les Artistes américains à Giverny. Vernon, France: Musée Municipal A.-G. Poulain, 1984.

Beaux, Cecilia. *Background with Figures: Autobiography of Cecilia Beaux.* Boston: Houghton Mifflin Co., 1930.

★ *Claude Monet and the Giverny Artists.* New York: Charles E. Slatkin Galleries, 1960.

Cowley, Malcolm. *Exile's Return.* New York: W. W. Norton and Co., 1934.

★ Dawson-Watson, Dawson. "The Real Story of Giverny." In Eliot Clark, *Theodore Robinson: His Life and Art,* pp. 65–67. Chicago: R. H. Love Galleries, 1979.

DuBose, Louise Jones. *Enigma! The Career of Blondelle Malone in Art and Society, 1879–1951.* Columbia: University of South Carolina Press, 1963.

Finlay, Nancy. *Artists of the Book in Boston, 1890–1910.* Cambridge, Mass.: Houghton Library, Harvard University, 1985.

Garland, Hamlin. *Companions on the Trail.* New York: Macmillan Co., 1931.

★ Gerdts, William H. *American Impressionism.* New York: Abbeville Press, 1984.

★ ———, et al. *Lasting Impressions: American Painters in France, 1865–1915.* Evanston, Ill.: Terra Foundation for the Arts, 1992.

Giverny en cartes postales anciennes. Preface by Rodolphe Walter. Zaltbommel, Netherlands: Bibliothèque Européenne, 1992.

Hoschedé, Jean-Pierre. "Les Amis de Claude Monet à Giverny." In *Claude Monet: Le Mal Connu.* Geneva: Pierre Cailler, 1960.

Low, Will. *A Chronicle of Friendships, 1873–1900.* New York: Charles Scribner's Sons, 1908.

Macdonald, Allan Houston. *Richard Hovey: Man and Craftsman.* Durham, N.C.: Duke University Press, 1957.

★ Meixner, Laura L. *An International Episode: Millet, Monet, and Their North American Counterparts.* Memphis, Tenn.: Dixon Gallery and Gardens, 1982.

[Perry, Lilla Cabot], *Informal Talk Given by Mrs. T. S. Perry to the Boston Art Students' Association in the Life Class Room at the Museum of Fine Arts, Wednesday, Jan. 24, 1894.* Boston: Boston Art Students' Association, 1894.

Quick, Michael, Eberhard Ruhmer, and Richard V. West. *American Expatriate Painters of the Late Nineteenth Century.* Dayton, Ohio: Dayton Art Institute, 1976.

Rothenstein, William. *Men and Memories: Recollections of William Rothenstein, 1872–1900.* Vol. 1. London: Faber and Faber, 1931.

★ Sellin, David. *Americans in Brittany and Normandy, 1860–1910.* Phoenix: Phoenix Art Museum, 1982.

Toussaint, Abbé Anatole, and Jean-Pierre Hoschedé. *Flore de Vernon et de la Roche-Guyon.* Rouen, France: Julien Lecerf, 1898.

General Periodicals

B., C.I., "Monet and Giverny." *New York Tribune,* September 8, 1901, pt. 2, p. 1.

Breck, Edward. "Something More of Giverny." *Boston Evening Transcript,* March 9, 1895, p. 13.

Burrage, Mildred Giddings. "Arts and Artists at Giverny." *World To-Day* 20 (March 1911): 344–51.

C., H. "Giverny and Its School." *Boston Evening Transcript,* March 7, 1895, p. 6.

Fahlman, Betsy. "Women Art Students at Yale." *Woman's Art Journal* 12 (Spring–Summer 1991): 15–23.

Greta [pseud.]. "Boston Art and Artists." *Art Amateur* 17 (October 1887): 93.

Hale, Philip. "Our Paris Letter." *Arcadia* 1 (September 1, 1892): 178–79.

Howard-Johnston, Paulette. "Une Visite à Giverny en 1924." *L'Oeil* 171 (March 1969): 28–33, 76.

King, Polly. "Paris Letter." *Art Interchange* 31 (September 1893): 65.

Meltzer, Charles Henry. "American Artist Colonies Abroad." *Hearst's Magazine* 24 (October 1913): 628–29.

P., L.L. "The Impressionists." *Boston Evening Transcript,* February 26, 1898, p. 15.

"Peintres américains en France." *Informations et documents* 22 (February 1, 1955): 20–31.

Rose, Ethel. "Shooting in France (Normandy)." *Scribner's Magazine* 49 (March 1911): 399–409. With illustrations by Guy Rose and Arthur B. Frost, Sr.

———. "Trout Fishing in Normandy." *Scribner's Magazine* 54 (October 1913): 455–70. With illustrations by Guy Rose and Arthur B. Frost, Sr.

———. "Coarse Fishing in Normandy." *Scribner's Magazine* 72 (September 1922): 281–92. With illustrations by Guy Rose and Arthur B. Frost, Sr.

———. "Giverny." *For Art Sake* 1 (November 8, 1923): 4.

Rose, Guy. "At Giverny." *Pratt Institute Monthly* 6 (December 1897): 81–82.

★ Toulgouat, Pierre. "Skylights in Normandy." *Holiday* 4 (August 1948): 66–70.

★ ———. "Peintres américains à Giverny." *Rapports: France—Etats-Unis,* no. 62 (May 1952): 65–73.

Warton, Charlotte. "A Girl-Student's Year in Paris." Parts 1–3. *Jenness Miller Magazine* 5 (March–May–June 1891): 452–53, 534–36, 609–11.

General Archival Material

Giverny, France. Mairie. Etat Civil, Département de L'Eure: Naissances, mariages, divorces et décès.

Richard Hovey Papers. Dartmouth College, Hanover, New Hampshire.

Lewis, Matilda. "Giverny, 1894." Typescript, 1894. Archives, Yale University Art Gallery, New Haven, Connecticut.

★ "Registre pour inscrire les voyageurs, 1887–1899, Hôtel Baudy, Giverny, France." Department of Prints, Drawings, and Photographs, Philadelphia Museum of Art, Philadelphia.

Archives Toulgouat-Piguet. Giverny and Paris, France.

Karl Anderson

[Anderson, Karl]. "Anderson's Impressions." *Bellman* 8 (March 5, 1910): 292–94.

Cox, Dorothy Davis. *Karl Anderson, American Artist.* Clyde, Ohio: Winesburg Press, 1981.

Karl Anderson of Westport: American Impressionist. Westport, Conn.: Westport-Weston Arts Council, 1984. Includes reprint of Preato article.

Langer, Sandra L. "Decorous Beauty: The Paintings of Karl Anderson." *Arts Magazine* 59 (December 1984): 74–76.

∗ Preato, Robert R. "Karl Anderson: American Painter of Youth, Sunshine and Beauty." *Illuminator* (Fall–Winter 1979–80): 8–16.

Price, Frederic Newlin. "Karl Anderson—American." *International Studio* 76 (November 1922): 132–39.

J. Carroll Beckwith

"Beckwith." *Art Interchange* 7 (October 27, 1882): 84.

Beckwith, J. Carroll. Diaries. Archives of the National Academy of Design, New York. Volume for 1895: New-York Historical Society, New York.

James Carroll Beckwith Papers. Archives of American Art, Smithsonian Institution, Washington, D.C.

Bliss, Howard. "Carroll Beckwith." *Arts for America* 8 (November 1899): 545–56.

The Collection of Carroll Beckwith, N.A. New York: American Art Galleries, 1910.

"J. Carroll Beckwith." *American Bookmaker* 7 (July 1888): n.p.

Kobbe, Gustave. "J. Carroll Beckwith." *Truth* 18 (October 1899): 255–58.

Larned, Charles William. "An Enthusiast in Painting." *Monthly Illustrator* 3 (February 1895): 131–37.

Mitnick, Barbara J., and Thomas Folk. "The Artist and His Model: J. Carroll Beckwith and Evelyn Nesbit." *Arts and Crafts Quarterly* 5 (1992): 12–18.

Straham, Edward. "James Carroll Beckwith." *Art Amateur* 6 (April 1882): 94–97.

Wickenden, Robert J. "The Portraits of Carroll Beckwith." *Scribner's Magazine* 47 (April 1910): 449–60.

George Biddle

∗ Biddle, George. *An American Artist's Story.* Boston: Little, Brown and Co., 1939.

Pierrre Bonnard

Dauberville, Jean, and Henry Dauberville. *Bonnard: Catalogue raisonné de l'oeuvre peint.* 4 vols. Paris: Editions J. et H. Bernheim-Jeune, 1965–74.

∗ Fermigier, André. *Pierre Bonnard.* New York: Harry N. Abrams, 1984.

Newman, Sasha M., ed. *Bonnard: The Late Paintings.* Washington, D.C.: Phillips Collection, 1984.

∗ Rewald, John. *Pierre Bonnard.* New York: Museum of Modern Art, 1948.

Soby, James Thrall, and Monroe Wheeler. *Bonnard and His Environment.* New York: Museum of Modern Art, 1964.

∗ Terasse, Antoine. *Pierre Bonnard: Biographical and Critical Study.* Geneva: Skira, 1964.

Vaillant, Annette. *Bonnard.* Paris: La Bibliothèque des Arts, 1992.

John Leslie Breck

∗ Corbin, Kathryn. "John Leslie Breck, American Impressionist." *Antiques* 134 (November 1988): 1142–49.

Memorial Exhibition of Paintings by John Leslie Breck. Intro. Benjamin Kimball. Boston: St. Botolph Club, 1899; New York: National Arts Club, 1900. Essays identical; exhibition content differs.

William Blair Bruce

Bonds, Gunvor. "William Blair Bruce, Caroline Benedicks och Brucebo." M.A. thesis, Stockholms Universitet Konstvetenskapliga Institutionen, 1977.

MacDonald, Colin S., comp. "William Blair Bruce." In *Dictionary of Canadian Artists,* 1: 96–97. Ottawa: Canadian Paperbacks Publishing, 1967.

Murray, Joan. "The Man Who Painted Ghosts." *MD* (December 1985): 30–32.

———, ed. *Letters Home, 1859–1906: The Letters of William Blair Bruce.* Moonbeam, Canada: Penumbra Press, 1982.

Karl Albert Buehr

Karl Buehr Papers. Archives of American Art, Smithsonian Institution, Washington, D.C.

Granger, Kathleen B. "My Most Unforgettable Character." *Reader's Digest* 94 (April 1969): 88–92.

Theodore Earl Butler

Gross, Sally. "Theodore Earl Butler (1860–1936): His Life and Work."

M.A. thesis, Bryn Mawr College, 1982.

∗ Love, Richard H. *Theodore Earl Butler: Emergence from Monet's Shadow.* Chicago: Haase-Mumm Publishing Co., 1985.

T. E. Butler. Paris: Bernheim-Jeune and Co., 1912.

Theodore Earl Butler (1860–1936). Chicago: Signature Galleries, 1976.

Paul Cézanne

Badt, Kurt. *The Art of Cézanne.* New York: Hacker Art Books, 1985.

Rewald, John. *Cézanne: A Biography.* New York: Simon and Schuster, 1948.

———. *Cézanne and America.* Princeton, N.J.: Princeton University Press, 1989.

Rishel, Joseph J. *Cézanne in Philadelphia Collections.* Philadelphia: Philadelphia Museum of Art, 1983.

Shiff, Richard. *Cézanne and the End of Impressionism.* Chicago: University of Chicago Press, 1984.

Venturi, Lionello. *Cézanne, son art—son oeuvre.* 2 vols. Paris: P. Rosenberg, 1936.

Weschler, Judith, ed. *Cézanne in Perspective.* Englewood Cliffs, N.J.: Prentice-Hall, 1975.

Emma Richardson Cherry

Wright, Lucy Runnels. "A Woman Extraordinary." *Texas Outlook* 21 (May 1937): 28–29.

Alson Skinner Clark

[Seares, Mabel Urmy]. "Alson Skinner Clark, Artist." *California Southland* 9 (March 1927): 28–29.

∗ Stern, Jean. *Alson S. Clark.* Los Angeles: Petersen Publishing Co., 1983.

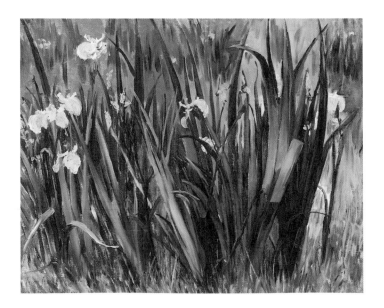

180. John Leslie Breck (1860–1899). *Yellow Fleur-de-Lis,* 1888. Oil on canvas, 17⅞ x 21⅞ in. (45.4 x 55.6 cm). Terra Foundation for the Arts; Daniel J. Terra Collection.

————. "Alson Clark: An American at Home and Abroad." In Patricia Trenton and William H. Gerdts, *California Light, 1900–1930,* pp. 113–36, 182. Laguna Beach, Calif.: Laguna Beach Art Museum, 1990.

Whiting, Elizabeth. "Painting in the Far West: Alson Clark, Artist." *California Southland* 3 (February 1922): 8–9.

Charles Conder

Gibson, Frank. *Charles Conder: His Life and Work.* London: John Lane, Bodley Head, 1914.

Hoff, Ursula. *Charles Conder.* Melbourne: Lansdowne Press, Lansdowne Australian Art Library, 1972.

Rogers, David. *Charles Conder, 1868–1909.* Sheffield, England: Graves Art Gallery, 1967.

Rothenstein, Sir John. *The Life and Death of Charles Conder.* London: Dent, 1938.

Dawson Dawson-Watson

A Collection of the Works of Mr. Dawson-Watson. Saint Louis: City Art Museum, 1912.

Curley, F.E.A. "Dawson Watson, Pinx." *Reedy's Mirror* 22 (December 5, 1913): 12–13.

* Dawson-Watson, Dawson. "Impressionism." Manuscript, 1894. Dawson-Watson family archives

————. "The Rolling-Pin in Art." *Literary Review* 1 (May 1897): 70.

————. "Impressionism." *Mirror* 17 (March 28, 1907): 33.

* ————. "The Real Story of Giverny." In Eliot Clark, *Theodore Robinson: His Life and Art.* Chicago: R. H. Love Galleries, 1979, pp. 65–67.

————. "Things Remembered." Manuscript, Dawson-Watson family archives.

Fisk, Frances Battaile. *A History of Texas Artists and Sculptors,* pp. 30–32. Abilene, Tex.: Fisk Publishing Co., 1928.

"Glory of the Morning." *Pioneer Magazine* 7 (April 1927): 5–6, 12.

Hutchings, Emily Grant. "Art and Artists." *Globe Dispatch* (Saint Louis), July 12, 1925.

"Kindly Caricatures, No. 99: Dawson Watson." *Mirror* (Saint Louis) 17 (March 19, 1907): 7–8.

Louis Paul Dessar

Andersen, Jeffrey W. *Old Lyme: The American Barbizon.* Old Lyme, Conn.: Florence Griswold Museum, 1982.

Cooper, Lena. "Louis Paul Dessar and His Work." *Brush and Pencil* 5 (December 1899): 97–106.

* Dessar, Louis. Interview with DeWitt Lockman, 1927. Typescript. DeWitt Lockman Papers, New-York Historical Society, New York.

McCormick, William B. "Louis Dessar, Tonalist." *International Studio* 79 (July 1924): 295–97.

William de Leftwich Dodge

Arkell, Georgia Fraser. "The Paintings of William de Leftwich Dodge." *Art Education* 7 (February 1901): 242–46.

Balge, Marjorie. "William de Leftwich Dodge: American Renaissance Artist." *Art and Antiques* 5 (January–February 1982): 96–103.

William de Leftwich Dodge Papers. Archives of American Art, Smithsonian Institution, Washington, D.C.

* Kimbrough, Sara Dodge. *Drawn from Life.* Jackson: University of Mississippi Press, 1976.

Platt, Frederick. "A Brief Autobiography of William de Leftwich Dodge." *American Art Journal* 14 (Spring 1982): 55–63.

"William de Leftwich Dodge— American Painter of Distinction." *Fine Arts Journal* 14 (February 1903): [42]–48.

J. Stirling Dyce

Les Artistes américains à Giverny, pp. 10, 15. Vernon, France: Musée Municipal A.-G. Poulain, 1984.

Johnson, J., and A. Greutzner, comps. *The Dictionary of British Artists, 1880–1940,* p. 159. Wood-

bridge, England: Antique Collectors' Club, 1988.

James Wall Finn

C., H.D. "The Knickerbocker Hotel: A Novelty in Decoration." *Architectural Record* 21 (January 1907): 12.

Cortissoz, Royal. "James Wall Finn." In *American Artists,* pp. 255–59. New York: Charles Scribner's Sons, 1923.

Mary Hubbard Foote

* Fahlman, Betsy. "Women Art Students at Yale, 1869–1913." *Woman's Art Journal* 12 (Spring–Summer 1991): 15–23.

Foote, Edward. "A Report on Mary Foote." *Yale University Library Gazette* 49 (October 1974): 225–30.

Mary Hubbard Foote Papers. Beinecke Rare Book and Manuscript Library, Yale University, New Haven, Connecticut.

Frederick Frieseke

The American Painter F. C. Frieseke: The Small Retrospective. New Bedford, Mass.: Swain School of Design, 1974.

Chambers, Bruce W. *Frederick C. Frieseke: Women in Repose.* New York: Berry-Hill Galleries, 1990.

Domit, Moussa M. *Frederick Frieseke, 1874–1939.* Savannah, Ga.: Telfair Academy of Arts and Sciences, 1974.

"Frieseke, at 68, Turns to Pure Landscape." *Art Digest* 6 (March 1932): 12.

Frederick Frieseke Papers. Archives of American Art, Smithsonian Institution, Washington, D.C.

Gallatin, Albert E. "The Paintings of Frederick C. Frieseke." *Art and Progress* 3 (October 1912): 747–49.

Kilmer, Nicholas, and Ben L. Summerford. *A Retrospective Exhibition of the Work of F. C. Frieseke.* San Francisco: Maxwell Galleries, 1982.

The Last Expatriate: F. C. Frieseke. Fayetteville, N.C.: Museum of Art, 1980.

Leclere, Tristan. "La Décoration d'un hôtel américain." *L'Art décoratif* 8 (1906): 195–200.

Lucas, E. V. "John White Alexander and Frederick Carl Frieseke." *Ladies' Home Journal* 43 (July 1926): 16–17, 126.

* MacChesney, Clara T. "Frederick Carl Frieseke: His Work and Suggestions for Painting from Nature." *Arts and Decoration* 3 (November 1912): 13–15.

* ————. "Frieseke Tells Some of the Secrets of His Art." *New York Times,* June 7, 1914, sec. 6, p. 7.

Occhini, Pier Ludovico. "Karl Frédéric Frieseke." *Vita d'arte* 7 (February 1911): 58–68.

* Pancza, Arlene. "Frederick Carl Frieseke (1874–1939)." In J. Gray Sweeney, *Artists of Michigan from the Nineteenth Century,* pp. 168–73. Muskegon, Mich.: Muskegon Museum of Art; Detroit: Detroit Historical Museum, 1987.

Pica, Vittorio. "Artisti contemporanei: Frederick Carl Frieseke." *Emporium* 38 (November 1913): 323–37.

Taylor, E. A. "The Paintings of F. C. Frieseke." *International Studio* 53 (October 1914): 259–67.

Walton, William. "Two Schools of Art: Frank Duveneck, Frederick C. Frieseke." *Scribner's Magazine* 58 (November 1915): 643–46.

Weller, Allen S. *Frederick Frieseke, 1874–1939.* New York: Hirschl and Adler Galleries, 1966.

————. "Frederick Carl Frieseke: The Opinions of an American Impressionist." *Art Journal* 28 (Winter 1968): 160–65.

Arthur Burdett Frost

"A. B. Frost." *New York Evening Post,* June 26, 1928, p. 14.

Frost, A[rthur] B. "From a French Sketch-Book." *Scribner's Magazine* 75 (March 1924): 263–70.

Lanier, Henry W. *A. B. Frost, The American Sportsman's Artist.* New York: Derrydale Press, 1933.

* Reed, Henry M. *The A. B. Frost Book.* Rutland, Vt.: Charles Tuttle and Co., 1967. A revised version is forthcoming.

————. *The World of A. B. Frost: His Family and Their Circle.* Mont-

clair, N.J.: Montclair Art Museum, 1983.

Mariquita Gill

D., J.I.H. [John Ireland Howe Downes]. *Mariquita Gill.* [New Haven, Conn.?]: Tuttle, Morehouse and Taylor, [1915?].

Edmund W. Greacen

* Knudsen, Elizabeth Greacen. *Edmund W. Greacen, N.A., American Impressionist, 1876–1949.* Jacksonville, Fla.: Cummer Gallery of Art, 1972.

Ellen Day Hale

* Chesebro, Alanna. *Ellen Day Hale, 1855–1940.* New York: Richard York Gallery, 1981.

Hale, Nancy. *The Life in the Studio.* Boston: Little, Brown and Co., 1969.

Ellen Day Hale Papers. Archives of American Art, Smithsonian Institution, Washington, D.C.

Hale Family Papers. Sophia Smith Collection, Smith College, Northampton, Massachusetts.

* Hoppin, Martha J. "Women Artists in Boston, 1870–1900: The Pupils of William Morris Hunt." *American Art Journal* 13 (Winter 1981): 17–46.

Peet, Phyllis. *American Women of the Etching Revival.* Atlanta: High Museum of Art, 1988.

Philip Leslie Hale

Castano, John. *Oils and Drawings by Philip Leslie Hale, 1865–1931.* Boston: Castano Galleries, 1951.

Coburn, Frederick W. "Philip L. Hale: Artist and Critic." *World To-Day* 14 (January 1908): 59–67.

———. "Philip L. Hale: An Appreciation." In *Philip Leslie Hale, Vermeer,* pp. [xvii]–xxii. Rev. ed. Boston: Hale, Cushman & Flint, 1937.

Folts, Franklin P. *Paintings and Drawings by Philip Leslie Hale (1865–1931) from the Folts Collection.* Boston: Vose Galleries, 1966.

Hale, Nancy. *The Life in the Studio.* Boston: Little, Brown and Co., 1969.

Philip Leslie Hale Papers. Archives of American Art, Smithsonian Institution, Washington, D.C.

Hale Family Papers. Sophia Smith Collection, Smith College, Northampton, Massachusetts.

Hardwicke, Greer, and Rob Leith. *Two Dedham Artists: Philip and Lilian Hale.* Dedham, Mass.: Dedham Historical Society, 1987.

K., A.W. "The Philip L. Hale Memorial Exhibition." *Bulletin of the Museum of Fine Arts* (Boston) 29 (December 1931): 113–16.

* Lowrey, Carol. "The Art of Philip Leslie Hale." In *Philip Leslie Hale, A.N.A.,* pp. 3–11. Boston: Vose Galleries, 1988.

William Howard Hart

Child, William H. *History of the Town of Cornish, New Hampshire, with Genealogical Record, 1763–1910.* 2 vols. in 1, p. 230. Concord, N.H.: Rumford Press, [1911?]; reprint, Spartanburg, S.C.: Reprint Co., 1975.

A Circle of Friends: Art Colonies of Cornish and Dublin, pp. 56–57. Keene, N.H.: Thorne-Sagendorph Art Gallery, Keene State College; Durham, N.H.: University Art Galleries, University of New Hampshire, 1985.

Philip Leslie Hale Papers. Archives of American Art, Smithsonian Institution, Washington, D.C. Hart's extensive correspondence with Hale.

Blanche Hoschedé-Monet

* Fourny-Dargère, Sophie. *Blanche Hoschedé-Monet, 1865–1947: Une Artiste de Giverny.* Vernon, France: Musée Municipal A.-G. Poulain, 1991.

Hoschedé, Jean-Pierre. "Blanche Hoschedé-Monet." In *Claude Monet and the Giverny Artists.* New York: Charles E. Slatkin Galleries, 1960.

———. *Blanche Hoschedé Monet, peintre impressioniste.* Rouen, France: Lecerf, 1961.

Henry Salem Hubbell

Catalogue of an Exhibition of Paintings by Henry Salem Hubbell. Godfrey, Ill.: Wade Memorial Fine Arts Building, Monticello Seminary, [c. 1920].

* *Henry Salem Hubbell: A Retrospective.* Coral Gables, Fla.: Lowe Art Museum, 1975.

Leon Kroll

Bowers, Fredson, and Nancy Hale, eds. *Leon Kroll: A Spoken Memoir.* Charlottesville: University of Virginia, 1983.

Lane, John W. "Leon Kroll." *American Magazine of Art* 30 (April 1937): 219–23.

Leon Kroll. New York: American Artists Group, 1946.

Josephine Miles Lewis

* Fahlman, Betsy. "Women Art Students at Yale, 1869–1913." *Woman's Art Journal* 12 (Spring–Summer 1991): 15–23.

"Les Salons des Indépendants de New-York, de la Chicago Society of Etchers, du Washington Water Color-Club de Baltimore, de la Brooklyn Society of Etchers, de la Berkeley League of Fine Arts," *Revue du vrai et du beau,* no. 64 (August 10, 1925): 18–19.

Mary Fairchild MacMonnies Low

* Gordon, E. Adina, and Sophie Fourny-Dargère. *Frederick William MacMonnies (1863–1937), Mary Fairchild MacMonnies (1858–1946): Deux Artistes américains à Giverny.* Vernon, France: Musée Municipal A.-G. Poulain, 1988.

* Smart, Mary. "Sunshine and Shade: Mary Fairchild MacMonnies Low." *Woman's Art Journal* 4 (Fall 1983–Winter 1984): 20–25.

Will Hickok Low

Dreishpoon, Douglas S. "Will H. Low: American Muralist (1853–1932), with a Catalogue Listing of His Known Work." M.A. thesis, Tufts University, 1979.

* Low, Will. "In an Old French Garden." *Scribner's Magazine* 32 (July 1902): 3–19.

* ———. *A Chronicle of Friendships, 1873–1900.* New York: Charles Scribner's Sons, 1908.

———. *A Painter's Progress.* New York: Charles Scribner's Sons, 1910.

———. "The Primrose Way." Typescript, 1930. McKinney Library, Albany Institute of History and Art, Albany.

Meixner, Laura L. "Will Hickok Low (1853–1932): His Early Career and Barbizon Experience." *American Art Journal* 17 (Autumn 1985): 51–70.

A Painter's Garden of Pictures Painted from Early Spring until Late in the Autumn of 1901 at Giverny in France by Will H. Low. New York: Avery Art Galleries, 1902.

Frederick William MacMonnies

Bahssin, David. "The Paintings of Frederick MacMonnies and His Life in Giverny." Typescript, 1984.

Brinton, Christian. "Frederick MacMonnies." *Munsey's Magazine* 34 (January 1906): 415–22.

Bullet, Emma. "MacMonnies, the Sculptor, Working Hard as a Painter." *Brooklyn Daily Eagle,* September 8, 1901, sect. 1, p. 2.

Dreiser, Theodore. "The Art of MacMonnies and Morgan." *Metropolitan* 7 (February 1898): 143–51.

Foote, Edward J. "An Interview with Frederick W. MacMonnies, American Sculptor of the Beaux-Arts Era." *New-York Historical Society Quarterly* 61 (July–October 1977): 102–23.

"Frederick MacMonnies' Home near Paris." *Town and Country* 60 (February 3, 1906): 16.

* Gordon, E. Adina, and Sophie Fourny-Dargère. *Frederick William MacMonnies (1863–1937), Mary Fairchild MacMonnies (1858–1946): Deux Artistes américains à Giverny.* Vernon, France: Musée Municipal A.-G. Poulain, 1988.

Low, Will H. "Frederick MacMonnies." *Scribner's Magazine* 18 (November 1895): 617–28.

MacMonnies, Frederick. Interviews with DeWitt Lockman, January 29 and February 15, 1927. Typescript. DeWitt M. Lockman Papers, New-York Historical Society, New York.

Pettit, Edith. "Frederick MacMonnies, Portrait Painter." *International Studio* 29 (October 1906): 319–24.

Leon A. Makielski

Burnet, Mary Q. *Art and Artists of Indiana.* New York: Century Co., 1921, pp. 295–97.

"Indiana Artists Series: Leon A. Makielski." *New Era,* February 10, 1912.

Willard Leroy Metcalf

Bolton, Theodore. *Memorial Exhibition of Paintings by the Late Willard L. Metcalf.* New York: Century Association, 1928.

Brinton, Christian. "Willard L. Metcalf." *Century* 77 (November 1908): 155.

Cortissoz, Royal. "Willard L. Metcalf, an American Landscape Painter." *Appleton's Booklovers Magazine* 6 (October 1905): 509–11.

———. *Willard L. Metcalf.* Academy Publications, no. 60. New York: American Academy of Arts and Letters, 1927.

de Veer, Elizabeth. "Willard Metcalf's 'The Ten Cent Breakfast.'" *Nineteenth Century* 3 (Winter 1977): 51–53.

✶ de Veer, Elizabeth, and Richard J. Boyle. *Sunlight and Shadow: The Life and Art of Willard L. Metcalf.* New York: Abbeville Press, 1987.

de Veer, Elizabeth, and Francis Murphy. *Willard Leroy Metcalf: A Retrospective.* Springfield, Mass.: Museum of Fine Arts, 1976.

Duncan, Walter Jack. *Paintings by Willard L. Metcalf.* Washington, D.C.: Corcoran Gallery of Art, 1925.

Ely, Catherine Beach. "Willard L. Metcalf." *Art in America* 13 (October 1925): 332–36.

Willard L. Metcalf Papers. Archives of American Art, Smithsonian Institution, Washington, D.C.

Shepard, Lewis A. "Willard Metcalf." *American Art Review* 4 (August 1977): 66–75.

Teevan, Bernard. "A Painter's Renaissance." *International Studio* 82 (October 1925): 3–11.

Thomas Buford Meteyard

✶ Kilmer, Nicholas. *Thomas Buford Meteyard (1865–1928): Paintings and Watercolors.* New York: Berry-Hill Galleries, 1989.

Richard Miller

Allan, Sidney [Sadakichi Hartmann]. "Masterpieces of American Portraiture (Richard E. Miller)." *Bulletin of Photography* 16 (June 2, 1915): 684–86.

Ball, Robert, and Max W. Gottschalk. *Richard E. Miller, N.A.: An Impression and Appreciation.* Saint Louis: Longmire Fund, 1968.

Pica, Vittorio. "Artisti contemporanei: Richard Emile Miller." *Emporium* 39 (March 1914): 162–77.

Richard Emil Miller (1875–1943). Bayeux, France: Hôtel des Ventes de Bayeux, 1991.

Seares, Mabel Urmy. "Richard Miller in a California Garden." *California Southland,* no. 38 (February 1923): 10–11.

Thompson, Wallace. "Richard Miller: A Parisian-American Artist." *Fine Arts Journal* 27 (November 1912): 709–14.

Claude Monet

B., C.I. "Monet and Giverny." *New York Tribune,* September 8, 1901, pt. 2, p. 1.

✶ *Claude Monet and the Giverny Artists.* New York: Charles E. Slatkin Galleries, 1960.

Elder, Marc [Marcel Tendron]. *A Giverny, chez Claude Monet.* Paris: Bernheim-Jeune, 1924.

Fitzgerald, Desmond. "Claude Monet." In *Loan Collection of Paintings by Claude Monet and Eleven Sculptures by Auguste Rodin.* Boston: Copley Society, 1905.

———. "Claude Monet: Master of Impressionism." *Brush and Pencil* 15 (March 1905): 181–95.

Fuller, William H. *Claude Monet and His Paintings.* New York: Lotos Club, 1899.

Guillaud, Maurice, et al. *Claude Monet at the Time of Giverny.* Paris: Centre Culturel du Marais; Guillaud Editions, 1983.

✶ Gwynn, Stephen. *Claude Monet and His Garden.* New York: Macmillan Co., 1934.

Hoschedé, Jean-Pierre. *Claude Monet: Le Mal Connu.* Geneva: Pierre Cailler, 1960.

House, John. *Monet: Nature into Art.* New Haven, Conn.: Yale University Press, 1986.

✶ Joyes, Claire. *Monet at Giverny.* New York: Mayflower, 1975.

✶ ———. *Claude Monet: Life at Giverny.* New York: Vendôme Press, 1985.

———. *Monet's Table.* New York: Simon and Schuster, 1989.

Kemp, Gerald van der. *A Visit to Giverny.* Trans. Bronia Fuchs. Versailles, France [?]: Editions d'Art Lys, 1990.

King, Polly. "Paris Letter." *Art Interchange* 31 (September 1893): 65.

———. "Paris Letter. Claude Monet." *Art Interchange* 31 (November 1893): 131–32.

Mirbeau, Octave. "Claude Monet." *L'Art dans les deux mondes* (March 7, 1891): 183–85.

Pach, Walter. "At the Studio of Claude Monet." *Scribner's Magazine* 43 (June 1908): 765–67.

✶ Perry, Lilla Cabot. "Reminiscences of Claude Monet from 1889 to 1909." *American Magazine of Art* 18 (March 1927): 119–25.

✶ Robinson, Theodore. "Claude Monet." *Century* 44 (September 1892): 696–701.

✶ Seaton-Schmidt, Anna. "An Afternoon with Claude Monet." *Modern Art* 5 (January 1, 1897): 32–35.

Stuckey, Charles F., ed. *Monet: A Retrospective.* New York: Hugh Lauter Levin Associates, 1985.

✶ Tucker, Paul Hayes. *Monet in the '90s.* Boston: Museum of Fine Arts; New Haven, Conn.: Yale University Press, 1989.

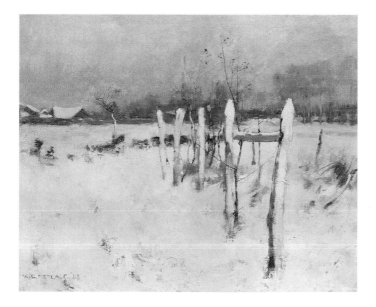

181. Willard Metcalf (1858–1925). *The First Snow,* 1888. Oil on canvas, 12½ x 16 in. (31.8 x 40.6 cm). Private collection; Courtesy of Kennedy Galleries, Inc., New York.

✻ Wildenstein, Daniel. *Claude Monet: Biographie et catalogue raisonné.* 4 vols. Lausanne, Switzerland: Bibliothèque des Arts, 1974–85.

✻ ———. *Monet's Years at Giverny: Beyond Impressionism.* New York: Metropolitan Museum of Art, 1978.

Pauline Lennards Palmer

Bulliet, C. J. "Artist of Chicago Past and Present," *Chicago Daily News,* February 8, 1936.

M., M. "Pauline Palmer." *Arts for America* 8 (January 15, 1899): 217–18.

Schulze, Paul. "Chicago's 'Painter Lady.'" *Bulletin of the Union League Club of Chicago,* September 1939.

Soady, Fred W. *Pauline Palmer: American Impressionist, 1867–1938.* Peoria, Ill.: Lakeview Museum of Arts and Sciences, 1984.

Sparks, Esther. *A Biographical Dictionary of Painters and Sculptors in Illinois, 1808–1945.* Ph.D. dissertation, Northwestern University, 1971.

Lawton S. Parker

McCauley, Lena M. "Lawton S. Parker." *Art Student* 1 (October 1915): 4–8.

Paintings by Lawton Parker. Chicago: Art Institute of Chicago, 1912.

Parker, Lawton S. "Another View of Art Study in Paris." *Brush and Pencil* 11 (November 1902): 11–15.

Pattison, James William. "Many Sorts of Realism." *Fine Arts Journal* 28–29 (September 1913): 545–49.

Sheldon, Rowland. "Two American Artists Distinguished Abroad: Lawton Parker and C. Arnold Slade." *Fine Arts Journal* 30 (May 1914): 140–51.

Webster, Henry Kitchell. "Lawton Parker." *Collier's* 52 (January 31, 1914): 23.

Zug, George Breed. "The Art of Lawton Parker." *International Studio* 57 (December 1915): xxxvii–xliii.

Ernest Clifford Peixotto

✻ "Ernest Clifford Peixotto." In *California Art Research,* ed. Gene Hailey,

p. 9. San Francisco: WPA Project, 1937.

"The Paintings and Drawings of Ernest C. Peixotto." *Mark Hopkins Institute Review of Art* (Summer 1903): 28–31.

✻ Peixotto, Ernest Clifford. Interviews by DeWitt Lockman, March 27, 1926; March 30, 1926; and April 1, 1926. Typescript. DeWitt Lockman Papers, New-York Historical Society, New York. For Peixotto's recollections of Giverny, see p. 3.

Robertson, Peter. "Peixotto and His Work." *Out West* 19 (August 1903): 134–37.

Lilla Cabot Perry

Feld, Stuart P. *Lilla Cabot Perry: A Retrospective Exhibition.* New York: Hirschl and Adler Galleries, 1969.

Harlow, Virginia. *Thomas Sergeant Perry: A Biography.* Durham, N.C.: Duke University Press, 1950.

Hilman, Carolyn, and Jean Nutting Oliver. "Lilla Cabot Perry: Painter and Poet." *American Magazine of Art* 14 (November 1923): 601–4.

✻ Martindale, Meredith. *Lilla Cabot Perry: An American Impressionist.* Washington, D.C.: National Museum of Women in the Arts, 1990.

Václav Radimsky

"Exposition Wenceslas Radimsky." *L'Art et les artistes* 11 (1910): 83.

Mádl, Karel B. "Václav Radimsky." *Volné smery* 3 (1899): 278–88.

S., H. "Studio-Talk." *Studio* 50 (1910): [246]–48.

✻ Sevecek, Ludvík. *Václav Radimsky: vyber z malírskeho díla.* Gottwaldov (now Zlín), Czechoslovakia: Oblastni Galerie, 1985.

Ellen Gertrude Emmet Rand

Cummings, Hildegarde. *Good Company: Portraits by Ellen Emmet Rand.* Storrs: William Benton Museum of Art, University of Connecticut, 1984.

Dearinger, David B., comp. "The Emmet Family Papers: An Inventory." Typescript, summer 1990. New York Regional Office, Archives of American Art, Smithsonian Institution.

Ellen Emmet Rand. Pittsfield, Mass.: Berkshire Museum, 1954.

Emmet Family Papers. Archives of American Art, Smithsonian Institution, Washington, D.C.

✻ Hoppin, Martha J., and Lydia Sherwood McClean. *The Emmets: A Family of Women Painters.* Pittsfield, Mass.: Berkshire Museum, 1982.

Louis Ritman

De Fleur, Nicole. *Louis Ritman, 1892–1963: American Painter.* Random Lake, Wis.: Times Publishing Co., 1967.

✻ Love, Richard H. *Louis Ritman: From Chicago to Giverny.* Chicago: Haase-Mumm Publishing Co., 1989.

The Paintings of Louis Ritman (1889–1963). Chicago: Signature Galleries, 1975.

Waterman, C. H. "Louis Ritman." *International Studio* 67 (April 1919): 63–65.

Louis Ritter

"Art and Artists." *Boston Evening Transcript,* October 25, 1887, p. 6.

"Art Notes. Exhibition of Mr. Ritter's Paintings." *Boston Evening Transcript,* January 28, 1888, p. 6.

Knowlton, Helen M. "Louis Ritter." *Boston Evening Transcript,* March 18, 1892, p. 5.

Ross, Marilyn H. "Louis Ritter." In *Explorations in Realism, 1870–1880: Frank Duveneck and His Circle from Bavaria to Venice,* pp. 54–55. Framingham, Mass.: Danforth Museum of Art, 1989.

Young, Denny, and Bruce Weber. *The Golden Age: Cincinnati Painters of the Nineteenth Century in the Cincinnati Art Museum,* pp. 97–98. Cincinnati: Cincinnati Art Museum, 1979.

Theodore Robinson

✻ Baur, John I. H. *Theodore Robinson, 1852–1896.* Brooklyn: Brooklyn Museum, 1946.

———. "Photographic Studies by an Impressionist." *Gazette des beaux-arts,* ser. 6, 30 (October–November 1946): 319–30.

Byrd, D. Gibson. *Paintings and Drawings by Theodore Robinson.* Madison, Wis.: University of Wisconsin, 1964.

Campbell, Pearl H. "Theodore Robinson: A Brief Historical Sketch." *Brush and Pencil* 4 (September 1899): 287–89.

Clark, Eliot. "Theodore Robinson." *Art in America* 6 (October 1918): 286–94.

———. "Theodore Robinson: A Pioneer Impressionist." *Scribner's Magazine* 70 (December 1921): 763–68.

✻ ———. *Theodore Robinson: His Life and Art.* Chicago: R. H. Love Galleries, 1979. Written in the early 1920s.

✻ *The Figural Images of Theodore Robinson, American Impressionist.* Edited by Bev Harrington, with an introduction by William Kloss. Oshkosh, Wis.: Paine Art Center and Arboretum, 1987.

Garland, Hamlin. "Theodore Robinson." *Brush and Pencil* 4 (September 1899): 285–86.

Harrison, Birge. "With Stevenson at Grèz." *Century* 93 (December 1916): 306–14.

✻ Johnston, Sona. *Theodore Robinson, 1852–1896.* Baltimore: Baltimore Museum of Art, 1973. Ms. Johnston is editing the Theodore Robinson diaries, Frick Art Reference Library, New York, and is preparing a catalogue raisonné.

Killie, Robert J. "A New Look at Theodore Robinson's Giverny Mill Views." Typescript, January 1987.

Levy, Florence N. "Theodore Robinson." *Bulletin of the Metropolitan Museum of Art* 1 (July 1906): 111–12.

Lewison, Florence. "Theodore Robinson: America's First Impressionist." *American Artist* 27 (February 1963): 40–45, 72–73.

✻ ———. "Theodore Robinson and Claude Monet." *Apollo* 78 (September 1963): 208–11.

———. *Theodore Robinson, the 19th Century Vermont Impressionist: An Exhibition of Paintings.* Manchester: Southern Vermont Artists, 1971.

Oil Paintings and Studies by the Late Theodore Robinson. New York: American Art Galleries, 1898.

Paintings in Oil and Pastel by Theodore Robinson and Theodore Wendel. Boston: Williams and Everett Gallery, 1892.

Robinson, Theodore. Diaries, March 1892–March 1896. Frick Art Reference Library, New York.

———. "A Normandy Pastoral." *Scribner's Magazine* 21 (June 1897): 757.

Sherman, Frederic Fairchild. "Theodore Robinson," c. 1928. Frick Art Reference Library, New York.

"Theodore Robinson." *Scribner's Magazine* 19 (June 1896): 784–85.

Theodore Robinson. New York: Florence Lewison Gallery, 1962.

Theodore Robinson, American Impressionist (1852–1896). New York: Kennedy Galleries, 1966.

Theodore Robinson, America's First Impressionist. New York: Florence Lewison Gallery, 1963.

Guy Rose

Anderson, Anthony, and Earl L. Stendahl. *Guy Rose: A Biographical Sketch and Appreciation, Paintings of France and America.* Los Angeles: Stendahl Galleries, 1922.

Berry, Rose V. S. "A Painter of California." *International Studio* 80 (January 1925): 332–34, 336–37.

Boswell, Peyton, and Anthony Anderson. *Catalogue of the Guy Rose Memorial.* Los Angeles: Stendahl Art Galleries, 1926.

⋆ Fort, Ilene Susan. "The Cosmopolitan Guy Rose." In Patricia Trenton and William H. Gerdts, *California Light, 1900–1930,* pp. 93–111. Laguna Beach, Calif.: Laguna Beach Art Museum, 1990.

———. "The Figure Paintings of Guy Rose." *Art of California* 4 (January 1991): 46–50.

⋆ Rose, Guy. "At Giverny." *Pratt Institute Monthly* 6 (December 1897): 81–82.

South, Will. "Americans in Paris." *Southwest Art* (November 1987): 48–53.

———. "The Painterly Pen." *Antiques and Fine Arts* 10 (April 1992): 120.

John Singer Sargent

Blashfield, Edwin Howland. "John Singer Sargent—Recollections." *North American Review* 221 (June 1925): 641–53.

Charteris, Evan. *John Sargent.* New York: Charles Scribner's Sons, 1927.

Downes, William Howe. *John S. Sargent: His Life and Work.* Boston: Little, Brown and Co., 1925.

Fairbrother, Trevor J. *John Singer Sargent and America.* New York: Garland Publishing, 1986.

Getscher, Robert, and Paul Marks. *James McNeill Whistler and John Singer Sargent: Two Annotated Bibliographies.* New York: Garland Publishing, 1986.

Hills, Patricia, et al. *John Singer Sargent.* New York: Whitney Museum of American Art, 1986. Includes William H. Gerdts, "The Arch-Apostle of the Dab-and-Spot School: John Singer Sargent as an Impressionist," pp. [110]–45.

John Singer Sargent and the Edwardian Age. Leeds, England: Leeds Art Galleries, 1979.

Mount, Charles Merrill. *John Singer Sargent: A Biography.* London: Cresset Press, 1957.

Olsen, Stanley. *John Singer Sargent: His Portrait.* New York: St. Martin's Press, 1986.

Ormond, Richard. *John Singer Sargent: Paintings, Drawings, Watercolors.* New York: Harper and Row, 1970.

Ratcliff, Carter. *John Singer Sargent.* New York: Abbeville Press, 1982.

⋆ *Sargent at Broadway: The Impressionist Years.* New York: Coe Kerr Gallery, 1986.

Henry Fitch Taylor

Agee, William. "Rediscovery: Henry Fitch Taylor." *Art in America* 54 (November 1966): 40–43.

Zorach, Marguerite. "Henry Fitch Taylor." *Art Review* 1 (February 1922): 19, 29.

George Albert Thompson

"G. A. Thompson." *Art Digest* 12 (April 15, 1938): 15.

"George Albert Thompson, B.F.A., 1898." *Yale University Obituary Record* (1937–38): 275.

Abel George Warshawsky

Moure, Nancy. "Abel Warshawsky." *Art of California* 3 (September 1990): 61–65.

Nelson, Helen C. "A Glimpse of Warshawsky's Europe." *International Studio* (March 1926): 78–83.

⋆ Warshawsky, Abel G. *The Memories of an American Impressionist.* Edited and with an introduction by Ben L. Bassham. Kent, Ohio: Kent State University Press, 1980.

Theodore Wendel

Baur, John I. H. *Theodore Wendel: An American Impressionist, 1859–1932.* New York: Whitney Museum of American Art, 1976.

⋆ ———. "Introducing Theodore Wendel." *Art in America* 64 (November–December 1976): 102–5.

INDEX

Page numbers in *italic* refer to illustrations. Page numbers in **boldface** refer to brief biographies for selected artists.

PHOTOGRAPHY CREDITS